006 - 013

Balloon
balloon363@mac.com

014 - 021

Base Design
158 Lafayette, 5th Floor
New York, New York 10011
+1 212 625 9293
basenyc@basedesign.com
www.basedesign.com

022 - 027

Carol Bokuniewicz Design
73 Spring Street, Suite 505
New York, New York 10012
+1 212 941 1350
carol@carolbdesign.com

028 - 053

Christoph Niemann, Inc.
416 West 13th Street #309
New York, New York 10014
+1 212 229 2798
mail@christophniemann.com
www.christophniemann.com

054 - 067

Design Machine
648 Broadway, 2nd Floor
New York, New York 10012
+1 212 982 4289
info@designmachine.net
www.designmachine.net

068 - 083

Famous Mime
715-719 Broadway, 12th Floor
New York, New York 10003
+1 212 998 3390
rebecca@cat.nyu.edu

084 - 095

GH avisualagency
55 Nassau Avenue #2A1
Brooklyn, New York 11222
+1 718 388 5519
info@ghava.com
www.ghava.com

096 - 107

Honest
224 Center Street, 5th Floor
New York, New York 10003
+1 212 274 8552
info@stayhonest.com
www.stayhonest.com

108 - 125

HunterGatherer
191 Chrystie Street, #3F
New York, New York 10002
+1 212 979 1292
www.huntergatherer.net

126 - 137

Ian Perkins
+1 646 256 7954
ianperkinsuk@hotmail.com

138 - 147

Infornographic
107 Suffolk Street, Suite 413
New York, New York 10002
+1 212 420 0081
us@infornographic.org
www.infornographic.org

148 - 161

Juliette Cezzar
350 Manhattan Avenue #4R
Brooklyn, New York 11211
+1 917 747 2953
juliette.cezzar@aya.yale.edu
www.juliettececzar.com

162 - 171

karlssonwilker inc.
536 6th Avenue, 2nd Floor
New York, New York 10011
+1 212 929 8064
tellmewhy@karlssonwilker.com
www.karlssonwilker.com

172 - 175

Lone
+1 917-770-3766
aware@lonepanther.com
www.lonepanther.com

176 - 187

Mainland
jennifer.lew@simonandschuster.com

188 - 211

Min Choi
min.choi@mail.com
www.minch.org

212 - 217

One9ine
54 West 21st Street #501
New York, New York 10010
+1 212 929 7828
info@one9ine.com
www.one9ine.com

218 - 239

Office of Paul Sahre
536 6th Avenue, 3rd Floor
New York, New York 10011
+1 212 741 7739
paul@officeofps.com

240 - 247

Sagmeister Inc.
222 West 14th Street, Suite 15A
New York, New York 10011
+1 212 647 1789
ssagmeiste@aol.com
www.sagmeister.com

248 - 265

Scanography
glen@scannn.com

266 - 285

Suitman
50 Murray Street #908
New York, New York 10007
+1 212 577 6567
young10@earthlink.net

286 - 299

Sung Joong Kim
96 Schermerhorn Street, #1B
Brooklyn, New York 11021
s_545@yahoo.com

300 - 303

Trollbäck & Company
302 5th Avenue, 14th Floor
New York, New York 10011
+1 212 529 1010
www.trollback.com

BISPUBLISHERS

Infiltrate: The Front Lines of the New York Design Scene

Herengracht 370-372
1016 CH Amsterdam
P.O. Box 323
1000 AH Amsterdam
The Netherlands

P: +31 (0)20-5247560
F: +31 (0)20-5247557

bis@bispublishers.nl
www.bispublishers.nl

Editors: Nic Musolino and Helen Walters

Research and coordination:
Ruchika Joshi, Michael Babwausingh

Art Direction, Design and Production:
Design Machine, Triboro

Proofreading: Steven Pearl
Video capture and stills: David Correll

Assistance and support:
Armando Merlo, Tyler Haser, Robert
Heissmann, Severine Landrieu, Natasha
Shah, Iris Sautier

Book layout: Adobe InDesign CS
Type: Politie Regular, 7 pt by Min Choi
Printing: D2Print

Special thanks: Mel Byars, Glen Cummings,
Paul Davis, Paul Elliman, Eugenia and
Gregory Gelman, Michel Gondry, Joshua
Goodman, David Heasty, John Jay, Emin
Kadi, Ellen Kampinsky, Ivana Kalafatic,
Sheila Levrant de Bretteville, John
Maeda, Noreen Morioka, Ravi Naidoo, Marty
Pedersen, Michael Rock, Kaoru Sato, Lou
Strenger, Rietje van Vreden, Rudolf van
Wezel, Alex Weil, Larry Wiesler

Printed in Singapore

ISBN 90-6369-044-4

Infiltrate / Balloon

A conversation with Sang Do Kim, principal, Balloon.

Gelman: So let's start from the beginning. You studied in Seoul, Korea. And after graduation you worked --

Balloon: I worked at Ahn Graphics in Seoul, a company my teacher founded. So I was picked up by my teacher, Ahn Sang-Soo, to work for him.

Gelman: Oh, really!

Balloon: You know him?

Gelman: Yeah!

Balloon: Everyone knows him. I worked for him. I worked for his company and was involved in his other projects as well.

Gelman: How many people worked for him at that time?

Balloon: You mean designers? I guess, almost 10 or 12. It's kind of a big company. And it's kind of -- he's at school, so he's less involved with the company projects than his own projects. I was in the company, so it went back and forth, work on a company project, then work with him on his own project. It was kind of nice. I did a really big project that I wouldn't have been able to do it if I hadn't met him.

Gelman: Was he a good teacher?

Balloon: Yeah, I really respect him. He's a really good teacher.

Gelman: And after that you went to Japan?

Balloon: We were designing an in-flight magazine for Asiana Airlines, one of the major airlines in Korea. It took a lot of effort to develop articles that were effective for both the Japanese and Korean markets. So Japanese people are one big part of it. I designed the Japanese section, but I'm Korean, so the typography and everything had to be done by a Japanese designer. The art director, Aki Koumura, actually he designed everything, and then he sent it to Seoul by FedEx. He didn't have a computer, so he did everything by hand, and then I transformed it into a computer file for the rest of the process. And I would choose photography and show it to him, and he would approve it. Basically he would have the content and typography; he was art directing, and I worked like a designer. That was the process, which was a really great experience for me. So I visited him, and saw how he worked, and saw what I felt like was the spirit of it.

Gelman: Did he have employees?

Balloon: He had only one assistant, but mostly he just worked by himself. Yeah, so that was the time when I was in Japan. He passed away right before I graduated here, so it was kind of a big loss, I think, but I really admire him, how he worked for his entire life and was really amazing. Just unbelievable. He would just sit there, and put himself into whatever field he was interested in, whatever he wanted to do. He didn't care about money, he didn't care about reputation -- he really impressed me. I might, well, I want to do it like him. I was influenced by him at that time.

Gelman: What is the focus of your work, your specific interests in design?

Balloon: I think, let me just tell you how it was before, and then maybe I can describe better how I am now.

Gelman: Okay, sounds good.

Balloon: I think there are a few influences on my point of view as a graphic designer. Everyone has them; in my case, the first was the experience that I had in college. I joined some student movements in college, was a political activist. I wanted to express myself, what I was thinking, my opinions. And I hoped that other people listened to what I was saying, and I hoped something would change. I just got out of college, and I wasn't that motivated about graphic design and everything.

Gelman: So, for you graphic design is a tool for communicating your opinion and your political ideas?

Balloon: Yeah, I think, right now I cannot say it's just political opinion I've kind of moved back or away from political issues, but still I think it's always --

Gelman: Present?

Balloon: Right. It is present. My opinion or someone else's opinion, it could be a good way of speaking, or just expressing. Unfortunately, I don't like communication -- that word, "communication," because communication is really kind of a safe way of talking. I mean, when I'm thinking of communication, with Speaker A, Listener B, these are positions of people who are talking to each other and listening to each other. But those are really safe positions. There are really subtle pictures in our heads. But then the subtlety is lost or ignored.

Not many people are trying to listen. So there's no -- there might be Speaker A, but there's no Listener B. Just someone speaking, and it just vanishes in a lot of cases. At times, I think someone is trying to diminish that process. Trying to make what someone is saying bigger, or make what someone is saying smaller, or just vanish. That is often a political issue.

Gelman: So what would you substitute for "communication"? Do you have a better word?

Balloon: Wow, well that's an English problem. <Laughs> I prefer "talking" and "listening." Because talking and listen include

Gelman: What about visual communication, like publishing?

Balloon: I guess in my terms, talking and listening include that visual communication, too.

Gelman: So you talk through images, through type?

Balloon: Right. Graphic design is more like visual exploration and visual expression. That's how I talk and how I want to talk. But the thing is, I got some kind of idea from that, like, how can I get attention from other people, how can I get..How can I talk more effectively to people?

Everyone wants to do it that way, but I'm more interested in the ways of saying, so I think that pushed me to look at the area of mistakes and errors, wrong stuff. Really wrong stuff. What I'm interested in is to look at that and try to develop a way to look at and listen. And then to create graphic design from the ideas that research.

Gelman: Sure.

Balloon: Does that make sense? It's hard to say. That was from my early work. I had to worry about cheap material, cheap process, a cheap way to make it, a number of things. I would have to create three posters in one night for some demonstrations and meetings and those kinds of things. That makes me think that I'm participating in some bigger plan or bigger movement as a graphic designer, and I was thinking: What's the role of graphic design in this? So I think that was my first influence.

Gelman: Okay, and what are your interests in now? What is the subject of your work these days?

Balloon: I don't know what the word is for it, what the proper word is, but it could be a hole, a crack; could be a mistake, could be an error. Like when you find your desk is perfect, everything is in order, everything is in the perfect position that you want, and everything is working well, and is so perfect. But there's a little, little, little, tiny thing that can annoy you, and you just can't help but pay attention to it. And you just look at it, and there's a tiny, tiny thing that you forgot. Maybe you buried it before in the deep background of your mind or whatever, but it's kind of something that one day you have to talk about, or you have to show it to other people. Like, kind of a ghost inside you.

Maybe this is too abstract to describe my work, but I'm really interested in the moment you find something you don't want to see, don't want to hear from again. You want to just totally forget. But it just returns from your past, from your mistake, maybe, I don't know. I don't know that it's not a crime or a bad thing you did, it's just -- I mean we are living under certain pressure to manage our lives, manage our status, and manage ourselves. You have to buy stuff to follow or to catch up, and everyone I think is in the same position, the same condition.

So I've found if I want to criticize how we live and how we forget and how we are, like harmful, for example, to other people, what's the strategy that I can say or speak of? And I think, make people find the tiny, little bad thing they don't want to see. It's kind of creating the ghost. So their mistakes are a surprise, or something that we all are afraid to see.

Gelman: The fear element, forcing yourself to look at what you are trying to avoid.

Balloon: Right. Right. Something like that...

■ rubber dome
A metal contact in a rubber dome under the 'D' key engages a contacts on the keyboard chip.

■ scanning signal
As the contacts meet, a scanning signal is sent along the lines to the keyboard chip.

■ keyboard chip
sends scanning signals to all the contacts. When the signal changes, the chip generates a code for the connected key.

■ connection to the computer
Bits which correspond to a key number (decimal 99) are sent via wire to the computer. The keyboard chip converts the bit to the binary code number equivalent of the lower case letter 'd'.

Infiltrate / Balloon

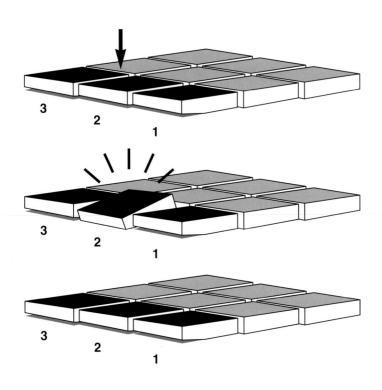

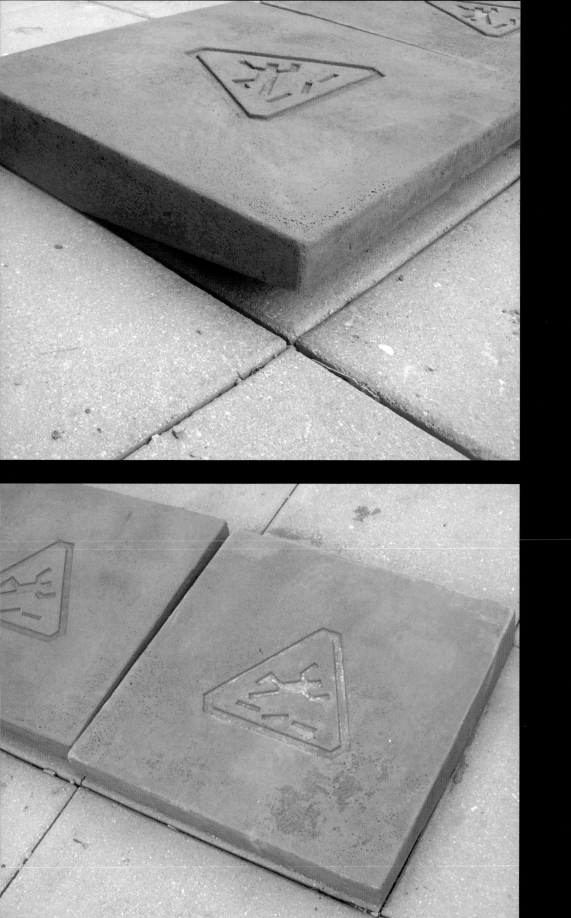

Page 008-009: Subject Processor, 2002. Experimental Project. Creative Director: Sang Do Kim. Designer: Sang Do Kim. Writing is a process of sequential mapping in order to embody the idea. It connects each different fragmental thought as a line of logical picture. But can we automate our writing with a machine? Subject processor falsifies your efforts towards thought-mapping through writing. It helps to choose words and tells what subject you are working on. It conceals your ideas and misstates your subject. In doing so, it distracts you from your train of thought and makes you question your dependency on our automated lifestyle. Shown: An investigative poster series "Typing on the Keyboard". Pages 010-011: Watch Your Back, 2002. Client: Block Watch. Creative Director: Sang Do Kim. This is a proposal of an installation to use transformed blocks on the ground. The block is meant to be unstable and shifted when people are stepping on it. Shown: Drawings for installation spot and function. Pages 012-013: Newspaper, 2002. Experimental Project. Creative Director: Sang Do Kim. If a "real" newspaper is a collection of the markings of the world, "The Newspaper Today" is a collection of the markings of the newspaper itself. It is an everyday collection of the markings found in daily newspapers -- their printing registration marks, calibration bars, crop marks, serrated edges where the pages are trimmed, etc. Through these markings, "The Newspaper Today" represents the newspaper the way a "real" newspaper represents the world through events, announcements, etc.

A conversation with Geoff Cook and Dimitri Jeurissen, principals, Base Design.

Geoff: I just got word from my partner, he's on his way. He's the creative director of the group, so we can start with other questions if you have them.

Gelman: What are you responsible for?

Geoff: The rest. <Laughs>

Gelman: Everything that's not creative?

Geoff: Yes. Everything that's not creative. Press, business, strategy, marketing, that kind of thing.

Gelman: You are not Belgian?

Geoff: No, I'm the only American of the company. There are 30 people in the company, and I'm the only American. Dimitri is from Belgium; the company was started in Belgium.

Gelman: What did you do before joining Base?

Geoff: I worked at Donna Karan for about six years. I left --

Gelman: Doing what?

Geoff: Marketing and strategy. So when I left Donna Karan, Base had been in Brussels since 1993 and Barcelona had just opened. I wanted to get out of fashion, and Dimitri and Tjeri, who's the third partner, in Brussels, wanted to branch out of Europe.

Gelman: When was Base founded?

Geoff: In 1993, with three partners: Dimitri, Tjeri and Juliette. They are three complementary people, because Dimitri is very much creative direction: imagery, photography, models, larger concepts. Tjeri is graphic design: typography, layout. And Juliette is a production wizard. Dimitri and Tjeri both dropped out of school and started the company. So basically they had never worked for a larger company. They started right out of school. And then Mark, our partner in Barcelona, worked in the Brussels studio but wanted to return to Barcelona, and that's how Barcelona happened. I met Dimitri as a friend -- his family owns a very good clothing store in Belgium, so I knew his parents first -- and then we started the New York office together. It's all happened very organically.

Gelman: I see.

Geoff: That's how it happens. No big, grand plan.

Gelman: Do you have plans for branching out in other places?

Geoff: We do. We've had already several offers for several countries, but we're not looking to expand just for the sake of expanding. It's really still a group of friends working together. So for the other offices or the other opportunities that we're looking at, it's really much more in that line. If someone that we know has a similar sensibility that allows us to continue doing interesting projects, then that's a possibility.

Gelman: What are the places that you're entertaining?

Geoff: Geneva, Sao Paolo, are the two at the front of our minds. We have offers from Helsinki, from Santiago. I think the lifestyle, certainly with Brazil, is a big plus. It's not like we're going to Boise, Idaho, to open an office. You know, if you have an offer to go work in Brazil when it's December here, now that's interesting.

Gelman: So this lifestyle element is important in your running a business?

Geoff: I think it's certainly important, and I don't want to infer that we don't think about the business. But some of the larger firms operate as "firms," and they have very strict business plans and very strict departments, whereas I think "fluid" is a very accurate term when applied to us.

Gelman: Aside from the fluidity factor, what's your business model?

Geoff: I think there are certain things that we're finding that we've learned from our different experiences. I worked at Donna Karan, and exclusively did everything outside of America. You learn certain things. I think, for example, that the model of an "advertising agency" is outdated. I think outside of ad agencies, branding agencies, call them what you will, branding agencies or graphic design companies, I think it's also outdated to build a 150-person palace in the middle of SoHo, with a million-dollar-a-month overhead, and say, "We're such-and-such agency, we're in SoHo. The world: come to us." I think that's a very outdated, American...

Gelman: What's your alternative?

Geoff: The alternative is to open regional, country-specific offices, where you are dealing with people in their own language, in their own culture, in their own city, and where you're operating on a certain cost-of-living standard. New York being the most expensive, or let's say the third most expensive city in the world -- Brussels, for example, it's a fourth of the price of operating in New York. So it makes sense just in terms of economics...

Gelman: Yeah, but the fees...

Geoff: Everything. Costs of operating are lower, cost of producing is lower, printing is cheaper, yet the quality is as good if not better. Salaries, yeah, it's all lower. But then again, the fees are lower. It's a model of distributing cost and profit centers, not the American way, you know, "Everybody come to us."

<Dimitri arrives>

Dimitri: Sorry I'm late.

Geoff: We saved the creative commentary for you.

Dimitri: All right.

Gelman: Tell me about the name.

Geoff: The office in Brussels started as Tus du Dua, which in French means "fingerprints." When we opened the U.S. office, it became clear that a change might be necessary. When I said it in America, people thought I was saying "chest of drawers." They had no idea what I was saying.

Dimitri: The first name was a school thing, so even if the second one wasn't much more thought of, we were looking for a short name and would work in Spanish, in English, and in Dutch, and in French at the same time. So you end up having a small selection. It has a reference to our work, which is pretty straightforward, pretty clear. We're not about a lot of graphic artifice, and I think Base is a good reference to that.

Gelman: Would you call your work "basic"?

Dimitri: No, not basic. There is a difference between basic and, I would say, non-decorative, or -- I'm always saying, I hate, and my partners agree, I hate graphic design.

Gelman: You hate graphic design?

Dimitri: In a sense. At the same time, it's what we do. So we're trying to avoid design for design, or graphic design for graphic design's sake. We're trying to convey an idea and keep it simple and clear. If that's basic -- though I think basic has a negative connotation -- but if that's what you mean when you say basic, then yeah.

Gelman: What do you hate about graphic design?

Dimitri: I hate when it's -- I hate when you feel that it's graphic design.

Gelman: Any examples?

Dimitri: You know, when you look --

Gelman: Like pairing Garamond and Univers?

Dimitri: No, it's not about type. It's about when you read a book, or when you look at a book on a certain subject, you don't think about the design. You're reading a book. If it's well designed, the question is not about, you know, it is this type or that type.

Gelman: So you like your design to be sort of in the shadow, in the background?

Dimitri: Yeah.

Geoff: Bringing the concept to the foreground.

Dimitri: Right -- we're trying anyway. I don't say we're doing, but we're trying. Once there is a line or type or you don't know why you choose it or you're sort of confused about it -- I think it's very important to avoid that. When you look at how we present our work or how...

Gelman: Does it mean that you're trying to be as objective as possible? Is that what you're saying?

Geoff: Objective, meaning without a point of view?

Gelman: Meaning, not subjective.

Dimitri: No, we're still doing a lot of art direction, we're still doing a lot of communication, so I think objectivity is very relative. It's never objective when you do a catalog and then you start re-touching an image. We're still selling a lot of dreams, ideas, brands, selling a lot of stuff.

Gelman: Let's say, objective to your brief, for example.

Dimitri: We're trying to be very honest. And very direct to the brief.

Gelman: And that can be personal as well?

Dimitri: Sure. Even the mediums or what we use can be personal.

Gelman: Okay, we talked a little bit about business. How do you choose your next project? How do you keep things interesting?

Dimitri: At a certain point, people are asking you to do what you have done right in the past. And then you continue doing the same thing over and over. When you're finally confronted with a subject that you've never done, and you can't say, certainly in America you can't say, "Yeah, I've done 17 magazines before, and I can do yours" because they won't hire you. So you start finding subjects that you want to do and initiate them. The market cannot always be as great coming up with the projects that you want to do, so you initiate some projects yourself. But most of it, I would say 80 percent of what we're doing is still in regard to client work, though people still want to see our other things.

Geoff: It's also a company aspect: Base is still a group, there are five part-ners, so unlike a company that sort of has one figurehead, from which everything is derived, with us there are different partners bringing different interests and different elements. And that might be through those offshoots.

Dimitri: We're trying to do everything -- you know, when you have the opportunity and you put a little money on the side, and you want to do this because it's interesting and a good subject. A lot of projects that we initiated before, like the Fax Free editions, was initially an idea to give to our clients, and then it became this thing that an editor came

by and saw and wanted to distribute. So projects can grow in another way than just responding to a brief or to a client. And it's a good balance - the balance between the subjects: cultural, fashion, industrial, editorial work - and trying to balance and stimulate all kinds of people that work with you. It's cool to work with these designers on a very restricted job, and then have this very free job, and say, "Let's do this magazine."

Gelman: Do you have any focus or special-ization? When you talk to prospective clients, how do you describe what you do?

Dimitri: We're trying to avoid that. Peo-ple who know us perceive a certain thing, a certain style or approach. I think mostly it's conceptual. It's not about the subject or what we're doing. It's more about our approach or how we think. It's not the form or the result or the shape; rather it's probably a simple, direct solution. So all together that makes the book that's over there, and probably somebody can read it and see the link between these jobs, and some can say, "Oh, I can't really read what you're doing because you're doing everything."

Gelman: Have you had experiences like that? Where a client wouldn't trust you with a certain assignment because you've never done it or because you don't seem to be an expert in something specific?

Dimitri: Sure. I think that if you're assigned to an institution or a museum where the element is way finding, and there's somebody coming who did that for the last 25 years, who puts a book on the table that's only way finding, the client is probably gonna be reassured in one way. And -- depending on the client -- probably not wanting to do it that way with a certain route with somebody who has a complete vision, or not a complete vision, but another per-spective altogether. So it can go both ways. The thing is that we're like that, and we're not trying to force it -- it's not a marketing policy. It's who we are. It's what we are.

Geoff: It is true that it very much depends on the individual, and some individuals need a very literal refer-ence. "I see this in your book, it's this style. I want this." And then there are other individuals --

Gelman: What do you do in that case?

Geoff: We try to see if what we do is applicable; for example, if you want this, we fit...

Dimitri: It's never that, exactly, because the subject is probably differ-ent, but it gives you an indication, maybe part of the brief, you know. If somebody says, "Oh, I love this," that doesn't mean that you have to do exactly the same thing. It means that you have some information that refers to your job or refers... it can refer to anything. I think the fashion world, for example, is a world that's very tough if you are not 100 percent in the fashion world, which we're not. We're maybe only 50 per-cent in the fashion world. So some people like it that you did a political party and a museum and editorial work, and that kind of conscience of knowledge will bring their brand or their project to another level; some can be super-focused and can only refer to their area, they may feel uncomfortable or insecure, and will go with somebody who only has that kind of scope of work. But for the moment, it's exciting to go from Puma to a political party to a museum to packag-ing for chewing gum.

Gelman: Which party?

Dimitri: We did the Socialist party in Belgium, which is a job I love to show here in America. I think what Base is built on is human relationships. It's relationships and friends of people and things like that. So that's a really important aspect. I like to work with people that I want to see every day. And that sort of generates what we're doing too, and the initiatives and the approach.

Gelman: Do you have the same approach with clients?

Dimitri: Not really.

Gelman: Do you have clients that you want to see every day?

Dimitri: I think we have really good relationships with our clients. I think we quickly have a very collaborative relationship, more than a client.

Geoff: There are very few clients that we don't want to see. No, I would say no clients that we don't want to see. So it's a very close relationship.

Dimitri: And now we have Christy Turlington! Who doesn't want to see

Christy Turlington? <Laughs>

Gelman: <Laughs> She's your favorite client?

Geoff: She's fantastic to work with.

Gelman: Do you invite clients into the creative process? You know, do you show sketches, do you allow them to kind of contribute ideas?

Dimitri: It's very important, because clients always have all the solutions. In the way they say it. They don't have physical solutions, but they bring the solutions in their brief -- there's this famous phrase that says, "The solution is always in the brief" -- and that's true, the more you know the client, the more --

Gelman: Who said that?

Dimitri: I don't remember who said that, but it always kind of sticks in my head. Every art school, at some point tells you to "think about the brief, because the solution is always in the brief." I think it's very important to have a very open relationship with the client. It's about talking with people.

Gelman: What differences do you see be-tween New York and Europe, in terms of operating a business?

Geoff: One we noticed immediately is that in Europe you deal one-on-one, with the people that are making the decision. But there are more levels here, where you go through the Assistant Marketing Manager, and the Marketing Manager, the vice pres-ident and then finally you're at the per-son that is eventually going to make the decision. Avoiding mixed-messages from the top, that's very important. The other thing that we realized is a sort of com-mercial awareness or element here in the U.S. that can be an impediment to doing challenging work -- America encourages perhaps a safer solution than Europe. And it's in all aspects. If you look at the magazines, for example, there are very few American magazines that are pushing boundaries. And it's the same in our world of brand identity as well.

Dimitri: I think everything in America is much like it always was, and I think it's much more marketing and business-driven. In Europe, there are still a lot of em-

Interview continues at:
http://www.infiltratenyc.com/002/

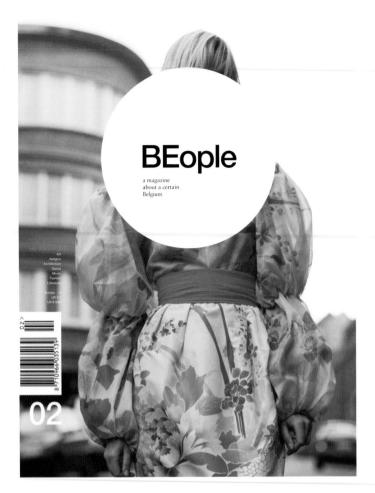

BEople

a magazine
about a certain
Belgium

Art
Religion
Architecture
Dance
Music
Fashion
Literature

Europe
UK £7
US $ 9.95

02

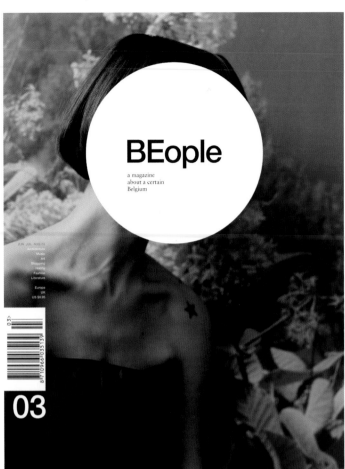

BEople

a magazine
about a certain
Belgium

JUN JUL AUG 03
Architecture
Music
Art
Shopping
Nanny
Fashion
Literature

Europe
UK
US $9.95

03

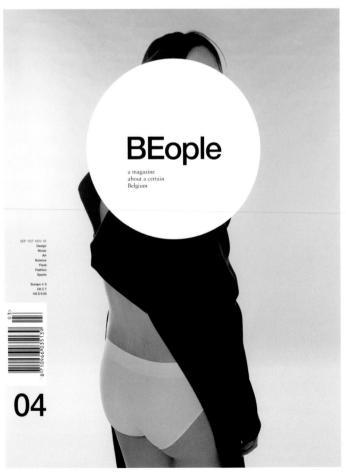

BEople

a magazine
about a certain
Belgium

SEP OCT NOV 02
Design
Music
Art
Science
Food
Fashion
Sports

Europe € 9
UK £ 7
US $ 9.99

04

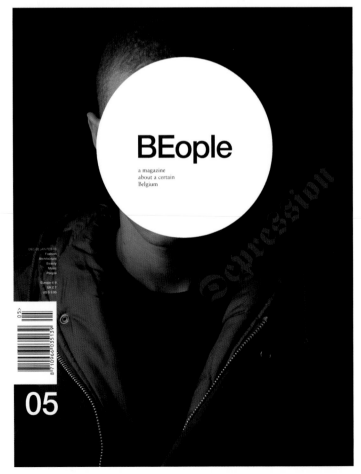

BEople

a magazine
about a certain
Belgium

DEC 02 JAN FEB 03
Fashion
Architecture
Beauty
Music
People

Europe € 9
UK £ 7
US $ 9.95

05

Pages 016-017: BEople Magazine Covers, 2002-2003. Publisher: Scoumont Publishing. Creative direction: Base. Design: Base. Photographer: Jan Welters, Vava Ribiero, Sofia Sanchez, Mauro Mongiello, Johan Coppens BEople is a "magazine about a certain Belgium". The "white circle" system for the covers were developed as a reaction to the formulaic "celebrity" system so prominent on newsstands today. Pages 018-019: Parti Socialiste, 2003. Client: The Belgian Socialist Party. Creative direction and design: Base. Photographer: Var. The PS hired Base to update its antiquated image made up of cliché socialist symbols (the fist, the rose). A concise, typographic solution was developed, with emphasis placed on "Socialist" as opposed to "Parti". The type appears in a red rectangle evoking a red flag (often waved throughout history during protests). Pages 020-021: La Casa Encendida, 2003. Client: Caja Madrid. Creative direction and design: Base. Photographer: Var. Illustrator: Var. La Casa Encendida is a social and cultural center Located in Madrid, Spain. For the development of the corporate identity, Base drew inspiration from short and quick messages, such as SMS, Post-It notes and e-mails. The result, a system of colored squares (shown on the communications materials here) is flexible enough to carry different pieces of relevant, quick information as governed by the center's programming. Graphically, the squares also provide an easily recognizable system throughout the many different pieces of printed matter.

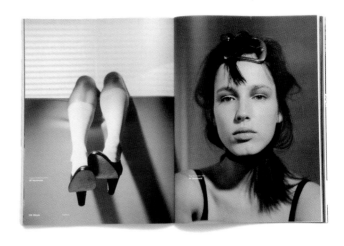

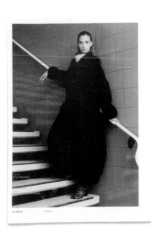
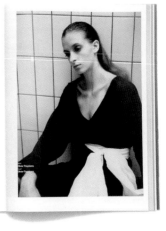

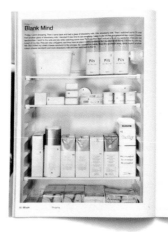
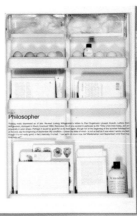

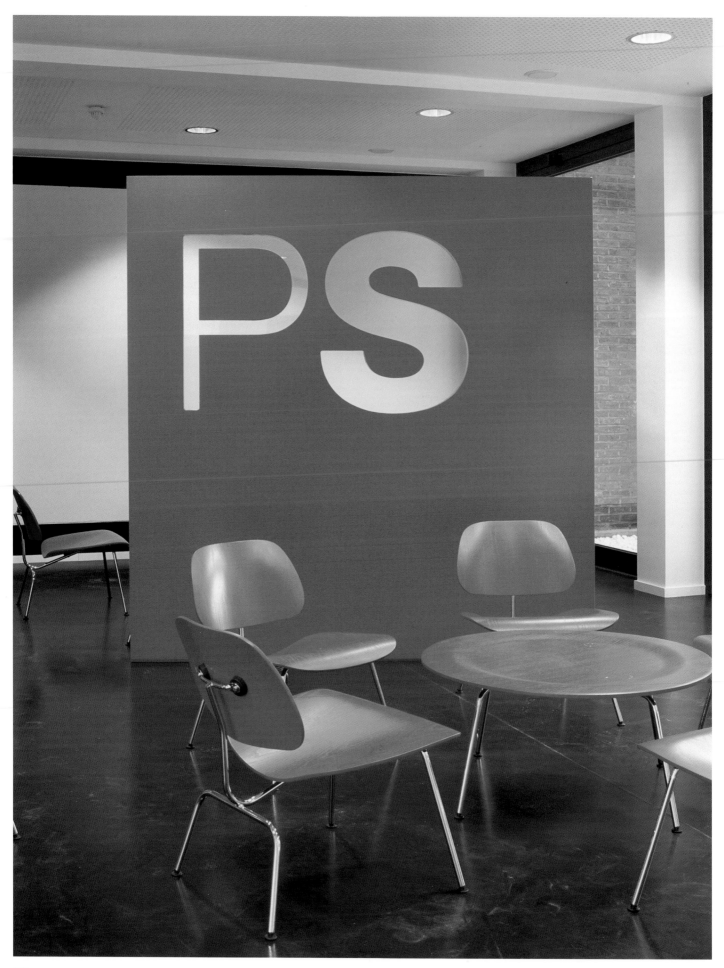

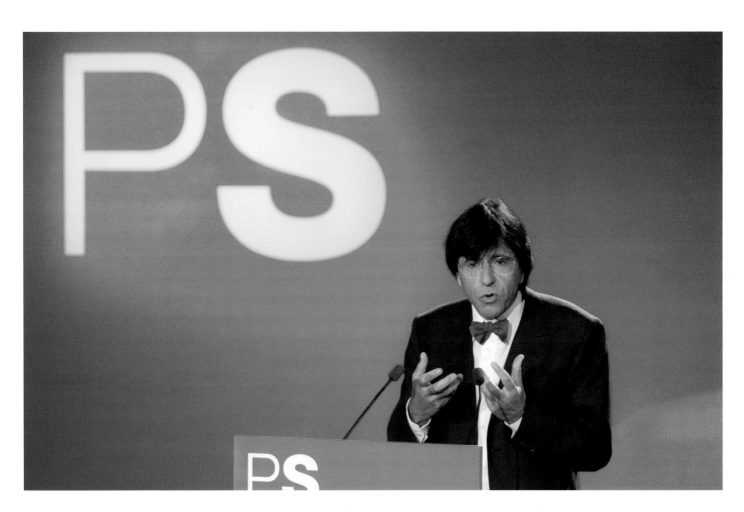

Infiltrate / Base Design

Sound and Vision
Conciertos y
proyecciones

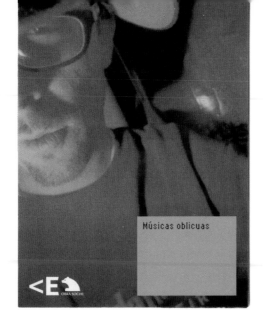

Músicas oblicuas

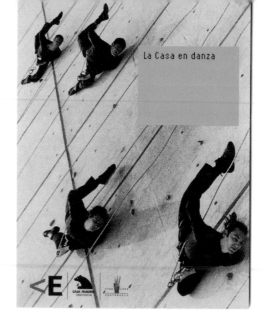

La Casa en danza

De Sur a Norte

Un repaso
al Dogma 95
Nuevas tendencias
en la realización
audiovisual

Toldos

Maider López

After Hours
Acto poético
con Ruth Gabriel

Músicas Oblicuas

María Bovo y
cel.lí Antúnez

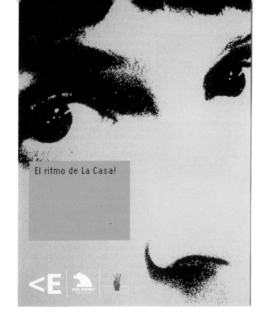

El ritmo de La Casa!

<E CAJA MADRID

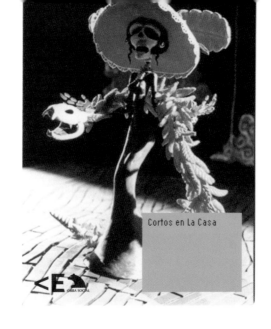

Cortos en La Casa

<E OBRA SOCIAL

<E OBRA SOCIAL

oz alta

mirada
gráfica

Entre líneas

<E CAJA MADRID

Experiencias
y visiones para un
mundo diferente.
Y sin embargo...
se mueve

<E CAJA MADRID

<E CAJA MADRID

Proyecto
Madidi

Programa de divulgación
e investigación científica
en Bolivia

En Familia

A conversation with Carol Bokuniewicz, principal, Carol Bokuniewicz Design.

Carol: So ask me anything! <Laughs> Ask away! So, do I decide what we talk about?

Gelman: No. Well, kind of. We probably can't not talk about Tibor and M&Co. Let's get that stuff out of the way.

Carol: Right, right. That's fine. We can do that.

Gelman: You started M&Co. with Tibor and at that time you both were kind of outsiders. You were experimenting, inventing your own ways of dealing with design and business. Then you left. At some point it all exploded and Tibor became almost a cult figure and M&Co. is now well known. You even outside our little design world. You weren't part of it anymore. How do you feel about it now?

Carol: Well, that's an enormous question. God. I'm not sure where to start with- that.

Gelman: How did you feel about that? Were you jealous, were you angry?

Carol: Well, I think, of course, one couldn't help but feel like there was a bit of theft involved in that, you know.

Gelman: You felt that some of your ideas were credited to other people?

Carol: Well, I think what I did, that I was a very big part of creating the path for Tibor, and I don't know if he would have ever gotten on to that path had we not been partners. Because we really learned together, and learned how to think together. You know, we were total rookies, and we started this company.

Gelman: How did you divide the responsibilities when you started the company?

Carol: Well I suppose the way it naturally broke down is that both of us were responsible for coming up with the ideas. Both of us were responsible for getting business. He did probably most of our administrative work, while I did the more hands-on design, so from the inception --

Gelman: Administration, like bookkeeping?

Carol: Yeah, all of that. All of that stuff. Yeah. So it was very, very much us starting this thing from absolutely noth-

ing. And you know, it was kind of miraculous. And you know, we got it anywhere at all, let alone as far as it ended up going. But you know Tibor always felt like this great outsider, being that he emigrated here from Hungary, and I think he had this real - passion - for being accepted. And I think that that's where this kind of drive, this crazy kind of drive came from with him, from within him. In the beginning when we were outsiders, we played off of that, because one has to. You can't just be an outsider.

Gelman: You were the one with the design degree?

Carol: Right. He had an English degree, or whatever he had. A Liberal Arts degree.

Gelman: He had to trust you on certain things.

Carol: Well, certainly. Certainly.

Gelman: Choices of typefaces and such?

Carol: Of course, of course. So I was like the hands-on, I would say hands-on person. And we did some really lame work for a really long time, because we were learning how to do it, number one. But the other thing -- I don't know how much people are aware of this -- I think that whole ethos of M&Co. came out of our limitations, not our strengths at that time.

Gelman: And what were those?

Carol: Well, those limitations were that neither of us were very skilled designers. I was still very, very young, and he didn't know the first thing about designing something. But he was a good thinker. I was a good thinker as well. And, I think that let us embrace --

Gelman: And neither of you knew much about business, right?

Carol: Not really. I mean, he probably knew more than I did, because he had been in management at Barnes & Noble, which is where we met, and he had to actually deal with building things, and dealing with budgets, and the reality of that. Staying within a budget, you know. This was really my first time out, really even knowing how to put a budget together. So, yeah, he was certainly more the 'businessy' guy. And he certainly became more the mouthpiece, because by the simple fact

that I spent many, many, many hours doing the work, so I think it naturally developed that he would do a little bit more of the client business. All that bullshit. But the whole sensibility did come out of, again, this limitation, so I think we were both attracted to the outsider art. Stuff in a sense -- stuff that was ugly. Stuff that was non-designed, you know, the vernacular. Like, I had a thing for the yellow pages. In the '70s the yellow pages were filled with fantastically awful art. Quite inspiring! <Laughs>

Gelman: How did you come to appreciate that ugly stuff?

Carol: I think there was something so honest about it, you know? And unself-conscious. And I think we were in this place where we were looking for something that wasn't slick like the big grown-up designers, who were really successful. They had all these skills, and contacts. We didn't really have a lot of skill. So I think both of us -- and I don't really remember how, I just remember being inspired once by the yellow pages, then just glomming on to that. Then Tibor got very into generic food packaging, so that was sort of the start of it. And besides that there was a real honesty I think to it and unself-consciousness. Of course, it was funny too, 'cause it was so ugly. It was great irony. So that became a real element in our work, because it was that intangible that wasn't expensive but was really powerful.

Gelman: And how did clients respond to that language of the vernacular?

Carol: It didn't work for everyone, needless to say. We weren't doing that for Manufacturers Hanover Trust, of course. But it certainly worked for rock 'n roll. And it certainly worked for our own work. We started doing these Christmas gifts that ended up really getting out of control over the years <Laughs>, that was our self-expression, our own personal work at that time. Anyway, where is this leading?

Gelman: I don't know. We're just talking.

Carol: So what were we saying? Am I bitter? <Laughs>

Gelman: You are very bitter <Laughs>. How were those Christmas gifts funded?

Carol: They were funded by us!

Gelman: It was pretty expensive, right?

Carol: It was, and we had all these lofty ideas that we'd get all this business from it, and that it would be a fabulous investment. <Laughs> No, now they make cute things, and books about Tibor. <Laughs> They're nice little mementos. No, we were sending them to -- God, I can't even remember, really. Certainly we were sending them to potential clients, and I suppose we sent them to some designers.

Gelman: Who did you consider as your potential clients?

Carol: Well, everybody, anybody. Anything in music was a potential client, but beyond that, I suppose we were looking --

Gelman: Like record labels? Or bands directly?

Carol: Uh, what was out? Most of it was personal contact. You know, we didn't approach labels, per se. It was either through an individual or through management, and then by referral and such.

Gelman: And how did they react to this Christmas stuff?

Carol: The audience in general that we sent it to? It was a very disappointing response, actually, as I recall. I do remember us being, you know, kind of demoralized by the fact that we sent out these brilliant little things, and we got, like, two calls. So we thought, why bother? But we continued at it, and I don't know exactly why Tibor continued to do it. I suppose because it was one of those things where you could absolutely control 100 percent.

Gelman: It was a creative outlet?

Carol: That's exactly what I'm saying. It was a way to demonstrate to the world without the chains of the client. Show what we could really do. So, I don't know what it ever did for us ultimately, because after a certain point we weren't discussing that stuff.

Gelman: What was your relationship to the design community at that time?

Carol: Well, almost nonexistent. Probably, again, because we were new to this game, and we were a little on the outside of it, we were --

Gelman: But you weren't ignorant or arrogant. You wanted to be accepted. Correct?

Carol: I think definitely we did, but would probably not admit that. I do remember being at these affairs, and Tibor and I being really skeptical, the two of us really skulking around, critiquing the work, how shallow it was, and how precious it was, and how they were focusing on all the wrong things. It was so dull and it was so anesthetized, and rar-rar-rar. So a lot of that, of course. I think it was defensiveness, certainly, feeling like we weren't allowed in the club yet. And I think that that's like a recurring theme with Tibor, being in the club or being president of the club. Not just "I want to be in" but "I want to run it." So he was always really driven in this way that was, um, I didn't have the same kind of need that he had. So I was the laid-back one, the quiet one, of the two of us. And he was just mad.

Gelman: How did you break up?

Carol: It was actually, when the actual split happened, it was actually very amicable. And I had gotten kind of enamored with the advertising world. I thought, Oh, we really figured out this design thing. Whatever. I thought - This really appeals to me. I see a lot of money, I see a lot of energy there. I had friends in advertising, and they just seemed to have this great life, it was really fun, and really --

Gelman: Did it also seem smarter?

Carol: Yes, and there was a great element of mental exercise that was really attractive to me. And we had always been participating in that mental exercise.

Gelman: Just different. Design [at that time] seemed a lot more about a certain purity of form, but not too much of ideas, and you were probably idea-driven.

Carol: Very much idea-driven. And I guess I felt like it was time to look beyond that. And probably, honestly, I had spent six years with Tibor, and probably got a little weary of it. And when I told him I wanted to leave, he didn't beg me to stay! <Laughs> So, he bought me out. And it was totally friendly and absolutely fine. And then we had a little bit of a falling out. And then, that took years to get over.

Gelman: How did that happen?

Carol: God, do I really want to talk about this? We had a legal issue with one another. Can I come back to that?

Gelman: Was it resolved?

Carol: We ended up being able to settle that. And then after that we kind of drifted apart.

Gelman: Naturally.

Carol: Yeah, we shook hands, and it was all kind of like, "Oh, we love each other so much, really, oh, we're gonna work together again..." And it was never quite the same. That sort of put us on a funny path. So I guess I'm mad at him for doing that -- or was, I mean, certainly I think I'm over it now. <Laughs> But certainly, there is a part of me that feels like I lost ownership to something that, I feel I should have enormous ownership of. And that is, I think, sad and unfair. But, here we are.

Gelman: Okay, so you started your own agency, and then what happened? Did you find in advertising everything you were looking for?

Carol: Oh yeah! It was perfect! <Laughs> Oh god, what a mistake! It was a lot different than it looked. I think that there is a great glamour to being part of a big established agency with great big clients and great big budgets, and first-class trips, and all these cool perks. But once again, I did a repeat of M&Co., which was starting everything from scratch, learning the job on the job, you know, totally trial-and-error.

Gelman: You had done it once, so you knew you could do it again.

Carol: I suppose, I suppose, right. That gave me the, I guess, confidence, or whatever it was, ignorance, to do it again. And it was really hard. Harder. And it wasn't as -- it certainly wasn't as gratifying. It was ridiculously un-gratifying creatively, and it didn't pay the big bucks! <Laughs> Because we were this little boutique agency, all girls, at a time when little agencies were emerging out of large ones -- people who actually knew what they were doing, people who had contacts to clients. We were just making it up as we went along. But we were reasonably successful, certainly. But it was just not a nice experience.

Gelman: How long did that last?

Carol: About eight years, I think. Seven years? Maybe seven years.

Gelman: And then you returned to design?

Carol: Yes. And then I said, you know I've done my stint, I've served my time. So I wanted to simplify, and get back to the core thing that was ever fun about any of this business, which was going back to actually being a creative thinker. And in the advertising world, it was probably, you know, a twentieth of my time doing anything at all creative, and the rest of the time, managing staff, dealing with clients, going after new business constantly; so it was all this other layered, shit, you know, that had to happen. And I just wanted to take the whole burden of that machine away, just be nice and nimble and small. And that's what I did. I just opened an office, and started doing advertising! <Laughs> On my own. But it was a -- well, I did other stuff too. But that's where the merging of the two have since come together. Even though I say I hate advertising, I do it every now and then, because it can be interesting. Mostly it's not. Mostly what happens is the creative process is great, and then in the execution, or somewhere along the way, it just gets mucked with, and the client, you know --

Gelman: Fucks it up?

Carol: Yeah, it has to go through so many layers that it just loses any of its purity and the real concept. It's so awful; it just gets too watered down. So I will do it for money, but I don't take joy from it. It's a practical thing.

Gelman: Well, isn't it fun to make money?

Carol: Yeah, that's good. I mean some-thing should come from it!

Gelman: Do you like to collaborate?

Carol: I think it's the only way to really do great stuff. I mean that, to me, the really joyful part is in collaboration. It's so much more fun, to have human contact while you're working. And you just get so much smarter and so much looser, and you can go all over the place. When just the spark of something stupid that someone says "So I think it's great." Just so broadening. So that's cool.

Gelman: Tell me about your interior obsession.

Carol: Hmmm. And that's the other thing. Well, I think again, the thing that I like about interior design is also that it's experiential. More so than graphics. It's way more fun for me to experience an environment than it is something two-dimensional. Well, it can be dynamic too, of course, but you know, for the sake of argument, it's just a two-dimensional experience. [Environments are] so much more connected to life. And although it contradicts everything I just said, in a sense that it isn't really, it's not normally that vastly conceptual, in that there are parts to it, like there are walls and floors and seating; there are conventions that you operate within, that, you know, breaking out of those conventions, there is no reason -- then it becomes theatre. But I think that's what's so appealing, is that it actually has more of a visceral response. You know, you really live it, instead of, "Oh, that's nice."

Gelman: When you work on an interior, do you think of a response that you want to get and develop the design from that?

Carol: I wonder. I've actually never thought about this.

Gelman: Or are you just kind of playing around? Trying different things?

Carol: No, it isn't quite that loose, no. But it's not, it's not quite as linear, it's not quite -- first of all, because I'm doing it for myself, it doesn't have quite the formality of process, where I have to organize all my things, my arguments, and get them ready to present to the client. Being the client, that formability is gone, so it's a little more fluid. But I think there is certainly a vision. Yeah, I think that there has to be a concept, uh-huh. There has to be a concept at the get-go, no question. And a certain sensibility. And I see that there are crossovers, to some degree, to what I do with interior design, like the play of irony, or like a silly color someplace where it doesn't belong...It doesn't have that kind of preciousness that I rebelled against in design and still do -- that preciousness, you know, and over-intellectualizing, and I think we should lighten up a bit about it. Like, I think I'm more intuitive than I am very calculating about it. And it's kind of hard for me to talk about it too.

Interview continues at:
http://www.infiltratenyc.com/003/

Pages 024-025: "Horse Whisperer," Direct Mail Promotion, 1999. Client: Smithsonian Magazine. Creative Director: Carol Bokuniewicz. Designer: Fiona Spear. Manufacturer: Kaufmann International horse furnishings. Smithsonian had an image problem, so we developed a direct mail program (based on a Smithsonian article on the real-life "horse whisperer") directed to the advertising community that changed and enhanced the perception of the magazine's editorial from stodgy and dull to vibrant and relevant. For over four years we pulled incredible response rates (18-39%) and significantly increased ad pages. Pages 026-027: "Tools of the Trade," 1998. Client: Ammirati, Puris, Lintas/Rover UK. Creative director: Carol Bokuniewicz. Part of a program to launch a new car model for Rover, which included branded retail products. Each of these tools featured in the photos were made of pure milk chocolate. Promotion is the poor stepchild of advertising. No surprise, considering the amount of tacky stuff that's out there. But there's great opportunity, since clients feel there's not as much riding on it, so they tend to lighten up a little. Plus, sometimes it's just fun to make junk.

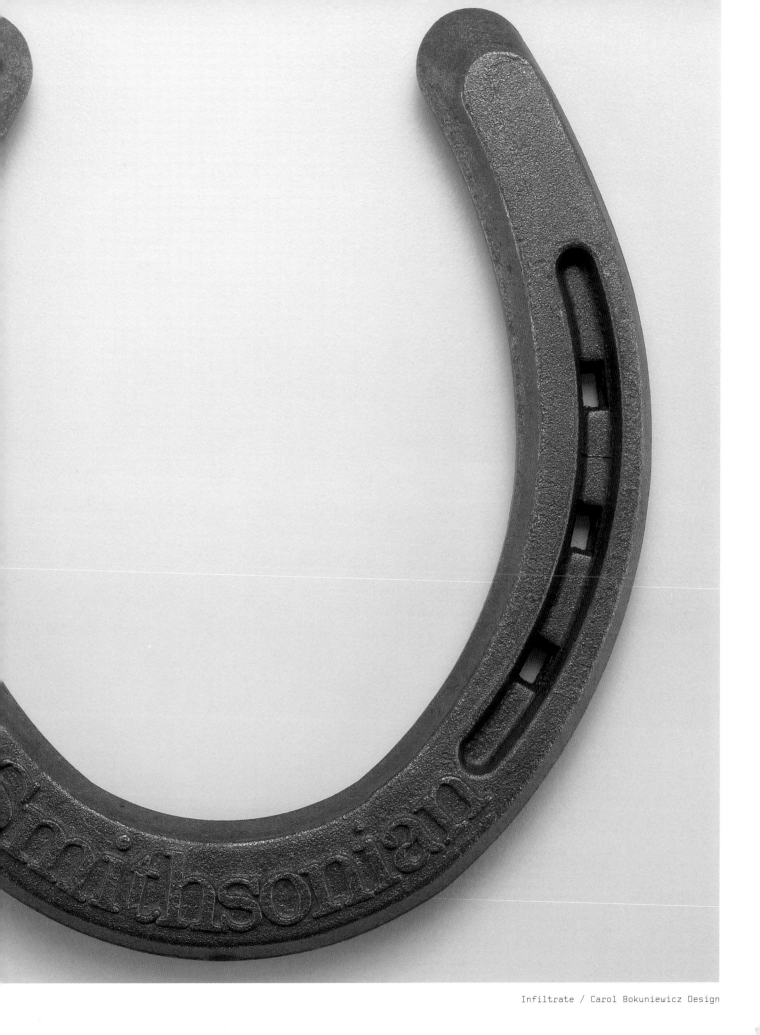

Infiltrate / Carol Bokuniewicz Design

Infiltrate / Carol Bokuniewicz Design

A conversation with Christoph Niemann.

Gelman: In the mid-'90s you've spent some time in New York as an intern. So you decided to come back after graduation?

Christoph: Basically, I knew my way around here a little bit and then in 1997 I finished my thesis and I came here and I said, "I'm going to stay here for one year, no matter what happens." I came here with my little bag and I said I'm going to try to be an editorial illustrator; that's the thing that I tried to do.

Gelman: Did you know a lot of people in New York then? How different was your first experience compared to Germany?

Christoph: Having worked as an intern, I got to know some people in the design community. I can't really judge the design community in Germany because I haven't worked there enough that the glimpses I got -- especially from the advertising world, which is the more predominant one -- are a lot harder to... It's a lot...people are not as friendly or endorsing. It seems to be there is a lot more fighting going on.

Gelman: Fighting?

Christoph: I just felt like it was harsh. When you compete against somebody you don't necessarily join together and have a great party. At the Art Directors Club events it was always very much about the competition part and not so much about the professional gathering and celebrating the beauty of the work; it was more like "I have a medal and you don't." But as I said, I hadn't been there long enough, not worked there long enough, to judge. But I know that coming here I was absolutely stunned.

Gelman: Stunned by the way people supported each other?

Christoph: You go to a design party and there are people from all the different firms who are competitors, in one room sipping wine, enjoying each other's company, and it's completely cool.

Gelman: Why do you think that is?

Christoph: I guess that in America people realize that design is only one profession among other professions. Like, basketball is sport among four of five different sports. When you play basketball you compete against other teams but on the same level you compete against someone who plays football or baseball or hockey. So when you start trashing your opponent and you say "he's worthless crap" then you don't only hurt your opponent, you hurt the entire field, which is going to backfire eventually. And I feel that in America people have figured that we need the competition and you need to be better than the other person but you still need to lift the profession. For example, if I ever did, unlikely as it is, get a million dollars for a job, it would be the stupidest thing to say "Oh, what an idiot! He doesn't deserve a million dollars for his drawing." Because if I get that job, if somebody's willing to pay that, that's good for everyone because people will realize that money is around. And if I get a client to pay me more money, or pay more attention, or give me more credit or whatever, that's going to benefit my competition.

Gelman: Well, basically what you are saying is that the more good design and designers there are, it's better for design and everyone benefits.

Christoph: And even if you are better than me, it's still good for me that you're around. There is no advantage in bringing you down even though you are my competition.

Gelman: And Europe isn't like that? Is it just because the communities are smaller?

Christoph: It's not necessarily...

Gelman: They are just nasty people?

Christoph: First of all they are spread out so you can't really just go across the street. In Germany, for instance, people are located in Berlin, Hamburg, Cologne, all over the place. I don't know anything about the photography community there, but there has just been an amazing work coming out, internationally acclaimed; and the same with product design; and all this techno design. There seems to be something that works within the audience there, whereas graphic design, publishing, you don't see that much German design. I know there's amazing stuff happening, but what I feel is lacking there is a community that just puts on the spotlight it deserves. Illustration, for instance, there are amazing illustrators, but there aren't any books, so nobody knows about it. So I think there are as many good designers elsewhere as there are in New York, but people don't know about them and that's why New York ends up being a better place to work.

Gelman: So you found the New York design community friendlier and more accessible?

Christoph: At least in my case. I called all these people and they just met me; that might just be a New York thing; that there are so many great companies that you can actually get through to people. I haven't heard of anywhere else where you can call up somebody and you might actually meet them the next day.

Gelman: You were calling people and getting them on the phone just like that?

Christoph: I was really surprised, but maybe it's also that when you come from Europe people say, "Oh, he traveled all that way." So maybe people are a little bit more open than when you say, "I'm from New Jersey and in town, give me an interview." And people give you a chance even though you are young; I almost feel they can't afford not to, which I think they rarely do anywhere else. And of course if you screw up you're out...

Gelman: But hold on, when you came you had a pretty good portfolio right?

Christoph: Yes, but I had no...

Gelman: What was the reaction to your portfolio?

Christoph: From most of the people that I know you rarely go somewhere and people say, "Oh, your work stinks!"

Gelman: True, it never happens.

Christoph: Usually people have reservations. They always say it's nice but whether they call you is a completely different thing.

Gelman: So nobody told you it was crap; everyone told you it was great.

Christoph: Strangely enough, the only places that I got work from by showing my portfolio were Rolling Stone and the [New York] Times. I think. These were the only two places where I actually went with my book and they gave me work based on that.

Gelman: You're still working with them?

Christoph: Yes. I still always present my portfolio, but most clients have seen something that was actually published in Rolling Stone, or the Times, or American Illustration.

Gelman: Tell me about your first client.

Christoph: The very first one was Rolling Stone in 1995. I did a drawing for Fred Woodward. And then there was the New York Times.

Gelman: And then it's just exploded. When did you get really busy?

Christoph: At the beginning I was incredibly busy, with far fewer jobs, because I was a lot slower. It took me a lot longer to figure out what people wanted and what I wanted, so a job that took me a week then might take just two days now. And I think it's that I'm not necessarily technically faster but I just...

Gelman: You understand better the art director's expectations?

Christoph: When they kill an illustration that you do for the New Yorker they do it for a different reason than when they kill something for Fast Company. You never really know it and once you think you know it, you're in trouble because then your work is probably bland. But still, you have a little better sense.

Gelman: So, there's no way of preventing rejections from happening?

Christoph: Often I am still stunned when they tell me "Our readers won't get it," but still you know a little bit better where to take it from there. Whereas in the beginning I just felt it was like shooting blindly in the air. I started getting more and more panicky and shooting more, but not really increasing my chances. Waking up in the morning and not having an idea for whatever deadline I had in the afternoon drove me completely nuts. Now, I feel at least when something gets killed, I can focus a little bit better. When it's getting tight I try a couple of routine tricks. Even if it's not brilliant, I know I can come up with something not too embarrassing.

Gelman: Is there anything in common among all those different publications?

Christoph: I'm not really sure, because when they call you, of course they call

you for either your style or your humor or just the fact that you can turn something around in an hour. So even though I work for all these different publications, I don't change my approach that much. I also feel like my stuff is very traditional, more in the middle.

Gelman: In what way?

Christoph: At some point you have certain ways of doing things, there are certain ways to draw, or to render a certain thing, that come easier to you. When you have 10 minutes you're not going to reinvent the wheel. But you try all the things -- all the things I do, the styles I have, are the result of a certain problem, and at some point I realized, This works. Then sometimes people call up and say "We saw that great thing that you did there," and they essentially want that style for a different idea they come up with. I try not to, but of course there are publications...after they kill the fifth sketch, I simply give them the style they had in mind when they called.

Gelman: You have developed a few styles as a result of this process. How many styles can you identify? Your work can be really varied. You seem pretty comfortable with a brush, you can work with Adobe Illustrator, you can do all kinds of different things with flat and three-dimensional pixels.

Christoph: That pixel thing has pretty much stuck with me. I just love to draw that way. I see it separate from most other stuff. I do a certain kind of flat acrylic painting that is the basic abstract shapes -- which is rarely requested becuase it's not something you can easily sketch and convince people to accept. Also the humor that you can use that for doesn't really work for a little 2"x3" spot illustration. So I've been doing three pieces a year in that style. And then the major bulk, which is very slick illustrator outlines, very flat colors, very straight shadows. The other thing is pretty traditional ink outlines, flat colors, in a comic-book style, people with big noses, that kind of stuff. And there are variations after I've done a couple of things in any style; sometimes you need something more ominous or evil, which are things where you have black silhouettes. When you have any kind of outline drawing it always looks happy and friendly to a certain extent.

Gelman: Cartoony.

Christoph: Yeah. And for a certain kind of work it just doesn't, never fits no matter how you draw it. At some point it looks like fantasy comic, which is also wrong. And there is just an outline of a face with a couple of highlights which essentially is a style I realize I fall back on unconsciously. I almost never do 3-D animation, but I did build a houses out of Legos® that were smiling at each other, for an article about [Disney's town development] Celebration. It was something that I tried to draw and it didn't look right. But the blocks of Legos were right.

Gelman: Do you think this ability to transform your style for the appropriate assignment is the result of your graphic design training?

Christoph: Absolutely!

Gelman: Because as an illustrator you would develop a certain style and that would be it. What's important for you in illustration?

Christoph: Well, it's always about the idea. I try to do funny stuff, and in the beginning, the 'showing how great you can draw part' was always important. Even if I had a simple idea, I would always make this really elaborate drawing around it. Which, in 90 percent of the cases, kills it. So today I have a super-tough standard of 'just ideas' and how to make them work, trying to draw ugly, and simple. Using the drawing as a tool to communicate.

Gelman: So you're saying if you have a good idea, the over-execution kills it?

Christoph: Not necessarily; sometimes you need exactly that. An example that Heinz Edelmann, my teacher in Stuttgart, gave us: You have a man and woman, naked; they are singing and jumping into a grave. Let's say that's your cartoon idea, for whatever reason. If you imagine that drawn in a Norman Rockwell-style, perfect, seeing every hair, it's just disgusting and weird. And if you show it abstract, in Piet Mondrian-style, where it's triangles and squares -- it's so abstract you don't care. Something in between is the right thing to make it funny and just the slightly off scene it should be. So for every idea there is exactly that one way to render it to be perfect. I always think something has to add up to exactly 100 percent. So if the idea is 90 percent, you need exactly 10 more percent of style or beautiful colors to top it off. If you do 20, that's too much. Five is too little. Sometimes you just need 90 percent of style too.

Gelman: You need to find that balance.

Christoph: Usually I feel like when you have a silly idea, you try to tone the whole feeling down a little bit, let the silliness work by itself. But other images work only through the crazy execution; because the execution carries it, where you have something incredibly detailed like some things I can show you later, weird drawings where ideas weren't that strong but the execution, stylistically, is just out there. And that's the thing that makes it work. Because there's no concept really to understand or to laugh about.

Gelman: Are you still teaching?

Christoph: No, I am taking a break right now to teach my little kid. Right now I am just a thesis advisor for one student, an illustration student. Very good. From the master's illustration program. Last year Nicholas and I co-taught a class, but that's design, conceptual design, pretty far from illustration. But then again I can't imagine teaching illustration. Saying "Let's all think about the way we draw trees." I don't think I could handle it.

Gelman: A class on how to draw trees like Christoph.

Christoph: I actually can't draw trees. And cats: with cats, I'm completely lost. I can't draw a cat unless I have a perfect reference.

Gelman: After this interview I will teach you to draw a cat.

Christoph: I would love to. Certain kinds of cars, sports cars I still can't draw. I can do chunky cars like those eastern European cars.

Gelman: Boxy cars?

Christoph: Those I can do without looking at stuff. Cats and trees are always a problem. I have a simplified version of a tree.

Gelman: So if you have to draw a cat or a tree you use some images from books or something? Or you say "I'm sorry, call Nicholas Blechman."

Christoph: Usually I find images. I have some books, or do research. I never go to stock image sites because the stuff like that never works. When you browse the Internet, actually Yahoo and Google are the best ways to find images.

Gelman: You probably draw outside of the assignments. What is the proportion of what you do for yourself and what you do for the clients?

Christoph: There is all this stuff that gets killed, if I take that into consideration, of course then... But things that are like self-initiated drawings in sketch books, drawings just for little projects. I think it's maybe one to two. Even when I am here I work, or when I am on vacations or weekends I try to draw for myself. But it's really a lot less than what I do here. Of course I find myself doodling away.

Gelman: But you don't consider this as an art? You don't show at commercial galleries?

Christoph: I totally don't believe in that.

Gelman: So basically you try to enjoy what you're getting paid for?

Christoph: I don't think you can really try to, I just happen to enjoy it but... It's just a matter of luck that I get actual jobs that I enjoy. If I were to get different jobs I don't think I would have the power to twist them around.

Gelman: What kind of jobs do you enjoy most?

Christoph: Sometimes it's having one hour and doing something, and it works out fine. It usually depends on if I am content with the idea that I come up with. If I like my idea and they like my idea too, then that happens to be the job that I enjoy. If I come up with crap or they kill an idea that I consider funny, then I hate the job.

Gelman: Do you ever reject jobs?

Christoph: Usually only out of time constraints. I hope I will be able to be more selective in the future, like rejecting really evil clients. I don't know about alcohol and tobacco, but I

Interview continues at:
http://www.infiltratenyc.com/004/

Infiltrate / Christoph Niemann

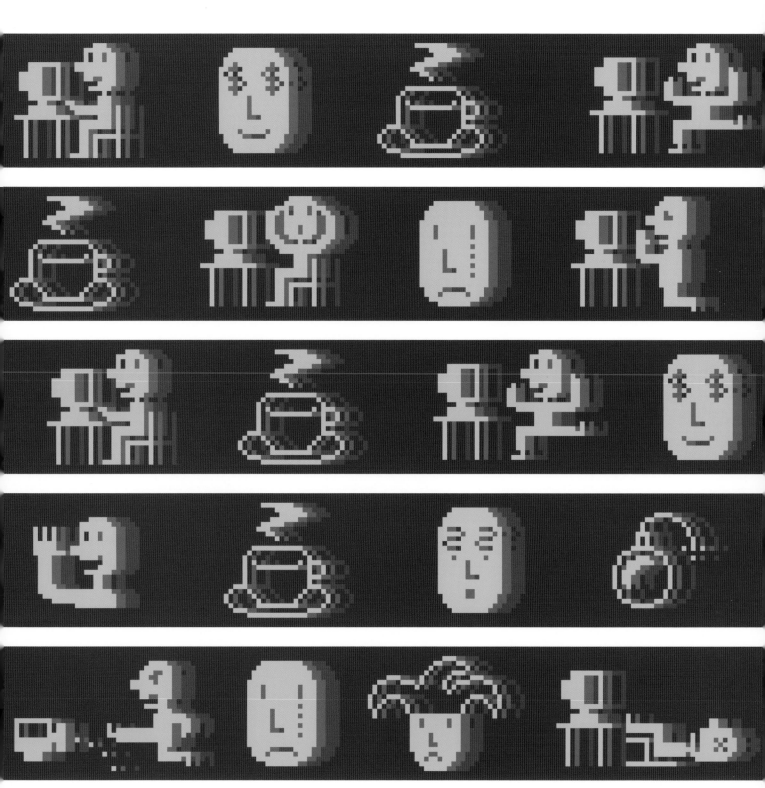

Infiltrate / Christoph Niemann

Infiltrate / Christoph Niemann

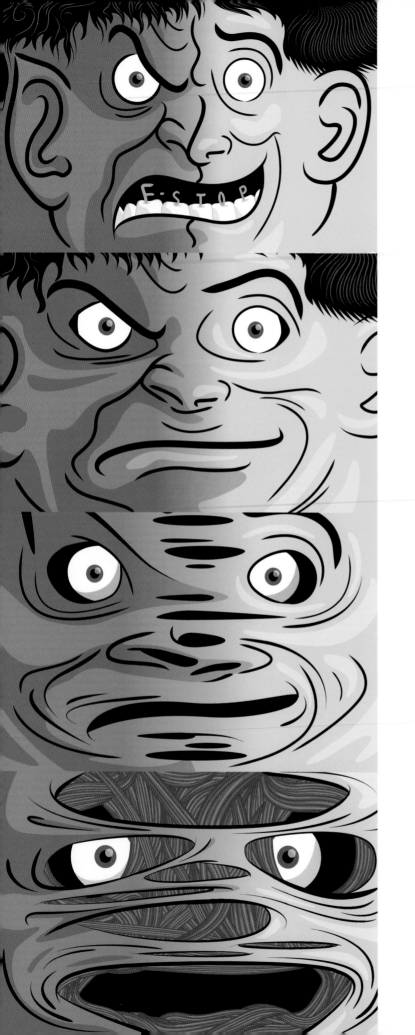

Page 032: Real Estate in New York, 2001. Client: *New York Magazine*. Creative/art director: Michael Picon. Illustrator: Christoph Niemann. The concept should be rather obvious for anybody who has ever looked for a place to live in Manhattan. Pages 033, 039-043, 050-051: Images from sketch book. Pages 034-038: F-Stop Catalogue, 2002. Client/Publisher: Font Shop, Berlin. Creative/art director: Stefan Sagmeister. Designer: Matthias Ernstberger. Illustrator: Christoph Niemann. The catalogue is a small but very thick book (approx 4.5 x 3.5 x 2), which showcases stock photos from designers around the world, that can be purchased on CDs. The concept Stefan Sagmeister created for the client is that all six sides of the book are illustrated (including the cut part of the book). The only creative direction I got was that the outside was supposed to be a head, and the inside pieces should show what is going on inside that head. Pages 048-051: Sketches and personal projects, 1999-2003.

Infiltrate / Christoph Niemann

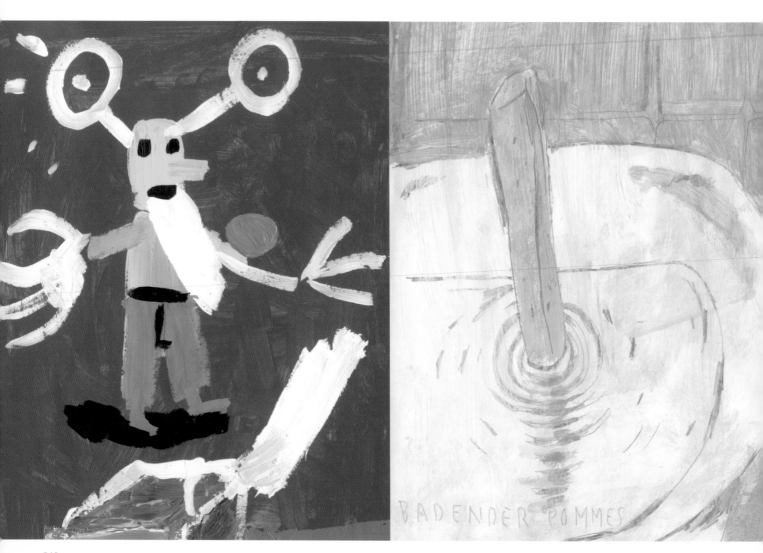

Infiltrate / Christoph Niemann

Page 030-031, 044-045: WWW icons, 2000-2003. Client: *Fortune Small Business*. Creative/art director: Scott Davis Designer. Randi Shapiro. Illustrator: Christoph Niemann. Each month *Fortune Small Business* features five to seven websites that are of interest to small-business owners. Each of them is illustrated with a pixelated icon in the proportion and resolution of the old Mac desktop icons (32 x 32 pixels). Pages 046-051: Personal projects, 1999-2003. Pages 052-053: Fights of Our Lives, 2002. Client: Otherwise. Creative/art director: Nicholas Blechman. Illustrator: Christoph Niemann. This book shows the history of presidential election campaigns in Canada in the 20th century. The portraits show all the candidates of the elections and are used throughout the book.

Infiltrate / Christoph Niemann

Fixogum...
n in
...stedain

Alle Fixogum
Dosen in
Amsterdam

ADDITION-SUBTRAKTION

Infiltrate / Christoph Niemann

054

A conversation with Armando Merlo, intern, Design Machine. Interview conducted by the DM crew.

Armando: Between that and the coffee, it's like, "Let's do it!"

Gelman: Okay. Armando, what are you drinking?

Armando: Not as exciting as what you're drinking, but it's a small, regular latte. I'm kinda thinking I should have went with the Triple Mocha Venti. Now that we have the lights on. <Laughs>

Gelman: Okay. Your internship at Design Machine is almost over.

Armando: Just about.

Gelman: How would you sum up your experience?

Armando: How would I sum it up? Exciting. Very, very educational. From a strictly design point of view, and an everyday working perspective, and dealing with different people that are involved in the whole industry, from clients to printers. And actually, in the office, a fun place; I mean, every student wants to get in a place where they get a lot of attention and they get to interact as much as possible with the creative director and get involved with projects and clients and stuff. Just a really fun experience.

Gelman: You said educational. What did you learn?

Armando: Not only how to be more responsible with things in a professional setting, but just, you know, things that beginning students aren't really exposed to. From talking on the phone to real clients and vendors, and meeting real deadlines and having to get stuff done.

Gelman: So basically, you're saying that you've learned to take responsibility?

Armando: I think I got a more real glimpse of what actually happens in the life of a competitive graphic designer. And just to be in that setting and not only a graphic designer, but a competitive studio, you know. A world-class studio, which is like —

Gelman: Tell me, how was it different from your expectations? Any disappointments? About the profession or —

Armando: No. absolutely not. I mean, the only thing that hits you pretty hard, and what most students aren't used to, is just the hours. But disappointments? There really weren't. I think to have had less responsibility, I think I would have been disappointed.

Gelman: You stayed long hours — how long?

Armando: At least 9-7. Ten hours a day at least. But some nights we were real late.

Gelman: Like what? What's the latest you stayed?

Armando: 11:30, 12:00, I think.

Gelman: Do you think other studios work like that?

Armando: I'm sure some do. Definitely not the majority. I mean, I don't know, but I really don't think so.

Gelman: And you didn't expect that?

Armando: No.

Gelman: When you are back at school, how do you think this experience will help?

Armando: Automatically, being assigned projects, I'll know how I'm gonna go about it. In a fast fashion, in a quicker fashion, an organized fashion, and to have everything planned out more professionally. Less as a student, and more as a young designer. A much more methodical way of working. Among other things I plan on blasting electronic music in the studio. <Laughs> At late hours.

<Laughing>

Armando: Definitely. All kinds. Which I think everybody will get a kick out of.

Gelman: Electronic music? What kind of electronic music?

Armando: Squarepusher. He's the man. He's the man. One late-night session...

Gelman: A little depressing, though?

Armando: Sometimes, but you need a little of that to appreciate the good times, I guess.

Gelman: But you need to play some happy music too.

Armando: Well, yeah. Squarepusher's happy.

Gelman: Mmmm, not really.

Armando: No? Mr. Oizo's happy.

Gelman: Yeah. So you're gonna blast Mr. Oizo?

Armando: Definitely. Well, I mean, not just electronic music, but all types of stuff. I've also learned that it's good to be grounded, to always keep active and keep fresh. Just doing that through music. That's actually one of the things I also really enjoyed.

Gelman: How did you come to know about Design Machine? It's a requirement in your program at Penn State to spend your last school summer in a real work environment, isn't it?

Armando: Yeah, it's a requirement that the summer going into your senior year, you do a summer internship and work in a professional studio. And our professors encourage us to apply at top firms, the most competitive agencies possible.

Gelman: Who chooses the companies? Do you get a list of recommendations?

Armando: Yeah. The first step is the student doing his or her own research on where they want to go. And then after that it's submitted to the professor, the professor figures out which company that student would be best to get the most out of the experience. So it was kind of easy for me. I mean, they encouraged everyone to go to New York. Some kids could, not a lot of kids wanted to, too far or too expensive, but I live relatively close by, and I just researched the top firms in the city. Just the top companies. So Design Machine was one of them.

Gelman: <Laughs> Well, you told me earlier that Design Machine wasn't your first choice. You wanted —

<Laughing>

Armando: Well this is how it was. That triple mocha is kicking in. That's it.

Gelman: You wanted to work with Stefan [Sagmeister].

Armando: Because he was my favorite designer. At that point.

Gelman: <Laughs> What do you mean, "at that point." He's not anymore?

Armando: Well yeah, I do. No, I still like him a lot. Very much. But I feel like I've seen a lot more work since that time, you know, a lot of different work. But no, I still like Stefan. But I mean, I researched Design Machine just as much as I did him or the other firms.

Gelman: Who were the other firms?

Armando: There were a whole bunch of them. I did a little bit of research on [James] Victore, but I found out that he does work upstate, I think. And I'm not sure he needed help, but I think I did a little bit of research on Imaginary Forces, and others, a couple of companies in L.A.

Gelman: L.A. would be fun!

Armando: Well, originally I wanted to go to L.A., but I just couldn't leave the East Coast.

Gelman: Why?

Armando: I don't know. I heard from a lot of people that L.A. was kind of, ehh. As it got closer and closer to the internship, I heard more and more that, you know, that New York is the place to be for the best design.

Gelman: You actually heard that? Because New York has more companies? Or better companies?

Armando: Just everyone really knows that's where trends are born in design and other stuff.

Gelman: I don't think it's true, though.

Armando: I mean, just being the center.

Gelman: Trends can be born anywhere. But this is probably the concentration of everything, business, art and creative industries.

Armando: I think that, and along with the fact that it was the closest.

Gelman: So tell me, if Sagmeister was your favorite designer, why didn't you, or, did you apply for the internship there?

Armando: No. I never ended up applying.

Gelman: Why?

Armando: I was informed that he wasn't taking interns. Whether that is true or not...

Gelman: So somebody told you and you just sort of gave up?

Armando: Well, at that point I was being advised by my professors, and pretty shortly after that, I was in the process of sending to Design Machine. So I think at that point, I was pretty much just focused on Design Machine.

Gelman: Focused. Meaning?

Armando: Meaning, that's where I wanted to go.

Gelman: So they recommended Design Machine to you, and you did research, and --

Armando: Yeah, I had already done some research on the company. At that point, I had already got Subtraction, the book, and I was in the process of reading it.

Michael: Why the East Coast? You said there was something that kept you here.

Armando: Well yeah, we talked about it. New York was in my mind.

Gelman: You live in New Jersey.

Armando: Yeah, I live in New Jersey. Bergen County, it's not that far.

Michael: North Bergen? Where?

Armando: North Bergen, the town? No. Bergen County. A toun called Saddlebrook.

Gelman: Stop this New Jersey talk!

<Laughing>

Michael: Yeah, you wouldn't want to waste valuable ink on New Jersey. <Laughs>

Armando: But yeah, let's start off simply: Number one, it's close. Number two, I've lived here my whole life. I mean New York is New York. I love the city. And some of the best firms were right here. So as it got closer and closer to the time, I kind of veered away from L.A.

Gelman: So your professor, Lanny [Sommese], gave you Dave [Heasty]'s information, right?

Armando: Yeah.

Gelman: So you contacted Dave, you came for the interview.

Armando: Yeah, first I sent a promo, then Dave actually contacted me, asked me to come in, and I interviewed. Then there was a period before I started working.

Gelman: When did I interview? February?

Gelman: How was the interview?

Armando: It was...an interview, a pretty serious one. A lot of other students were kind of talking about their real casual--

Gelman: It wasn't casual here? What do you mean?

Armando: Casual in a sense that, you know, it was just really, like, bullshit. "Okay, cool." Whereas, in my interview, I was actually asked serious questions about design and about my intentions.

Gelman: Like what? Like "What's your favorite color?"

Armando: Yeah.

Gelman: That's a very serious question.

Armando: But I mean, no, stuff that really is appropriate. It was like a real interview. It wasn't, just, bullshitting around, it was actually, we want to know what you're thinking, and what typefaces you used.

Gelman: Oh yeah, you couldn't even remember what typefaces you used in your own portfolio!

Armando: What? I remembered them!

Josh: <Laughing> No you didn't!

Gelman: Some of them. <Laughs>

Armando: Some of them. I don't know, what else? What other on-the-spot questions was I asked? The interview, wasn't, you know, just a, "All right, cool, fuck, all right." Put it this way -- I left the interview not really in a way I was happy with how it went.

Gelman: Yeah, but you forgot your backpack, so you had to come back.

Armando: Oh yeah, I was nervous as shit.

<Laughing>

Armando: I was nervous as shit. Yeah. Yeah, that was fun, after a serious interview, trying to make the best impression, be a responsible intern, and I leave my fucking backpack here.

<Laughs>

Armando: But now that I look back on it, it was helpful. It was a good interview.

Gelman: How do you evaluate your contribution to Design Machine?

Armando: The only thing I can really say is how much I tried to contribute, and that was a lot. I worked as hard as I could, and I really did my best.

Gelman: Are you satisfied with the results? And you think it was, well --

Armando: I had the best internship in my class.

Gelman: You think so?

Armando: Without a doubt.

Gelman: What other place -- what other stude -- what oth.. Yeah, this coffee makes me into a dyslexic.

<Laughing>

Armando: That's because your mind's thinking too fast for your mouth.

Gelman: It's skipping sentences.

Armando: Like, "What...studio...work at...some...other?"

<Laughing>

Gelman: Hello? <Laughs>

Armando: Um, Rolling Stone magazine, Jane magazine, an ad agency called Red Tettimer, these are all in New York. Somebody did one for a company down in Maryland called, HZ -- I always screw this up -- HZDG or something? And a couple in Pittsburgh, but I can't really remember at this point.

Gelman: So you've already shared your experiences with your classmates?

Armando: Actually, I forgot to mention, one my classmates actually stayed with me; he did his internship at a place in New Jersey called S3. So he was kind of with me for the ride, we were with each other for the ride for a couple weeks. Yeah, he knows a little bit about what happened. We'd come home and share stories or whatever. We only hung out with the other interns once. I was always working, but I guess they were too.

Gelman: <to Josh> What else should I ask him?

Josh: What projects he got to work on.

Gelman: Yeah, are there any projects that you were involved with that you want to talk about?

Armando: Well, the first thing for me that comes to mind is the website. A lot of that was already structured, but, you know, I can't even explain how much I learned from that. Just building new pages and doing all that stuff.

Gelman: Any clients?

Armando: Estella. It was really, really interesting, it was awesome to see the Time Labs space being built and HK Restaurant. Skidmarks project, rubber stamps, decks, Virtual Beauty, the endless buttons. And then, toward the end, it was great being able to work with Dmitry from Deelite. He's pretty cool.

Gelman: Michael, are there any questions that you want to ask?

Michael: I didn't prepare.

Gelman: You don't need to prepare, just something that you really want to know, if you were to ask him --

Michael: Yeah, yeah. Well, now that the internship is over, you have just one year -- you're going into your senior year, right?

Armando: Yeah.

Michael: Could you conceivably see yourself working for Design Machine once you graduate, if circumstances allowed?

Armando: Yeah. I loved working here. I liked it a lot. I mean, it's a great place to work. Everyone is -- it's a machine, it's an ongoing thing, and it's tight; everyone's working as a team, and especially as an intern, it's really cool.

Interview continues at:
http://www.infiltratenyc.com/005/

03.31.99

Page 057: "Opinion," an animated sequence, part of a gallery installation. Spring Paper Expo and Fall Paper Expo posters for The Art Directors Club, New York, 1999. Designer/Art Director: Alexander Gelman. Next: Opening sequence for nonstock.3, interactive CD-ROM/Catalogue of alternative stock photography, 1999. Designer/Art Director: Alexander Gelman and Kaoru Sato. Next: Spread from The Complete Run, art catalog for Roth Horowitz Gallery, 2002. Next: Skateboard design for Untitled (Skidmarks) series, 2003. Burton Snowboards logo treatment, 2002. Page 057: "A" in "A". Invitation to the event at The Art Directors Club, New York. Creative Director/Designer: Alexander Gelman. This simple invitation featuring a letter A with a ghost of an A hidden inside, was distributed throughout the design and advertising community in early 1999. After it was published on numerous occasions this modest design became somewhat influential: one clueless headhunting agency blindly adapted our design for their poorly executed direct mail and print campaigns. One day it just appeared in our pile of junk-mail. Beware of imitations, and even more importantly poor business practices.

.tif

3.t

.tif

5.t

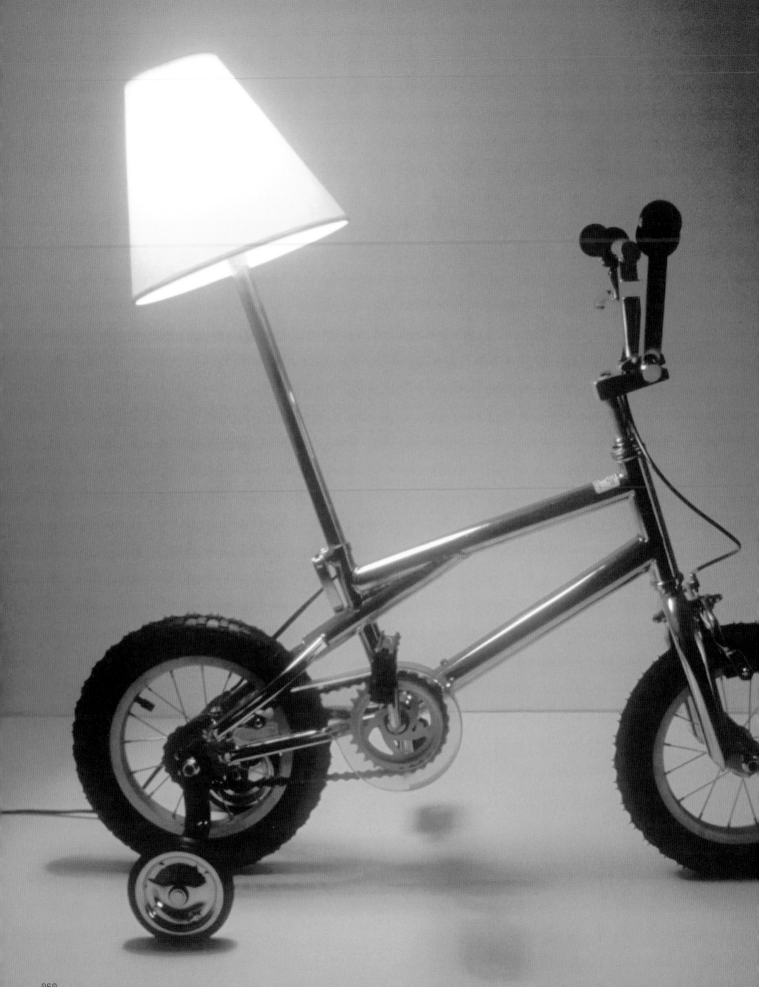

 lamp

tems, 16.75 GB available

6.tif

2.tif

Page 058: Stills from "Red," M&M's TV commercial spot, 2004. Featured Artist/Director/Designer: Alexander Gelman. Agency: BBDO, NY. Agency credits: Ted Sann, Chief Creative Executive Office. Charlie Miesmer, Senior Executive Creative Director. Susan Credle and Steve Rutter, Creative Directors. Becky Friedman, Producer. Production, design, animation, and special effects: Charlex. Production credits: Alex Weil, Creative Director. Steve Chiarello and Bennett Lieber, Producers. Bryan Godwin, CG Supervisor. Tony Tabtong, Animator. Stephen Mann, Technical Director. James Fisher, Lighting. Philana Dias, Flame Artist. Pages 058 (Right image) and 061: "Lamp," an animated sequence, part of a gallery installation, 1997. Art/Design/Animation: Alexander Gelman. "Glass on Table," 2002. A series of conceptual charts for "Subtraction," an ongoing research project. Author/Designer: Alexander Gelman. "2003," an animated sequence. Design/Animation/Photography: Alexander Gelman. Page 060: Lamp-Bike, 2001. Page Creative Directors: Alexander Gelman, Kaoru Sato. Designers: Alexander Gelman, Kaoru Sato, David Heasty, Alyssa Philips; Lamp-Bike for the World Studio Foundation. Page 062: Signal and battery level treatment for AT&T Wireless TV commercial spot, 2004. Art/Design: Alexander Gelman. Agency: Ogilvy & Mather. Agency credits: Bill Oberlander, Executive Creative Director. Don Kurn and Don Mulkey, Creative Directors. Melinda Kanipe, Senior Art Director. George Feinn, Senior Copywriter. Patti McConnell, Executive Producer. Melissa Mapes, Producer. Cornelia Henning, Assistant Producer. Production: Tool of North America. Editing: Consulate. Post Production/Effects/Design: Charlex. Post Production and Design credits: Alex Weil, Executive Creative Director. Alexander Gelman, Design Director. John Zawisha, Effects Editor. Bryan Godwin, CG Supervisor. Philana Dias, Flame Artist. Tony Robbins, Flame Artist. Jeet Tailor, Designer. Jason Carswell, Animator. Steve Mann, Technical Director. Anthony Patti, Lighting. Alan Neidorf, Smoke Artist. Bennett Lieber and Dan Connors, Producers. Page 063: Instant ashtray for Takeo paper, 2000. Designer: Alexander Gelman. Page 064: T-Shirt series for Untitled (Skidmarks), 2003. Creative Directors: Alexander Gelman, Kaoru Sato. Designers: Alexander Gelman and Kaoru Sato, Armando Merlo. Page 065: Tadanori Yokoo. Invitation for an exhibition of Tadanori Yokoo at Roth Horowitz Gallery, 2003. Creative Director: Alexander Gelman. Designers: Alexander Gelman, David Heasty, Andrew Roth. Artwork: Tadanori Yokoo. Page 066: Spreads from "Subtraction: Aspects of Essential Design", 2000. Creative Directors: Kaoru Sato, Alexander Gelman. Designer: Alexander Gelman. Photography: Peter Lindbergh. Page 067: "Side," 1996. Watch design for 1997-98 Swatch collection. Creative Director/Designer: Alexander

A conversation with Rebecca Ross, principal, Famous Mime.

Gelman: You are always involved in a lot of things. It seems like you always try to take on more than you can handle.

Rebecca: Yeah, that's a definite feature of me.

Gelman: How do you manage?

Rebecca: It's working out fine. I think generalism is overrated. I think I've got generalism down pretty well now, but after graduate school studying design it sort of came to --

Gelman: I wouldn't call it generalism though.

Rebecca: What would you call it?

Gelman: Just multiple interests.

Rebecca: Multiple interests. That's right. Well, I guess in my mind they're fairly related. A lot of what --

Gelman: I think you go with it pretty deep. Generalism is normally something that remains on the surface.

Rebecca: I guess so. I've always been interested in basically the same things in art and technology, design and technology, in symbols and what they have to do with technology, what they have to do with typography, what they have to do with design, all three places. After studying design for three years I came here, and this is a computer-science facility. Although it's a bunch of computer scientists trying to be creative, I'm here as a creative person. I get involved with the creative aspects in a lot of their projects, which mostly have the goal of being technically innovative, and they're recognizing that it's possible to be technically innovative and creatively innovative at the same time. I guess "interdisciplinary" is the word I would use to describe myself. When I was in graduate school studying design, I was the computer person studying design. Now I'm with a lot of computer scientists, and I'm the designer in the place where all the computer scientists are.

Gelman: You're the design person.

Rebecca: The students I teach are equally interdisciplinary. Actually, they're interested in a lot of different things at once. They want to really pull together their motivation to be creative with very particular, practical skills that aren't normally the skills of a computer scientist.

Gelman: It's interesting, this activity still hasn't been successfully categorized anywhere yet. What's the current name for it, "computational design"?

Rebecca: I don't know if it has a good name, I mean there's multimedia and new media.

Gelman: Although it attracts a lot of attention, there's still a very limited number of people and schools involved in this kind of research.

Rebecca: I think there's the problematic equation of design skills and computer skills that happens a lot in some of the new media programs. If you know how to use Adobe Illustrator, then you know how to make graphics, when in fact they are two different activities. I think that is actually what goes on in a lot of these interdisciplinary programs, and makes it hard for the work to be rigorous. I guess I'm trying to think of --

Gelman: How does it work? Are you driven by certain skills that you have and trying to apply them to something? Or do you start from an idea where you imagine the end result, and you learn to gain the skills to realize it?

Rebecca: Generally, I have a lot of ideas; more ideas than I ever --

Gelman: That's what I thought.

Rebecca: More ideas than I ever have time to move forward with. And so a lot of what I do is juggling between 10 to 15 things that I want to make at one time and maneuvering around the city and seeing what other people are doing and what things I can learn to do. Some projects move forward and others get pushed back, or to the side, rather. I essentially pick up new skills to finish projects, or to start projects, and in the process of picking up those new skills I get more ideas for more projects, so it's kind of swimming forward in that way. That's fun because I'm always learning new things but it's hard because sometimes I know I want to do something in particular but I just don't have the expertise.

Gelman: You probably have a lot of unfinished projects.

Rebecca: I have a lot of unfinished projects; that's true.

Gelman: Do you have a lot of finished projects?

Rebecca: I would probably say no but other people might say yes. Well, I guess a project is finished when it goes out into the world. I have a couple of projects that have been out in public and maybe that's what makes them finished, if they're out in public and people are interacting with them. So in that sense a few things weren't finished, but maybe I didn't think they were finished. But they are finished because now they're crumpled in a ball on the floor of my closet, or something like that. Maybe that's what finished means. In biology if all your biological systems reach -- they go back and forth and back and forth, the definition of what happens when your biological systems achieve equilibrium is that you're dead. And it's kind of that way, there's no equilibrium, it's just back and forth and back and forth. It's very energetic.

Gelman: It's a continuous process.

Rebecca: Yes, exactly.

Gelman: So you feel that as long as you're motivated, as long as you're working on something, you're in your perfect state. And it's not about finishing something.

Rebecca: Although I have goals, I keep working on that. That's exactly what I enjoy doing every day. That's exactly what I want to do.

Gelman: Do you want to talk about specific projects you're working on currently?

Rebecca: I'd say that the past few years I've been working on the relationship between the hand and the machine. How does the hand relate to the machine, and when we're making things out of pixels, how are the values that are associated with making objects by hand associated with the process of making something digitally? I guess the past few years have been a whole lot of experimentation in that area.

Gelman: A physical computation?

Rebecca: A little bit.

Gelman: Or robotic computation?

Rebecca: Really much more about semiotics; the course that I'm teaching right now is called Pixels and Bits. Basically all the students in the class are like über-[Adobe] Photoshop users, and the idea is to undo their knowledge of software. They're basically writing Java applets in response to design problems, two-dimensional design problems. And the problems are interactive; they're basically creating compositions like we used to create with Ploka, but they're creating them on the computer out of pixels.

Gelman: Do you use DBN [John Maeda's Design by Numbers]?

Rebecca: I actually do like DBN but I wanted them to have more expandability in the future. A lot of them already did come into the class knowing how to program. Basically they're programming in response to visual problems and that's interesting. The idea is how do you get dirty with pixels, how to get really messy. You make a big mess and find your way out of the mess, and then you know it. So the idea is that they're making a big mess with pixels. I think that what I was doing, trying to see were what kinds of new things that I can make out of data. What are the properties of data and how can those properties be kind of twisted and bent and how can physical actions be applied to them? How can they have weight, how can they be heavy, and how can they be meaningful? I think where that took me was to a lot of different sorts of experiments with data visualizations in informational graphics in which I would essentially really play with the relationship between an information graphic and the thing that graphic refers to. And really try to address the space between an information graphic and the situation that it represents. And vary that space, and twist that space in different ways.

Gelman: By space, do you mean that vehicle that brings information to the user?

Rebecca: It's sort of a semiotic space: the distance between a signifier and the object that the signifier refers to. So with a computer, essentially it's the manipulation of abstract symbols, that's what you're doing with the computer. Designing something on the computer is

Rebecca: ...manipulating abstract symbols that are instructions ultimately to some type of output device, in the case of print, or for the user.

Gelman: So that's the space?

Rebecca: Right: One side of the screen, between zeros and ones and images that are legible to people. That's sort of the space I'm interested in, as a sort of narrowing down -- I don't think of narrowing down as in focusing on one discipline over another discipline -- I'm more narrowing down in sort of my interests in information and data. I'm moving towards work that asks people to participate in data and participate in information in as many ways as possible. I guess before I was interested in starting to move towards work that assembles people's local smarts together to form large data sets that then may be competitive in some way with institutionally generated data sets. And spatial data, cartography, has become important to me in the past year, questioning maps and finding maps for communities to create their own maps of their situations -- various types of communities to create their own maps in which there's no one person who controls the whole map and developing interfaces that give people access to each other's expertise. That's kind of where the work is going right now.

Gelman: That's where your GPS comes in?

Rebecca: I did a few data collection projects in the past few years. One of them was with magic marker and one of them downloads information from websites, some of them collect information by hand. I sort of assembled a toolbox for visualizing different kinds of data by moving it from one part of culture to another and re-visualizing it. And now I'm moving definitely towards spatial data and the reason I think spatial data is really interesting is because with spatial data there's always this concrete world that one is referring to with data. For example, a couple of summers ago I was working on Fresh Kills [the site of the largest New York City landfill] on Staten Island, and I did a bunch of research in advance of going there. The database that I looked at was a U.S. Geological Survey database, which reported Fresh Kills as deciduous forest. Now anyone that spends time at Fresh Kills can look around and know well this isn't a deciduous forest at all. There are no trees. It's a total inaccurate summary of that space but yet it is the official summary.

Gelman: Juxtaposing data.

Rebecca: Really, contrasting the way a person's eyes and ears and hands relate to the way the situation that they are in is being described from a distance.

Gelman: Human perception versus reality.

Rebecca: Well, more like a method of reporting on a situation from a great proximity from that situation compared with...

Gelman: Inside versus outside.

Rebecca: People in their regular lives being experts on the situations that they dwell in as opposed to sort of central institutions elsewhere having that expertise. You know best about your house; no one else knows your house better than you do. I think that a lot of technology doesn't credit people's own smarts within their own settings. I'm interested in starting to move towards work that assembles people's local smarts together to form large data sets that then may be competitive in as many ways as possible. I guess before I was trying to look at information in a really critical way and trying to kind of manipulate it in a variety of ways and now I'm working with access to information, interfaces for accessing data, collecting data and making people aware of their capacity to participate in data sets.

Gelman: Tell me about the Growing House.

Gelman: About the Growing House?

Gelman: It was fun to watch.

Rebecca: I like that project because essentially a house is something so solid and we take our own home, our houses, very much for granted. They're stable, and we definitely take the stability of home for granted in a particular way. The idea was to use media to undermine that stability and so the house is continuously rebuilt over and over again by technology and by slides, essentially, in this case. The idea is that something that's made of bricks, it's a solid physical structure, and the idea that technology enables it to come down and up and down and up and up, it seems to make sense right now. It would be interesting. I guess I'm interested in the way that computers relate to activities like building walls. Walls are so solid and specific and permanent even though they're really not. They feel so stable and information is so liquid but it has many physical components to it.

Gelman: It's interesting that you utilized a slide projector.

Rebecca: I really like the sound of the slide projector, for one, and the slide projector enabled it to be staggered in this rigid way.

Gelman: There's something really peaceful, something un-digital about it.

Rebecca: Although the slides themselves are digital; I generated the slides on computer and printed them out to slides. There's something about pushing the light though the image that seems important in this case. The slide projector is right there and you can see. The sound is pretty important because that's an artifact of the physicality of this process of it going up and down.

Gelman: What else?

Rebecca: What I'm working on right now and what I'm getting my students involved in, we're making a map of the NYU campus here. What I'm hoping to do is to create essentially a layer of graffiti, a layer of digital graffiti on the campus. The first phase of the project is to create a map of campus that's like a bulletin board system. A regular old web-based bulletin-board system except that all the information is specialized to particular places on campus. The next phase is to make that system assessible to mobile devices with search functionality and a really good interface for people. Also there are cell phones that have certain ways to calculate positions without GPS. GPS is a prohibitively expensive technology, so what we're doing is starting with the campus. The students are using it for strange things already.

Gelman: Like what?

Rebecca: One student who has two different names, screen names, which he signs on as and has a dialogue with himself on the board. They use it to advertise events; somebody put some things up like "what did you do today in five words or less," and then everybody would have the task of trying to write down what they did in five words or less. But they also advertise films that they're screening, or making; if they need help with a certain weird prop for a film. Whatever they are working on, they'll use it as a communications/information infrastructure. What I'm hoping to do is to move that to a more spatialized kind of to a map of campus. And what would happen is, eventually people will have portable devices, and they'll be walking around campus, and they'll be able to access stories that are related to different spots on campus. This afternoon I'm going down to the Grand Street Settlement on the Lower East Side where they have a computer activity center for kids. I'm starting to talk to them about a similar project with the girls' rap groups. They have these rap groups where a bunch of girls get together after school to talk about issues relevant to teenage girls. We're probably going to work on a map of the Lower East Side where they embed their stories about it into the map. So it will be a map they create of their own neighborhood based on individual stories. I'm working on projects like that. I'm also involved in a whole lot of different kinds of work up here, working on a project with the NYU Medical School, a system to augment learning with rich media, collaborating with a surgeon up at the med school. That's been a really interesting process. On a small scale, a couple of the projects I'm working on have to do with zooming interfaces in particular. Last year I developed a typeface for use in zooming in on data spaces and the letters are all drawn on a small grid and as the grid scales up and down, the letters are redrawn as strokes. Right now I'm making a specimen of this typeface and it's in a form of a chat room.

Gelman: Nice, but you still don't have any lowercase.

Rebecca: I don't have lowercase. I'm working on lowercase actually. The more important thing to me is this chat room. What happens is that wherever you type it becomes 28 pixels high in the center of the screen, but you can pan and zoom to any part of the space, so if you type here and then you pan over and zoom out; you're still typing 28 pixels high, but the other text is small because you've zoomed out of it. So it's going to be this multi-user writing space that you can have different conversations in different spots, at different scales. That's something I'm working on right now.

Gelman: Do you capture some of these conversations?

Rebecca: The system is in progress. Actually, I haven't built the system yet.

Interview continues at:
http://www.infiltratenyc.com/006/

™ Folder

Campaign Finance Bill Wins Final Approval in Congress

OK

Suicide Blast Rocks Jerusalem, Leaving Up to 40 Wounded

OK

Flying Puck Caused Rare Brain Injury

OK

Pages 070–071: Rebecca Reading Under Pixel Tree, 2002. The Okay News, 2002. A re-formed newspaper that runs in the background of everyday computer use. Every 20 minutes OkayNews delivers a headline from that day's New York Times to an operating system warning box with the single button "Okay," which must be pressed to continue using the computer. Page 072: PDA Guided Tour, 2002. A PDA-based tour, in which tourists are encouraged to add their experiences with locations. Over time, the accumulations of these experiences becomes a community authored, or decentralized, map. Watch, 2002. Watch is a wristwatch that cross-references the wearer's position with a small set of environmental, economic and social statistics about their location in space. Watch provides a means for wearers to immediately juxtapose the way in which they experience the world through statistical summaries with an understanding they derive in person with eyes, ears, and hands. Page 073: Dog, 2002. Packaging for a robot dog that senses and alerts in response to high levels of radiation. Pages 074–075: Zoom, 2002. Alphabets made using a combination of hand and algorithmic techniques. Each set has its own unique set of rules associated with its forms. Pages 076–077: Other Pictures, 2002. A proposal for diagramatic television and film content. These examples juxtapose realistic audio with depictions of activity taking place that wouldn't normally have presence in video. Page 076: Numbers, 2002. Alphabet. Pages 078: Houses, 2002. Images for a sketchbook. Page 79: Touch Interface, 2002. A cycle of formal experiments with touch-based interfaces to data. In the first experiment, the arrow, adhering to the laws of gravity, pushes toward the bottom of the screen, unless the user pulls it back upward. Pages 080–081: From a series of political messages, 2002. Posters for LGBT installed to critique the cliché "Gay and Proud" by opening it to a community in which one claims membership by declaring a distinction from the group at large. Warning and Pages 082: Hand in Machine, 2002. Instructions legible to postscript laser printers for getting one's hand into the machine.

UPGRADE YOUR DOG NOW!

I WANT HARVEY TO FALL INTO A DEEP, BLURRY RIP VAN WINKLE DAZE AND I WANT TO PARK THE SKYLARK MOTHERSHIP ON TOP OF A MOUNTAIN AND WALK AROUND TO THE TRUNK AND OPEN IT. I WANT HARVEY SNORING LOUDLY AS I UNZIP THE DUFFLE BAG AND REACH MY HANDS INSIDE, AND I WANT TO—WHAT—TOUCH EINSTEIN'S BRAIN. I WANT TO TOUCH THE BRAIN.

'DRIVING MR. ALBERT' BY.MICHEAL PATERNI

A STROKE-BASED MONOSPACED
FACE MADE OF STRAIGHT LINES
CONNECTING POINTS ON A
SCALABLE GRID.

INSPIRED BY KEN PERLIN'S
ZOOMING LINE FONT,
DEVELOPED FOR USE IN PAD-BASED
ZOOMING APPLICATIONS.

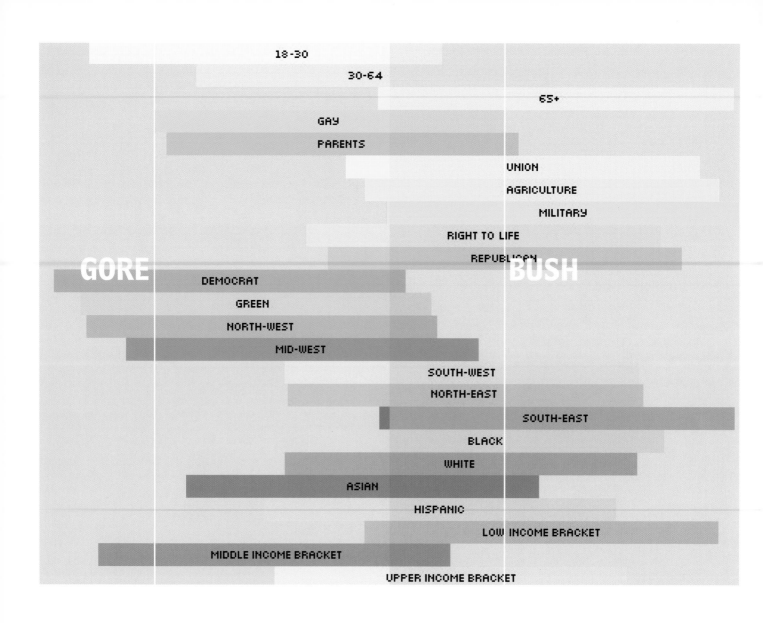

GORE BUSH

18-30
30-64
65+
GAY
PARENTS
UNION
AGRICULTURE
MILITARY
RIGHT TO LIFE
REPUBLICAN
DEMOCRAT
GREEN
NORTH-WEST
MID-WEST
SOUTH-WEST
NORTH-EAST
SOUTH-EAST
BLACK
WHITE
ASIAN
HISPANIC
LOW INCOME BRACKET
MIDDLE INCOME BRACKET
UPPER INCOME BRACKET

0 1 2 3 4 5 6 7 8 9

The Matrix (1999)

FISHBURNE

FILM STOCK

CAMERA

EFFECTS

MOSS

PANTOLIANO

SOUND

LIGHTS

REAVES

EDITING

CREW

$64,757 PER MINUTE

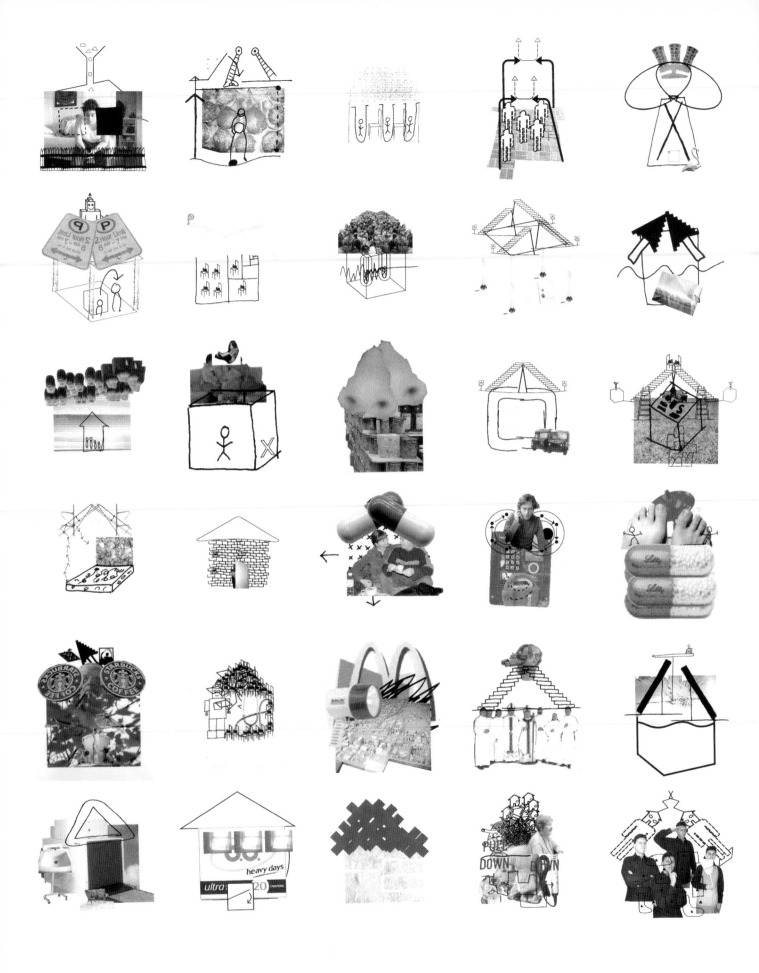

I am
married
and
gay

I am
not a virgin
and
have anal sex

I am
MEXICAN
and
a bottom

I am
Gay
and
Ghetto

I am
an ASIAN LESBIAN
and
NOT YOUR FANTASY

I am
a girl
and
i like girls

I am
a dyke
and
I DON'T HAVE A U-HAUL

I am
QUEER
and
HAPPY

I am
a jock
and
not homophobic

I am
naughty
and
like to play

I am
sensitive
and
skilled

I am
closeted
and
hate it

I am
and

I am
HANDSOME
and
pansexual

I am
and

I am
and

DECONSTRUCTION: A MALL IS A POOR SUBSTITUTE FOR A COMMUNITY

```
% % Title ...
newpath
-17 625 moveto
10 600 38 575 66 550 curveto
98 522 101 500 98 461 curveto
95 430 96 399 85 367 curveto
76 340 56 301 47 286 curveto
38 271 35 227 66 254 curveto
79 264 113 345 138 324 curveto
142 320 137 289 137 284 curveto
136 256 135 228 134 201 curveto
134 190 131 177 134 166 curveto
141 135 167 153 167 177 curveto
167 195 175 292 190 299 curveto
198 303 200 233 202 224 curveto
204 206 206 142 223 132 curveto
256 110 247 203 247 217 curveto
247 226 250 295 252 293 curveto
260 283 258 249 260 236 curveto
263 213 267 189 269 165 curveto
270 147 297 141 300 163 curveto
302 179 302 197 304 213 curveto
306 240 301 266 301 293 curveto
301 335 306 357 324 396 curveto
335 374 345 351 359 331 curveto
365 322 426 267 420 307 curveto
417 325 401 345 395 364 curveto
390 378 383 393 377 408 curveto
365 433 358 456 344 480 curveto
326 510 307 528 285 552 curveto
257 583 252 605 237 640 curveto
218 667 171 737 136 774 curveto
% % FLOW
stroke
```

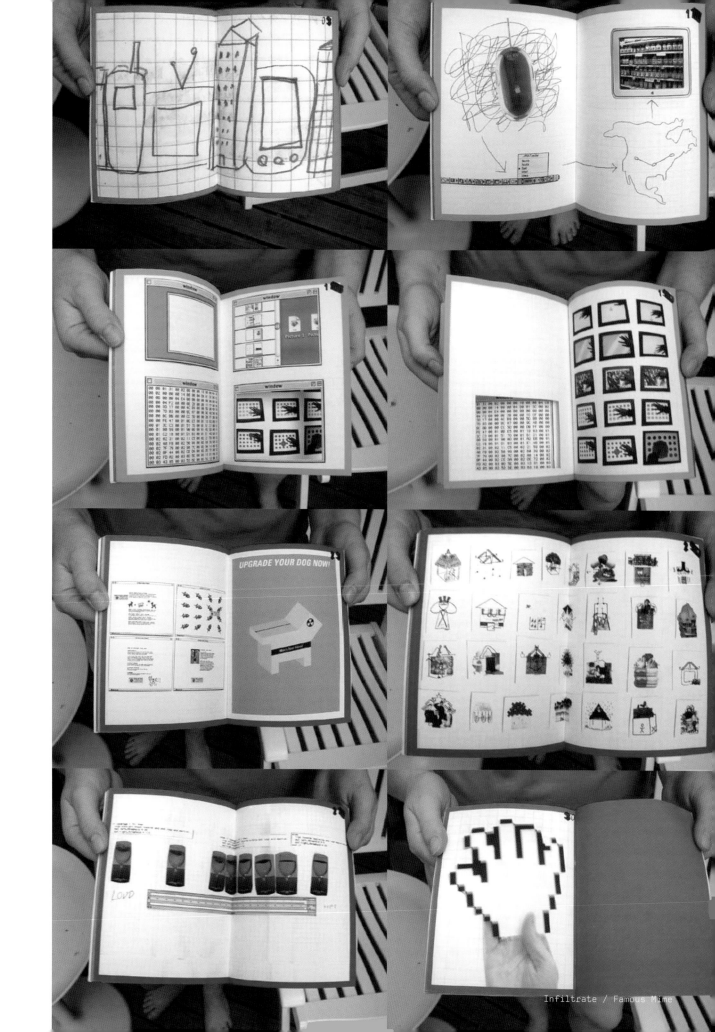

A coversation with Randall J. Lane, Derek Lerner, David Merten, Sadek Bazaraa, members of GH avisualagency.

Gelman: How would you describe yourself? As a design company, or a group of artists, or something else altogether?

Randall: We all have a history in fine art. Sadek is the exception to that; he is more from industrial design and engineering. We came together to design across all media. And as things have evolved, we've always kept in tune with being four individual artists bringing our individual likes and dislikes and talents into the firm. So we're definitely a design firm, but it's a design firm made up of individual artists who like to explore the collaboration between four people in ways that extend beyond graphic design -- group shows, solo shows as Graphic Havoc, T-shirts, book publishing, things like that.

Derek: The name of the company -- which just recently has been modified and evolved to "GH avisualagency" -- signifies who we are. We're visual thinkers, and that's what we do. It doesn't matter to us what exactly the medium is, we develop creative and unique solutions to visual problems through creative thinking.

Gelman: Is there a divide between work for clients and work that you are self-initiating?

Randall: We have a number of client-based projects and we have jobs where we're doing more artistic stuff, but still for a client, and then we have things that we as a group or individually are putting out there as Graphic Havoc. We do have a shopping cart on our website, and last year we self-published a book that we sold [out]. We do one-off T-shirts, screen printed posters, things like that. But a lot of time is spent working on clients jobs. Right now we're very busy, but when some of that slows down, we concentrate our time on "our" projects.

Sadek: Often we're exploring our own ideas, things that we like, and taking surveys of things around us, accumulating ideas and information. You know, a lot of times we'll use those ideas if the right job or specific client need comes up, where it can become an outlet. Or if that doesn't come around, they may become more personal work or things we'll pursue outside of the client realm. There's a constant process of thought that's going on, and it ends up in various places, depending on the project.

Gelman: Do you always find outlets for the ideas you have, whether you have to spend money and actually publish it on your own, or to sell it to a client?

Sadek: Not to sound like a cliché but it could be considered just more of a life-style. Doing and thinking about things creatively and getting it out there, how ever. I think the fun or joyful aspect is in the creating, and wherever it ends up, it ends up. Sometimes. <Laughs> I don't know if that's true all the time.

Gelman: Tell me a little bit more about your creative backgrounds.

Randall: Well, the three of us went to the same college, but at different times, the Atlanta College of Art. I studied drawing and painting. Derek was independent with some computer and video editing, if I'm not mistaken?

Derek: Uh-hu. With a lot of printmaking.

Randall: And David was painting with some computer stuff too, right?

David: Yeah, it was individualized, but it was mostly drawing and painting.

Randall: So we each had gone to art school to explore being "an artist." For me, I grew from graffiti culture into an interest in graffiti culture. And the graffiti culture really got me interested in typography, and an interest in typography led to graphic design. All of this was happening at the same time the Mac was getting a lot more powerful and a lot more accessible. So those things lining up led me to graphic design. And then doing exploration of graphic design for, you know, 10, 12 years now.

Sadek: I started out at Georgia Tech pursuing engineering, and after doing that for about three years wanted to do something creative in a different way. So I went into the industrial design program, and I was doing music, playing in bands, and that opened up a whole other world to me. And there's actually someone else that we often don't talk about in situations like this because he's not sitting here, but there's a fifth -- we have an L.A. office -- and Peter Rentz is manning the industrial design program, I met Peter, who had graduated years before me, with a physics degree, and he went back to school for industrial design, and that's where we met. I had also gotten interested in graffiti and learned a lot from Peter, who was also friends with these guys. I quit the program after about two years. Then Peter, who was working with these guys, introduced me. That's how I fit in to the circle. Through Peter.

Randall: We all still individually pursuing our artwork outside of the collaboration. Derek has a show in October.

Gelman: Different from what the company does?

Derek: Completely. I think all of us kind of strive to do something that is different that is about us or what we are thinking about.

Gelman: And the individual initiatives are supported by everyone else?

All: Oh yeah. Of course. Definitely.

Randall: You can't help but have it influence the whole collaborative. Each person pursues what they're interested in on their own, whether it's painting or drawing or, in Sadek's case, music.

Gelman: You're still playing music?

Sadek: I kind of put my instruments down for a few years, but have recently picked them back up.

Gelman: What do you play?

Sadek: I mostly played guitar before, but now I'm attached to a laptop and a computer, appropriating old ideas, and because I have a new instrument at hand, it's new and old at the same time. I wouldn't call it anything outside of experimentation at this point, done in my kitchen for hours and hours. <Laughs>

Gelman [to Randall]: And you paint?

Randall: Yeah. Painting and drawing. I'm also exploring some sculpture, and that influences what I bring to the table as a designer. My wife and I also have some projects that we're working on.

Gelman: Your wife is also an artist?

Randall: How would you describe her?

She is not a traditional artist but definitely a creative person. She does freelance for film and video production, styling for film and video, but also in Columbus, Ohio, where she's from, she's put on burlesque shows and things like that.

Gelman: How about you guys? What are your personal projects?

Derek: Mixed media, really. Drawing, painting, printmaking.

Gelman: Printmaking? You did a lot of that at school, right?

Derek: Right. Some photography, mostly drawing. But some stuff with the computer added in to photography and painting squashed together.

Gelman [to David]: How about you?

David: A mixture of everything, from photography to drawing and painting. We definitely want to pursue other things. We'd all go crazy if we were Graphic Havoc 24 hours a day. I love sleeping. <Laughs> Sleeping is a new project of mine.

Gelman: How long have you been in business?

Randall: Ten years. We started in 1993 in Atlanta, Georgia.

Gelman: All five of you?

Randall: No, actually just Derek and I started the company in 1993. Then David came on, and Peter.

Gelman: And now you have five partners. Do you have employees?

Derek: Kind of.

Randall: It's structured so everybody has equal say in the company. There aren't any formal positions.

Gelman: Do you ever argue?

All: Yeah. <Laughing>

Gelman: How do you get along?

Randall: I think we get along great, considering we have four or five strong-willed individuals trying to get a project or numerous projects done. Of course there are times when we're at each other's throats.

Gelman: When you get a project, do you identify a specific person to be in charge of it?

Randall: It depends on the size of the project and how busy we are. But in a perfect world what we try to do is, if we get a project in from a client, each of us works on a design draft, and then we show everything.

Gelman: So it's like a competition?

Randall: In some instances. It depends on the job and how busy we are.

Gelman: I assume you split the money equally...

Randall: Yeah, we all get paid the same. Basically it's salary, and then other money goes into projects, or new computer equipment, or things like that.

Gelman: So whatever is on top of salary you just invest back into the studio.

Randall: Right.

Gelman: None of you are from New York originally? Why did you choose New York?

Randall: We had been in Atlanta for at least 10 years as adults, and the company was doing well, so we just decided to move. There's not really any option beyond New York. We fleetingly talked about San Francisco, or maybe somewhere in Europe. We were all single at the time, and young, so we said let's just do it and see what happens.

Gelman: You mentioned that graffiti culture influenced your work. Were you part of a graffiti scene where you came from, or do you have any kind of relationship with the New York graffiti scene?

Randall: For me, personally, getting into graffiti, it's impossible not to be aware of New York graffiti. New York is the home of graffiti. I haven't been a graffiti writer in New York City, but I pay attention to what happens, just like I think anyone outside the city interested in that culture pays attention to what happens here.

Sadek: It was just kind of a general interest that I had. I tried my hand at it for a while in Atlanta, and it kind of came and went for me. I didn't practice very much or stay with it, but it permeates a lot of things I do. I latched on to more of a bathroom style of graffiti. More of like just random markings and stuff. Not a traditional sense of --

Gelman: Not spray can.

Sadek: Well, even if it was created with a spray can, but just more random markings—a different style of graffiti than most people associate with the word.

Gelman: Are you still writing?

Sadek: No, no, it was a very short period of time where I was so fascinated with the complexities and the culture itself. I have a tendency to, when I get excited about something, I'll want to experiment with it or experience it for a while, to develop my understanding a little bit further. So I couldn't really resist. I would study magazines and look around at things, so a typical course of action was to pick up a can and hit some walls and doodle around on paper and stuff like that. But it was too damn hard. <Laughs>

Gelman: What's hard about it?

Sadek: I don't know. I just don't think I have the hand for it, really.

Gelman: Was it just hard to make a satisfying image?

Sadek: I have really high standards for myself. I got what I needed out of it, but the time needed to take it to the point where I would have been satisfied was too much. The enjoyment wore off to where I didn't necessarily want to put the time into it. I moved on to other outlets after trying my hand at it.

Gelman: Can you tell me about any specific projects? For example, your book; how did you decide to make a book?

Derek: It was something that we really wanted to do for a long time. All of us have been very attracted to books for a long time, and we were approached by a small printing company in Atlanta to design their corporate identity, which we did in trade for free printing of the book. As far as the process goes, we had a certain amount of pages a piece to do whatever and then a number of pages on which we collaborated.

Gelman: How long did it take you to...

<All laugh>

Randall: Well initially, I think we started early designs for it in 1996, maybe 1998. Yeah. We started doing some of the early designs and talking about it, and decided to do it, and it was published last year.

Sadek: But our move was in the middle of that, and often client work...

David: Definitely. It got put on the back burner many times.

Sadek: Finally, we were like, "All right, it's time. We're gonna do it." After we really picked it back up, I think it was a year, maybe.

Gelman: This book is an interesting hybrid of client work and personal work.

Derek: No, there's no client.

Randall: No, there's no client work in it. Everything is personal work and collaborative work as a group. Some similar-looking stuff has been done for clients.

Gelman: But the printing company --

Randall: No, we bartered the identity for the printing.

Sadek: It was the first book they had done. They did quite a bit of work, but they had never done a book.

Gelman: How did you distribute it?

Randall: We self-distributed it, put it up on our website for sale. We contacted the New Museum store and they bought a number of copies. A lot of it was just people had heard about it and bought a lot of copies. Magma Books in the UK bought a bunch of them, like 80 copies.

Derek: And they're all numbered. All 1000.

Gelman: Can you tell me about some client projects?

Randall: We've recently done two campaigns for Triple Five Soul, the fall '02 and spring '03 campaigns. For the fall '02 campaign, we worked with B+, a hip-hop photographer from California. We did ads, posters, point-of-purchase displays, trade show graphics, a look book, stickers. Lots of ads. And then in the spring '03 that we just finished up, we did all of that, but we got to choose the photographer. For the spring '03 ads we built sets -- they always work with musicians. So the spring '03 was Blackalicious, Mia Doi Todd, El-P, and King Britt. And for each group or individual we built a set.

Gelman: Who was the photographer?

Randall: Jody Fausett was the photographer. The look book was interesting, a box with cards inside. The ads have just recently hit magazines. And the look book was given out at ASR, which is a clothing trade show out in San Diego.

Derek: In the midst of working on this campaign, we were approached by Curious Pictures to collaborate with them on developing three spots for Target. Peter worked on that.

Gelman: Is it done yet?

Derek: Yeah, they're on the air.

Derek: They dealt with the animation and the concept and such, but the way that it looks and most of the illustration is us. Lots of album design along the way. Just finished up Prefuse 23 on Warp Records. Sadek worked on that.

Randall: We've recently been working with an underground hip-hop magazine that's been around for years, and they --

Gelman: What's the name of it?

Randall: Elemental magazine. They approached us -- they've increased their distribution -- to completely re-design the magazine.

Derek: The new issue just went out the door, what, two days ago?

Randall: I saw you looking at the plaque <Points>; they gave us that plaque.

Gelman: They gave it to you? <laughs>

Randall: Yeah, we had done the re-design of the magazine, so they gave us that. They also had started in Atlanta and recently moved to New York. Actually right across the hall. What else have we been doing?

Sadek: I guess we did a website for Kaws recently and worked with him laying out one of his books of package paintings.

Gelman: How do you like working with him?

Interview continues at:
http://www.infiltratenyc.com/007/

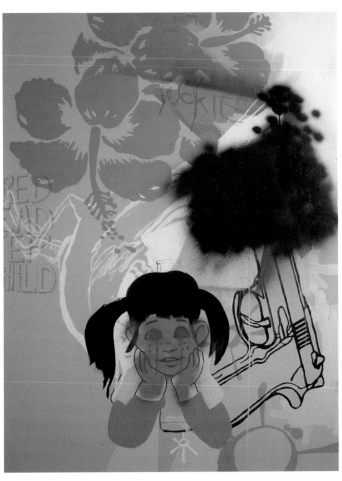

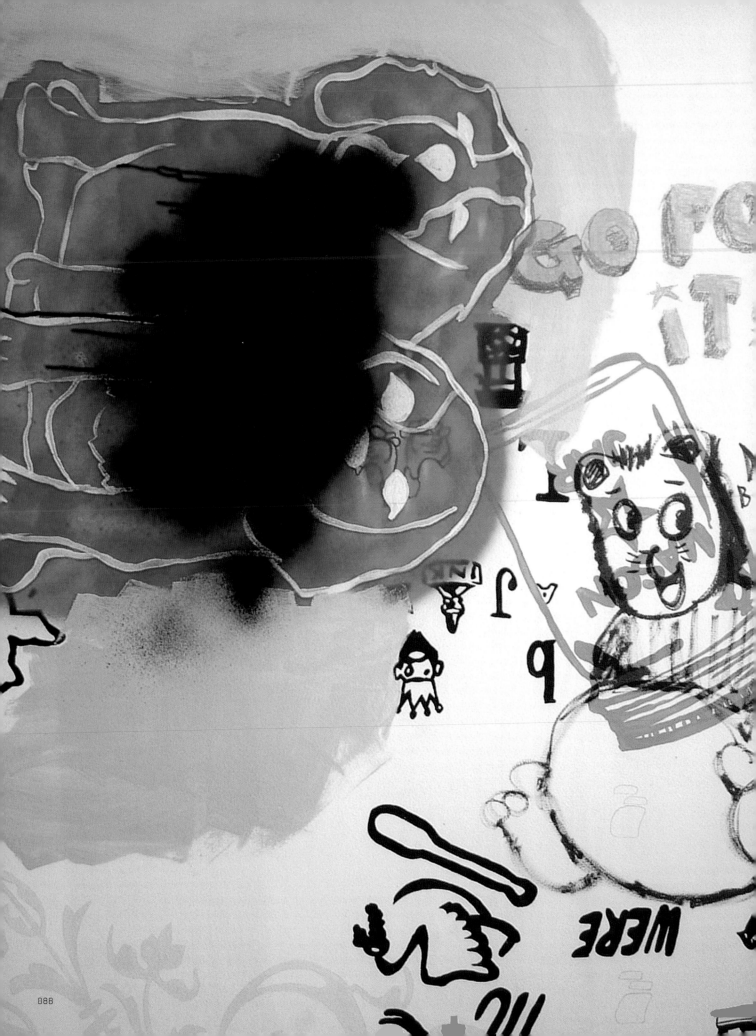

Pages 086-087 (clockwise from top left): A Certain Kind of Beauty, 2003, Concerns Concerning Uniformity and Deterioration, 2003, The Inability for the Average Man to Believe Someone Actually Painting This, even, 2003, and Breathing New Life into the Art world (go for it) number I, 2003. Client: GH avisualagency for 55dsl. Creative direction, design, illustration: GH avisualagency. Production: Mixed media on wood panel. Page 088: Place the Carnivore at the End of the Table, 2003 (top), Quantum Physics as Described by a Giraffe, 2003 (bottom). Client: GH avisualagency for 55dsl: Creative direction, design, illustration: GH avisualagency. Production: Mixed media on wood panel. Page 089: Young Blood Gallery opening invitations: Glass Show II, 2001, Group Show, 2001, Kelly Teasley, 2001, and Graffiti Loser, 2001. Client: Young Blood Gallery. Creative direction, design, illustration: GH avisualagency. Printer: Thomas and Bohannon Printing.

the album leaf / on!air!library!

639980003222

t.a.l
1.another day
2.essex
3.lamplight

o.a.l.
4.ex's and ~~he's~~ oh's
5-7.pass the mic (p,a,c)
8.faux fromm

Infiltrate / GH avisualagency

the **thomas** and **bohannon**
printing company
3833 roswell road suite 104
atlanta ga 30342

the **thomas** and **bohannon**
printing company
3833 roswell road suite 104
atlanta ga 30342

to:

the **thomas** and **bohannon**
printing company

the **thomas** and **bohann**
printing company

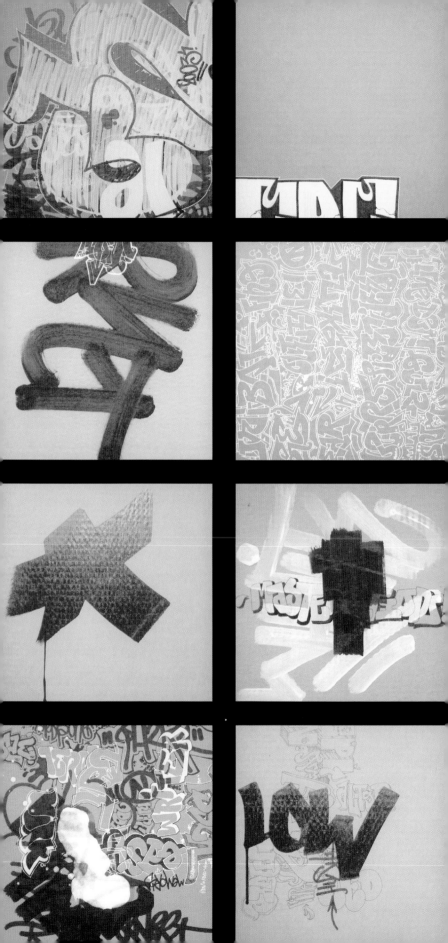

Page 090: "The Album Leaf/onlair!library!" split EP, 2003. Client: Arena Rock Recording Company. Creative contributors: Bryan Collins. Creative direction, design, illustration: GH avisualagency. Photographer: Bryan Collins. Page 091: THIS IS MY BAD ASS GH T SHIRT/ALL EIGHT CYLINDERS, 2002. Client: 2k. Creative direction, design, illustration: GH avisualagency. Page 087: GH One-Offs, 2003 (One-of-a-kind hand-done T-shirts created for various outlets). Publisher: GH avisualagency. Creative direction, design, illustration: GH avisualagency. Production info: Screen printing, stencils, and other mixed media. Page 092: Letterhead, 1998. Client: Creative direction, design, illustration: GH avisualagency. Page 093: Timmy Says: Oh No Not Again (go for it) number II, 2003. Client: GH avisualagency for 55ds1. Creative direction, design, illustration: GH avisualagency. Production: Mixed media on wood panel. Page 094: Miscellaneous pages from "The Elizabeth Kent Story," 2001. Creative direction, design, illustration: GH avisualagency. Page 095, top: ThomBo Moving Announce-ment, 2003. Client: Thomas and Bohannon Printing; Creative direction, design, photography, copywriting: GH avisualagency. Page 095, bottom: Scout™ summer collection announcement, 2002. Client: Scout™. Creative direction, design, illustration: GH avisualagency. Page 095, bottom: Scout™ summer collection announcement, 2002. Client: Scout™. Creative direction, design, illustration: GH avisualagency.

A conversation with Cary Murnion, Stella Bugbee and Jonathan Milott of Honest. Interview conducted by Helen Walters and Gelman.

Gelman: How did it all begin?

Cary: We started our company at a good time. It was during that whole dot-com hype. We did some start-up companies, some established companies. And that helped build up our portfolio. We did a site for MoMA, and our two good gallery sites, Luhring Augustine and Andrea Rosen. During that time everybody needed a site. And also during that time we were continuing doing print: book design, logos, stationery, packaging...

Stella: Collateral.

Cary: Collateral. So we were doing both at the same time. And then the year when everything bombed we had no websites for a while.

Stella: For like a year. <Laughs> Six months. No paid websites.

Jonathan: We had Kate Spade.

Cary: But because of us being able to do print stuff we were able to keep ourselves going during that hard time.

Jonathan: It's the opposite of most businesses, where for the first five years you don't make money. Our first year we made good money... We were like "this is so easy, this is great" and then the next year...

Gelman: Well, all the budgets were --

Cary: Yeah, the budgets were clipped. We felt, as everyone else did, that the dot-com stuff was overpriced, that it would level out. Websites came down to the print level. Firms had hired 20 people but then had to fire them; it came back down to what the normal level was. We always kept small. It was always the three of us. Always. We were able to keep on doing exactly what we had been doing. We didn't have to take on big corporate clients to then pay our employees. We could keep on doing...

Stella: But also our strategy was to take projects that allowed us to do the print, the web, the advertising, the installation for one client. We don't just do web, we don't just print. We take a company and we do everything for it, so you have a more integrated, resolved design solution. That has sustained us as well. But we've been really lucky to be able to make it through last year because it was really rough.

Cary: A great client that came along right at the right time was the New Museum. They wanted to redo their logo and we pitched for it and we won it against other companies and that was just perfect. We did the logo and started doing the advertising and signage, and now the website. And that's a two-year project we've been working on.

Stella: I don't think we realized how lucky we were when we graduated at that time. We just kind of quit our jobs and did it. I think 10 years ago we wouldn't have been able to wait a while, before we could have done something like that. And during the dot-com craziness we were still working from an apartment. It was just the three of us taking as little as we could, so that eventually we could have a studio.

Helen: Was that because you were expecting it was all going to end?

Cary & Stella: We did.

Gelman: It was kind of clear. The real question was when.

Cary: We basically made an effort to not hire anybody -- there were times we could have but we said, "Well, we're not sure how long this is going to last."

Stella: And we never wanted to borrow any money; we never had to borrow any money. Even when we worked at our other jobs and did freelance we never spent the money, so we kind of knew we were never going to ask anybody for any help and we didn't want to have to go into any debt for it. And thus far...

Gelman: And that allowed you, at some point, when you got some extra time, to experiment?

Stella: Definitely. Oh yes. I think we always do experimental projects.

Jonathan: When we were first all together, even when we were working our separate jobs, basically what we were doing were experimental side projects or unpaid jobs where we had as much freedom as possible, doing small sites or our animations. We all started doing animations and motion graphics -- purely experimental, just to see what we could do, just to get our reel together. It was a while before we had that.

Cary: Now we are at a point where we are going to publish our own magazine. It's completely done. We have been working on it for a couple of months now. As everyone seems to do, you do some client work so you can do experimental, non-paying jobs that hopefully inform the other work you get.

Gelman: What's the name of the magazine?

Stella & Cary: Honest! <laughs>

Jonathan: That was always something that we were thinking when we did our first site, State of Agenda. Right from the start of that site we wanted to have a forum for our side projects or other artists we knew. So we have a section called Road to Nowhere that's purely non-commercial stuff, maybe not even good ideas. Just stuff we wanted other people to see.

Gelman: I remember that.

Stella: Or things that we do for clients that get rejected. Whatever. Goofy animations you find on websites for cats. It's almost a cross between a time capsule and a sketchbook for us, a sort of mental landscape. And that's one of the main sections of our site. I would say every six months or so we sit down and re-evaluate what we are doing, who we are working for, what we want to be doing. We always keep a list of goals, and experimental side projects are always number one on the list, whatever form they take: animations, publishing, something...We have a featured artist section on our website where we work with people that we like and put them on our website, show their work. Those things are obviously why we do it.

Jonathan: I think the interesting thing to see in just three years is that when we don't do the side projects you see the commercial work falling off. If we're not doing our own thing, and we are just trudging away -- even though most of our commercial work is fun for us and what we've chosen to do -- if we don't do our side projects one of us will not do any work...You can really see that we're a little uninspired if we are not doing a side project.

Stella: Our website is in and of itself -- that.

Gelman: How would you describe it?

Stella: Our website?

Gelman: The kind of design you do, your approach?

Stella: I'd say with our client work we really try to be specific to the client. I don't say we have a style.

Cary: We can work for a museum and then for a rock band. I think we would get really bored if we had a style because then you do the same thing over and over again.

Stella: I'd say we don't have a singular visual style but I think we have an approach that we apply to every job, which is to push it as far as possible within what makes sense for that client. If it's for a bank we still try to push it as far as we can. We know it's not going to look like a band website but we still want to push it as far as it can go and we still think of ways that will challenge them, and try to get the best from them. So it's more a process that we apply to every client that we have. I'd say for our website, our personal work is about being fun and quirky and true to what we feel inside. We try to pursue things that interest us.

Gelman: How do you divide responsibilities? How much do you collaborate on some of those experiments?

Stella: The sort of illustration style on our website is mostly Jon. And each of us has specific interests. I work with groups that have done projects that tend to be political, or architectural, or involve teaching; and those are my side projects and they will appear on the site, and in our portfolio certainly. Each one of us has interests, but the website itself is mostly Jon's illustration. And then all the things that are very much all of us. There's really no...

Jonathan: I think there was a lot of discussion. It's not like I just went off into my room and designed the site. There was a lot of discussion about using the

Cary: Stella's done a lot of websites this year and that was something she hadn't really done much of before. And you've done, what, three websites this year? Three big ones. All really differ-ent ones. And I think that's what makes us stronger, because it's not just one person doing one thing. We all have to be able to do everything because, say, one of us is gone, we can't have a situation where 'the web person' is gone... We have to be able to work together. That's served us fine.

Gelman: You seem pretty comfortable tak-ing on something that you don't know much about and learning by doing it.

Stella: From each other.

Gelman: I remember your story with teach-ing. Where you had to learn a course right before teaching it?

Cary: Oh, yeah. Our first broadcast design class. The first class we taught was "The History of Broadcast Design." We all wanted to teach in the future but didn't really know how to go about doing it, so I called up the head of the design department at Parsons to ask him what steps we should take to eventually become teachers. To our astonishment he said, "You can start teaching in two weeks." I said, "Okay." So in two weeks we had to get together a syllabus and learn the history of broadcast design, because we didn't know too much about it ourselves!

Stella: Well, the first class I started teaching was typography. Even if you are involved with typography every day at work it's a totally other thing to have to articulate it to a group of freshmen and sophomores who have never experienced typography before. I think that's the best thing, at least for me, about teach-ing is that you do have to express what you don't normally have to express. So I think that's helped me in dealing with clients or people that don't really understand design. In teaching you have to verbalize what you are looking at and what you are thinking. And verbalize what somebody else is thinking, and the way they have visualized it. It's definitely a different process, and most designers that don't teach don't have to...

Cary: I want to ask you the same thing [to Gelman]. Is that what you think about teaching? Is that what you like about it?

Gelman: Absolutely.

Stella: You have to articulate your own feelings and it helps you develop your own feelings.

Gelman: I actually started teaching at Parsons as well, about eight years ago.

Stella: Oh, yeah?

Cary: And you taught like two years?

Gelman: Two years. It was 1995.

Cary: And now you are at Yale?

Gelman: Then I taught the portfolio class at SVA, then Cooper, and now Yale and MIT.

Cary: Is there a certain school you like better?

Gelman: Yale.

Stella: Well, yeah. I would imagine.

Gelman: It's a totally different experi-ence. Students are older and more seri-ous.

Stella: Yeah, it's more of a dialog.

Gelman: Absolutely. It's more like hang-ing out with peers. They work on their own projects. You are just trying to get into it, to understand it and see if you can help or not. It's not that kind of teaching where you tell them what to do.

Jonathan: I think that that's the biggest dilemma as a teacher that I've had to think about. There are the kids in the class that know that they're doing and are focused and can move forward. And they are the most exciting, as a teacher, they gravitate towards and push them on. "Great idea, go!" And then there are the kids that are just lost. And as a teacher should you say "Those kids are just crazy" and forget them? Or should you push them and say "You just need to find what it is that's most exciting to you"?

Gelman: Well, the most interesting are actually those who are not lazy but who are lost.

Stella: Who are not necessarily getting it. Both of my parents are teachers. My mom teaches English as a second language to adults. She's always drilled it into my head that teaching is for the students who aren't doing well. Those are the stu-dents that you need to teach. You need

to talk and guide the good ones but the really difficult challenge of teaching is the ones that don't get it and are hard to teach. So I've been hearing that.

Gelman: But there is another aspect of it. There are always students who are not motivated and who don't want to do any-thing and you can stop paying attention to them, because it's not your job to get them excited about graphic design.

Jonathan: It's tough, though, because there are a lot of people like that.

Stella: Especially undergraduates.

Helen: Do you get to follow the students? Do you just teach one year?

Stella: Well, I've been lucky -- the first class I taught was sophomore typog-raphy, first semester, but then I immedi-ately went to teaching juniors and sen-iors. Now I only teach seniors. So I've had a bunch of the same students three or four times. It's really nice. It's really nice to have had them in the first class. I won't probably have that ever again because now I'm just teaching seniors. But it's been lovely to have them grow and watch them come up.

Gelman: I had some students returning to my class and even working with me after graduation. It's interesting to watch those seeds that you are planting grow, take off, and live their own independent lives.

Stella: Mmm hmm, that's true.

Helen: What are you working on now?

Jonathan: A side project that we are working on right now is a video that we directed and we're editing and doing some animation for. It's for Craig Wedren, who used to be in Shudder to Think. It's all live-action direction. So that's one of our bigger side projects.

Helen: Do you worry about spreading your-self too thin over print, direction, web?

Stella: For us it just sustains us cre-atively and I don't think it will hurt to do that. It informs everything we do.

Cary: And it opens up new opportunities. I think that both directing and doing-

Interview continues at:
http://www.infiltratenyc.com/008/

inkblots to represent what we think Honest is. We had a lot of discussion about everything that went into it. We don't just disappear into our computers and do whatever the hell we want. We talk about things.

Stella: And certainly the level of inter-activity on our website is something we all push and discuss and strive for. And that's something we apply to all our clients as well. We sit and we push each other collaboratively.

Gelman: So all three of you are involved in every project for every client?

Stella: To some degree.

Cary: That sometimes happens. Of course it depends on the project, But we all pitch a design and the client picks one and whoever gets picked...

Gelman: Gets to lead the project?

Cary: Sometimes it's a big project, like the New Museum, that we are all working on because it's so big. So we all talk together on things. It depends on the size and also the interest. If one of us really loves a project you can say "Well that person can focus on it and take it. We don't have a set studio thing. We're all friends first. We met in school, we were all friends and that's why we wanted to form this studio.

Jonathan: We were. We were friends.

Cary & Stella: <Laughs>

Cary: Now we are just business! Actually the friendship, I think, is the thing that informs our design process.

Stella: Well, certainly there's always a manager or a key person that speaks to the client -- just for efficiency. In the case of the New Museum, it's all of us.

Cary: It seems to happen naturally.

Stella: Jon came mostly from a web back-ground, I came mostly from a print back-ground, Cary from a broadcast and print mix. In the beginning we all handled projects based on those categories, now we all do everything.

Cary: A little bit of broadcast, a little bit of print.

Stella: A little bit of web.

Page 098: Honest Magazine Logo (Issue One). Creative/art direction/design, illustration: HONEST. Page 099: AIGA Fresh Dialogue Poster, 2002. Client: AIGA. Creative/art direction/design: HONEST. Photographer: Albert Vecerka. Printer: RGA Reproductions. Honest, along with Base, were the speakers at the 2002 AIGA Fresh Dialogue. We created an identity around ear plugs. Who wants to hear young designers talk about their tiny new careers? We didn't think anybody, so we even handed out ear plugs at the door. The plugs also visually represented our interest in creating images that are ambiguous and open to odd interpretation. Page 100: Honest Poster, 2001. Creative/art direction, design, copywriting: HONEST. Printer: Commercial Press. This poster was made to announce our name change from Agenda to Honest. We chose the name because of its ambiguity and contradictory aspects. Is Honest Inc. genuine, sincere, truthful? Does a client actually want a design firm to represent them in an honest manner? Can, should, or is design meant to be honest? The poster was designed to invite similar questioning of the word "honest," and slowly allows the viewer in on the joke by becoming more and more ludicrous. Page 101: Voyage, 2003. Client: Neomu. Creative/art direction, design, illustration: HONEST. Our friend Deanne Cheuk created Neomu, the smallest magazine in the world. All proceeds from Neomu go to charities globally. For issue No.5 we were asked to contribute to a flipbook that was incorporated into the magazine. For our spread, we were given the boat image and could do anything we wanted around the image, so we naturally thought of a guy with big hairy toes in a bathtub. Pages 102-103: Stayhonest.com. The "Road to Nowhere" section is where we put non-client work or client-rejected work, 2001. Creative/art direction, design, and illustration: HONEST. This is the section of our website where we list our favorite books, movies, magazines, music, magazines, and artists. We also have a few posters and things for sale. Page 106: Nike, 2002 Winter Olympics. Client: Nike. Creative/art direction, design, and illustration: HONEST. Animation: Imaginary Forces. Production: @radical.media, Wieden+Kennedy. Honest illustrated a series of six TV commercials for Nike that ran during the 2002 Winter Olympics. In the spots, Charles Barkley and Marion Jones take part in a "winter exchange." The low-fi style of the art was meant to emulate an exchange student illustrating a journal or letters back to his family. The spots act as offbeat guides to some of the more obscure sports, such as curling, while also featuring popular sports like snowboarding. Page 107: Creative Time at the Anchorage, 2001. Client: Creative Time. Creative/art direction, design, and illustration: HONEST. Making hip graphics for a New York dance club is not as easy as you'd think. These images are what we created when pitching a new identity for a local hot spot. This kind of thing is not exactly our forte, so we ventured into the land of "filters," something we generally try to stay away from. But in this case we thought the more filters the better; the club was cheesy so we strove for something cheesy and cool at the same time. What better way to do this than to pile on the filters? Not surprisingly, the club didn't go for it, but from our pursuit of cheesiness, a series of images evolved that we developed and used on promotional material for Creative Time. Poetic justice.

1.

1. The number of infants born with additional fingers has been increasing annually by 20 percent since the late seventies. Researchers believe this is an evolutionary step directly related to computer use.
HST Journal of Medicine, 2001

2.

2. Doctors are divided on how to treat the large growths appearing on the lower backs of many middle-aged Americans. The medical opinion is that extra tissue grows in response to long hours sitting in chairs while working on computers. The boil is actually a third buttock.
HST Journal of Medicine, 2001

HONEST

stayhonest.com

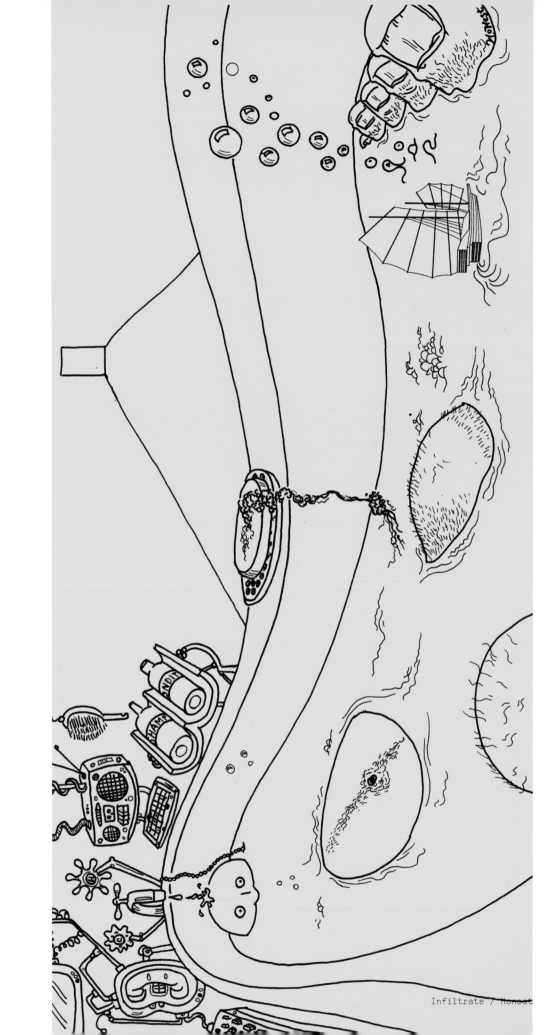

Infiltrate / Honest

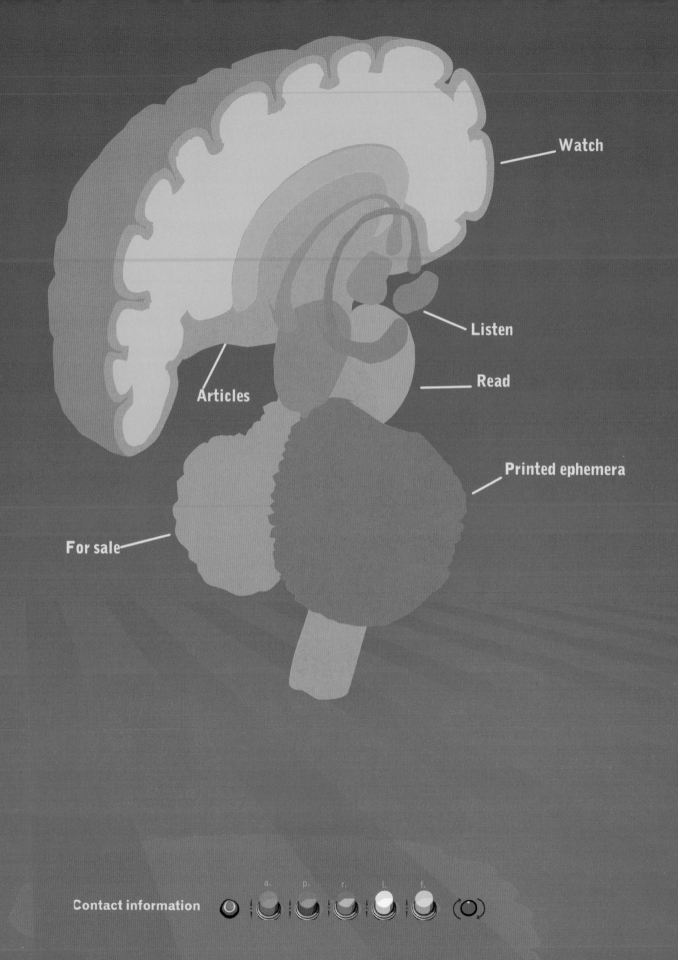

Watch

Listen

Read

Articles

Printed ephemera

For sale

Contact information

Infiltrate / Honest

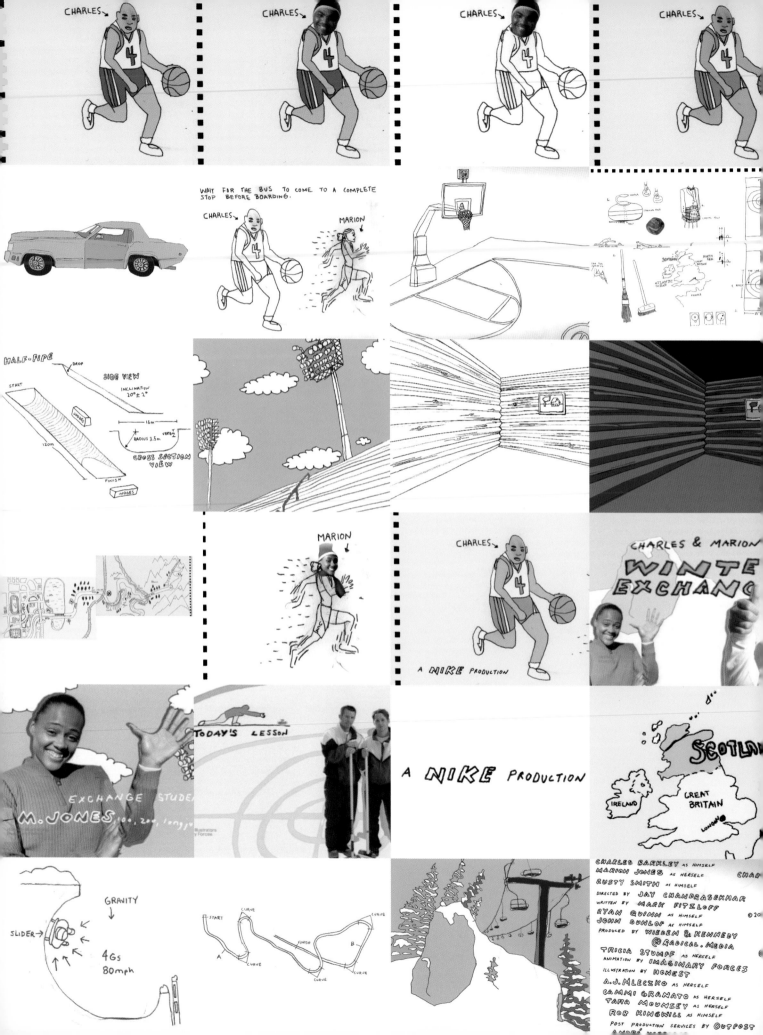

A conversation with Todd St. John of HunterGatherer. Interview conducted by Helen Walters and Gelman.

Helen: Was it mainly T-shirts?

Todd: Well, when we started the company, what we liked most was that you could do everything associated with it. So we could do shirts, and then we could do posters that promoted them too. We'd spend probably half the time on these posters that promoted the shirts and then we used to do trade show booths and put way too much work into all that. It was more just an outlet to spend our time doing it, but the primary product when we started was definitely shirts, and it's still the primary product.

Helen: And so when did HunterGatherer start?

Todd: 2000. Officially.

Helen: And that's still you and Gary [Benzel]?

Todd: Yeah, basically it's in New York and the way we do it is everything is based out of here, and when I can collaborate with Gary, I do. It's on a job-by-job basis. There are other people working here and Gary comes in if it's the right project.

Helen: And what is he doing full-time?

Todd: He opened a store in San Diego this summer called Igloo. It's maybe a third our stuff and the rest is other people's stuff. He does design out there, and then we collaborate on stuff occasionally. And he goes surfing. He has a much better life than any of us, basically.

Helen: Damn him! You're not tempted to move to San Diego?

Todd: Sometimes, yeah. I'm tempted to move back to Hawaii sometimes.

Gelman: Right, you're from Hawaii.

Todd: Yeah, originally.

Gelman: So HunterGatherer is more of a business where you work for clients? Have you done any stuff for clients as Green Lady, or was that purely products?

Todd: It was purely products. It was basically all our own products. When we started HunterGatherer we were in a funny position because we had done Green Lady for a while and there was a certain group of people who were familiar with that. We also did a lot of video work and client work and traditional graphic design work, and those people knew us for that, and it was a little schizophrenic. I felt like the people over here knew this, and the people over there knew that.

Gelman: Nobody put them together.

Todd: Well, yeah, some people. But not a lot. Not a lot. I worked day jobs at different places, so when I started this, one of the ideas was to hopefully start something where it was all under the same roof.

Gelman: You had a full-time job at MTV at some point.

Todd: Yeah, I was there for a little under two years.

Gelman: That's kind of an average.

Todd: Average stay there at MTV? That's probably about right. Tour of duty.

Gelman: Yeah.

Todd: It was a good place. Part of it was a learning process because before I'd gone there I had been interested in doing some of that stuff.

Gelman: Motion stuff?

Todd: Motion and film stuff and TV and video. And I thought about maybe going to school to learn some of that, but it wasn't financially viable...When MTV came along I thought, "This is a good way to learn it, and they pay you."

Helen: You learned it on the job.

Gelman: The best way.

Todd: Yeah, it worked out well. While I worked there, I didn't actually do that much, but it started the ball rolling. A lot of the MTV projects on the reel now were actually done after I left there. But that's how it started.

Gelman: You kept MTV as a client after you left.

Todd: Right. When I left, I didn't throw a tantrum and say "Fuck you all!" Though there were days I was tempted to.

Gelman: Only a few years ago there were no design companies in Brooklyn. Now there are tons of new design companies here. It's almost cooler to have a company in Brooklyn than in Manhattan now.

Todd: Yeah. <Laughs>

Gelman: You live in Manhattan and commute to Brooklyn to work...

Helen: Isn't that backwards?

Todd: I've got it all screwed up. When I started, I lived here. And then I moved twice last year. Currently I live in Manhattan. But I like it down here, you get more space and everything. It is sort of close and far away at the same time.

Helen: And look at your view!

Todd: It is hard to beat the view. But you know the elevator breaks, and there are mice in the building.

Gelman: But you get mice in buildings anywhere. And elevators break in Manhattan too...

Todd: Yes, but it breaks with some regularity.

Helen: How long have you been in Brooklyn?

Todd: Coming up on four years in May.

Helen: Have you seen the area change radically? DUMBO is now this hip, happening area, isn't it?

Todd: Yeah.

Gelman: It has been happening for a while now, supposedly.

Todd: Yeah, it has been happening for the last 10 to 15 years. Everyone says it is going to be the next big thing, but it never really happens. A lot of it is happening very deliberately because there is a lot of investment. One or two people own almost all the buildings, so it is developing in a different way than, say, Williamsburg, which was cheap space.

Helen: It happened in London as well. Artists used to live in Hoxton, where there were all these factories and warehouses. There was lots of space and nobody would live there because it was in the East End and kind of grim. And suddenly it became the most fashionable place in the world. All the artists had to leave because the warehouses were converted into fashionable office and loft living spaces.

Gelman: That's exactly what happened to SoHo. All the artists are gone. Now it is a big shopping mall. As late as 1993, when I moved there, it was barely a couple of restaurants and tons of galleries.

Helen: I can't imagine it. It's just so chichi now.

Gelman: So, tell me, this product business is kind of seasonal because you take your products to certain trade shows, take your seasonal orders...

Todd: Yeah, not so much anymore, we haven't really done those in a few years, but yeah, it tends to be the way people order. Somewhat seasonal, but we do continually rotate new stuff in and update.

Gelman: Can you tell me a little bit about your year. What happens when?

Todd: You mean as far as the year goes?

Gelman: Yeah.

Todd: It is pretty loose.

Gelman: Because I remember I called you maybe March or April and you were leaving for, like, four weeks.

Todd: Oh yeah, vacation.

Gelman: Yeah, how does that work?

Todd: I wish it was like four weeks. I think that it was more like two weeks. But yeah, like when do I take vacations?

Gelman: Yeah.

Todd: Whenever I can. It just depends. It used to be we were busy around September because people were buying for winter and spring. But now with the mix of the company being part product, part other stuff, it seems like as soon as we get done with one thing, like a commercial, we have to jump back on the product end, which has been put off. It is just like this see-saw of what we are doing. Which is kind of nice though, because you finish up with something where you're

Todd: ...working on the computer screen, and then go to something that is completely on fabric.

Gelman: What is the proportion between your own products and your client work?

Todd: I would say probably 30 to 40 percent is our stuff, but it is hard to put a number to it. What I try to do is split down the middle. What I try to keep in our heads so that if it starts to shift too much one way, we can pull back a little bit. A lot of times the product stuff starts to overlap with what other people ask us to do, so we end up working with a clothing company and some other labels.

Helen: How many people do you have working here? Do you have a full-time staff?

Todd: I've got one person full-time. A producer keeps everything together part-time and Gary is there whenever he can pitch in. Depending on the project, we will sometimes bring in whomever we need, an animator or someone. Not so much on the design end, we don't hire that out.

Gelman: Just to execute?

Todd: Yeah, I think everybody contributes stuff. The way we work is pretty open and collaborative as far as talking about ideas and stuff, but I am the only person here with the actual design background.

Gelman: Are you planning to grow the company or do you prefer to stay small?

Todd: For now this size is good. I really like it. Five years down the line, I cannot so sure. I might be too burned out to design anymore. <Laughs> But for now -- especially after working elsewhere -- it is nice to have things go and not worry too much about running the business.

Gelman: The responsibility.

Todd: Yeah, and the time. I am not that good at actually running a business. If I was to get bigger it might take more of my time than a more capable person. So I try to keep it small.

Helen: What are you working on right now?

Todd: We just finished a spot for the Discovery Channel; we just pitched a big identity project for a network. We are doing some stuff with a Japanese clothing company. We are doing some stuff for a U.S. clothing company, a new round of our own products. That kind of stuff.

Helen: What kind of products are you going to do?

Todd: We are working on our own table, a small, collapsible table. We are working on a bag and some other small stuff. One of the ideas behind the HunterGatherer stuff is the use of camping-style architecture, ideas like collapsible, portable, mobile, nomadic, and also trying to use materials based on fabric as a structural element. Most of the stuff is small and portable and informed by camping or camping engineering.

Helen: Do you do any camping?

Todd: No, hardly any, <Laughs> But yeah, HunterGatherer has a little bit of that idea to it, and having moved quite a bit myself, the idea of portability and collapsibility has an appeal. And also coming from a background where we were doing a lot of stuff with clothing and fabric. It's probably been informed by that, rather than a real slick industrial design kind of feel.

Helen: It is a good extension of your line of branded fashion items.

Todd: Yeah, we have gone with the stores that are already carrying our stuff.

Helen: So they will take the whole range?

Todd: Street-wear lines and that kind of thing, yeah. But I wouldn't think to approach Moss or Totem, because that is a little bit of a different market.

Gelman: Moss always has a great collection.

Todd: Yeah, they have beautiful stuff. I would be a little intimidated going to Moss because their price range is a little bit higher. Our stuff tries to be more accessible, price-wise. It's a little bit more democratic than some of the stuff in Moss.

Helen: So is designing democratically important?

Todd: That was part of the appeal of getting into T-shirts. Design, as opposed to fine art, is more of a mass medium and has a much broader reach.

Helen: Did you ever try doing fine art?

Todd: Growing up, not really, but probably because I didn't have much exposure to it and didn't feel like it was something accessible. What probably affected me more as a kid was magazines, so when we started to do some stuff on our own, making a T-shirt seemed much less as-suming than making a painting. If you make a T-shirt, you can make 200 of them for $10 each. It seemed somehow less pretentious than making something for $3,000.

Helen: So how do you feel now that you are exhibiting in art galleries?

Todd: Well, we don't do a lot of it, but I think that it's nice. It is very occasional. I see it as an extension of what we already do, with a slightly different audience, different considerations, and different ways of presentation. It's something that sits there for a long time whereas you might pass some of our other work on the street and have five seconds to process it.

Helen: So you have to think about it completely differently?

Todd: Yeah, it is completely different, but still you use some of the same language. Even clothing graphics have to have that immediate appeal factor that isn't particularly cerebral. It exists on a level of, "Does it catch my eye?" Hopefully what we do has something to it so that when you see it as a group, you pick up on bigger themes -- but also so it works with an immediate impact.

Helen: Do you find yourself revisiting themes time and time again?

Todd: Yeah. <Laughs> We only have so many ideas. If you get old enough, you have to start recycling things. I think the evolution -- ideas of futility, ridiculousness, attempts at greatness and utter failures -- is that kind of thing. We tend to do stuff that is small in scale so it revolves around our lives and where we are traveling.

Helen: How do you decide what themes you are going to pursue? Or what you are going to do next? Do you have long conversations with Gary? Or can you go off in your own direction if you want to? Like with Green Lady.

Todd: It seems like we start to work on stuff, and we get 10 ideas and six of them will start to relate, and you might see some general ideas develop. When you see those six you maybe throw four out and come up with two others that fit into that set. There's not really a set way of how it goes, but that's how it seems to go most of the time.

Helen: Both of you are on the same wave-length then?

Todd: I think so. It is definitely hard when you are on opposite coasts, but yeah. I think that we are interested in similar things, and I have known Gary for 12 years now.

Gelman: Did you go to school together?

Todd: Yeah, in Arizona; Tucson.

Helen: So how come you went from Hawaii to Arizona to San Diego and then to New York?

Todd: I had enough of warm climates, I wanted more misery in my life.

<Laughing>

Todd: Enough of these resort towns!

Helen: No more of an easy life!

Gelman: Can you talk a little bit about your work for clients? There is probably some overlap and then some things that are totally different in commercial work?

Todd: Yeah. A lot of the Green Lady stuff and HunterGatherer stuff may lead to a lot of the stuff that we do for clients. Maybe not so much of the video/TV side of it, but definitely with prints and consultation on products there's a synergy. We try to keep them pretty separate, but if there are certain themes that we are thinking of, we draw on it.

Gelman: You wouldn't let a client borrow any of these ideas?

Todd: We try not to. There have been times when a client will come and say...

Gelman: "I want that."

Todd: Yeah, especially if it is something that was used directly in one of the lines. We say that we have already done it.

Gelman: It is already on the shelf.

Interview continues at:
http://www.infiltratenyc.com/009/

NXSL

NIXONSALTLAKECITY01

NIXONNEWYORKCITY01

AS01

Pages 110-112: Nixon Promotionals, 2002. Client: Nixon. Creative contributors: Todd St. John / Gary Benzel. A series of designs introducing a new clothing line for Nixon, primarily a watch company in the skate/snow/surf market. The company's personality has to do with themes of travel, locations, and time. The freeway interchanges have to do with all three and relate to the southern California freeway landscape. Page 114: Stickers and skate wheels produced in conjunction with the Arkitip 0002 Exhibition, 2001. Page 115: Arkitip 0002, Exhibit at Alife, New York, 2001. Client: Arkitip, Alife. Creative contributors: Todd St. John / Gary Benzel (as Green Lady) and Dave Kinsey. Arkitip 0002, Exhibit at Alife, New York, 2001. Client: Arkitip, Alife. Creative contributors: Todd St. John / Gary Benzel (as Green Lady) and Dave Kinsey. Production: 400 hand-painted panels were painted in Brooklyn (blue) then shipped to California to be finished by Kinsey (Black/Gold).

ARKITIP
SITE SPECIFIC CREATED ART MAGAZINE
EXHIBITION0002
NEW YORK > 21 JUNE 2001

ARKITIP. alife

114

HUMANS ONLY

GREEN LADY

ARKITIPEXHIBITION0002JUNE212001NEWYORK

Infiltrate / HunterGatherer

GREEN LADY. 00

Page 116: Silkscreen prints for an xhibit at RedFive, San Francisco, 2001. Creative contributors: Gary Benzel, Todd St. John. Production: Silkscreen on Bristol board. Page 117, top: Green Lady Poster, 2000 line, 1999. Creative contributors: Gary Benzel, Todd St. John. Production: Offset litho on paper. Page 117, bottom: "Green Lady at Houston" Houston Gallery, Seattle, 1999/2000. Creative contributors: Gary Benzel, Todd St. John. Production: Silkscreen on paper. Page 118, top: Various Green Lady clothing designs, 1998 & 2000. Creative contributors: Gary Benzel, Todd St. John. Production: Silkscreen on cotton. Page 118, bottom: Nixon woven beanies, 2001. Client: Nixon. Designers: Gary Benzel, Todd St. John. Page 119: Green Lady Palm Pillow, 2001. Creative contributors: Gary Benzel, Todd St. John. Production: Silkscreen on cotton. Pages 120-121: MTV Sports and Music Festival Animation Sequence, 2001. Client: MTV. Creative Direction and design: Todd St. John. Additional contributing talent: Robin Hendrickson, Craig Metzger. Additional animation: Stuart Weiner. Music: Perfect Generation.

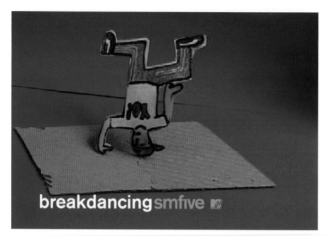

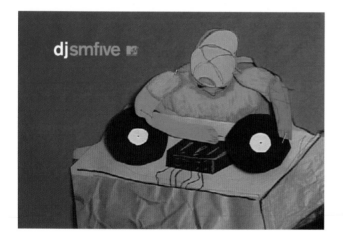

Pages 122-123: MTV Spring Break, 2002. Client: MTV. Designer/Director: Todd St. John. Photographer: Todd St. John.
Stuart Weiner, Todd St. John. Composer: Amalgamated Superstar. Page 124: Arkitip 14, 2002 (Cover Design and section of interior). Client: Arkitip/Scott Andrew Snyder.
Creative contributors: Gary Benzel, Todd St. John. Page 125: "Surf" (Repeat pattern), 2002. Client: HunterGatherer. Creative contributors: Todd St. John/Gary Benzel.
Production: Silk-screen on paper, fabric and wood. Page 125: Limited run T-shirt, 2002. Client: Earth Music. Creative contributors: Gary Benzel, Todd St. John.

124

Infiltrate / HunterGatherer

A conversation with Ian Perkins, principal, Ian Perkins Creative.

Gelman: British designers in New York are usually from London: RCA, St. Martin's or London College of Communication. You are a rare Brit -- you've never studied in London. Tell me about your choice of college.

Ian: I selected Bath College, which is in the southwest of England, near Bristol. And the reason I didn't go straight to London was because I thought that I'd spend the rest of my design career working in London. And I thought that studying in London. And I thought that studying in a different city would give me a chance to live in a different environment than one that I'd end up in for the rest of my professional career.

Gelman: So it turns out you didn't end up in London after all; you ended up here in New York.

Ian: Yeah. But that came -- I worked in London whilst I was at college, so whenever I had a break at college, I'd work in London. And after working there so many times, someone knew somebody in New York, and I ended up getting a job over here through a company over there.

Gelman: Was that an easy transition?

Ian: Easier than I expected, yeah. That was when the economy was really good and people were looking for designers from other places.

Gelman: What has changed?

Ian: Ah, I think people are a little bit more, um, careful about taking people on. It seems a little bit slower, workwise. The turnover just seems to be a bit slower, in work coming in and work going out. And obviously it's a bit different from my perspective because I'm doing kind of my own thing at the moment, rather than working for other people. So I'm having a different perspective on design.

Gelman: And so, with all this traveling, did you manage to keep your existing client relationships, or is it mostly New York-based?

Ian: Most of the clients I've got are actually in New York, with a couple that are New York- and London-based. And they've all come through friends of friends, or friends of colleagues; my network has grown out of people that I know, that needed things done. And, slowly, they've referred me to other people. And I've ended up growing a list of people that I work with and I've been working with for the last couple years on and off, as changes come up with their projects or they start new side things, and, that's been really interesting to do, on my own, and sometimes with a couple of other people if I can.

Gelman: You also manage to do your own experimental work. Can you talk about that?

Ian: The experimental work comes from a drive to try and develop ideas into something that might be useful in the future. So instead of just designing things for the sake of it, I've tried to design things that I might be able to use on a project in whatever situation comes up.

Gelman: How do you choose the subject, for your explorations and experiments? Is there a specicific area of graphic design you'd like to focus on?

Ian: I've concentrated on typefaces because they're something that I can see myself using. And I've tried to be as experimental as I can with my typefaces, because I haven't had any constraints or restrictions.

Gelman: You aren't answering to someone else's expectations....

Ian: They don't have to be legible if I don't want them to be, they don't have to look nice if I don't want them to. And they can just be fun and inventive. And I can put my ideas to use. It also gives me a bit of a structure. 'Cause I know that there are so many variants, and they have to conform, so it gives me something to focus on.

Gelman: So how do you apply these explorations?

Ian: Often, experiments that I do on my typefaces go back and end up being used as logotype solutions or single logo solutions, for just an initial or something. I end up interchanging my identity work with my typeface work quite a lot. And at some point I'd like to get more into magazine art direction and working with type in magazines so that I can deal with display fonts and headline types, as well as text-based fonts.

Gelman: In London you worked with some of the best advertising agencies, such as BBH, and in New York you've worked with some really interesting, serious design companies, like C&G. Can you talk a little about the differences: here versus there, advertising versus design?

Ian: The major differences have been the types of people that I've worked with in those fields. I've found the people that I worked with in advertising are very intellectual and very -- they'd have a lot of creative ideas that were really interesting, conceptual points. But then they would struggle to visualize it.

Gelman: And the designers?

Ian: Whereas the designers are maybe the reverse of that, and they can really visualize things beautifully, and just sometimes come up with more straightforward, conceptual roots.

Gelman: Did you find advertising to be a satifying work experience?

Ian: I definitely found advertising a lot of fun; the attitude of the companies was very interesting. There were a lot of people that were really good at what they do, all working together from different fields, like music, interactive, and just visual design.

Gelman: Did the differences affect your design process?

Ian: What I've found is that whenever I approach any problem, I do it in a similar way, and it is always: Learn about the subject, figure out exactly what the problem is, come up with a creative idea, make it look nice, then develop a couple of alternatives. And that kind of way of working seems to be very flexible to whatever discipline the final result is. So when I've worked in packaging or advertising or graphics or identity, it's been a similar process, but a totally different end result.

Gelman: What is it about New York that is the most interesting to you? Your girlfriend is in New York?

Ian: Yeah, that's quite an important thing.

Gelman: Did you two met here?

Ian: Yeah.

Gelman: Where is she from?

Ian: Upstate New York.

Gelman: So she is a --

Ian: A native, pretty much.

Gelman: Why New York? What attracted you here in particular?

Ian: I think New York first attracted me because of the diversity and the non-conformist sort of fashions. And I just felt that there was a larger level of acceptance for any style and any sort of thing that you're into. Whereas in London I find that, like, everybody likes to have the newest cell phones with the best rings, and everybody likes to wear certain clothes, and I felt still a little trapped by --

Gelman: The necessity of fitting certain expectations?

Ian: There's just a certain atheistic standard in London that everybody seems to like, a kind of, either a kind of funky Tomato-type work or very kind of clean, 1970s Swiss design that's done by some of the smaller design studios that just kind of concentrate on pumping out that very clean, crisp, but very retro feeling, like very sort of sans-serif, Helvetica-based projects.

Gelman: And you don't feel comfortable doing any of that? How does your interest differ?

Ian: I like work that connects directly to people's emotions; from when I was a child, I liked posters with animals and illustrations and fun, visual things, rather than colder, clean, Swiss things, which is something I've only learned as I've entered deeper into design, been educated, and done my own research; those things have come to light. But my initial interest is in more of a kind of...

Gelman: Messy?

Ian: Yeah, a kind of messy, lowbrow, illustrative-type message, which I think communicates very quickly to people. I'm not so interested in doing, like, bus timetables, as I am in doing, say, poster graphics. That's just like what personally excites me within the visual world and what I'm attracted to. It's the kind of thing I want to do myself.

Infiltrate / Ian Perkins

131

Infiltrate / Ian Perkins

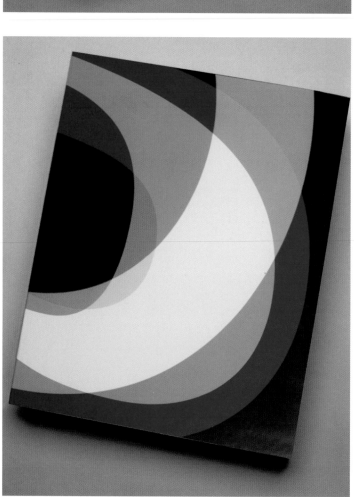

Pages 127-129: DIY (Do It Yourself). Based on instruction assembly diagrams for furniture and car repair, this font is a complete family. The 2-D version, DIY-Flatpack, is available in regular and bold. The 3-D illustration is based more closely on the exploded diagrams used in instructions. Pages 130-131: Concerto. Concerto was original- ly conceived to have musical tones assigned to key keys as well as graphics, so it played a tune as you typed. Certain well-known phrases may have yielded other well-known tunes. The font has since been developed to use exact musically correct forms, and is available in two versions -- instrumental (with the five bars) and accapella (with- out). Pages 132-133: (molecular). The idea that other designers build fonts from a series of basic parts has been parodied here. The font also makes a connection between the systematic building of language and shapes, to letters, to sentences, to paragraphs, and that of atoms to molecules, compounds, to cells and life itself. Each atom was given a unique size, and the way various atoms bond was studied and their valences used to build a chemically correct font. For example oxygen bonds only once, hydrogen twice, so my 'cee' is H20. Pages 134-135: Backhand. This font was inspired by the way ink sinks into the skin when messages are noted on the back of a hand -- a poor man's PDA. The project will be repeated as my skin ages and becomes looser, which should affect the ink spread of the design, as will alternate climates or seasons. It has since been re-created in English winter and Australian summer (this design was produced in New York City summer on 24 year-old white skin.) Pages 136-137: Anita Giraldo Identity. Client: Anita Giraldo. Art director/designer: Ian Perkins. Assistant designer: Matt Gill. Assistant production: Michelle Miller. Anita is a New York-based pho- tographer, who produces multiple exposure images for advertising and magazine work. Her overlaid style of work was re-created typographically, using thee fonts and the print colors of CMY. While the complete mark spells out her full name, individual letters were cropped and used as decoration or in abstraction on portfolio covers and promotional items. For the secondary text on items such as stationary and mailers, copy was kept to three lines, each line using one of the three fonts from the logo, all optically balanced and in the mix color made by CMY.

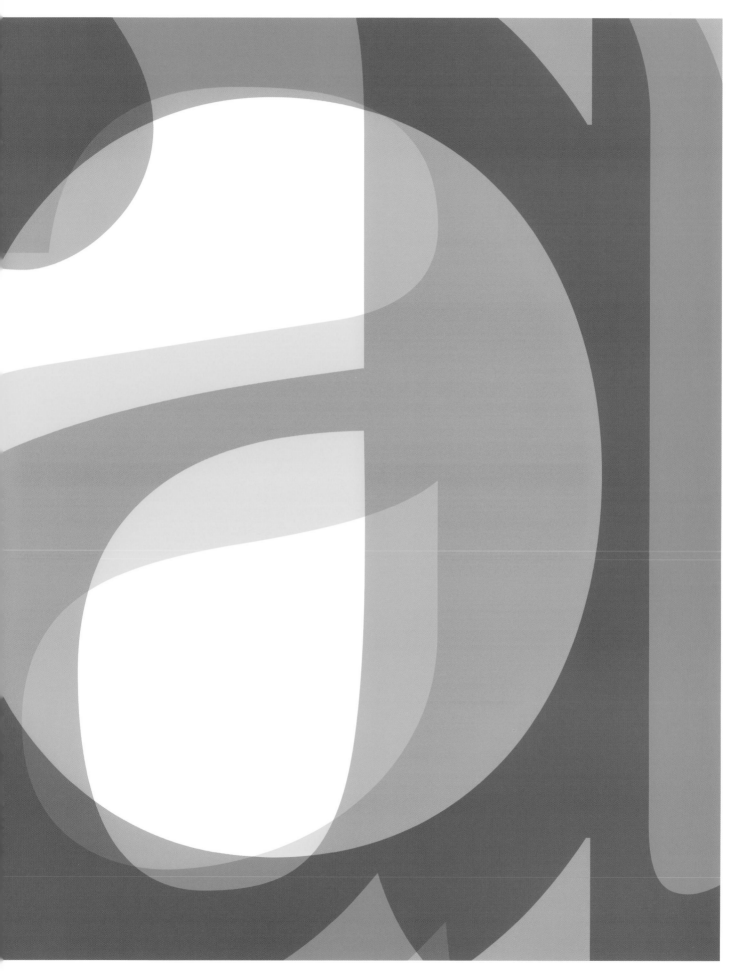

Infiltrate / Ian Perkins

A conversation with E.J. Mablekos and Miguel Angel Hurtado, partners, Infonographic.

Miguel: It's funny how design is like a family in New York, even though we're kind of outside of that.

E.J.: You know, there were two other design companies in this office before us; it just gets handed down.

Miguel: I mean, it's not like we're special. Actually the opposite; more like we're not accomplished enough. We've always been in the periphery of design. He [E.J.] came from the corporate background. I came from music. I think that's why we went to design school. Anything we know about design we learned ourselves, no design history or anything like that. I don't know if that means anything in terms of community. I think we've been lucky, 'cause we've been lucky enough to find -- to look for and find -- clients that we want to work with. Like Tokion, Zoo York, Paper Denim even, Triple Five, you know, these are all things we can relate to. We want to surround ourselves with that, spend our day working with interesting people.

Gelman: How did it begin?

Miguel: We've never -- thankfully, we've never solicited, just cold-called a client and said, you know, "Hey, can we do your website." When we started, hip-hop was really strong here in New York, and we went to a lot of shows, events, and met a lot of people; most of it has been through informal friendships.

Gelman: Always Lower East Side?

Miguel: No, not at all. We just kind of got here recently, but the Lower East Side is the home for this scene. And by luck, our office is right around the corner, Tokion, which is right around the corner, just before we got this office. Triple Five is out in Brooklyn, Zoo York is in the meatpacking district. And we've just been lucky enough to be surrounded by that kind of thing.

E.J.: Yeah, I mean, Tokion was -- I guess we were just hitting them up, wanting to do their site. That was sort of our first major thing.

Gelman: Is Adam still involved?

E.J.: Glickman? Yeah. I think he's --

Miguel: He's the one who has the name. I had known him through I guess, like, the hip-hop scene, and then he took it all from Japan to here...

E.J.: And then when he moved from the West Coast to here, we did the site, and then started talking to Triple Five Soul. It got a pretty good response, and then the guy from Paper Denim actually just wrote us, said, "I like [the site]."

Miguel: Great client; he's really amazing. A really good business. And he's able to do pretty interesting stuff that -- I mean basically everything that was getting imported, and he was one of the first Internet companies to do it.

Miguel: When it comes to clients, I have to want to work for these people. That's why I dread corporate work. We do it when we need to, but most of the time with corporate work, I don't even see their faces. It's all through e-mail and phone.

Gelman: Is that good or bad?

Miguel: Well, sometimes I think it's good, sometimes --

Gelman: Because you don't want to hang out with them?

Miguel: No, not that at all. I wouldn't want to hang out with them in the confines of their job. Because going to a corporate place, the cubicles -- these people are kids, they're our age, they probably look at the same sites we do, listen to the same music, they just have a different job. And so they'd probably be really cool to hang out with. But in the terms of the corporate mindset, it's just an environment we chose to avoid.

Gelman: What kind of corporate clients do you have? What kind of work have you done for them?

Miguel: We've done a lot of work for [the advertising firm] BBDO, General Electric, PeopleSoft, Jeep, Cingular.

E.J.: Mostly it's through agencies.

Gelman: Which agencies?

E.J.: Atmosphere, which is the digital arm of BBDO, Deutsch, and the Corporate Agenda -- it's a smaller sort of place -- sort of an annual report shop, but they have these larger clients, and we get some of their stuff. Usually the corporate stuff is more like production. And I have to say -- those guys do good work, the designers. They're good guys.

Gelman: So they hire you usually for a specific, smaller part of a larger campaign, and usually that is a web banner or an online game?

Miguel: Yeah, or an applet. It's usually because they like the way we make things move. We're good with detail work, and they like that.

Gelman: How did you get into information graphics?

E.J.: I've always been interested in it. My original position at Studio Archetype was Information Designer. Obviously, it was an interactive shop, so it was interaction design, but there was also a lot of things like site maps, illustrating how these interactive systems were going to work. That was my main focus. Here, we were asked to do information graphics for Sportswear International and Fader, which was much more interesting content.

Miguel: Beats an annual report any day.

Gelman: E.J., you came from a business background?

E.J.: I went to Carnegie Mellon. We both went to Carnegie Mellon. I was in a program that was business mixed with design.

Gelman: What was the name of it?

E.J.: It's a program called Graphic Communications Management.

Gelman: Okay, so you actually know what you're doing.

E.J.: Yeah, I guess.

Gelman: Most designers open a company, and have no clue about business, just learn by making mistakes. How do you divide responsibilities?

Miguel: We each have made inroads with "to each his own." For big websites or things we find interesting, we work together.

Gelman: Working together, meaning discussing, or designing components?

Miguel: Yeah, and putting them together and whatever.

Gelman: Together or competing?

E.J.: We don't really follow that sort of structure. I think our strengths and weaknesses allow us to mesh in different ways. I don't think we have the perfect process, but we just sort of talk about it, both have different kinds of ideas...

Miguel: We have different approaches. He's very clean, almost --

E.J.: Almost systematic, just solving the problem.

Miguel: I come at it from more of an atmospheric approach: socio-political, what does it mean, what does this remind you of, a color, the wording. Even down to the movement: this movement implies this, that movement implies that. I guess it's just our personalities. And then we usually meet somewhere in the middle. I think that's the basis for our success.

E.J.: Our limited success. <Laughs>

Miguel: I'd say it's pretty ideal.

Gelman: Do you have employees?

Miguel: We have some subcontractor friends, you know some dot-com veterans.

Gelman: Are you planning to grow?

Miguel: We always have this discussion. I don't think we have that ambition, because we like the responsibilities we have now, we like the space we have now.

E.J.: There's a lot of times where we sort of realize we can't do all this work. Then you start running the numbers inside your head, "Well, you know we could hire someone to do it, then if we start doing more of that." It starts to become more of a business, worrying about what your employees are doing. We're more worried about just getting things that we want to do. So if that means fewer projects, then that's what we have to do.

Gelman: What happens if you get calls from a bunch of really interesting clients, with requests that just the two of you can't physically handle?

E.J.: Physically in terms of workload, or in terms of like skill?

Gelman: Either.

Miguel: We'll find some dot-com veterans to do the parts that we don't like to do.

Gelman: <Laughs> Like what?

Miguel: I mean, we're pretty obsessive about our work, even like the littlest thing. Maybe database stuff.

E.J.: To be fair, a lot of the stuff we can't do.

Gelman: Do you write your own code?

Miguel: Some. Back-end we try to always give away.

E.J.: In [Macromedia] Flash and Action Script, I think we're pretty skilled.

Miguel: It's at the point right now where programming is pretty creative.

E.J.: And that's why we want complete control, because you can push that. But if someone needs e-commerce functionality, frankly we don't know how to do it.

Miguel: Or want to.

Gelman: Well it's pretty straightforward, isn't it?

E.J.: No, totally. We just get other people to handle that. I have a lot of experience designing that stuff, so we just develop the screens and hand it off.

Miguel: You know, we'll design up to the point of the button on the cash register, but we don't go beyond that. We're doing a project right now where even words on the shopping cart, everything from beginning to end, is designed. We're trying to keep people in the atmosphere up until the moment that they buy it and get a receipt.

E.J.: For something like that, I have no problems. It's not like I wouldn't want anything, when you ask about hiring people, what we do, as a business model, having the ability in-house to be able to develop store websites, quickly, having a back-end here do it, I think that would be good to present to any client who came to us. But it's just sort of not really what we want to take on.

Gelman: And there are all kinds of other issues, like dealing with the client, and administrative issues, traffic...

Miguel: Right. We like to be as hands-on with the client as possible. Also, we're a supremely creative outfit. Anything else might be a distraction. Having anyone else in the company could really disrupt the flow that we've had. Administration? Sure, but it'd be off-site. In terms of the studio, we just want people of like minds designing.

Gelman: "Off-site" meaning?

Miguel: Not in the office. Like our tax guy, or the person who sends out our invoices. If we ever get someone to do that, I don't know if we want them to be in here necessarily.

Gelman: So it's a possibility that you could set up a sort of unit that takes care of the administration.

E.J.: It's more about moving forward in terms of what projects we're able to work on. No "We've done these three things, let's hire four guys and just expand it so now we have two teams, and four projects going on." The only reason to do that would be for the money.

Gelman: Which is a good enough reason.

E.J.: It is a good reason.

Miguel: Well, not -- I mean we're both veterans of the dot-com age, and we saw it at its worst, when people would expand with no need to, and it was all about the money. And we saw where that led. We saw the ugly side of it. So at this point we're just about filling our day with people and projects that we like doing.

E.J.: If you make a strong enough hourly rate, you can make as much as you can by leading a group of people or whatever. It's all about the project and the task at hand; if you can handle it, handle it with as few people as you can.

Miguel: It's not that we don't want to deal with people. We enjoy people. It's not that we want to only design by ourselves, but the system that we have, it's uninterrupted, it works.

Gelman: So it's really flat. There's no split of responsibilities?

Miguel: We try to keep it 50/50, you know? If he does something, then I'll take care of the next thing.

E.J.: We keep our books separate. That way we don't have any problems over money or anything.

Gelman: Do you ever have any conflicts?

E.J.: Creative? Or business?

Gelman: Either.

Miguel: Sure, of course. People always say "Avoid getting into business with friends." And I agree. We've been friends since college and have always been talking about this. We see each other as equals, and I think that's really, really rare. But once you do that, you can have the most wretched fight and the next day laugh about it. Because it's an equal talking to an equal, so it doesn't mean anything. It's just a disagreement. So we've come out of it unscathed.

E.J.: I mean, it's also about setting up a system where like I need to handle my shit, and he needs to handle his shit. And if he's not handling his shit, then I don't worry about it, because it's not my job. I guess at a point it could be my problem, but it's more about going into business with friends. I mean, people say don't go into business with friends, but I think the reality is that most companies are started with good friends.

Gelman: Tell me about handling your own shit. Can you talk more specifically, about your accounting, for example.

Miguel: We have one Tax ID, and the name. Everything goes through the name of our company, but it goes into separate accounts.

Gelman: There are two different bank accounts?

Miguel: Yeah, with one name. So, I could get a check, and it could go into either bank account.

E.J.: But he'd obviously put it into this one. <Laughs>

Gelman: So one of you makes more money than the other?

Miguel: Absolutely.

Gelman: Who's making more money? <Laughs>

Miguel: He is. He has a much higher threshold for corporate work than I could ever wish for...

E.J.: Yeah, I mean --

Gelman: Well, that could be a reason for conflict or resentment.

Miguel: Why? I don't want to be doing the things that he's doing, and that's why if they give us any corporate work I look straight at him, because he's got the threshold for it. On the flip side, some creative project that would take a lot of work and we'd get no money for, he'd probably give it to me. You know, unless it was something that really spoke to him, which often happens. Or we'll do it together. We just have different sides.

E.J.: And that's one of the things which is definitely not scalable. It really helps with there not being any fights or problems, 'cause then none of the fights are about money or anything. It's about stuff that at the end of the day really doesn't matter. It might be that money is the thing that matters, but it's an easy thing to fight about.

Gelman: What happens when you work on the same project together?

Miguel: It's usually 50/50.

Gelman: You just split it?

Miguel: Or if it like involves a lot of photography, which is usually what I do, or if it involves a lot of programming, which is usually what he does, it --

Gelman: It's kind of ambiguous, which is why you have to negotiate.

Miguel: That's the good thing about our system, and the good thing about us, is that we're always willing to give the other person the benefit of the doubt. We break projects up into tenths -- into 10 percent pieces. So if I'll be like, "You did 70 percent of this job, so I'll take 30 percent," he'll be like, "No, you should take 40, I'll take 60."

Gelman: And that's usually easy to resolve between you?

Miguel: It has been so far. We haven't had one fight over money.

E.J.: There's three types of projects that we might take. One is the sort of like Tokion, Triple Five Soul, Paper

Interview continues at:
http://www.infiltratenyc.com/011/

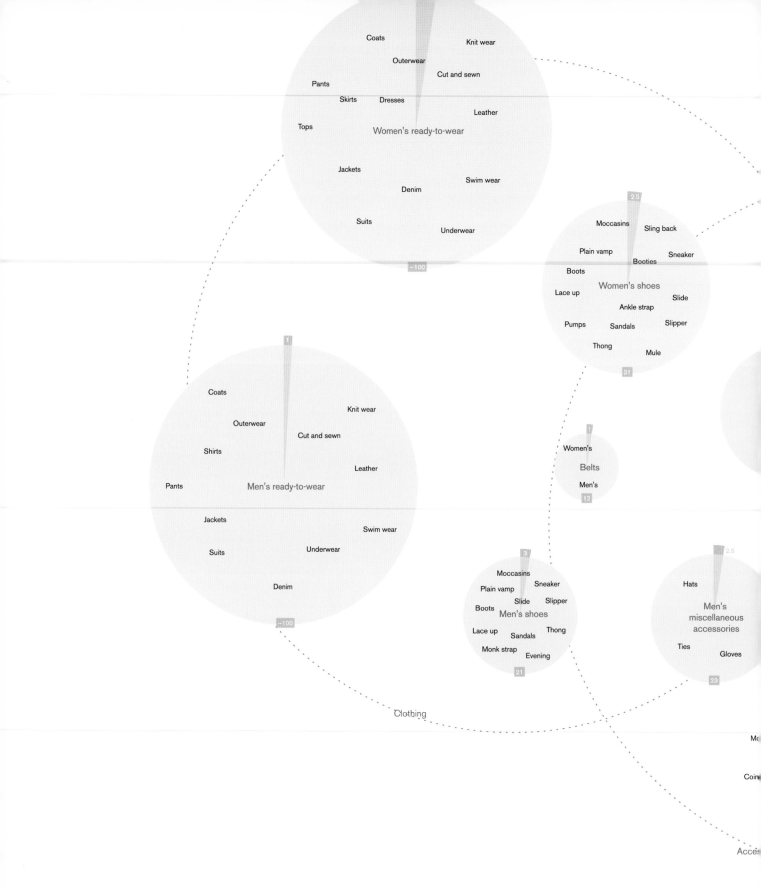

Coats
Knit wear
Outerwear
Cut and sewn
Pants
Skirts Dresses
Leather
Tops
Women's ready-to-wear
Jackets
Swim wear
Denim
Suits
Underwear
≈100

2.6
Moccasins Sling back
Plain vamp Sneaker
Booties
Boots
Women's shoes
Lace up
Slide
Ankle strap
Pumps Sandals Slipper
Thong Mule
31

1
Coats
Knit wear
Outerwear
Cut and sewn
Shirts
Leather
Pants
Men's ready-to-wear
Jackets
Swim wear
Suits Underwear
Denim
≈100

1
Women's
Belts
Men's
12

3
Moccasins
Plain vamp Sneaker
Slide Slipper
Boots
Men's shoes
Lace up Thong
Sandals
Monk strap Evening
21

2.5
Hats
Men's
miscellaneous
accessories
Ties
Gloves
23

Clothing

Mc

Coin

Acces

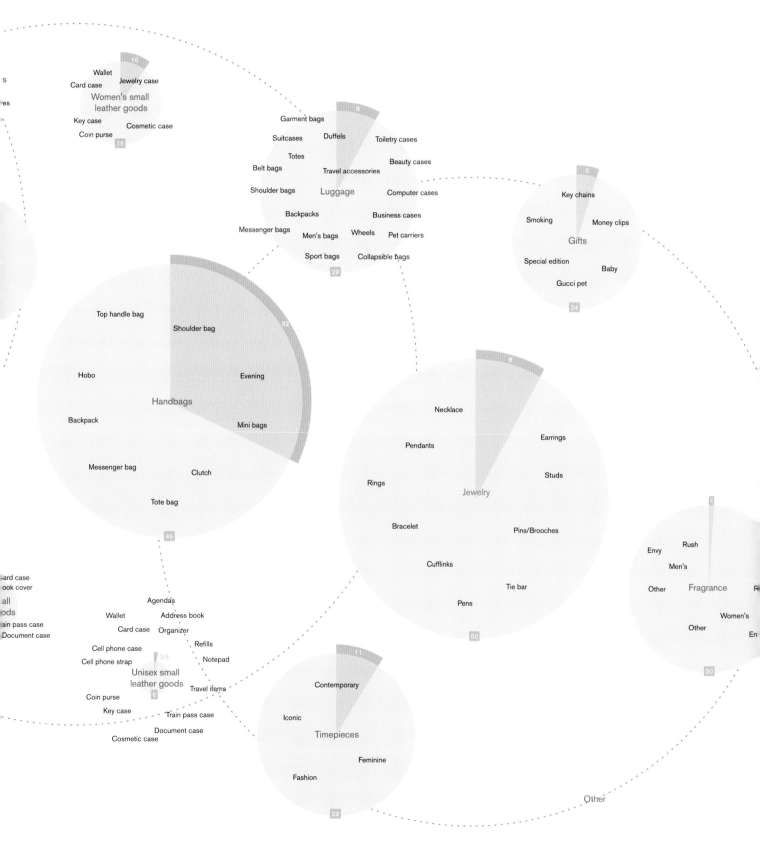

Women's small leather goods

Wallet
Card case Jewelry case

Key case
Coin purse Cosmetic case

15
10

Luggage

Garment bags
Suitcases Duffels Toiletry cases
Totes Beauty cases
Belt bags Travel accessories
Shoulder bags Computer cases
Backpacks Business cases
Messenger bags Wheels Pet carriers
Men's bags
Sport bags Collapsible bags

29
3

Gifts

Key chains
Smoking Money clips

Special edition Baby
Gucci pet

24
5

Handbags

Top handle bag
Shoulder bag
Hobo
Evening
Backpack
Messenger bag Mini bags
Tote bag Clutch

49
32

Jewelry

Necklace
Pendants Earrings
Rings Studs
Bracelet Pins/Brooches
Cufflinks Tie bar
Pens

50
3

Fragrance

Envy Rush
Men's
Other Fragrance
Women's
Other En

30
1

Card case
ook cover
all
ods
rain pass case
Document case

Unisex small leather goods

Agendas
Wallet Address book
Card case Organizer
Refills
Cell phone case Notepad
Cell phone strap 2.5
Travel items
Coin purse
Key case Train pass case
Document case
Cosmetic case

6

Timepieces

Contemporary
Iconic
Feminine
Fashion

29
11

Other

143

Time

2:21

Score

0

Pages 140: Shifty, 2003. Creative director/Programmer: E.J. Mablekos. I was thinking about this game mechanic for a while and finally got around to building it. The maze columns rotate and shuffle up and down until a path is cleared through the board. The hardest part was making sure there was one unique solution for each level. Try it out at www.bitrub.com/shifty. Page 141: Iron-On Stickers for The Fader, 2002. Client: The Fader Magazine. Designer: Miguel Angel Hurtado; These were '70s and '80s Americana inspired decals for The Fader Magazine. Simple outlines of powerful American machines "sponsored" by The Fader. Pages 142-143: Gucci line sheet diagram, 2000. Client: Gucci. Designer: E.J. Mablekos. This diagram was developed during the concept phase for a redesign of the Gucci website. The goal was to make the product line quickly understandable and help the team decide where to focus our attention in the early phases of the project. Several layers of information are overlaid, including an affinity diagram of the product line, number of items in each category, and projected profit from online sales. Page 144: Starpong!, 2001: Creative director/Programmer: E.J. Mablekos. One-player 'pong' with four paddles. Try to knock the ball into the stars for extra points. Check it out at www.bitrub.com/starpong. Pages 146-147: UNIFA "Evolution" Exhibit T-shirt Series (Tokyo, Japan), 2002. Client: UNIFA; Designer: Miguel Angel Hurtado. An international exhibit sponsored by UNIFA, a Japanese fashion line, whose theme was 'Evolution.' At the time, the United States was about to wage war on Iraq, and tension over terrorism in New York City was high. These are depictions of natural animal evolutionary traits (Gills, Shells, and Claws) artificially copied by man for the purpose of war (as Gas Masks, Bullet Proof Vests, and Weapons).

A conversation with Juliette Cezzar.

Gelman: You seem to work a lot with architectural books. How did that come about?

Juliette: I graduated from architecture school and when I first moved to New York I looked for an editorial job and didn't find one. So I got recommended to Peter Eisenman because he needed someone to deal with publications and archive material, so I said, "Sure, I can do that." I was 21, knew absolutely nothing. So I went to work for him, and after about a year I was tired of filing and really dying to do something that was creative. So I did a couple of exhibitions and put together some catalogs and we were always fighting about money, and because of that he gave me this little sort of bone in a way. He said, "Why don't you design this little book for me?" because he had a contract to do one of these tiny books in a series. Right around the time we sealed that, I quit. <Laughs> And so that's where it all started: with that one book.

Gelman: So you decided you wanted to do more books?

Juliette: I think I've always wanted to do books. The best thing I did in architecture school was a thesis book. I spent six months making the book. And it was four months making the book. And it was this tiny, little, silver book, and I would show it to people here, and when I asked them for advice they would say, "You really don't want to do architecture do you?" And I said "Well, I guess not."

Gelman: So that was an easy transition to graphic design?

Juliette: It was very easy, though it wasn't an easy transition mentally. I was perfectly willing to say that I was making books -- that to me was a thing. And it was Peter Eisenman who suggested to me at some point, "Y'know, why don't you just be a graphic designer?" And I said <Scowling> "Be a graphic designer? Who would want to do that? It didn't sound good at all. So it took a while and it took doing different kinds of projects to make a decision to go to school and get a degree and be serious about it instead of... Because for a long time I thought I was just doing it for now and I that I would go back to architecture eventually and get an internship somewhere and start drawing bathrooms again and live the rest

of my life. That I was just taking a break. So it was kind of a vacation spot that turned into a...home. <Laughs>

Gelman: Besides Peter Eisenman you worked with quite few other interesting personalities. Can you talk about some of them?

Juliette: Well, working with Peter was definitely a real education for dealing with all of these other people, because most of them are, um...

Gelman: Difficult people.

Juliette: Difficult people. I love difficult people. I'm an expert at difficult people at this point. I worked with Daniel Libeskind on a book and I worked with Karim Rashid on a book. There are always all other kinds of difficult people, but these stand out the most. Each one of them has made a name for themselves and they are all about 15-20 years apart in age, so I got to see all of the different sides of what happens when you you have the world thrust on you when you are maniacal about your work. And they are all maniacs. Maniacs not in terms of like a crazy person, but like maniacs as in like they were constantly 'on,' always wanting to do stuff, always wanting to work. And I like that because it's all energy. You either hate it or you like it. So I started to enjoy working with them, trying to figure out at what point do I say "Oh well, this is your thing, and this is my thing," and how do I get them excited about things, and how do I get them to focus on what we are doing? And there's always drama. That's the thing, because they like drama.

Gelman: Arguments?

Juliette: Well there's always a struggle because there's always a last-minute decision that changes everything, as in "Oh, well, we have to change the format of the whole book," or "I decided last night that we need to change all the material." That's happened every time. And I like problems; that's the thing. I like solving problems and they make a lot of problems. The publisher calls me and says, "What do we do? What do we do?" And we talk and compromise on things but there's always some crazy thing that happens that frees everything up.

Gelman: Can you imagine yourself working in a situation where everything is nice?

Juliette: No, not at all.

Gelman: When a client is easy and allows you to do anything...

Juliette: No, not at all. I can't do it.

Gelman: You can't function like that?

Juliette: I can't function like that. I'd just get bored, I'd find some other -- I'd set my desk on fire or something, make sure that something is happening that needs to be fixed. I'm just not interested. I'm not interested in self-expression, for example. I can sit around and talk all day if I want to do that. I like it when you have this impossible thing, when you have an impossible mountain to climb like the Tower of Babel and somebody comes to me and they want this impossible thing. I like to say yes, I can do it, and just try. And if you get like 80 percent there, you come up with something that's really good. But if you are striving towards something you know you can do, what is that?

Gelman: As an architect you can understand what they are trying to do?

Juliette: I can see what they are trying to do.

Gelman: And as a graphic designer you can translate it into a book.

Juliette: Into images and graphic design. There's a translation that's already taken care of, but on top of that, I think people have liked working with me or sought out working with me because I am the person that says their impossible idea, their ridiculous idea, is something that will be done and we'll do it.

Gelman: So you are not afraid to....

Juliette: I never say "Oh, no, we can't do that, it's not possible." I'm not afraid to take it on, basically. A lot of people say "Ehhhh, we don't want to really deal with stuff." And I come up with impossible stuff." And I come up There's always this first meeting where we talk about the book and what it can be and the idea always starts right there anyway. I get really excited.

Gelman: How do you manage to take control of the process and the final outcome?

Juliette: I always -- or I try to -- come

up with some sort of organization or war scheme for the book, or some sort of logic, I should say, that it has to follow. If that's there and if they agree to that then I'm fine. Then if they want to change it from blue to red I don't care.

Gelman: You are leading the project.

Juliette: Once the structure is laid down then it's very easy from there. Because then I say "We have to follow this."

Gelman: And you are always the one who comes up with the structure?

Juliette: The visual structure is always mine, and you can see this if you put them all next to each other. Like where things go, what order, what's the syntax, and that, to me, controls everything. Other people are focused on individual pages or they want to change the stuff that's in the book or the text; they don't like this typeface, or they want it to be red. I care about what things are in relationship to each other and as long as I get to set that up, which nobody else seems to care about, I would say that I'm still 90 percent in charge of the book. But if you ask my client, he would say that he is 90 percent in charge of the book and the rest is just going and putting it into Quark. But that has everything to do with how I talk about it when we are together and how we relate. People give me ideas too, mostly in presenting larger and larger problems. Sometimes they give me some good things to go on. When I first started working with Daniel Libes-kind, I showed up at his office and they said "Oh, well Daniel has had a brilliant idea, we're going to put the book in alphabetical order." That to me was just not very interesting, but it was a problem that led to this structure for the book as a solution. What should it be like? Should it be like this, should it be like that? It was a lot more ambitious than we ended up.

Gelman: So you agreed to put it in alphabetical order?

Juliette: Yeah, because it didn't go against what I was already thinking of doing, which was a non-chronological organization that was in a line and not divided into chapters. I wanted to actually do some other organization, not by type but by some other kind of adjacencies of things. But it worked out fine.

Gelman: What about Karim Rashid?

Juliette: Karim Rashid was a lot more difficult, actually. I would say that book is...

Gelman: It was a very important book for him. His first book.

Juliette: It was such an important book for him and it was a very important book for me, because this was at the point where I had decided to commit myself to doing graphic design. That was the thing. The challenge there was that when I first went to go talk with him he said, "I want it in a techno style." And these were words I had never heard before, and I couldn't really figure out what he meant. So I thought, I guess I should use some of those techno typefaces. Because, again, it's about the relationship of the materials to each other. I don't really care about what it looks like, it's whatever. And he was just so obsessive about the book that we ended up -- and I tried very hard to come up with a scheme that would be flexible enough to accommodate a lot of changes, because I knew he was going to be very difficult with the material. And he was. We would finish the book, I'd make a dummy, I'd give it to him and he would change 75 percent of the material. And then give it back to me. And it was just like, "Okay, start over." It was just a very strange process.

Gelman: How could you change 75% of a book?

Juliette: Oh, because he didn't like this photograph; instead, he wants the one like that.

Gelman: Different shots of the same chair?

Juliette: Actually, no. There was a lot of swapping. He wanted it to be comprehensive. It isn't actually everything he's done, because there's still like another 50 projects out there. He's done a lot of stuff. He would just keep changing and changing and changing.

Gelman: What were the considerations for changing things?

Juliette: Very individual.

Gelman: He wanted to include specific clients or specific ideas?

Juliette: Specific clients, specific things that he liked. This isn't a book about ideas like the Eisenman books are. Certain kinds of objects that he really liked, he had to have them, other things that he wanted to claim ownership of in a weird way. He was really concerned about speculative projects he had done, to get them out and have a sort of design copyright to them by having them printed in this book.

Gelman: By publishing them.

Juliette: Because a lot of people have the same ideas about industrial design, so he just wanted to claim them first. People often confuse his work, for example, with Marc Newson's work.

Gelman: What kind of ideas? Certain shapes?

Juliette: I'm trying to think of a specific one. Yeah, he would just make prototypes of things. He made a series of watches, for example, which I kind of liked, where an LED...

Gelman: For which client?

Juliette: He had done them -- for Swatch or whatever, but they didn't buy it.

Gelman: So he wanted to get it published...

Juliette: Architects do the same thing, publishing unrealized projects -- it's a kind of marking the territory. Eisenman always had this thing about the power of books over architecture, and this was part of it. Books do a good job communicating ideas to other people. And with Karim, he really loves his work. Which I kind of like. It's interesting. It's so over-the-top. It's not just his obsession with himself, where he's concerned about his persona. He's really obsessed with his work. He loves it. Which is a beautiful thing if you think about it. I can't say that I always feel like that about the work that I do. When I started working on the book, I asked him "Does your work break down into categories?" and he said, "Oh yeah, sure I'll give you this whole thing." And he gives me a CD and there are 25 categories, at which point you don't really have categories and they're like "lightness" and "immateriality" and whatever. And I'm like "Oh my God, what am I going to do?" Because I have a very rational mind, I break things down, things that are blue over here, things that are red over there. Whatever it is, I want clear-cut distinctions.

Gelman: Yeah, to call them categories, you need to have more than one piece per category.

Juliette: I would ask him "Do these projects fall into these categories?" and he would say, "No, they kind of overlap." I would show him a project and he would say "Well, that could be lightness or that could be immateriality."

Gelman: Immateriality?

Juliette: So I sat in his office for about an hour and said, "Listen, what we are going to do is we're going to make symbols for each of these categories and then for each project we're going to assign the symbols." Like you have in a guidebook for restaurants, you know, you can smoke there, so that you can look at a project and see that it goes with lightness and immateriality and morph and whatever. And then I said, "When we are done we'll just organize the projects so you are just moving from one category into the next." No clear-cut divisions in the book, basically. No chapters, no divisions. And it worked. As a scheme it worked. I think.

Gelman: That was okay for your ideas to be presented verbally?

Juliette: I made a very initial sketch of what I thought the table of contents for this idea should be like. I said "We'll make this big cloud of stuff."

Gelman: So he's able to appreciate a good idea as soon as it's...

Juliette: Yeah, I would say so. He just wasn't able to stop the book. In the end I pulled away from him a lot. I wanted him to stop so that we could finish the book.

Gelman: Just changing?

Juliette: Just kept changing, and changing, and changing.

Gelman: Was he pleased with the outcome?

Juliette: I don't know actually. I have no idea. I don't even know.

Gelman: Do you guys still talk?

Juliette: We exchange holiday cards every year. I've been meaning to go talk to him. I was very unhappy with the book -- that's the thing. In the end, the production was terrible, just terrible, and the publisher was just pushing to get it out, so after six months of swapping images and all this, in three days I set all the text and placed all the images and did all of that stuff and I really didn't get a chance to do the iterations. On top of that, there was a pile of changes because the publisher pulled a fifth color that was previously promised. I didn't get to see it and revise it. Really, I just had to do it all in one shot, because everything was always at the last minute. It was a mess. And then it just got tossed through their production department, no color correction, no nothing. So I was mad at everybody for giving what should have taken three months and a lot of care no time at all.

Gelman: Do you know how successful this book turned out?

Juliette: Well, it's in its second printing already.

Gelman: What was the first run?

Juliette: I think it was 15,000. I'm shocked. But I guess everybody knows him and it was marketed well. It was in the window of Barnes & Noble for months during Christmas. And now they are doing a second printing, and they're printing it with all the same mistakes as the first printing.

Gelman: So they never called you for the second edition to say, "Hey, you know there's an opportunity to fix a couple of things?"

Juliette: No, no one ever saw anything wrong with the book except for me and Karim. That was the thing. I mean I look at it and see a lot of problems. They just want to get it printed. The publisher's job is to say, "Let's go. Let's go. It's time to print." They lose a lot of money when it's late, they know that. But they don't really see that they lose on the quality, especially the production

Interview continues at:
http://www.infiltratenyc.com/012/

Infiltrate / Juliette Cezzar

	1	2		3	4		5	6		7	8		9	10		11	12		13	14		15	16	

Row 1: TITLE ← TITLE → | book info | Acknow. | Foreword → | ← TOC → | ← INTRODUCTION → | ← | **1**

Row 2 (17–32): GUARDIOLA | **2**

Row 3 (33–48): → ← — ARONOFF (FREDERIC JAMESON) — | **3**

Row 4 (49–64): — → ← — MILAN (long text) → | **4**

Row 5 (65–80): — → ← — KOIZUMI — ← | **5**

Row 6 (81–96): — COLUMBUS CONVENTION CENTER — ← | **6**

Row 7 (97–112): — BANYOLES OLYMPIC HOTEL — | **7**

Row 8 (113–128): → ← — NUNOTANI OFFICE BUILDING — → ← | **8**

Row 9 (129–144): — EMORY CENTER FOR THE ARTS — → | **9**

Row 10 (145–160): TEXT TO COME ← | **10**

Row 11 (161–176): ← — TOURS — → ← | **11**

Row 12 (177–192): — KLINGELHOFER — (long text) → ← | **12**

Row 13 (193–208): — FRANKFURT REBSTOCKPARK (RAJCHMAN) → ← | **13**

Row 14 (209–224): MAX REINHARDT HAUS → ←| | | | | ← | **14**

Row 15 (225–240): — DUSSELDORF — → ← | **15**

Row 16 (241–256): ← — CHURCH (long text) — → ← | **16**

Row 17 (257–272): — PAPERART EXH. → ← — GENEVA LIBRARY — | **17**

Row 18 (273–288): — → ← — BERLIN MEM. | **18**

Row 19 (289–304): (GALIANO) → | **19**

Row 20 (305–320): | **20**

152

Contents

1 2 3 4 5 6 7 8 9 10 11 12 13 14 15

R.E. Somol Dummy Text, or the Diagrammatic Basis of Contemporary Architecture

16 17 18 19 20 21 22 23 24 25 26 27 28 29 30 31

Peter Eisenman Diagram: An Original Scene of Writing

32 33 34 35 36 37 38 39 40 41 42 43 44 45 46 47

Interiority:
Grids

Peter Eisenman Diagrams of Anteriority Peter Eisenman Diagrams of Interiority

48 49 50 51 52 53 54 55 56 57 58 59 60 61 62 63

Interiority:
Cubes

64 65 66 67 68 69 70 71 72 73 74 75 76 77 78 79

Interiority:
El-forms

80 81 82 83 84 85 86 87 88 89 90 91 92 93 94 95

Interiority:
Bars

Index

96 97 98 99 100 101 102 103 104 105 106 107 108 109 110 111

112 113 114 115 116 117 118 119 120 121 122 123 124 125 126 127

128 129 130 131 132 133 134 135 136 137 138 139 140 141 142 143

144 145 146 147 148 149 150 151 152 153 154 155 156 157 158 153

160 161 162 163 164 165 166 167 168 169 170 171 172 173 174 175

Exteriority:
Site

Peter Eisenman Diagrams of Exteriority

176 177 178 179 180 181 182 183 184 185 186 187 188 189 190 191

Exteriority:
Texts

192 193 194 195 196 197 198 199 200 201 202 203 204 205 206 207

Exteriority: Exteriority:
Mathematics Science

208 209 210 211 212 213 214 215 216 217 218 219 220 221 222 223

Appendix

Peter Eisenman The Diagram and the Becoming Unmotivated of the Sign

224 225 226 227 228 229 230 231 232 233 234 235 236 237 238 239

Infiltrate / Juliette Cezzar

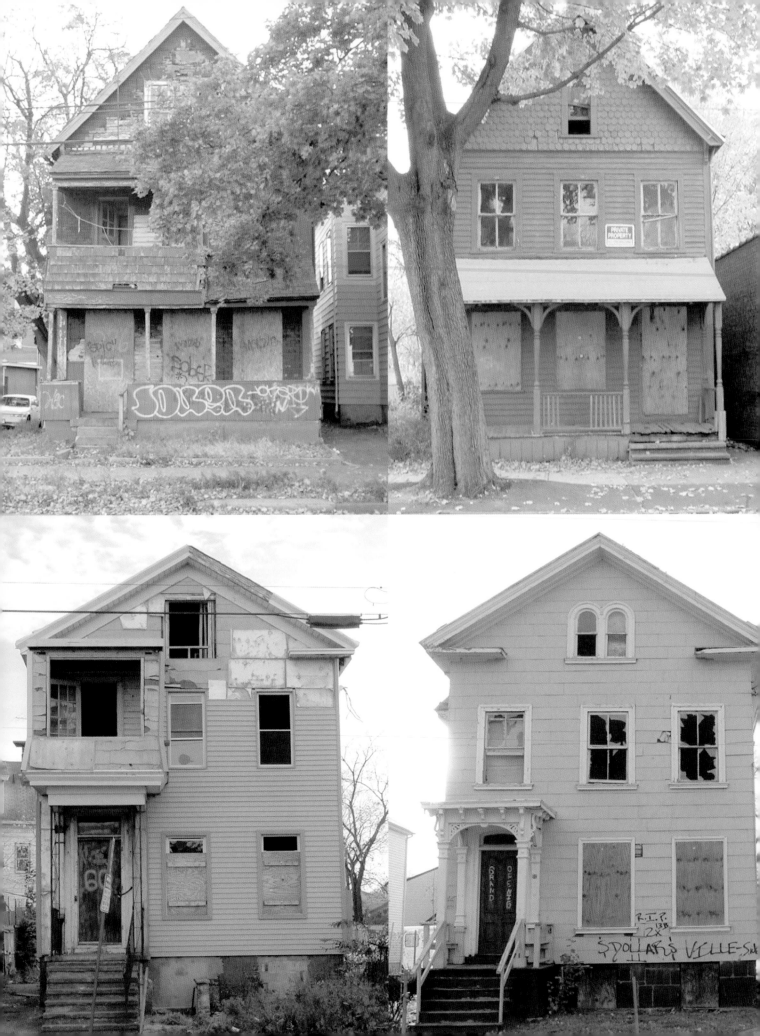

Pages 146-147: TheInternetLadyWhoIsThereAlways, 2002. Designer/Photographer: Juliette Cezzar. TheInternetLadyWhoIsThereAlways is an interactive "being" with an opinion about interactive design. She does not wish to elicit any kind of response from the user. In fact, she gets annoyed when her concentration is broken. She is busy at all hours of the day, reading, knitting, drawing, writing, making paper airplanes, etc., and if you click in her box, she will look up and pause, or scowl and put away what she is working on. In essence, she is an "un-interactive" project. She is me more than I am, constantly tooling around by herself, irritated when she is bothered, and absolutely content when she is not. Pages 148-149: Blurred Zones: Investigations of the Interstitial, by Peter Eisenman, 1998-2003 (Diagram). Client: The Monacelli Press. Designer: Juliette Cezzar. I was determined to do something spectacular; the author was determined to calm it down, and the publisher was determined to get me off the project altogether. After a three-year gestation, I released the book with minimal revision, to preserve good things in this book that I now could not or would not do, moves that informed my work but would have disappeared forever had I imposed a total purification when given the chance. Pages 155-157: Home, 2002 (Spine & Spreads). Designer/photographer: Juliette Cezzar. I started photographing abandoned houses when I was in college. The book is both an attempt to document an ongoing project and to emphasize our tendency to allegorize objects in our landscape. These buildings are just buildings, and they point to a specific kind of poverty and neglect, but once they no longer have a purpose they become abstract, anthropomorphic objects that evoke so much more than the social events that bring them about. Pages 158-159: Day Planner, 2001. Designer/illustrator/copywriter: Juliette Cezzar. A project of a series of posters about "flow," realized as flowchart for getting through a day. The poster high- lights the allegorical potential of an object even when it has no inherent meaningfulness. Page 160-161: Monochrome Poster, 2000. In response to the observation that I tended towards monochromatic outfits, I photographed myself over several weeks documenting if this was indeed the case.

Infiltrate / Juliette Cezzar

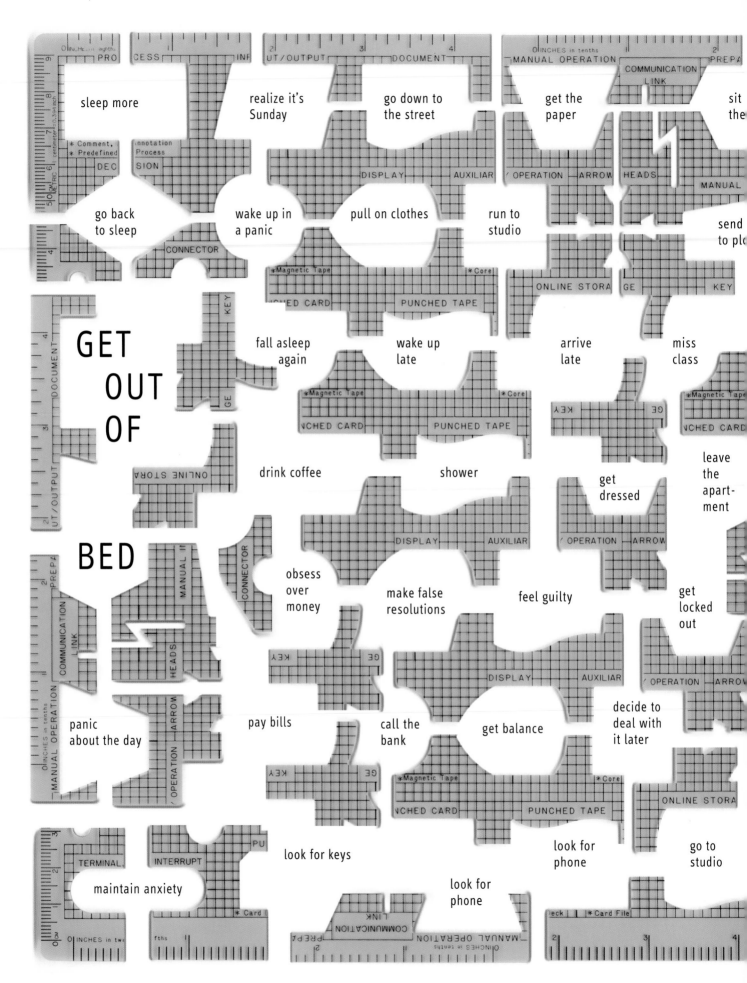

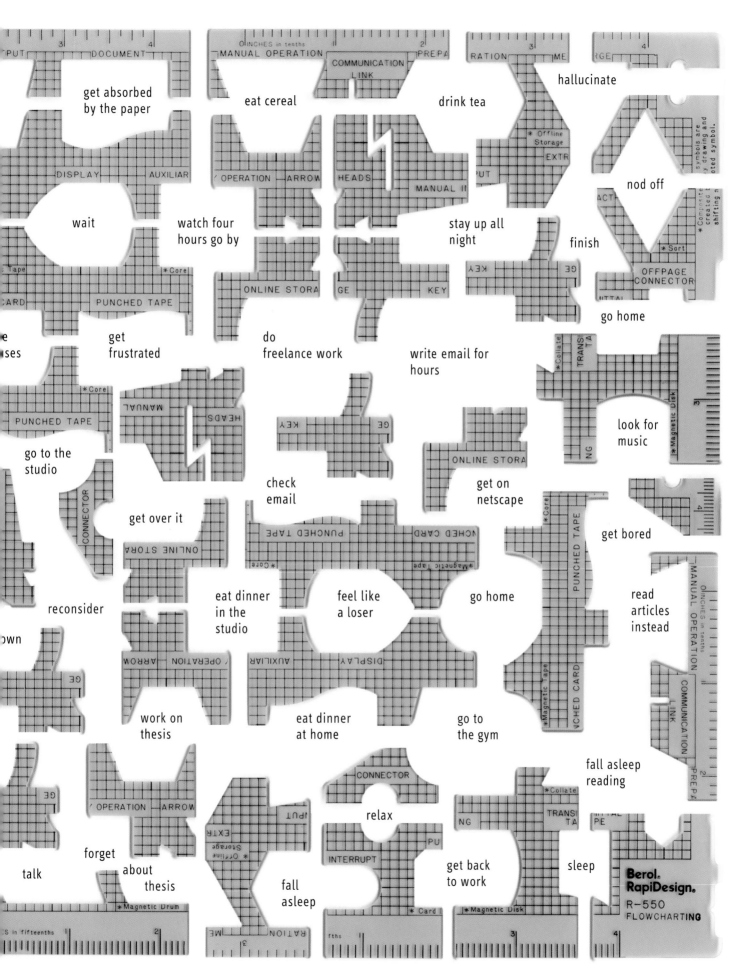

get absorbed by the paper

eat cereal

drink tea

hallucinate

wait

watch four hours go by

stay up all night

finish

nod off

go home

get frustrated

do freelance work

write email for hours

look for music

go to the studio

check email

get on netscape

get over it

get bored

reconsider

eat dinner in the studio

feel like a loser

go home

read articles instead

work on thesis

eat dinner at home

go to the gym

fall asleep reading

talk

forget about thesis

fall asleep

relax

interrupt

get back to work

sleep

Berol. RapiDesign. R-550 FLOWCHARTING

Infiltrate / Juliette Cezzar

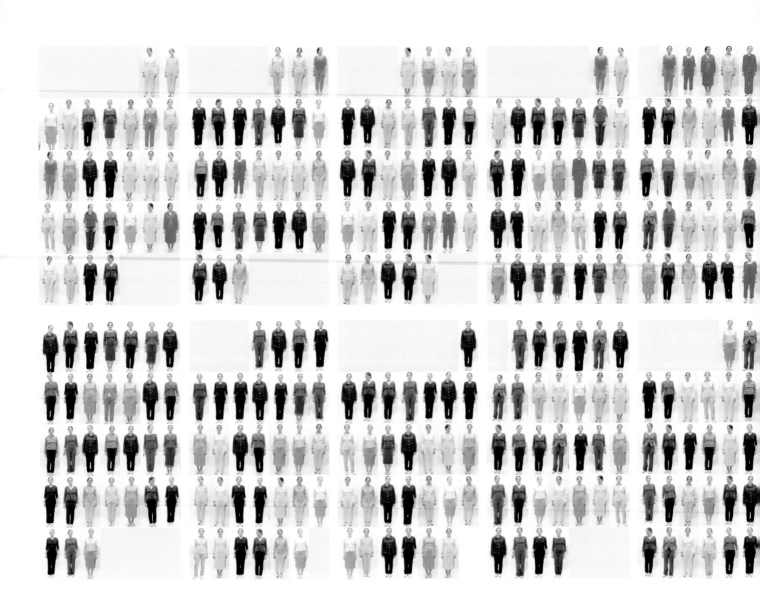

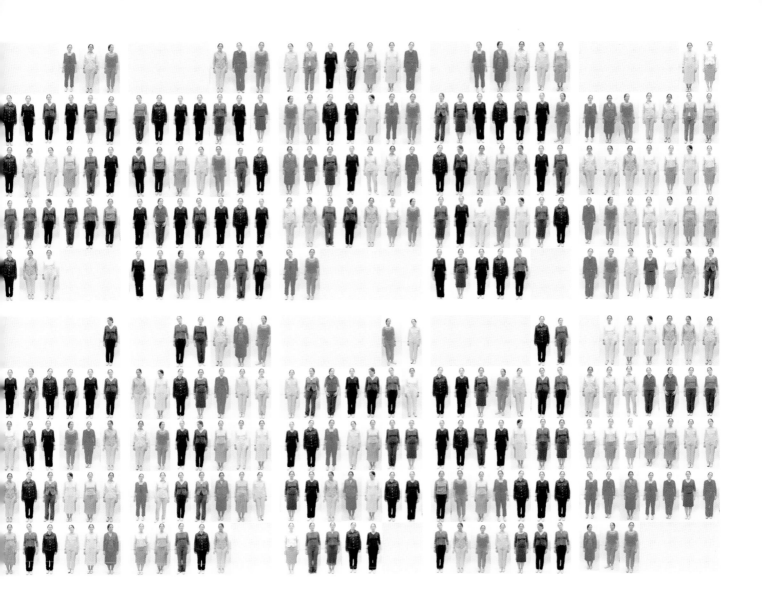

Infiltrate / Juliette Cezzar

A conversation with Jan Wilker and Hjalti Karlsson, principals, karlssonwilker inc.

Gelman: Nice clock.

Hjalti: Got it for like, $5, at Ikea.

Gelman: Really.

Hjalti: Maybe $6.

Gelman: And this?

Hjalti: It's not all Ikea; one or two Ikea things is okay.

Gelman: Okay, let's begin. Tell me, how did two guys from Europe decide to start a company in New York?

Hjalti: I have been here 11 years; I studied here in New York and then I...

Gelman: Where did you study?

Hjalti: Parsons. Then I freelanced for a few years and then worked at Stefan's; when we started the company I had been here for eight or nine years. In the beginning I was like, "Yeah, yeah, this is the start of business and somehow we will be okay," then I realized that all the contacts I had were just designers, so it wasn't that easy to get clients. So far it has been word of mouth; in the beginning there were a couple of jobs that came from Sagmeister when he took his sabbatical...

Gelman: He passed you his clients.

Hjalti: One or two came here, but most new work was from word of mouth. And then we did this mailer about half a year ago, a year later, sent to people that we knew and to some record companies, and somehow we got three or four clients from this.

Jan was in Germany at this time; there were a couple of clients that he knows from Germany, such as the CD projects.

Gelman: So you do work for clients in Germany?

Jan: Ya, but I think in this case it was more like a friend. I was a student the whole time I was in Germany, so I didn't have any existing client relationships. I just did my stuff and when I came here thinking Hjalti had been here for all these years and he was going take care of this for me. We started without any big plan or anything. We just started in our

little bubble, sitting here and waiting.

Hjalti: Yeah.

Jan: And when anyone asks how, how did we get clients -- we never asked ourselves this question in like the first six or eight months. And when we somehow tried to answer this question, we didn't have much of a plan because we were just waiting and sitting around.

Gelman: Sitting around and doing what? Drinking beer or watching TV?

Jan: When we don't have much to do, we do the things we don't do when we are busy.

Hjalti: The office and all.

Jan: Like the database, or invoices. I think this is all stuff we both --

Gelman: Love doing?

Hjalti: No, stuff that you push away.

Jan: Or cleaning the office. Or upgrading equipment. Maintenance.

Hjalti: Or doing stuff that you don't do when you are busy.

Gelman: It is really clean right now. Does it mean that you're not really busy at the moment?

Hjalti: No, we had a party. We are sort of busy; we have a party every three or four months when it gets super dirty in here; it is a good excuse to clean.

Gelman: It's a good motivation.

Hjalti: And it is a good excuse for everyone to meet our friends.

Gelman: How would you describe your approach to design?

Jan: I think it is somehow -- <Laughing> I don't think we have a philosophy or anything. It sort of just depends on the project or --

Gelman: Usually designers have extensive reasoning and philosophies behind their decisions. You don't seem to bother.

Jan: I can't see any other way of doing it than the way we do it. It is a super personal style; if we think it is funny, then it is just funny and we get a kick

out of it. Most of the time, we don't even think of other people or the client.

Gelman: Is being funny your main criteria?

Jan: No.

Hjalti: We're not trying to be silly. We just try to enjoy doing these things.

Jan: We are really happy when we do something that we have never seen before or that just makes no sense; most of the time, design is this nice thing and there we want to overcome this super nice looking "design-y" stuff. We have something that is a little bit off. We sent out -- this black and white stuff in which we make fun of our design and we really hate all these people looking at all these design books. But somehow we cannot get away from this.

Gelman: Do you have an issue with common sense?

Hjalti: What do you mean?

Gelman: You've mentioned that you look for solutions that are kind of "off" or "don't make sense" and that seems to be more interesting or stimulating --

Jan: To us.

Hjalti: Yeah.

Jan: But we don't think that we work against common sense because, in the end, it is just design. We enjoy this. But I don't think that fun is, or playing fun, is the driving force, more just enjoyment and playing with things.

Hjalti: I've been doing this for like eight, 10 years, and it's so easy to get a project that is just done like a routine. You have just done this before, so you have to tweak it a little or twist it, so it becomes new for you.

Gelman: You always look for fresh approaches?

Hjalti: Guess so, yeah.

Jan: I think that all of this is a personal way; it's not that we are looking to reinvent design. If we somehow think it is fresh for us...it still might be super old to someone else.

Hjalti: Yes, and we are not saying that no "Nobody has seen these things before." I think that it's just fresh for us, and that's all right with us.

Gelman: How many years did you spend with Stefan?

Hjalti: Four. Four years.

Gelman: And you?

Jan: Three months.

Hjalti: I started there and sort of told myself I would be there for a year, year and a half. And I really liked it, and it was so easy, just me and him and an intern. No worries. I didn't have to think about getting clients, I worked on projects that I liked, so this was the easiest job that I could imagine.

Gelman: He'd bring all the jobs?

Hjalti: Yeah and these were like all nice jobs, like CD jackets for big bands; it was all just interesting work.

Gelman: How much autonomy did you have on individual projects?

Hjalti: From Stefan?

Gelman: Yeah.

Hjalti: It depended on the project. Quite often, the concept came from him or we talked about it from the beginning, so maybe the actual design part was more mine; it varied from project to project.

Gelman: Jan mentioned that he was a dysfunctional intern. Is it true?

Jan: No, I said...

Hjalti: No, no, no. He was pretty good.

Jan: And I really enjoyed it. This had a huge impact on me because it was the first real job that I had.

Gelman: First real job?

Hjalti: I think that he was a very good intern; I mean, he is sitting here, so I have to say something nice.

Gelman: He said that he was the worst intern.

Hjalti: No, maybe this was a joke. It was

a good, happy time. Jan was there first for three months and then in the end he was there for like...

Jan: And for me this was a dream, a shitty student from Germany, coming to this really nice New York studio.

Hjalti: All these things, this was nice. Do you want something from Dunkin Donuts?

Gelman: Sure. How often do you go there?

Jan: Everyday; at least one of us.

Hjalti: We go there quite often.

Jan: At least once a day the question gets asked, "Who wants something from Dunkin Donuts?"

Gelman: And it is right below.

Hjalti: Yeah.

Jan: We get this coffee smell, in the morning. Then it changes around one, becomes more salty, I think because of the bagels with onion and garlic. They do these things right underneath, so we have the coffee and chocolate.

Hjalti: We are pretty much used to this. People come in and are like, "Whoa, what is this smell?" Yesterday I went home and met my girlfriend, she hugs me, kisses me, and she is like, "Hey! You smell like Dunkin Donuts. Have you been eating?" And I am like, "No, come on. No, I just came straight from work."

Jan: But I think that it is nice to be right above Dunkin Donuts, because you can tell everyone "We are located at 14th and 6th, right above Dunkin Donuts."

Hjalti: Yeah, and their sign is right by the window.

Jan: And it is nice to have people in the morning say good morning to you.

Gelman: Do they know your names?

Hjalti: No, and for a while I think they didn't even like us, because we would take our garbage outside and put it in their pile. They were complaining...

Jan: We didn't pay for this.

Gelman: Ah.

Hjalti: So they were complaining "Don't put your garbage there blah, blah, blah."

Gelman: We are right next door to Wendy's and our second floor window faces the back. It's all the Wendy's garbage bags with rats and stuff; you can hear them screaming at night.

Hjalti: But do you have them in the office?

Gelman: No, but we have mice from time to time.

Hjalti: Ya, same with us.

Jan: So do you guys have Wendy's for lunch?

Gelman: No. You have to be pretty desperate to go to Wendy's. There are a lot of good restaurants around.

Hjalti: Here we have Dunkin Donuts, then you have McDonald's in front, cheap pizza place.

Jan: Burger King, Taco Bell, all of this. It is so stupid. There is one Chinese place on 14th we order from everyday.

Hjalti: We literally order from them three times a week. We call and say, "Hello," and they are like, "Hey, 536 6th Avenue, what do you want?" They know us right away.

Jan: We had mice as well, then they were gone, then a few days ago we found this forgotten glue trap in the closet, with a skeleton. It was horrible.

Hjalti: We quickly closed it, so it is still sitting there, it is horrible!

Jan: Still there? Huh, maybe the smell isn't from Dunkin Donuts.

Gelman: Do you crave Dunkin Donuts when you're away?

Jan: No, no, because when I travel there is always so much going on I don't have time to think about it.

Hjalti: This is true, because when I went to Iceland, I do not crave or miss anything...

Gelman: Anything of New York?

Hjalti: Not the food; maybe if I stayed their longer, I would miss the Chinese place <laughs>, but not likely.

Jan: What I miss the most when I am in Germany is my own place, my apartment. When I am there at my parents, very quickly I feel like I am in jail.

Hjalti: Like you're 15. When I go to my parent's house, my room is exactly the way that I left it.

Gelman: With stupid posters and stuff?

Hjalti: Stupid posters and medallions and stuff, Bee Gees...

<Laughing>

Gelman: What kind of medallions?

Hjalti: Soccer, volleyball, and then two or three for ping pong.

Gelman: Really?

Hjalti: Ya, but this was like, ages ago.

Gelman: So you were a champion of ping-pong and soccer?

Hjalti: No; I don't know how I got them.

Gelman: Do you still play soccer?

Hjalti: No, I haven't played in ages.

Gelman: I know a few guys who regularly play soccer; Peter Hall, for example. [To Jan] How about you?

Jan: Every German boy plays soccer in this, uh, what is it called?

Hjalti: Leagues.

Jan: For six years; then I switched to field hockey, which was very girlie.

Hjalti: What is field hockey?

Gelman: Field hockey? With a round stick.

Jan: This was very girlie; yes it was, wasn't it?

Hjalti: Girl! Girl! Sissy guy! <Laughing>

Jan: It was actually very rough.

Gelman: The ball is like a brick.

Jan: When you play hard.

Gelman: What is your work day like?

Jan: I think that it is around 10 to 7.

But somehow we never leave around 7. Even if we just sit here and have a beer and hang out. I don't know if this is good or bad, but we made this whole set up here so comfy and cozy for us to sit here and hang out. We used to have PlayStation here so...

<Laughter>

Jan: But we stopped that.

Gelman: No work would get done?

Hjalti: Ya.

Jan: And why would we have apartments if we could always be here?

Hjalti: There was like a period in December that we had the PlayStation over there and we would just be playing all day long; we even stayed late to play <Laughs> and people thought we were super busy because it was light in here, so we were like, eh, oh...

Gelman: Do you have a favorite PlayStation game?

Hjalti: I think Jan is more into this.

Jan: He is the Pac Man champion. There is some fighting game, it is so cool. And a super old arcade game, Dig Dug, we played this like crazy. We got this compilation CD with all these games on it. And Grand Theft Auto was so much fun, now that one came out from these guys in Brooklyn -- they live in Brooklyn.

Gelman: Tell me, how did you come up with your company name?

Hjalti: For a while we were going to call it Rocket. We don't know why, we just liked the name. Then we just decided against it.

Jan: I think that it is more personal. It is not a name that you would remember or just write down karlssonwilker.

Gelman: You just liked the way that it sounded?

Jan: No. I think that it was just that we had no other name, I mean, than karlssonwilker. This company is just Rocket was funny, but it was more generic to us, so we thought it was good to have

Interview continues at:
http://www.infiltratenyc.com/013/

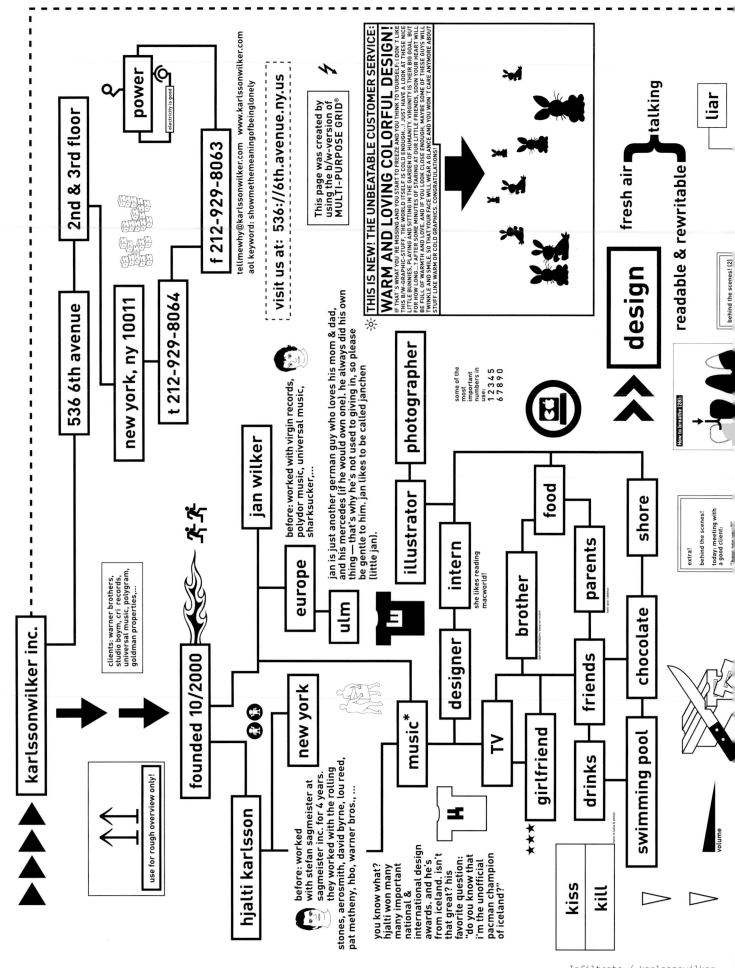

karlssonwilker inc.

536 6th avenue

2nd & 3rd floor

power
electricity is good

new york, ny 10011

t 212-929-8064

f 212-929-8063

tellmewhy@karlssonwilker.com
www.karlssonwilker.com
aol keyword: showmethemeaningofbeinglonely

visit us at: 536://6th.avenue.ny.us

This page was created by
using the b/w-version of
MULTI-PURPOSE GRID®

THIS IS NEW! THE UNBEATABLE CUSTOMER SERVICE:
WARM AND LOVING COLORFUL DESIGN!
IF THAT´S WHAT YOU´RE MISSING AND YOU START TO FREEZE AND YOU THINK TO YOURSELF: I DON´T LIKE
THIS B/W-GRAPHIC-STUFF, THE WORLD ITSELF IS COLD ENOUGH...I JUST HAVE A LOOK AT THESE NICE
LITTLE BUNNIES, LAYING AND SITTING IN THE GARDEN OF HUMANITY. VIRGINITY IS THEIR BIG GOAL, BUT
FOR NOW LONG...AFTER SOME MINUTES OF STARING AT THE FRIENDS, SOON YOUR HEART WILL
BE FULL OF WARMTH AND LOVE. AND IF YOU LOOK CLOSE ENOUGH, MAYBE SOME OF THESE GUYS WILL
TWINKLE AND SMILE, SO THAT YOUR FACE WILL WEAR A GLANCE AND YOU WON´T CARE ANYMORE ABOUT
STUFF LIKE WARM OR COLD GRAPHICS. CONGRATULATIONS!

design

fresh air
talking

readable & rewritable

liar

How to breathe [28]:

behind the scenes! [2]

extra!
behind the scenes!
today: meeting with
a good client:

jan wilker

before: worked with virgin records,
polydor music, universal music,
sharksucker,...

jan is just another german guy who loves his mom & dad,
and his mercedes (if he would own one). he always did his own
thing — that´s why he´s not used to giving in, so please
be gentle to him. jan likes to be called janchen
(little jan).

europe

ulm

photographer

illustrator

intern
she likes reading
macworld!

designer

brother

food

some of the
most
important
numbers in
use:
1 2 3 4 5
6 7 8 9 0

shore

parents

chocolate

new york

music*

TV

girlfriend

friends

drinks

swimming pool

founded 10/2000

clients: warner brothers,
studio boym, cri records,
universal music, polygram,
goldman properties,...

hjalti karlsson

before: worked
with stefan sagmeister at
sagmeister inc. for 4 years.
they worked with the rolling
stones, aerosmith, david byrne, lou reed,
pat metheny, hbo, warner bros.,...

you know what?
hjalti won many
many important
national &
international design
awards. and he´s
from iceland. isn´t
that great? his
favorite question:
"do you know that
i´m the unofficial
pacman champion
of iceland?"

use for rough overview only!

kiss
kill

volume

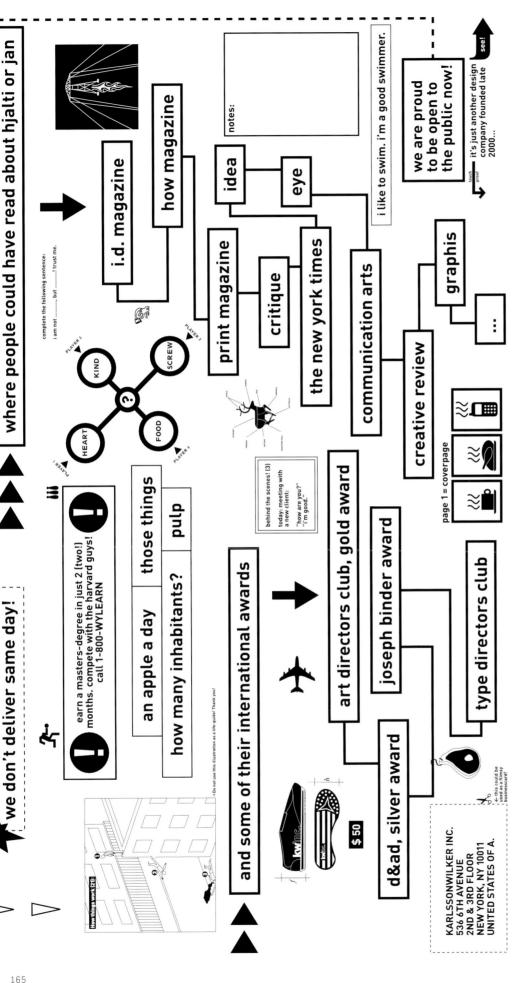

where people could have read about hjalti or jan

complete the following sentence:
i am not but I trust me.

i.d. magazine

how magazine

idea

eye

i like to swim. i'm a good swimmer.

we are proud
to be open to
the public now!

touch
proof

it's just another design
company founded late
2000...

see!

print magazine

critique

the new york times

communication arts

creative review

graphis

...

page 1 = coverpage

PLAYER 2

PLAYER 3

KIND

SCREW

?

HEART

FOOD

PLAYER 1

PLAYER 4

we don't deliver same day!

new!

earn a masters-degree in just 2 (two!)
months. compete with the harvard guys!
call 1-800-WYLEARN

an apple a day

those things

how many inhabitants?

pulp

behind the scenes! [3]
today: meeting with
a new client:
"how are you?"
"i'm good."

→ Do not use this illustration as a life-guide! Thank you!

and some of their international awards

art directors club, gold award

joseph binder award

type directors club

d&ad, silver award

$50

← this could be
used as a flimsy
businesscard!

How things work [2]!

KARLSSONWILKER INC.
536 6TH AVENUE
2ND & 3RD FLOOR
NEW YORK, NY 10011
UNITED STATES OF A.

Pages 164-165: Opening announcement, 2001. Creative direction, design, illustration, photography, & copywriting: Jan Wilker/Hjalti Karlsson. Production: Cheap 23" x 32" newsprint, one-color. Our opening announcement. The back showed a big photo of us in our office wearing oversized suits with cut lines on them to make them fit. We even got some jobs through this one. Page 166: Scott Fields, 96 Gestures, 2001. Client: CRI/Blueshift records. Creative director: Jan Wilker. Designers: Jan Wilker and Miriam Wilker. This CD is part of a series of releases for CRI/Blueshift records, a label dedicated to contemporary composers and experimental jazz. For each, the exterior is one spot color and the interior is Black and White. The CD shown incorporates the addition of hot-stamped blue lines. Page 167: Muck, poster for a band, 2001. Client: Virgin Records; Creative directors: Hjalti Karlsson/Jan Wilker. Designer: Jan Wilker. How animals communicate. Pages 168-169: Curious Boym, 2002. Client: Princeton Architectural Press. Creative direction, design, and illustration: Hjalti Karlsson/Jan Wilker. Photographer: Ella Smolarz (cover). Monograph for Studio Boym, a product and industrial design company based in New York. The cover was die-cut. The die was then used as the invite and coaster for the book release party. Mr. Boym would come to our studio every once in a while packed with beer and we would talk about the project until we were all wasted and had to go home. Page 170: Doglamp, 2001. Client: World Studio Foundation. Creative directors & designs: Jan Wilker/Hjalti Karlsson. We were invited to participate in an annual benefit. Lamps were redesigned for an auction where all the proceeds went to scholarships for disadvantaged students in art and design. The plastic dog is from Italy. Page 171: Identity system for the German Psychology Academy, 2002. Client: Deutsche Psycologen Akademie. Creative direction, design: Hjalti Karlsson/Jan Wilker.

1. PERFORMANCE 2 TIME: 68:54. CD 2. PERFORMANCE
4 TIME: 66:57. CD 3. PERFORMANCE 5 TIME: 62:26
RECORDED LIVE IN THREE TAKES WITH: ████████████

TOTAL PLAYING TIME OF ALL THREE DISCS: 3:18:17
℗&© 2001 COMPOSERS RECORDINGS, INC. 73 SPRING
STREET, SUITE 506, NEW YORK, N.Y. 10012 PHONE
(212) 941-9673 WWW.COMPOSERSRECORDINGS.COM
(CRI LOGO) (BLUESHIFT LOGO) CD 2001 DDD
(COMPACT DISC LOGO) THE BARCODE IS LOCATED ON
THE SPINE

Spine text (left case): BLUESHIFT CRI · 96 GESTURES · BARCODE 0-90438-20012-7 · SCOTT FIELDS ENSEMBLE

96 GESTURES SCOTT FIELDS ENSEMBLE

CARRIE BIOLO,
VIBRAPHONE. STEPHEN DEMBSKI, CONDUCTOR.
SCOTT FIELDS, ELECTRIC GUITAR. FRANÇOIS HOULE,
CLARINET. ROBBIE LYNN HUNSINGER, OBOE,
ENGLISH HORN. JOSEPH JARMAN, ALTO SAXOPHONE,
Eb FLUTE. ROB MAZUREK, CORNET. MYRA MELFORD,
PIANO. JASON ROEBKE, DOUBLE BASS. DAMON
SHORT, DRUM KIT. HANS STURM, DOUBLE BASS. MATT
TURNER, CELLO. DYLAN VAN DER SCHYFF, DRUM KIT

Spine text (right case): BLUESHIFT CRI · 96 GESTURES · BARCODE 0-90438-20012-7 · SCOTT FIELDS ENSEMBLE

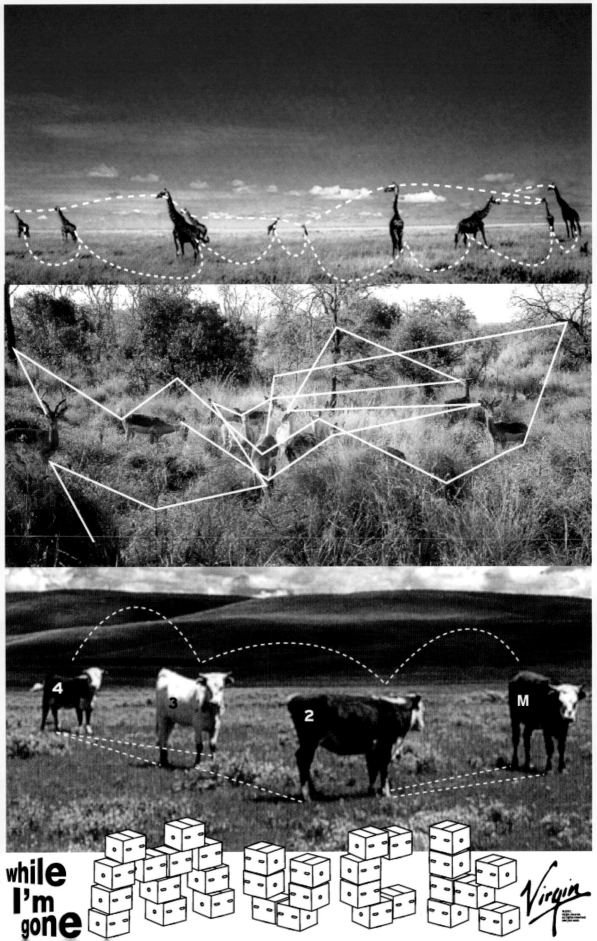

DESIGN WORKS

A Conversation with Steven Mark Klein and Michael Felber, partners, Lone.

Gelman: This time let's keep it interactive. No monologues please. Question, answer. Question, answer. Okay?

Steven: No problem.

Gelman: Okay. So, what's going on?

Steven: We're getting interviewed. *<Laughs>*

Gelman: Okay.

Steven: I'm just giving you straight answers this time. This is the classic detective-peep procedure -- you're the detective, we're the perps. Give me a question, and I'll give you an answer.

Gelman: Tell me a little about your background.

Steven: I turned 53 in December '03. I was born in Brooklyn, New York, I live in Brooklyn, New York. I attended School of Visual Arts from 1968 to 1971. I was in the second group of people that received a BFA from SVA. I spent the '70s supporting myself by working for George Wittenborn, the art book dealer on Madison Avenue and for the Strand Bookstore, with some pretty illustrious alumni. Later I helped set up Books & Co. While I was working at Books & Co., Constance DeJong, a downtown-based experimental writer who was involved romantically with Philip Glass, introduced me to Philip Glass. Constance and I produced a book under the imprint Standard Editions, about Philip's research into how Ghandi developed the idea of passive resistance. We published it as a limited-edition paperback with the title of Philip Glass' opera about Ghandi, *Satyagraha*. From that point on I was involved with Performing Art Services, which represented Philip Glass.

I began to produce, promote and publicize avant-garde theatrical productions. I met my future wife, the choreographer Molissa Fenley, one night in the late '70s at the Mudd Club. I helped to produce her work through the late '70s and early '80s, then we divorced. The key work was *Hemispheres*, performed in the fall of 1983 at the Next Wave Festival/Brooklyn Academy of Music. Molissa did the choreography, the African-American composer Anthony Davis did the score, Francesco Clemente did the sets, Rei Kawakubo created the costumes, and Robert Mapplethorpe shot the PR photos. Johnathon Rose's label, Gramavision, produced the album and Doris Saatchi presented the work in London. This collaborative strategy has been a model for all my subsequent projects. I spent the rest of the '80s involved with the New York nightlife industry. Nightclubs, bars and restaurants, too numerous to mention, except the key one being the Saint, where I started. Simultaneously, I advised Keith Haring in 1984 on the formation of his Pop Shop in Tokyo. Then I completely burned myself out: I was a drug addict. My only home was the club Save the Robots. I needed some time off. I had always had this mad passion for modernist architecture and design. In 1988 I was introduced to David Van der Hurd, who had created the design gallery Modernism. We collaborated on a series of exhibits together. We created the first exhibition of Philippe Starck's work in New York. Then we did a British show, which introduced Ron Arad, Danny Lane and Jasper Morrison. I was involved with the sale of Italian modernist prototypes. (Memphis, Alchemia). I briefly moved to Detroit, and using all sorts of prototypes from Milan, helped design a nightclub in Pontiac, Michigan, called Industry. I came back to New York, and through an introduction, met Bill Fine, the vice president of Brant Publications, which publishes *Interview*, *Art in America*, and *The Magazine Antiques*. Bill thought I should get involved with the advertising and the marketing community. In 1992 the first event I produced was the 10th anniversary of Swatch. We did a 10-day curated DJ extravaganza. Most of the DJ's are now legends, such as Masters at Work and Junior Vasquez. It ended with a concert at the Sound Factory, where Moby had his first large-scale public performance. I spent the next couple years being a bridge for downtown corporate cultural sponsorship. They all needed cool factor. I sponsored the third issue of *Blind Spot*, the art photography magazine. I sponsored a year of Giant Step/Groove Academy events and concerts. Over a three-year period, I helped to sponsor The Wooster Group, Willem DeFoe's theatre company in SoHo. At that time I was also involved with Italian architect Aldo Rossi's office in New York, Studio di Architec-tura. That's where Michael and I met. Michael Felber, my business partner, had just arrived from Switzerland. We set up a quick design component within Studio di Architectura. From 1996 to the present, I have held every imaginable art and creative director position. I worked on a wide array of global branding, advertising, marketing, sponsorship, alternative process work and repositioning projects. Meanwhile, I've become the most senior alternative, street-based brand author in America. Traditionally, I would be the executive vice president creative director at a major agency. I would let the kids bring in the cool factor and go off to the Hamptons for the weekend in my Land Rover and play with my children. For me that scenario is death. To feel alive I stay on the street. I live the work. I'm committed and passionate.

Michael: My story: I grew up in Switzerland, in Bern, which is the capital. I attended the School of Visual Arts in Biel. Right after, I started my own design company in Switzerland, called CRUZ. We were two partners and worked with Scott USA, Vision Street Wear, H.B. Snowboards. We originally did graphics, catalogs and print work, and then started producing custom fixtures and exhibit booths for large international sports retail conventions. In '96, after three years of CRUZ, I moved, with no specific motive other than cultural inspiration and diversity, to the States. I started to work for Aldo Rossi/MAP, where Steven was the creative director. We designed the SoHo store for Levi's Silver-Tab division, which was the prototype for a repositioning of Levi's to a younger, urban-fashion-oriented audience. Tragically, that fell in the time when Aldo Rossi had a fatal accident and the design team dissolved. In '97 I joined a small, unknown, six-person company called OVEN. One of our first major clients was MoMA: We did the website for them that helped us to attract high-profile art and fashion clients. Starting in '99 we did Tiffany's website for about three years. OVEN was able to attract a great amount of fresh talent. Many of its innovations for commercial web and interface design are now industry standards. We were the pioneers of bringing Flash technology into interface creation and were able to persuade major corporations to use it to their advantage. This enabled OVEN to grow rapidly from six to 250 people in 2000, with global offices including Hong Kong, Tokyo, Sydney, London and Paris. It busted at the beginning of 2002. Then Steven called and we created Lone.

Steven: We started Lone in August 2002.

Michael: Currently we brand luxury restaurants, hotels and bars, and have become the hospitality experts. Looking forward, we are starting a holding company in Switzerland for the development and management of our own brands. We want creative control. The first one is ALICE, a luxury chocolate brand.

Steven: Next question. *<Laughs>*

Gelman: You guys, can we just do the question, answer, question, answer? Last time, it was a four-hour monologue. It's interesting, but really hard to read.

Steven: If you have a sheet, just do it. Question, answer. Question, answer.

Gelman: Well, I don't have a sheet, I want to react to your answers, so I don't have a sheet.

Michael: We'll just keep it short.

Gelman: Except now you've answered everything.

Steven: Doubt it. We didn't answer anything.

Michael: We can talk about our attitudes, things like that. What we do and what we are trying to express...

Steven: Why we design? We did this before, you know. We design for pleasure and money. That's why. Within the graphic component that we've put together for Infiltrate, underneath our self-portrait, we placed the concept of "authors of fortune." This is based on the idea of soldiers of fortune, professionals for hire. Not emotional. You're given your assignment, you negotiate the deal, you do it. You get paid and you leave. Clean.

Michael: The higher goal is brand authorship. We see design as storytelling.

Gelman: As what?

Michael: Storytelling. Basically branding is about creating a personality and integrating the personality into a story.

Gelman: A story to consumers?

Steven: It might not necessarily be. What I find most times -- I can't say this for everybody, and it is more so the American market than the global market, even though we're supposed to be the global power-branding source -- is brands like

body, yet there really isn't anyone who replaced him.

Steven: Before this project, nobody knew who Murakami was, except for a few people in the art world. The person isn't Warhol, but the media has become Warhol. It just points in the same way Andy did and value is created. Murakami's art had a value of $20,000. Condé Nast pointed distractedly like Andy, and now Murakami's art is worth $250,000.

Gelman: He was exhibiting at Pompidou and MoMA and everywhere for a long time --

Steven: Yes, but if you stopped anybody on the street and even if you asked 99 percent of the people who bought the product, they still couldn't even pronounce his name. They don't even know who the guy is. It's become a blockbuster for them. And I think that is one of the most interesting issues for designers and design at this moment. Usually we've been asked to create this thing, it will mature into the market, it will find its place in history. Now our clients don't want to hear that. We have been involved in a winner-take-all, post-IT meltdown, venture-capital project that expects a streetculture with authenticity, but a Madonna, Matrix, Eminem-like, "we put in $20 million, a month later we want to see $20 million back" return. Back to the main topic, the issue of Infiltration.

Since I have been involved with this upclose for 30 years, I have access to levels of celebrity and media that are desired and also unique. We have been able to show, just in the last 10 months, how you can apply the same methodologies that work for all the credible, street-graphic crews around the world. Here's the example -- a T-shirt is the medium, a graphic application is the signifier, and collectibility is the goal. The strategy of limited edition is the desired response to the purchase and its overall cultural factor. The street design community discovered something that previously only existed in the art world. Limited editions started as a print phenomenon, and then contemporary photography realized its potential. Street graphic artists zeroed in on that limited issue to create their cool factor value. Lone panther can do a T-shirt for a $50 million property in an edition of a 100 that is not for sale. Get it to Drew Barrymore, she wears it to the premier of Charlie's Angels 2

Interview continues at:
http://www.infiltratenyc.com/014/

Obviously, the Mini Cooper has a 50-year heritage and over $100 million was poured into the relaunch. Jet Blue had hundreds of millions of dollars behind it, and George Soros was the major player, so that lent visibility to it almost immediately. We needed a just-add-water solution, so we went with JAMES. And pretty much, once you hear the name JAMES, you aren't going to forget it, and you're not going to mispronounce it. Globally, everyone says JAMES the same way and you know how to spell it immediately. Intuitively, there is a JAMES typeface and a JAMES color. Our game plan the last 10 months has been to communicate personality through one word, one typeface, one color choice that is already in the world. Not get ahead of the world. Be in it, join bits and pieces of brand code together that go under the surface, but not so far under that anybody really has to work to understand it.

Gelman: So you're saying that making people work is not good?

Steven: Well, if the client is coming to you, in this particular moment, in this economy. First -- investors do not want to lose their money and they do not want to wait to get the money back. We are put in a position as branders that our solutions work in a way similar to Hollywood. Studios expect to earn back their investment in the first and second weekend after opening. From the Monday after the second weekend you are making a profit. This was an unheard of system until recently, but now it's totally accepted. No one questions it anymore. Even though these aren't media projects, the media so affects every other business in the world today. High fashion is using the blockbuster mentality now. It has been published that the Murakami project for Louis Vuitton contributed $345 million dollars, which is 10 percent of their global sales. This illustrates the blockbuster shift. Based on this, Target is now working with Murakami.

Gelman: It's art, you know inviting an artist --

Steven: Yes, but they keep saying he's the Andy Warhol of our age, and we know this is a grand exaggeration. This is one of those great bits of PR storytelling for people, who, now that Andy's dead, can take anything and say that it's an Andy Warhol phenomenon.

Gelman: People will say that about any-

hook, it will stick. And then, when you're out shopping, it tends to work.

Gelman: It leads you.

Michael: Well, that is the story part, and then there's also the personality part. Brands like Nike pretty much take over the function of a personal identity. They not only communicate their positions to the audience, but also become a replacement identity. For whatever it is, it could be sneakers, cars, handbags. Strong brands tend to replace personal identities almost completely because it is so hard for most to personally compete with the influence of media and express their personality otherwise. You just buy those brands with a generally accepted and understood identity already out there, street, punk or pop; it becomes really your identity. That's why we see brands as personalities. They have all those defining elements of personalities.

Steven: Lately, we've been creating brands based on the example of the classic European luxury brands, which for the most part are family names. After a 100 years, they have become massive global signage systems of personal value. In the way today's economics work, people want instant recognition in the first business quarter. <Laughs> Three months, everyone in the world has to know what the brand is. As opposed to taking 100 years.

Gelman: It's possible?

Steven: Yes. One of the things that we think shortcuts the process for the client is you give the brand a person's name instead of trying to invent names, like Accenture, Verizon, etc. Frankly, the weird names were created to justify a process that results in a massive billing for the client.

Gelman: Venator Group or Altria.

Steven: Yes. They spend millions of dollars, hoping that someone retains it. We believe you have to use names that you just hear once and you never forget.

Michael: This is the process that we have used recently. This saves the client time and millions of dollars.

Steven: We were asked to brand a new hotel group based in America, where we were given an array of companies that the investors would like to be associated with. Like the Mini Cooper and Jet Blue.

Coca-Cola, Tylenol or Nissan, they still don't know that. They still don't know they're telling a story.

Gelman: Who doesn't understand?

Steven: The client. They do not understand that they are telling a story.

Gelman: What kind of story?

Steven: A fiction. All of the attributes that we ascribe to brands -- they don't improve your life. They don't make you a better person. They don't help you succeed. It's a fiction. But the trouble is the client actually thinks it isn't a fiction. They believe it's fact! <Laughs> I've always been viewed as subversive, because that we are very sophisticated storytellers. Just like all the legendary authors develop memorable stories. Tell a good story, and it's gonna move mountains. You know, the facts, no one checks the facts on the great stories that we keep telling over and over and over. People respond to the storytelling, not the facts. It's that simple.

Gelman: Some great corporate religion?

Steven: They are inasmuch religions. The people that keep religions alive, they understand the power of a good plot <Laughs>, yet no one can prove any of this stuff. You cannot prove anything in the Koran, you can't prove anything in the Old Testament, and you can't prove anything in the St. James Bible, but they're still damn good stories. And, if told well, and visualized well and acted out well the masses do respond; they follow unconditionally.

Gelman: What kind of response is expected from your stories?

Steven: Belief. Faith and belief. And at the end of the day, Coca-Cola wants you to believe that it's real, Nike wants you to believe that you can do it, and Volkswagen wants you to believe that it needs you to activate the driving experience. These positions are castles made of sand. We all have too much going on in our lives to really get into a deep questioning of this stuff. We do it a little bit, but the average person has no time. They just see three hundred billion dollars worth of media a year, and it's just absorbed. And if the picture is pretty enough, and the words are simple enough to remember, and the jingle has a little

Infiltrate / Lone

A conversation with Jennifer Lew, principal, Mainland.

Gelman: What kind of shoes are those?

Jennifer: These are Ballerina shoes. I had my Doc Martens, but nobody shovels snow in Queens, so I almost fell.

Gelman: You were born and raised in Queens?

Jennifer: Right.

Gelman: You are one of very few designers in this book who were actually born here. You are probably used to the fact that most people around you -- schoolmates, co-workers, colleagues -- are not originally from New York.

Jennifer: I went to high school in Manhattan and studied fashion design, and there were people from all the other boroughs. When I got to college, suddenly I was the only New Yorker.

Gelman: How do you feel when all these people come to your neighborhood and...

Jennifer: Claim it?

Gelman: Yep. Claim it.

Jennifer: You know, sometimes it gets really tiring because there is always some renegade designer thinking that New York is still grungy and a graffiti-infested place and they go and post crap up. They think because they are in New York and they can do that, they are designers. That frustrates me. But I do like the fact that people are bringing somethink new, something I don't have because I stayed in New York, stayed in Queens. But I know the streets, I know what's going on. I've taken the subway my entire life. Versus the people who come here and say, "Oh, New York is such a great place for tourists." I'm past all that, and somewhat jaded.

Gelman: Do you like the changes in New York over the past decade?

Jennifer: It changed in a good way in that it's safer to walk down the street and take the subway by yourself. Growing up, it was never like that. There was graffiti everywhere. There were hoodlums ready to mug me. I've had people spit on me, though that has more to do with racism. Now it's more welcoming, but also commercial. Now everything is about selling this, selling that. Open up more shops so people will buy. It has its pros and cons.

Gelman: And there are more tourists.

Jennifer: And there are tons of tourists everywhere and they have to see everything that's New York. Walking down an alleyway is fucking awesome to them.

Gelman: Did you ever think about leaving New York and going somewhere else?

Jennifer: Yeah, once I make enough money I'm out of here.

Gelman: Where are you going?

Jennifer: Amsterdam. Any place where I can actually speak English.

Gelman: Where did the name of your company come from?

Jennifer: I work mainly by myself. I am my own little sweatshop, so if you want, you can associate mainland China with sweatshops and my business model. I'm self-motivated and I like being in isolated areas and working myself hard. I'm my own brutal Chinese foreman. Brutal, but fair.

Gelman: How did you discover design? When did you first realize that it was what you wanted to do?

Jennifer: It started when my sister was 16 -- in the '80s -- and she had this jean jacket with tons of buttons on it. New Kids on the Block was really in and really cool and we had these humongous five-inch buttons that we would buy from Sam Goody, because that was the coolest place to go. So we would buy all these buttons and wear them. Crazy stuff. Crazy buttons that say "That's cool" and "Rad." I don't like accessories, but I'm still into buttons. I needed to give something out after graduation. We are recycling trends. One-inch buttons. It's my one obsession. And I just keep making more and more.

Gelman: What about your obsession with accumulation?

Jennifer: I think a lot of my work comes from thinking about accumulation. I'm really perplexed by the fact that people need to collect. Collect toys, magazines, or porn. Porn, that's fascinating to me because it's no longer about the porn anymore; it's more about the collection. You can collect pennies too. But the way that you collect pennies is different from the way that you collect porn. With pennies you just have change.

Gelman: You have a friend who is collecting porn, right?

Jennifer: I'm not going to tell you what, but he collects everything. From the '70s to the new stuff. He has walls of it in his living room. He's so open about it, so proud. It's not even about the content anymore, it's about how much you have. I try not to collect anymore, although I do end up collecting work.

Gelman: What kind of work?

Jennifer: My own work. I don't collect other people's work.

Gelman: But collecting your own work is not really a collection.

Jennifer: I like to think it is.

Gelman: I can't say I'm collecting my own work. I just make work and I keep some of it, and I throw some stuff out.

Jennifer: And it becomes a collection.

Gelman: You call it a collection?

Jennifer: Of course. It's definitely a collection.

Gelman: When I think about a collection it's more like collecting antiques.

Jennifer: I remember collecting New Kids on the Block cards. It's definitely a collection, because if you're only missing one thing, you aren't fulfilled.

Gelman: So it's about completeness?

Jennifer: This whole idea of accumulation came from noticing that I have a huge collection of some things. I have a huge collection of used batteries, boxes of used batteries. It started out because I didn't know how to recycle them. I didn't want to throw them away, and I didn't know what to do with them. I don't even really like them, y'know. I've been collecting batteries for six years now. I mean you can recycle them but then some guy on the subway train is going to get them and sell them back to you for a dollar for seven. Let me just tell you about those batteries: if there was an X-ray machine, only this much <Holds *thumb and forefinger a fraction of an inch apart*> is actually working and the rest is just shot. It's really shady.

Gelman: They pack old batteries and sell them as new?

Jennifer: It's easy. You just get one of those machines that sucks out all the air and wraps the batteries in cellophane.

Gelman: Oh yeah?

Jennifer: Yeah, they just strip off the aluminum foil that's over the battery, then just package it and resell it on the street and subway.

Gelman: That sounds like a lot of work.

Jennifer: No, it's not actually; have you ever ripped off the label of the battery, like a Duracell battery?

Gelman: No. I haven't played with batteries very much.

Jennifer: Oh. Well, I have. I've even eaten batteries.

Gelman: You've eaten batteries?

Jennifer: Yeah, one exploded and I tasted it, and it gave me a sting throughout my whole body.

Gelman: So it shocked you?

Jennifer: Yeah, it shocked me.

Gelman: How old were you?

Jennifer: <*Laughing*> I think I was just 16, old enough to know I shouldn't eat it. I didn't know what came out -- it was this brown liquid. And for some strange reason I thought it would be like caramel, sweet, but it wasn't. And it is probably still there, that's what's scary.

Gelman: Where?

Jennifer: In my box of batteries.

Gelman: In the box of batteries that you

Interview continues at:
http://www.infiltratenyc.com/015/

Infiltrate / Mainland

Page 177: Horse Dressed as a Unicorn, 2003 Designer: Jennifer Lew. Photographed by Peter Meretsky. Page 178: Vegetables, 2002. Designer: Jennifer Lew. Photographed by Peter Meretsky. When I made Bunny Cat, I made these vegetables. Initially these were accessories for the cat. As simple as they seem, they were a bitch to sew. Page 179: Eggs, 2002. Designer: Jennifer Lew. Photographed by Peter Meretsky. I thought the design was perfect for the concept. It comes in two colors: beige and tan. Why? Because that's what's sold at the supermarket. Pages 180-181: Bunny Cat, 2002. Designer: Jennifer Lew. This is my second child. It was natural to have a cat wearing a bunny suit because all that could be seen were the eyes and nose. There's an element of surprise that's sweet and innocent when you find out it's a cat inside. Pieces like this involve major tailoring to make sure it fits comfortably. Pages 182-183: Turtle, 2002. Designer: Jennifer Lew. Photographed by Peter Meretsky. This is my first baby. It has a feeling inside. If you did this in real life, you'd be a turtle murderer. That's fucked up. Page 184: Penguin, 2002. Designer: Jennifer Lew. By far, the most phallic piece I have made. After removing the black suit you'll see a white body. It was unnecessary to have any other colors or shapes added to the body. Penguins are supposed to be black and white with some orange. Page 185: VHS, 2002. Designer: Jennifer Lew. Photographed by Peter Meretsky. Unfortunately the video cassette is a dying format. I still believe in its greatness and love my VHS player deeply. This is my homage. Stay with us, VHS. I love you! Page 186: Peppermints and Knife, 2002. Designer: Jennifer Lew. Photographed by Peter Meretsky. Red and white is a great color combination. These peppermints were painfully annoying to sew because of the continuous seam and small size, but I also love it because of those stupid reasons. Page 187: Hamster and Pigeon, 2002. Designer: Jennifer Lew. Photographed by Peter Meretsky. The prototype for this series, based on my cousin's weird pets, was hand drawn with a Sharpie marker instead of the later silkscreen version. The idea came to me fast and the Sharpie was the only thing that I had to execute my concept. Those are the best moments as a graphic designer. The pieces also come in a cotton drawstring bag for storage.

A conversation with Min Choi.

Gelman: What is your interest in design?

Min: I guess my interest in graphic design is schizophrenic: I'm very interested in making typefaces. I have this huge respect for those who actually make typefaces. I really like the craft that is involved. Not just these new typefaces; I also like to see and try to understand very classic fonts as well. At the same time I've been always interested in sort of reading graphic design and writing about it, specifically, the more theoretical aspects.

Gelman: Is there any specific theory or area that is a subject of your research?

Min: I'm interested in political aspects of graphic design, a sort of looking at a certain aspect of surveillance, and how it can become related to graphic design based on the common ground of knowledge, vision, and power. Graphic design and visual information delivers the specific privilege of knowledge to those in authority. More recently, I've gotten interested in design in public spaces. For example, I'm getting more interested in typography in space. Not necessarily big spaces, such as Times Square, but it can be a toilet, it can be an elevator, it can be this microscopic space which has a more specific psychology to it -- how graphics and typography can interact and mediate people, and the space as an interface. That's my broader interest; at the same time I'm still making typefaces.

Gelman: Once you said that you are not using your own typefaces.

Min: Hardly. No.

Gelman: Why is that?

Min: I don't know. It always feels weird to see my... I sometimes use my typefaces for screen work, but I guess on the screen you can't really tell...

Gelman: Yeah, it's all pixels...

Min: I don't know, it feels... I guess it's more interesting to see other people using my typefaces. I'm not against using my typeface for my own project but I just don't feel comfortable with it.

Gelman: Often graphic designers design their own typefaces to have a certain unique look throughout their work. You just enjoy making typefaces for other people.

Min: Not always, for example, I started Politie and Zephyr with plans for certain specific applications in my work, but I ended up using Monotype Grotesque and Helvetica. After I design a typeface I always drop them. It's funny.

Gelman: Most of your typefaces I know are monospaced. Is that always the case?

Min: Most of them.

Gelman: What do you like about monospace typography?

Min: I like the texture that's created in the text. Monospaced type is very mechanical, very mathematic. All the characters are the same width, so you can actually calculate how many letters can fit in a given space. But at the same time, the resulting texture looks very regular. It has its own unique rhythm. It's not as homogeneous as many other proportional typefaces. It's a little quirky, a combination of the mechanical and these irregularities.

Gelman: One of the typefaces in the book is inspired by Wim Crowel.

Min: Yeah, right.

Gelman: When you worked on this font were you in touch with him? Did you communicate with him at all?

Min: No, not really.

Gelman: Did you show him your final result?

Min: I thought he was dead.

Gelman: What?

Min: I didn't know he was still alive.

Gelman: He's very much alive and very much around. You should try to get in touch with him.

Min: I thought he was in the same generation with Paul Rand... So I was wrong. <laughs>. Politie was a direct adaptation of his design.

Gelman: What did you change?

Min: I had to change the wider characters, "W" and "M," to fit with narrower ones. I had to expand "I" or "R," which are normally narrower than other letters. It seemed like the original design seemed to be implying a monospace font because it's very modular, geometric.

Gelman: Well, when he did this typeface, it was designed for a typewriter for monospace use. When Foundry in London was adapting for the computer, they made "W" and "M" wider, turning it into a regular font called Gridnick.

Min: Yes, Wim Crowel's original designs never were released as a font before. He designed the letters but never released them as a typeface, and then later British typographers took them and made a proportional font. So I had to change it a bit, some of the characters, and spacing as well.

Gelman: You do a lot of interactive and web work.

Min: I used to do a lot. I used to do a lot of very shameful websites.

Gelman: Shameful websites?

Min: Well, they were shameful. Not because they were commercial necessarily, but I just...I used to do a lot of websites...

Gelman: Where?

Min: Back in Seoul, I used to work for this web design company. So I'm trying to not do that kind of stuff right now.

Gelman: What is your take on interactive design? What's important for you on the internet?

Min: I don't know if I can say this, but the design of a website doesn't really have unique features.

Gelman: Because a certain language has been established already?

Min: Right, it seems to have become conventionalized.

Gelman: You seem to find ways to make it unexpected and fresh. Your site is very user friendly and intuitive yet completely original.

Min: Yeah, well, in my own interactive work, I try to keep this sort of roughness of technology. For example, I don't like Flash animation. I don't use it to make websites.

Gelman: Why?

Min: To me the [Macromedia] Flash and Shockwave interactive pieces seem a bit closed compared to HTML and JavaScript based ones. With JavaScript-based websites you can see the code, and you can get the script, so you can see how it actually works behind the surface; with Flash, it's impossible.

Gelman: Too many layers.

Min: Right, exactly. And in most cases I suspect Flash is just done to make it more sleek.

Gelman: And annoying.

Min: Right, Yeah, yeah, all the time. <Swooping hand motion> Whoosh! And now it's becoming a part of that cluttered web landscape.

Gelman: You definitely have that sort of rough, undesigned quality in your work. Is it what you are trying to achieve?

Min: In a way. And I remember, I think it was Paul Elliman -- a teacher and a friend -- one of his first websites has this text on it, "Why do you need navigation when you have it on the browser?" You have back and forward buttons on the browser so you don't need the same buttons on the page. I agree with that. I like that attitude. Just letting it go, not making anything too sophisticated.

Gelman: Well, in the case of Flash it actually wouldn't work... Tell me about your interest in surveillance and all this military stuff, stealth bombers and

so on. Where did all this come from?

Min: We are all living in the same world, and we share a certain level of common background. I'm from Korea -- South Korea, which used to be a hugely militarized country. It's been under military regime control for, like, 30 years, and everyone had to serve in the army.

Gelman: Did you serve?

Min: I kind of escaped that. I had to do some related service for three years.

Gelman: You didn't pretend to be crazy or anything?

Min: No, but you have to work for a specific company, a designated company, and I had to go to boot camp.

Gelman: You went to boot camp?

Min: Oh everyone, everyone -- every male in Korea -- is supposed to go.

Gelman: Did you like it?

Min: Oh no!

Gelman: Did you hate it? You hated it?

Min: You know it wasn't as bad I had expected, I must say, because the people running it are human beings. But it was a horrible, horrible experience. I was put in military formation, and the principles of military formation are strikingly similar to principles of modern typography. Arrange the soldiers into a block, like arranging text or like arranging letters into a body of text.

Gelman: In monospace fashion.

Min: Monospace is kind of strange inbetween thing. For example, monospace seems very militaristic because it has to be very equal, but at the same time it doesn't look really like that way when you see the result, because the letterforms are not homogenized or regular; they are not really disciplined. They are sort of wild. The army shouldn't be that wild. They have to be really disciplined. That's how I got interested in the militaristic, disciplined aspect of design.

Gelman: You are not a military guy. With all your interest in the military aesthetic, you are attracted to it, but you don't want to be a part of it.

Min: Yeah, yeah that's always been difficult. There is a fine line between just being attracted and actively contributing. I have to say I'm attracted to that language and aesthetic. For example, the Stealth bomber is just beautiful. It's very rational and minimal. I assume they never considered the aesthetics when they were designing it. I don't know what the essence of the beauty is, but it's very strange, I think. The Stealth bomber. The form of that bomber. I guess the typeface was part of my own effort to understand the beauty, to understand its form.

Gelman: A very formal exercise. There's nothing military about that typeface, I have to say.

Min: No. The typeface doesn't look militaristic.

Gelman: But it's an interesting exercise.

Min: I wanted to use that form as a way of understanding it. You do that -- make something to understand something.

Gelman: So what did you learn working with the Stealth bomber shape?

Min: I don't know. I don't want to mythologize it. But there is some aspect that cannot be reduced to a certain theory. You can say that it is beautiful because it's functional; it is beautiful because it is extremely geometric; but you can't really explain the whole aspect by saying that. I think you can't ignore that it has a very disturbing existence. It is a weapon, a scary weapon. You can't ignore that. And the fact that the form is geometrically very attractive and the fact that it is actually a very lethal weapon, I think that temptation is something that makes it strong.

Gelman: Danger is a part of its appeal.

Min: It's a danger thing. It's a dangerous attraction. You have to admit that.

Gelman: So what are your plans?

Min: I'm thinking of doing some long-term research about typography in spaces. Done right, it will be a big commitment. Other than that, I try to resist becoming a full-fledged professional designer. I like to keep it sort of amateur.

Gelman: Play around.

Min: Yeah, so I don't have to commit to only one area.

Gelman: You do work to feed yourself, right?

Min: Yeah, yeah, sure. I'm not against it. I just want to have a satisfactory balance between the commercial work and other more speculative work.

Gelman: What kind of clients or projects are you interested in?

Min: You mean if I could just choose certain clients, what kind of clients would I choose?

Gelman: In your research you are interested in certain issues. Is there any practical application of that interest as well? Like branding, for example, or information design.

Min: I find I have a hard time with branding. It's the one thing I try to distance myself from. I think I've done enough of that. I don't like the whole idea of corporate identity or brand-identity design. I'm uncomfortable with it. Identity through design -- I don't really like that idea. I don't mind doing very strict typesetting jobs. I like actually doing typesetting. I pretty much enjoy that. And I don't mind doing extremely conservative book design. I'm very comfortable with that. But I'm not comfortable with adventurous branding work.

Gelman: Why is that?

Min: I just don't like identity design. The whole premise of identity design.

Gelman: So you don't like to present companies as something they are not?

Min: Well, it's more an issue of the notion of identity through design than honesty or dishonesty. We are always making rhetorical decisions when we are designing something. There's always a possibility -- some element of 'like' or dislike to come into it.

Gelman: Sure.

Min: That in and of itself isn't problematic. But I think it's more problematic to assume that you can construct an identity through branding or design. For example, you remember the scene in Fight Club, where Edward Norton describes how his own identity is being constructed by different brands, like Ikea. That what you are wearing determines your personality. What brands you use to present yourself to other people.

Gelman: Of course.

Min: There's something pathetic in that. That whole idea and practice as well. However innovative, however creative that might be.

Gelman: Is it because this idea of a made-up, designed identity, conceals the true identity?

Min: Well, nowadays, you can't even imagine true identity without design. Everything's designed. My point is everything is overdesigned. Too precious, too sophisticated, too carefully designed. Some things can be just left undesigned, I think. Not everything has to be perfectly designed in a perfectly harmonious way. You don't have to be such a perfect person, in a designer's point of view. I guess that's my point. Corporate identity design tries to do that precisely, to make it perfectly coordinated. To make an organization look like it's perfectly coordinated -- one person. Like, the FedEx guy should be always the FedEx guy. Everything from FedEx should look like it's from FedEx, nothing else. I'm not sure about that idea.

Gelman: What would be your solution if FedEx would ask you to consult them on their branding?

Min: Their branding? Well, I would set up some sort of system that destroyed their logos. Not in any particular way, just a random way. I don't know, that's a dumb idea. So people can just change the logo or anything. Or maybe I can give them FedEx set in Helvetica. Or, no, no, no, Helvetica is now sort of a cool typeface. Maybe Courier would be better.

Gelman: Courier?

Min: FedEx in Courier. Or Chicago.

Gelman: Right now they are using Futura. What's wrong with that?

Min: They are?

Gelman: I think it's Futura, right?

Josh: Think so.

Interview continues at:
http://www.infiltratenyc.com/016

DO NOT READ THIS MESSAGE. THANK YOU. ------------- END OF MESSAGE.

Figure 1. Central Nervous System
A simple movement like pressing a key of a remote control can be organized by cerebral hemispheres themselves without associating with the higher levels of the brain. Specifically, it is a region of the cerebrum called 'primary motor area' which will govern the movement. The motor impulses originated there are sent, through the brain stem (consisting of the thalamus and hypothalamus, the midbrain, the pons, the medulla oblongata) to the motor neurons.

Figure 2. Motor Neuron
The neuron, also called the 'nerve cell', is a basic cell of the nervous system. It transmits nerve impulses. A typical neuron has a cell body containing a nucleus and two or more long fibers. Impulses are carried along one or many of these fibers, the dendrites, to the cell body. Bundles of fibers from neurons are held together by connective tissue and form nerves.

Mechanism of Remote Control: Introduction

Basic mechanism of remote controlling involves four entities: the central nervous system; the motor neuron; an external controlling device (usually called simply a 'remote control'); and the receiver of the aimed mechanic.

The central nervous system [Figure 1], consisting of the brain and the spinal cord, can understand a given situation and determine necessary action. It generates an appropriate 'command' which will be transmitted through a series of motor neurons. A motor neuron [Figure 2], which is sometimes called the 'motor nerve cell', consists of a cell body and a couple of long fibers, 'dendrites'. Impulses are carried along these dendrites to the cell body. At the terminal of the nerve, the 'axon' of the motor neuron contacts the muscle and transmit the impulses. The muscle then conduct an appropriate action, in this case pressing a key of a remote control.

A remote control [Figure 3] can sense the pressure onto a key, and generate a specific binary sequence of electronic signals. The sequence is amplified and then translated into infrared light. This light, emitted from the LED of the remote control, is sensed and decoded by the receiver [Figure 4] of the aimed machine. Finally, the receiver generates an appropriate command and transmit it to other parts of the machine.

Figure 3. Remote Control
The integrated circuit [U2] detects the key-pressure, and then translate it into a binary sequence, specific to the key pressed. That signal is sent out to the transistors [Q1–4] and amplified. In turn, it is transmitted to the infrared LEDs [Light Emitting Diodes], which translate the signal into infrared light.

Figure 4. Receiver
The infrared light emitted from a remote controls is decoded by the receiver. The sensor, a photo diode, receives the light which has been modulated by the emitter at a frequency of 40 KHz. Tone decoder interprets the binary pulse of the light and give an appropriate command to the body of the machine.

Infrared Control Range: 26 ft ± 30° (Scale 5:100)

Legend:
- VCRs
- Cable Converters
- Home Automation
- Video Accessories
- Satellite Receivers
- TV/VCR Combinations
- CD Players
- Televisions

Figure 1. Range of Infrared Control and controllable home appliances (Sample: RadioShack 4-in-One Light-Up Remote Control)

TYPE

TYPEMACHINEGUN

PLACE YOUR MICROPHONE. AIM YOUR TARGET KEYS. FIRE.

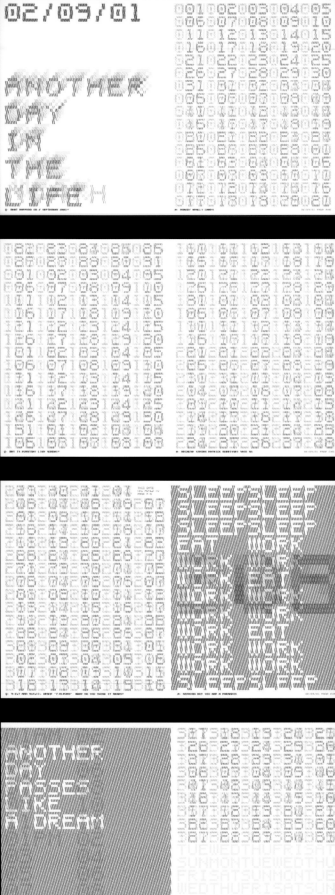

Page 190: Do Not Read This Message, 2000. Page 191: Pseudo-scientific diagrams, mimicking the pages of medical textbooks, 2001. Illustrating the remote control as an extension of the human body. Pages 192-193: Type-Machine-Gun, 2001. An experimental word processor, Type-Machine-Gun helps the users create dynamic word images by generating and distorting characters according to keystroke. Connected to a microphone, the program is sensitive to the noise one makes when stroking the keys: type hard, and you'll get "wilder" words; type softly, and the words appear gentler. Pages 194-195: 02/09/01, 2001. The 30 dates of September 2001 were distributed to the 30 participants. My date was the second day of September, and preliminary research suggested nothing interesting about the particular date. So I decided to take this nothing-in-particular nature as my theme. Three layers of numbers and letters in three different colors display the entire 365 days of the year in three different modes: thus, September 2 would be "245", "2" and "Sunday" all at the same time. Captions were included in the bottom margins to comment on the repetitive nature of the days (and, perhaps, the design). Pages 196: Specter, 2002. Specter is a fugitive magazine. The form of the magazine, a temporary digital projection, is also fugitive: this is a magazine today's technological ghosts hovering around the edges of our perception. The form of the magazine, a temporary digital projection, is also fugitive: this is a magazine today's technological ghosts hovering around the edges of our perception. It won't leave any physical evidence behind. Page 197: Thesis Show Invitation, 2002. For the invitation of the graphic design thesis show, newspaper never to be printed; it won't leave any physical evidence behind. Page 197: Thesis Show Invitation, 2002. For the invitation of the graphic design thesis show, newspaper format was chosen: sending out invitations is like delivering the news. It would also reflect the content of the show, because all the participants had created newspaper projects, which were to be exhibited. The paper contains short descriptions of all the pieces to be exhibited. Unlike usual promotional materials, however, it has no reproduction of the work but the relatively sized black boxes, leaving a room for imagination: "to see the images, come to the show."

194

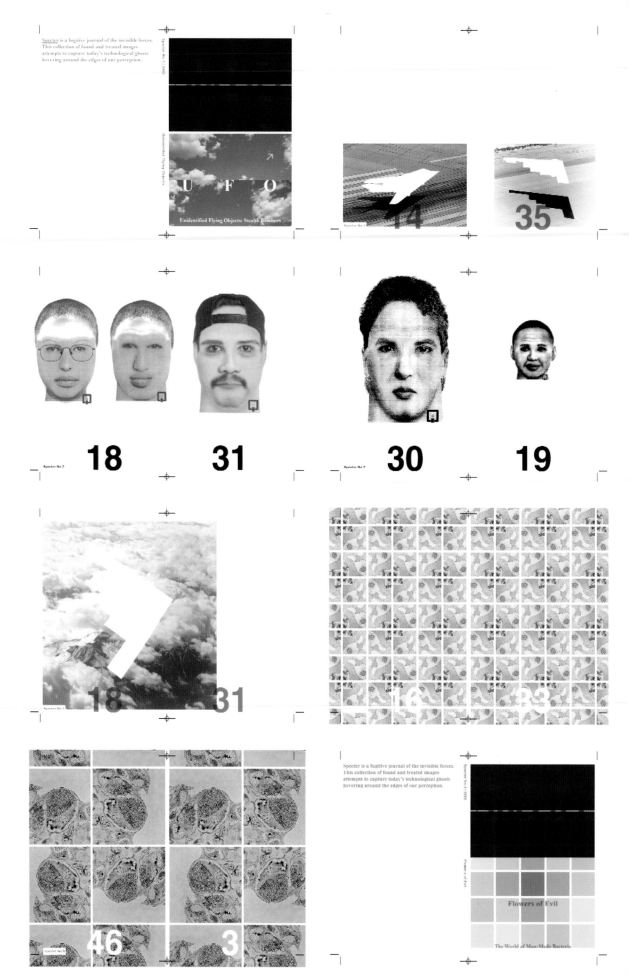

Fictions
Sung Joon Kim

Rules: News
A new rule will be added if an element is deemed harmful to the graphic narrativity of the product. If a conflict arises, the new rule will always override the earlier rule. The system is inherently arbitrary.

404
Those annoying little block eyes.

Current_t_cy
Your money is not static.

Mirror
A short series of investigations on the mirror as an object.

Products
Announcements of new products are always exciting. In this logo, the product itself is secondary, the priority is on its presentation.

House of Usher
Cropped video images of a multi-living complex in New Haven and words from Edgar Allan Poe.

Non-Symbols
No comment.

Gothic 545 Ke
... or Interchangeable Gothic is currently available only in a single weight.

Dry_Brush
Poster for a restaurant sign based on the basic shape of the Suisei Matrix. Originally designed for Current_t_cy, it was unfortunately rejected in the final screen.

Graphic Design Work
Designs for the printed matter for the lecture and exhibition initiated by Deana Rin in 2001.

MAP
A map projects itself onto the world.

Stages
Slides must be sent for viewing in a Kodak carousel slide tray (Universal or Transvue 80). Submit no more than 20 (twenty) permanent-quality color slides — Manually. The slides should indicate at the individual's imprint, front and direction end. In addition, should demonstrate the applicant's ability.

Mirror / Surfaces
Surfaces are just surfaces.

Browsing
Jonty Valentine

Nikon Posters
A disembodied visual index of the mechanics of the camera.

Flow
These posters reflect the process of flowing as much as the subject of flowing. The poster series and more letters are of their production process than the final product. The production of the work is a matter also a team of consciousness, the making process a browser.

Animal Series Butterfly Moths
Entomology, float, seasonic phobia, migration, wings.

Marginal Marks
This catalogue of marginal marks highlights the visual qualities of the marks that readers make into the margins of books as a kind of Cliff's Notes summary of the content. The underlined passages and added notes are informal and uneat horizontal, and yet they impose a new order on the information being presented. The real haul is for future readers to consider the information from their perspective, and highlight the personal engagement with the system. They prove a humanizing idea that indexing is not just arbitrary, alphabetical, historical, chronological etc., but based on meaning for real people.

Index of Indexes
This photocopy book documents the material quality of face-edge tabs from reference books.

Spiegel im Spiegel by Arvo Pärt, for Cello And Piano Test
A graphic index also a representation of a piece of music in book form. Each book is a phrase.

Nikon Process
This book documents the development of the Nikon posters series. All posters have been folded and cut down into a book form. This is a record of changes in the visual from over the project.

Flow Process
Documentation book of the development of the Flow project.

Allegory & Algorithm
Juliette Cezzar

Hello
What does the sound in a room look like?

Allegory
Abandoned houses, like supernovas, are surprisingly beautiful before being torn down or renovated, reminders in both the landscape and cityscape of our own fears and desire.

Day Planner / Escape Plan
The ultimate allow-list template would be one that could be a diagram in itself, a solution to the daily questions of everyday life.

Design Machine
Push the input button to make a card. The machine chooses one of many sets of instructions from designers in the show.

Feed Me With Your Kiss / Ocean
A blue ball-point pen makes a mark in every panel in a song.

Interdisciplinary Critique Invitations & Trading Card
The designer makes information. Someone else makes it of them.

Today's Color Is: 2001
A song in color worn each day in a pixel in a larger image.

Very Meaningful Turtle Posters
Rather than describe things as they are, these posters describe a process and an inability to let go of the meanings of words. Beware of the homicidal fishy.

Two Ways to Look at Eyeglasses
The quantitative description of eyeglasses can never truly describe the experience of wearing them.

Doublespeak
This movie tells a particular story of a gradual movement, from Turkish to English and from written to spoken language.

Eight Seconds
Eight seconds can feel like a blink of an eye or an eternity.

Entropy
When a clean and balanced typeface moves towards a simplification on a grid of six squares, chaos results.

Instruction Book
The pure instruction book would contain only instructions for using the book itself.

Which Came First
A recipe for a chicken omelet.

Today's Puzzle
The crossword puzzle is an allegory for daily life, in that it presents yesterday's solution, today's puzzle, and today's issues.

TheInternetLadyWhoIsThereAlways
this being is constantly busy at all times of the day; writing, knitting, reading, asking paper air planes, etc. A critique on interactivity; in being alone, looks up, and sees it when it is bothered.

Cultural Addiction
Allen Hori

Headline News
SEX SPY MURDER!

News as Banner Ads
Headlines are for canings).

Watching Their Names Go By
Pepsi. Budweiser. FedEx.

Cigarette, Cigarette
A public dissection.

Subscribed
How many magazines do you subscribe to?

Lady Madonna
Something in your eyes is making such a fool of me.

Decca
fast, fast, and more fast.

Platypus
Duality. Contradiction. Electro-magnetic. Mutation.

Distracted
Too little, too parallel, too little.

Thank You
A polite typeface.

Mirror
Hey look it's me! A collaboration with Sung Min Choi and Kenneth Kim.

Childhood Memory
Rosengarten (Ice Cream & Spell).

Parts & Wholes
Margarita Barrios Ponce

Strained
A documentation book of the Strained project, organized into set categories.

Unstrained
A documentation book of the Strained project, organisation determined by chance.

York Street
A falling rain in retrospect a system that asked the reader to focus on details determined in part by the Georges Perec "The Street." The analysis highlights different messages derived from the same experience through sensory inventory.

Scan [A]Part
Expel [A]Part
Tread [A]Part
Time [A]Part
New lives as a photographic calibration of individual marks

December 19, 1999
This piece is an intimate presentation of a war. Parallel forms of communication illustrate physical distance from the event. A voice-over and footage of the aftermath are used as an intimate device that expresses an emotional proximity.

Strainer Shadows
This poster series as part of the Strainer project.

Flow : Comma
Posters series dealing with the concept of "flow" through extraction and pause.

Flow : Page Inserts
Posters series dealing with the concept of "flow" through connection, extraction, pause, detail, and taxa.

Strainer
The strainer questions the relationship between want and waste through its filtering capacity, making it a useful metaphor. What is filtered? What makes that which is filtered use or refuse?

I was Born
The original structure of George Perec's essay dealt with time through reprogramming the words of Who, what, when, where, how, and why, bringing about new relationships between words.

Reporting on the Mark
What is the message or meaning of a newspaper when read only as an arrangement or sequence of graphic marks?

Pharma
A typeface designed to be used at very small sizes for the purpose of emergency and pharmaceutical information.

Disrupting the Boundary
An interpretation of Alice Lee's thesis presentation on boundary and transition. The user literally disrupts the boundary between a whole and its components, and finds content will hint the parts.

Local News
A section of an online newspaper explores shifting content with and long form. This is collaboration between Margarita Barrios Ponce, Jonty Valentine, and Sung Jo Kim.

Earthquake
A local newer application of a distant earthquake until he uses to desktop screen.

Handling Distance
Rebecca Ross

Stuff
This poster questions how a flow of pixels on a computer screen can interact with a flow of things in the world. It suggests that there is great potential to play in the mismatch of the two.

Data Structures
Consider the two of data from a tree (12-high) low resolution photograph of the room (3x) low-pixel area) to the wall of our studio (42-high) to a photograph of the moving under the two (0.9M) but his 18"x24" poster.

Hand in the Machine
Poster (pt. code defines the shape of a limb. This is a call to action toward illegible and hardcore scanning, but not completely or hopelessly, if still legible structures.

Red Green Blue
The reduction of distance between the abilities and the pixel is away of taking it, but the hand, as both a means and an attitude toward scale, resist size value in the design and use of media. This book collects a wide set of designs that explore text and page inserts that are scalable for and examples of extraction under scalar tangible.

Liquid
Interact with this video by making noise. The louder you yell, the more disturbed it gets. This is a simple exploration of an interface that is physical in a way that is completely different from a keyboard or mouse.

Noncube
This project just appears and oscillates on its own flatness and perceived depth with its interface of touch. Interacting perspective lines are removed from a rotatable cube are removed through a touchscreen. The result is a continually morphing shape that sometimes rest stunningly to a cube and sometimes rest as an unrecognizable flat shape.

Building
The solidity of a building is compromised by the fluidity of a slide program in which the building is continually built and re-built.

New
Kenneth Kim

Walk 1
The crosswalk signal is an everyday division in the urban environment, counting down the seconds before the next safe passage.

Relax
Signs and symbols in the city reveal hidden messages to the urban explorer.

Late-Breaking News
Sixteen front pages of the New York Times of important dates in history.

World Wide Weather
A newspaper that reports daily on the weather.

Monitor
A TV channel identification. This channel exists as a transparent layer on top of regular television programming. It tracks what you are watching and who else is watching with you.

Election
A side by side comparison of a live event, as covered by two networks.

Zip
Poster series. The zipper is a metaphor for the true working of space, hiding and revealing moments of invisible content.

Flow
Poster series. The feeling that all this has happened before. Then it goes away.

Mirror
The screen is like a mirror, reflecting and distorting what is real. A collaboration with Sung Min Choi and Allan Banir Li.

Flux
There is a collapse of space between the television and the door. The interior, played with a mirror in joy when happens on and off the screen.

Need Clear View of Sky
You are now here
You are nowhere

A journey through the flow of urban space.

Walk 2
Push button for walk signal. Walk. Don't Walk. Repeat...

WARNING: SURVEILLANCE SPOTTERS IN OPERATION

WARNING: SURVEILLANCE

WAR SUR SPO IN O

WAR SUR

REPORT SURVEILLANCE CAMERAS IN YOUR NEIGHBOR PUBLIC SPACES.
PLEASE FILL THE FORM WITH ANY INFORMATION YOU HAVE.

CAMERA LOCATION: STREET ADDRESS OR INTERSECTION

DATE

POINTING DIRECTION

☐ NORTH
☐ SOUTH
☐ EAST
☐ WEST

MOUNTED LOCATION

☐ SHOP FRONT
☐ INDOORS
☐ STREET POST
ETC

☐ ROOF
☐ ATM
☐ RED LIGHT

VISIBILITY OF THE CAMERA ☐ VISIBLE ☐ HIDDEN

OWNERSHIP OF THE CAMERA ☐ PRIVATE ☐ GOVERNMENTAL

NOTES

Page 199: Here or Now, 2001. Text: Kenneth Kim. This 'fake' CCTV monitor screen presents a surreal portrait of the perfectly ordinary building. It combines the prerecorded video footage of the building and correctly working date/time display. One's expectation of surveillance and control promoted by its visual form is betrayed by the fabricated nature of the images. The ambient sound of the building and no trace of its human inhabitants are meant to reinforce the chilling experience.Page 198: New Haven Surveillance Spotters is a proposal for an internet-based platform for interventions in the 'control space'. This project started from the idea of drawing a map of CCTV cameras in New Haven area. Since it was practically impossible for an individual to make a comprehensive map, a system based on the principle of peer-production was conceived. Page 200: Nomo Typeface, 2001. Page 201: Monospace Font Test Pattern 2002

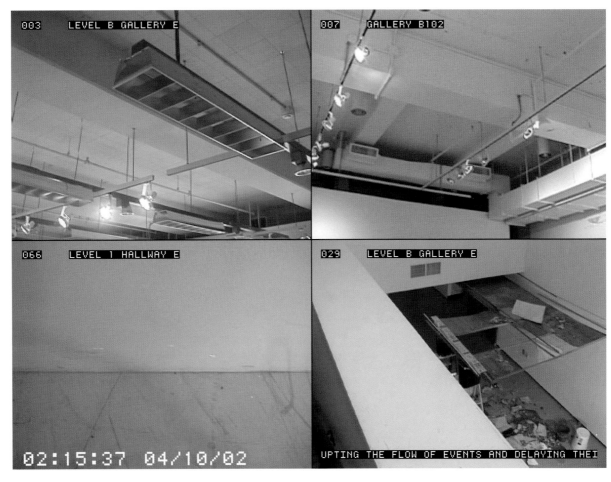

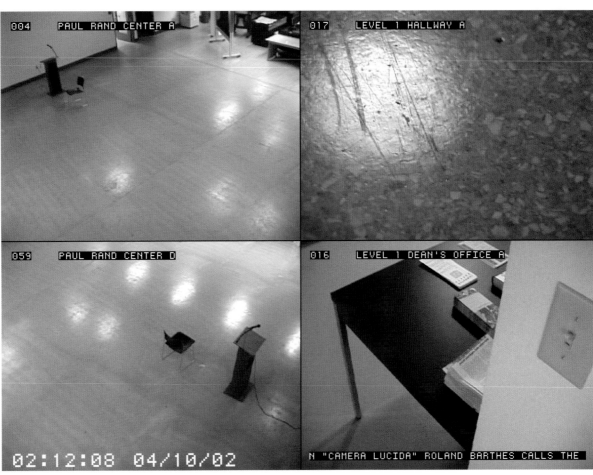

A B C D E F G H I J K L M N O P Q R S T U V W X Y Z
a b c d e f g h i j k l m n o p q r s t u v w x y z
[({ 0 1 2 3 4 5 6 7 8 9 ! ? @ # $ % & * § ¶ })]
A B C D E F G H I J K L M N O P Q R S T U V W X Y Z
a b c d e f g h i j k l m n o p q r s t u v w x y z
[({ 0 1 2 3 4 5 6 7 8 9 ! ? @ # $ % & * § ¶ })]

A pangram is a series of words which contains all the letters of the alphabet. For many years they have had a practical application, as typographers have required such sentences as specimen text. The most famous English pangram is probably The Quick Brown Fox Jumps Over The Lazy Dog

A pangram is a series of words which contains all the letters of the alphabet. For many years they have had a practical application, as typographers have required such sentences as specimen text. The most famous English pangram is probably The Quick Brown Fox Jumps Over The Lazy Do

NoMo:light**&Bold**

Aa Bb Cc Dd Ee Ff
Gg Hh Ii Jj Kk Ll
Mm Nn Oo Pp Qq Rr
Ss Tt Uu Vv Ww Xx
Yy Zz 01 23 45 67
89 &↑ !? @: %* ¶°

Aa Bb Cc Dd Ee Ff
Gg Hh Ii Jj Kk Ll
Mm Nn Oo Pp Qq Rr
Ss Tt Uu Vv Ww Xx
Yy Zz 01 23 45 67
89 &↑ !? @: %* ¶°

A B C D E F G H I J K L M
N O P Q R S T U V W X Y Z
0 1 2 3 4 5 6 7 8 9 ! ? @
a b c d e f g h i j k l m
n o p q r s t u v w x y z
0 1 2 3 4 5 6 7 8 9 & ß ¶

A B C D E F G H I J K L M
N O P Q R S T U V W X Y Z
0 1 2 3 4 5 6 7 8 9 ! ? @
a b c d e f g h i j k l m
n o p q r s t u v w x y z
0 1 2 3 4 5 6 7 8 9 & ß ¶

monospaced font test pattern

family	style	encoding	format	character width	ascent	descent	bitmap format	bitmap scale
Proba	Regular	Macintosh	PostScript Type 1	600	730	260	raster	12

Oh my god! Your is ■■■■■■■■!

Hush!
Don't look back!

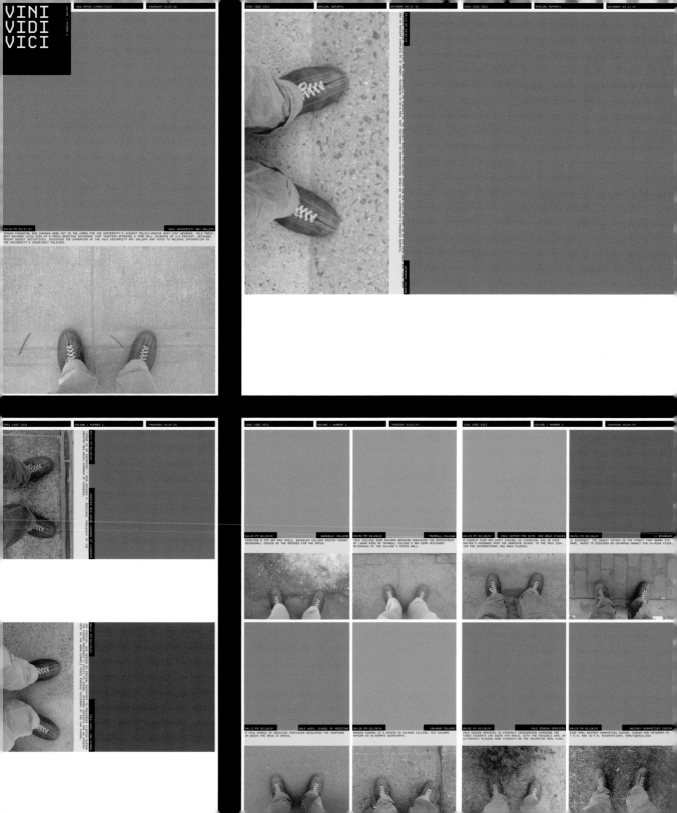

uniformer original symbol

morph

new symbol

Page 203: Vini Vidi Vici, 2001. The role of newspaper as a means of communication is inseparable from the control of territory. For a repressed national community, establishing its own newspaper is considered as the first step towards independence. As the name ["I went, saw, and conquered"] suggests, Vini Vidi Vici was conceived with this notion of newspaper as a territorial control device. Pages 204-209: Uniform/Traces of a Rhino, 2001. This poster set is an experimentation on a particular software function ("morph"). A number of different marks, which had been made to represent certain qualities of the rhino, were "morphed." The results, which still had traces of the original marks, were overlapped to form a more or less homogenized whole. The process reminds me of the way an army is built: different individuals are given special treatments to assemble a unified totality. Page 210-211, 209-210: Visibility, Surveillance and Graphic Design, 2002. This book explores the implications of surveillance as an area where the visual meets control. To reflect its theme, an extreme method of concealment was taken: All the textual information is printed inside the folded sheets, leaving only images and "code" numbers on the visible surface.

 [more or less]

Infiltrate / Min Choi

Infiltrate / Min Choi

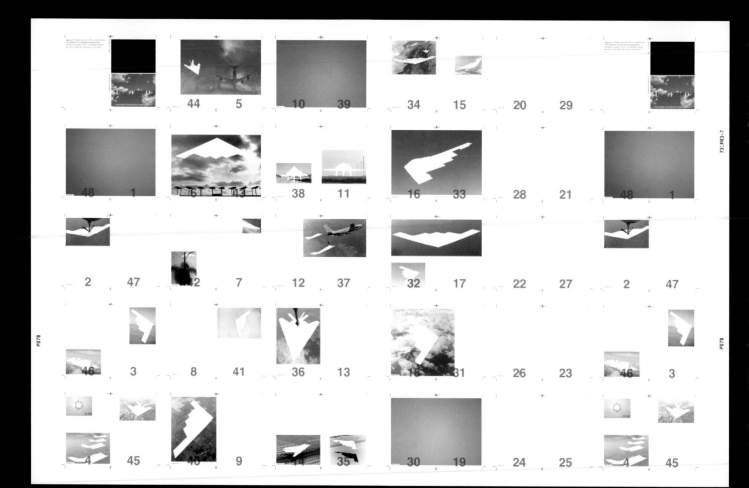

A conversation with Matt Owens and Warren Corbitt, principals, OneNine.

Gelman: Okay, camera is on. You can talk now. How did you start working together?

Warren: How did we get to be?

Gelman: And why.

Matt: It's been maybe a six-year process.

Warren: Mmm hmm.

Matt: I met Warren through a friend when he was working at *House and Garden* and *GQ*. This was in 1996 or so. He was working for Condé Nast and doing a bunch of different stuff as a designer. I was working at a company called Echo 5 with a mutual friend of ours, John. Warren was interested in going to grad school and I had just gotten out. Warren was interested in going to Cranbrook and he knew that I had gone to Cranbrook, so we met a couple of times, and talked about the pros and cons (of Cranbrook) and how it was; and then Warren got out of Condé Nast, he left for grad school, and freelanced for awhile.

Warren: I was running a studio called Nine.

Matt: And then went to grad school.

Gelman: Here in New York?

Warren: Yeah, it was the solo, one-man, out of your apartment studio thing, but I was doing a lot of work for CKS/Site Specific. I was freelancing at *Esquire* magazine and doing something for Roger Black.

Gelman: Was it all web stuff?

Warren: No, because *Esquire* was print. I was working with IAB, Roger Black's old company, for a while, doing stuff with them. And then CKS. I did that right up until I went to grad school.

Matt: And see, when I met Warren, he was doing more of the print side. I had done print a long time ago, but when we met I was totally immersed in the web world. Because when I got out of grad school in 1995 that was what was going on. I never had done any in school but then started to do it right at the end of Cranbrook. I had done the first Cranbrook site. I was like "Oh, this is cool. It seems like there are a lot of jobs here." I had no interest -- I didn't want to go do print de-sign necessarily. Right after Warren went into grad school in 1997, I quit my job and freelanced for two years, and Warren and I kept in touch; while he was doing that, I was here in New York working out of my apartment solo-style for two years. I was just doing my own stuff, and just freelancing, freelancing, freelancing. So it's weird for me because everybody was making tons of money working for companies. I was at my house, eating cheese sandwiches.

Warren: In boxer shorts.

Matt: In my boxer shorts for two years.

Gelman: Did you make any money in that time?

Matt: I made a lot of money. I was doing a lot of work. I was doing a lot of just whatever.

Gelman: And experimenting...

Matt: Yeah, yeah; tons and tons. Yeah, and that's all Warren was doing at grad school, tons of his own work. We didn't have to do that much client work. And so after two years, in 1999, Warren was at Cranbrook with the Makelas, and super good friends with Scott [Makela], and you were there when the shit went down. And I was here, just working, getting to that point where I was so introverted, doing my own stuff and working alone. I was getting to the point where I couldn't have conversations with people. I was getting a little cabin fever. A little too much being alone 12 hours a day. So at the end of your graduate school experience...

Warren: Basically in April of 1999 I was facing graduation, and I didn't have a plan. Matt and I had been chatting back and forth through e-mail but not even that much during that time. And I just sent him this blind e-mail saying, "Dude it hit me today that I'm graduating. What the hell am I going to do?" At that same point Matt was going though a bit of, Okay, I'm one guy. I can only go so far with a certain amount of ability to take on a certain-sized job, and therefore money. So we had started to think about maybe setting up a small company. So I sent this e-mail off and he said, "Well, why don't we chat and see if we can set something up?" My girlfriend at the time was living here, she had graduated already, and so I flew down in April and we just started talking from there about the possibility of setting up a studio. In May, Scott passed away. So I stuck around Cranbrook up until the very beginning of June, working with Laurie to finish up a project that he had been awarded right before his death. And then I came back to New York and we immediately started.

Matt: June 1.

Warren: Yeah, June 1.

Matt: And I had talked to Warren about finances. I said, well, I had been working for two years and had money saved up.

Warren: Thank God! I had none.

Matt: Warren had contacts. I had contacts. We were both 27, 28. It wasn't like we were 22. We had been out there and doing things. So when Warren moved here I basically said, "We're going to work but we're not going to get jobs. We're not going to get hired by someone."

Warren: I mean, it was an option, if nothing else panned out.

Matt: But we'd already done that.

Warren: The market was so -- at that point, I mean I remember it, anything was possible in 1999, because people were just handing out money. There was this real feeling in the air that you could just start your own company and do it. By getting clients early on we felt very comfortable. We were liquid within three months -- profitable. So we were saying "Let's just keep doing this; see what happens."

Matt: But it wasn't like money was ever-flowing. It's because we were grown-ups, we had some clients already...

Warren: We knew people.

Matt: We had legitimacy. We were ready.

Gelman: You had a body of work by then.

Warren: Right. But it was a very good time. Even with massive skills now, if you were to try to do the same thing in this current economic market it would be substantially harder. Design was very important in 1999. Design, I think, was much more important and much more of this fascinating thing to businesses than it is now. Starting when we started aided us a great deal. Could we have done it as well without the contacts and the portfolios of who we had worked with? No, definitely not. But it definitely was a good time to do it.

Matt: Also, I think for both of us, it's just like anything else: skill and ability take us only so far. And then it's timing, luck, all those things play into it as well. It's weird, we're this weird anonymous company; we started at a good time, we were older and had reputations individually, which helped us a lot. When we started the studio we had a couple of decent-sized jobs that allowed us to basically become self sufficient, hire Lee full-time, get a studio. We got a couple of jobs that earned us the disposable income to become fully realized and legitimate. And now, three years down the road, what you have is that we started our company when other companies were reaching their apogee, and then they crashed. We were reaching our apogee as they were crashing, and now we've leveled off and we're good. Now we're organized. We have a studio and all the trappings of a real business, health insurance, etc. And so now people see us as established, now people say, "Oh yeah, I've heard of you guys, you've been around for awhile." You know the last few years we've been speaking a lot and going out of town and going different places. I think it's good for us because we've remained small but we've been doing bigger things and that's been really helpful for us. It wasn't necessarily done as a grand plan, but it also wasn't unplanned.

Gelman: What do you think changed in terms of the kind of work you do and your approach to business since all the dot-coms folded?

Matt: We've mostly stayed the same. Between 2000 and now, I don't think we are working any differently. We're dividing up our labor more. We're doing more broadcast stuff, we're taking more print jobs, we're doing web. But we're doing them all at the same time.

Gelman: What is the ratio between print, broadcast, and web?

Warren: I'd say 70 percent interactive, 30 percent print and broadcast.

Matt: And one month we'll be doing 80% broadcast, 20 percent web.

Warren: We just did these huge projects for Sony that took over the entire studio for a month. And that was all video.

Matt: Right -- we just did that Sony stuff that took up 80 percent of the studio's time. It's gone and a project that's totally web-based is taking up 80 percent of the time. And that will go away and then two projects will take up 80 percent -- two different kinds of projects. It depends.

Gelman: Who designed your tattoos?

Matt: It's a collaborative project, of course. My buddy Dave comes to the studio from time to time. He lives in Avon-by-the-Sea, New Jersey. Dave's an awesome guy. Super good guy. He and I just met through tattoos and stuff. He's from the Jersey shore. I've met a bunch of people down there. My girlfriend is also from New Jersey. There's a whole scene out there that no one knows about. Well, people know about it.

Gelman: A Jersey scene?

Matt: Jersey's the shit. The Jersey Shore is great. There are a lot of different people, like Dan Hayes from Baltimore who does a lot of poetry and Dave and a lot of different people. So, for us, I think we feel really lucky to be where we are right now. I have major issues with the design world; for me, at least I think the issue is to just do good work and do the things you want to be doing. And if that means spending less money to do more interesting work, or spending money on things that don't make money because it's going to help the studio as a whole...thinking in those terms too.

Gelman: That was actually my next question. How does your self-initiated work fit into this process?

Matt: I think as long as you --

Gelman: When you spoke about clients, you didn't mention how much time you spent...

Matt: Just fucking around?

Gelman: Yeah, just trying things?

Matt: Well, I think that's important. For me you can't really do fun things unless me you try out fun things. You can't just wait around and go, "Well, that's an amazing client they just found us, and we're going to do great stuff." You have to be thinking about the things you want to be doing and then doing them. It's a step-by-step process.

Gelman: One influences another.

Matt: Sure. Always. Or you'll be doing a project for a client and you might do something or mess around with an idea that might not see the light of day in that project but is utilized elsewhere later on. And that happens a lot. Or we'll be like, "Remember that thing you were messing with that went nowhere, or you were doing for yourself? Is there an application in this space?" That happens visually, that happens technologically. Like we did a project for Sony and we had to shoot all these products and they were like fake...

Warren: Prototypes.

Matt: Prototypes. They were not finished. So on one end we were like "Great, we're going to shoot all these products on a green screen and knock them around, it will be cool." But in doing that, we failed. We had to shoot it a different way because the green screen didn't work because the products were too reflective, and other issues. But then we had another opportunity and through that mistake we were able to figure out how to do it correctly later on. If we hadn't had taken it upon ourselves to try, and fail, in one circumstance, we would not have been able to succeed in another. And that happens whether it's a photographic idea, or a conceptual idea, or a technical idea.

Gelman: Does that mean you take on an assignment that involves things you haven't done before?

Matt: Yeah.

Gelman: You say, "Yeah, we can do it." And then learn in the process?

Warren: Or you know you can do it but you haven't quite done it before. I think one of the things that I've always been proud of our studio for is that if there's a cool opportunity but we're not quite sure how to do it or there might be a really expensive way to do it, but they don't have the money, we work really hard and enjoy figuring out a way to actually do it, but affordably. Like the stuff we did for Cooper Hewitt: We did the whole Vitra chair museum online for them. We were originally going to shoot the chairs in 360 degrees, but we couldn't do it. We couldn't fly them in time, so we just got the little miniatures, reproductions, put them on a Lazy Susan from Bed, Bath and Beyond, shot them in 360 on that. Silhouette them and you've got spinning chairs on the site. So, "Well, they can't get us the real chairs so I guess we're not going to do it," turned into "Well, we can figure out another way." And it's such a better site because of it.

Gelman: And 3-D rendering would be overkill for the web.

Warren: Yeah, for certain things we do the rendering, but for this we just...

Matt: Like for the Sony project we just finished...

Warren: We rendered.

Matt: Half of it was a line that had rendered products. They had...

Gelman: They gave you the files?

Matt: The files looked great. We basically just shot and animated them. They looked awesome. But then we had another line, and they weren't developed enough. They were just physical sculptures like big blocks of wood painted to look like products. And so what we had to do was come up with a smart way to make them feel as interesting as the 3-D rendered ones, but they were real. That required us to set up a photo shoot here, spend a whole weekend, shoot all the projects incrementally at different angles, silhouette them out, Rotoscope them, yeah, a million times more work. But the end result... If you're like Joe Schmo, like anybody, and saw the 3-D files, and saw the ones we made, they're equally good pieces.

Warren: Mmm Hmm.

Matt: They look really good. We basically had to solve that problem. And in doing that we had to do much more labor but there was no other way to get the effect. It's similar to moviemaking. We have to tear down this sign and make a new sign because without it, the shot's wrong. And that's the same thing with design. You have to work within the limitations, but at the end of the day, however much effort you put into it is how much you get out of it.

Warren: I think one of the operating principles of our studio is getting your hands dirty. We're not a bunch of art directors that sit on our high chair and order people around. A very integral part of our process is actually producing and figuring it out. Because you're invested in it. And when you're invested, it actually becomes a better piece because it's part of you. It's not just something that's floating out in the ether, it's something that you are sitting with until two in the morning hand-silhouetting out each and every product. You know the products at the end of that, and you're really invested in having it turn into something really amazing.

Matt: Also once you go through a certain process, whether it's a print piece, or a broadcast piece, or an interactive experience, you've done enough of them over three of four years where you've seen a lot of different circumstances. It's all deductive reasoning -- it's kind of stupid to say, but fundamentally I'm a problem solver. I don't care if it's a rock video or a wedding invitation, it's a problem to be solved. And there's a way to deductively go about that. What's the narrative experience? How should it feel? It doesn't matter what the medium is; all of those kinds of ideas apply. That's what we bring to the table as designers.

Gelman: How does it work when there is no problem to solve? Do you create one for yourself? Do you set certain parameters?

Matt: Both. Warren and I went to Cranbrook, and we are both un-Cranbrooky on a certain level. Like I think we both came from that environment and have done zany and experimental, decontextualized work, but I think both of us brought to bear a little more of a regimen. When I come up with an experimental project, it's treated similarly to a client project. I'm not just getting a piece of paper and doodling. It's like, okay, I have this idea. It's kind of an interesting idea, but I don't have a client project that I can fulfill it in. What I'm going to do is set up the structures of a project, a brief for it. So that I can begin to solve it clearly. That's what I do because I don't think there's any other way to manage those experimental things in the broader context of all the other work. You have to treat it seriously. Within that seriousness, you can doodle around and play. You can have fun. But you have to say "I'm going to do a dimen-

Interview continues at:
http://www.infiltratenyc.com/017/

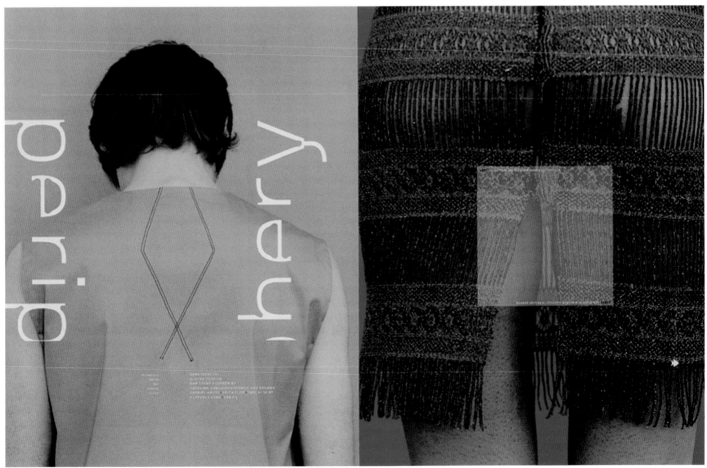

Pages 214: ESPN Next Typography, 2000. Client: ESPN Magazine. Modular three dimensional typography developed for *ESPN* Magazine's Millennium issue. Page 215: *Raygun* Magazine Cover and Spread. Client: *Raygun* Magazine. Pages 216-217: Maxwell NOW, 0000. Complete branding campaign for Sony artist Maxwell's Album NOW.

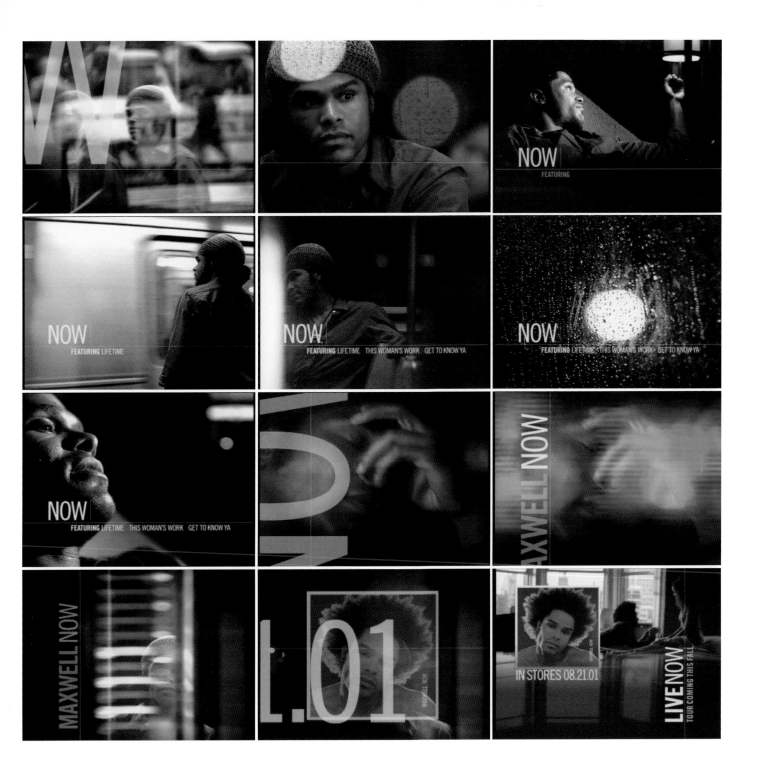

A conversation with Paul Sahre.

Gelman: Tell me what you've been up to lately. Whenever I see you you're always into something new.

Paul: Yeah, I just got through with that Doyle experiment, and I pretty much know now that I have to be working for myself from here on out. It was a good experience for that alone. To know what work you should work. So now it's, "Try to figure this out, and keep doing the work that I want to be doing. Right now the office is kind of hopefully a 50/50 split between design in this room and silkscreening in the other room. The other room is print and drawing, and I do some other things, and it's not bringing in any money -- so I end up spending more time in this room than I'd like to. As far as the work goes, probably 50 to 60 percent of my time in this room is done with book jackets. I am also publishing and co-authoring a book on Ham Radio.

Gelman: Ham Radio? What do you know about Ham Radio?

Paul: I didn't know anything when I started working on it. That's been a six-month learning process that's just finishing up now, thank God. Because bringing a project of that scope into an office of this size is really difficult. It's the overhead thing; it's just amazing how quickly that can get out of hand. I couldn't do as many book jackets as I do without keeping it lean. It's impossible. They just don't pay.

Gelman: At the same time, you've always been doing a lot of non-profit stuff such as the SoHo Rep [SoHo Repertory Theatre].

Paul: SoHo Rep. I developed their identity, and I've been working with them for five years. I'm on the board now, which is kind of a process of experimenting with a client and, actually, calling them a client is maybe not so appropriate 'cause I'm not getting paid. It's been an interesting process to get that involved with a client, and really get in there and have some say in how things run. My biggest frustration with that at this point is that it's almost impossible to get posters printed. Unless we silkscreen them ourselves here, something we do quite often, it's just these postcards, which aren't so satisfying. And I've also been getting sick of the iden-tity that I've set up too, which is kind of a problem.

Gelman: Are you going to change it?

Paul: The thing is, it's this dot thing, this sticker thing, and the reason it worked is because they have no money. And it still works for that same reason. They have so little ability to get this stuff in front of people that changing it now doesn't make a lot of sense, because it's working. Originally, the idea was that the dot would start going away and it would be a little thing somewhere in the corner. We just finished a poster and the dot is not there at all, so that's satisfying. Since we print them ourselves, when you basically show up with a pile of posters and say, "here, "they really can't complain. But you know, again, that's all time consuming. As I said, for financial reasons I end up having to be in here doing work and not [being] as much in that room as I'd like. I mean, if there were three of me, I wouldn't have enough time to do all the work that is popping up.

Gelman: That you want to do?

Paul: Yeah, yeah. So it's a constant thing.

Gelman: Let's talk about that work. You were working on a silkscreen series with strange sentences.

Paul: The Rejection Series, I guess I'm calling them. But they're just word pieces, silk-screen in editions of 10, because I eventually plan on showing, though they were part therapy when I was doing them. It's also a way of making things that are outside the realm of work that I normally do. But I really don't consider that work any different.

Gelman: What about your drawings of people looking up?

Paul: I'm also doing a series of large-scale pencil drawings. That has been really satisfying, although, again, that has been stalled in the same place for a month. It's a series of large-scale drawings of people looking up at the sky in terror. They were originally called the Wrath of God series, and there will be at least 10 of them when it's done. But I've been photographing people here, just people who come by the studio and pose under a light. Actually, that "X" up there is "God," and they stand here and look up. <Laughs> And it's odd, because I had the idea for doing the drawings before 9/11, and then just after 9/11, all of a sudden there was this other meaning to them. It wasn't meant be specifically about that, but I guess it is now. But the satisfying thing is that the reason that I got into graphic design to begin with goes back to the way I would draw in high school: super-realistic pencil drawings -- I was drawing Trans-Ams, guitars and shit. Then I stopped, and now, now there's an idea involved in it. But it was really wild, just picking up a pencil and being able to just do it, not having done it for 20 years.

Gelman: And you feel totally in shape?

Paul: As far as the drawing.

Gelman: You didn't lose anything?

Paul: No, it's exactly the same. And actually, the other side of it is that I don't want to get that good, because there's a certain kind of quality that I want in the drawings that isn't quite right. I just did a couple of sketches and, bam! Right into it, and it seems like it's working. <Laughs> I still have to carve out enough time to get back to them. And we were talking about the whole "When you're not doing it for money and you're doing it for yourself", is there any exterior motivation? Sometimes I think that's the hard part of personal work. If you don't have a deadline, is it ever going to get done?

Gelman: What are the criteria?

Paul: Well, these word pieces, the Rejection Series that I was talking about, there are probably 50 of them, but I planned on many, many, many more. One of the motivating factors of doing it, the therapy part, kind of went away, because they were based on a wrecked relationship. It was just kind of a way to say things that no one would want to listen to. But I think they were pretty compelling. Those were actually interesting because I felt like I was the client and was hiring myself to find a way to voice something. So the desire in me said, "Okay, well, we can find a way to figure it out." You know the form of them is really not emotional; there is absolutely no emotion. The form is, it's just kind of gray, and it's all Chicago, [typeface] but the stuff that's being said in them is really, really emotional. So I'm hoping that what happens is that people bring their own stuff to it. Because you know, we all have that relationship stuff, even though it's over-exaggerated. So anyway, the bottom line for me is that it really helps to inform and keep applying it to what you're doing. It's important for me. I think it's important for any creative person to have outlets in some way.

Gelman: But even your commercial work is not that --

Paul: Commercial?

Gelman: Not that commercial.

Paul: Yeah, well, that's true. I do have a couple of --

Gelman: You draw, you cut paper, you silkscreen, all that stuff for book jackets and posters.

Paul: Yeah, and the other side of that is I don't really feel there's that much difference between any of the work that I do. I approach it the same way. But you know, everybody has a different level of being able to deal with the commercial pressures. I like money just as much as the next person, but when it comes down to it, you actually have to be able to do it. I'm just, like, allergic to a lot of stuff. I mean, I try...

Gelman: What are you allergic to?

Paul: Well, you know, some of the stuff that's a bit more commercial. That stuff just isn't that interesting, because it's not about...I'm not gonna say it's not about me, it's not about me, but it's just so involved in this kind of other thing that's way beyond your control, and so out of proportion. And you have to be able to sleep at night too, I suppose.

Gelman: You mean when you work with a client?

Paul: No, no, I guess I'm just talking about a certain genre of work that I don't do. Um, I can't really give you an example of what I'm talking about, but it's just the really commercial work.

Gelman: But you do get involved in commercial work. Do you reject it?

Paul: Yeah, the sellout thing, like

if anyone is invited to sellout, everyone sells out. Oh, I've had plenty of opportunities to do all kinds of different things.

Gelman: And you've done commercial work.

Paul: Yeah, a few websites. I've done some work for Audi; I've just done some work for Morgan Stanley recently, but you know on those levels, I still hope it's interesting. Getting back to this thing about doing the work or not doing the work, I don't think I really have any control over it. Because I think, you gotta want it, you know? With some projects, you're just not motivated to do it, so you just don't. And it's not that you don't want the money, but there just isn't something interesting enough one way or another. That stops that stuff from happening, other than the lack of somebody coming with a big suitcase of money and going, "Hey, would you like to, uh..." <Laughs> You know what I mean? No one's ever knocked on the door and said, "Here's a million dollars, would you do this? Do something for Phillip Morris or whatever." But I am always complaining about the Phillip Morris logo appearing on the SoHo Rep's materials. It's totally ridiculous!

Gelman: Why?

Paul: Well, it's just—

Gelman: Are they giving money?

Paul: Oh, yeah, they're giving money.

Gelman: So what's wrong with it?

Paul: Um, it's Phillip Morris, you know? There's an obvious reason that they're doing it, and sure there's a benefit to it, but it's so inappropriate for the theater. To be getting money from Phillip Morris. It just, it...

Gelman: Well, tell me, if they stopped accepting money from Phillip Morris, would they have to close down or could they go on?

Paul: Well, that's a good question. They wouldn't have to close down. They'd find ways to operate without Phillip Morris. But it'd be a lot harder. And again, it's like, who isn't taking money from Phillip Morris? So my complaining about it hasn't stopping it from happening. Even as a board member. But I do feel like there are appropriate relations, appropriate corporate relationships that a theater can have. This just doesn't happen to be one of them. I mean, it's an experimental theater, and it just is Phillip Morris. And in the end, it's like saying, "Well, would you do cigarette packaging?" That's always the example everyone brings up. I personally wouldn't do cigarette packaging, but you know I have no problem -- you know, if some-one likes to smoke, and, you know, like my friend Neil Powell has done some of that stuff. He's a smoker; he's a really great designer, and a really great guy, very conscientious guy. So, more power to him, you know. I just think it's a personal choice...

Gelman: Who is your dream client?

Paul: Uh...whooo. You know, I don't... That's really hard to answer. My dream client would be a client that paid me well and let me do good work for them. You know?

Gelman: Not the tobacco industry!

Paul: Not the tobacco industry, no. I also don't eat meat, so I wouldn't, probably wouldn't go there. Also anything that has to do with weapons.

Gelman: You know, if you start talking about industries now, you'll realize that you can't work for any industry.

Paul: Yeah. I know. But the dream client thing, I don't know. I just think, and you probably hear this answer from a lot of people: We want to make our ideas happen. You want to get paid what something's worth, you want to get paid well, and you want to do good work. You want to feel proud about what you're doing. You know, actually, my dream client: someone who would pay me to silkscreen posters. <Laughs> Like, my own work, silkscreening posters. That would be great! But of course, that's ridiculous, since there's only a certain amount of money available for somebody to actually be using their hands to make something, especially with what we do. So that's not something worth counting on. It'd be great. <Laughs> But it ain't gonna happen.

Gelman: Okay, your experimental projects, the silkscreening, those wood things...

Paul: Yeah, the wood scenes.

Gelman: What triggers those kinds of projects?

Paul: I'm not sure exactly what triggers that, but the one thing I do know is that I have probably 10 of them lined up, waiting.

Gelman: Can you talk about them?

Paul: Well, I've got this UFO series that I'm really interested in making. It will be a series of posters. I'm really into UFOs and outer space. I've been collecting and I've got a lot of weird books on UFO evidence and...

Gelman: Have you been to the UFO museum in Roswell [New Mexico]?

Paul: No I haven't, but it's definitely someplace I'd like to go. I've tried to incorporate that stuff into other things that I'm doing, but there's a UFO series in the wings and another book that I want to publish and figure out. Basically a book that documents a class that I've been teaching at Parsons for the last six or seven years.

Gelman: What do you teach?

Paul: Well, I teach graphic design at SVA and Parsons, and this semester I'm doing a senior portfolio class and a freshman two-dimensional design class. So I get them in their first class and their last class. It's cool.

Paul: Getting back to the personal work, I'm trying to think, see this is the thing -- the drawings, the series of drawings I was telling you about? I had the idea to do that, like, five years ago. It's just been waiting for me to have the time and the motivation to do it. I have this tendency to do a series, so if you pause, what have you done? The drawings, the Rejection Series and the wood scenes, I don't feel like I actually finished them. I just stopped doing them and moved on to something else. I have all these canceled checks, my parent's canceled checks -- from 1964 to 1978, I think -- every single one of them. And I've been mounting them to large panels, and that's something that I can't tell you why I'm doing it, I'm just doing it.

Gelman: It's like collecting.

Paul: Actually, I don't know if I have it here, but I have a series of books that I'm doing where there's a book on O.J. Simpson by Paula Barbieri; and it's got this just heroic-looking sunset on a beach with his girlfriend at the time that the killings happened. It's like My Life with O.J. or something. And this started when I was sitting in as the creative director at Little Brown, but I just grabbed one of the books and started circling every reference to O.J.

Gelman: You worked at Little Brown?

Paul: Yeah; I sat in as creative director for a month.

Gelman: Why did you leave?

Paul: This was right before the Doyle thing, so I turned it down because it was too much of a commercial situation.

Gelman: You didn't like being there?

Paul: Yeah, it was just, designing book jackets. It was kind of interesting to get in there on that level just to see what went down. I think it was a good learning process for me just to be doing more book jackets because the more information you have, the more chance you have to get something through. You know, you're always relying on that person to care about what you're doing. If that person isn't going to invest some political capital defending what you're doing, then it's never gonna get done.

Gelman: You were talking about something else, about that O.J. Simpson thing.

Paul: Oh! I'm sorry. I was just talking about, like, the motivation to make things that don't necessarily have a point, and this definitely didn't have a point. But I just, I was just...when I was there for a month, you know, you get to go in the back and see their back shelves, and this was one of their books. Anyway, I just started circling in the book every reference to O.J., and on every single page, you know, you go through the book from the cover to the spine, and on every single page, there are hundreds of circled O.J.s throughout the book. So it's a beautiful, interesting thing now. And I did a series of them now, and I've been giving them away. I also had this phase where I was painting chairs. This was another thing that I did, that Eames chair back there. It's broken, and people would come to the studio and sit down. And I'd always have to try to stop them because it was broken; the thing would fall over. And so, I was

Interview continues at:
http://www.infiltratenyc.com/018

Infiltrate / Paul Sahre

Infiltrate / Paul Sahre

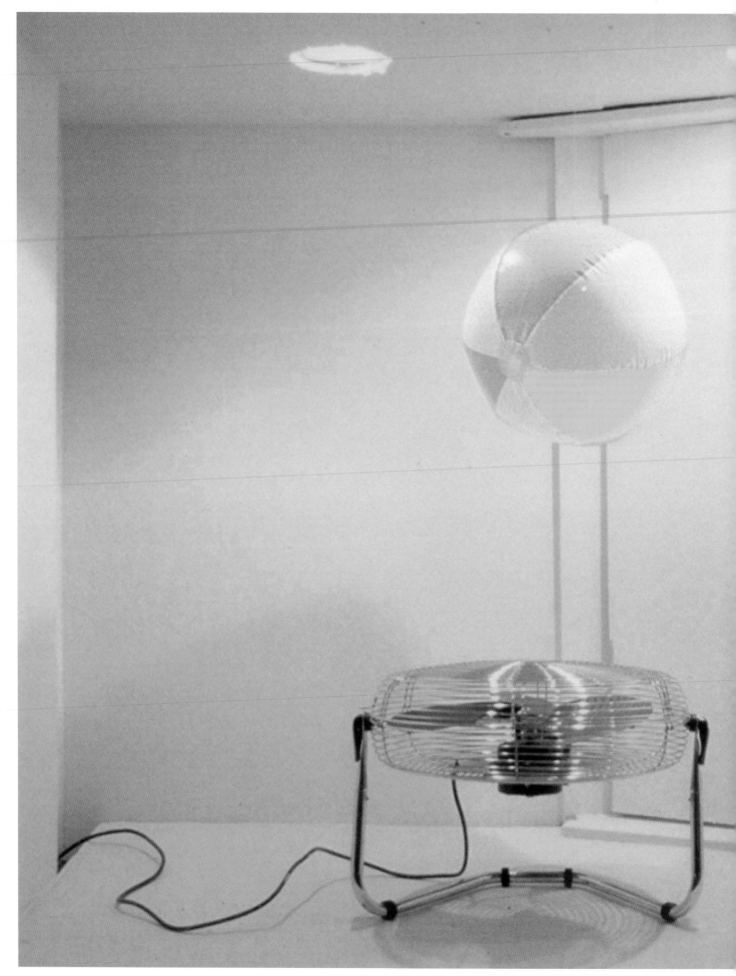

Pages 220-227: Theatre windows. Client: SoHo Repertory Theatre. An ongoing series of window displays for the SoHo Rep. Each window relates to a performance. Creative director: Paul Sahre. Designers: Paul Sahre, Rogier Klomp, Jason Fulford Michael Ian Kaye, Brian Rea. Curator: Office of Paul Sahre. Pages 228-231: Postcards, 1997-2002. Client: SoHo Repertory Theatre. Design: Paul Sahre. Postcard designs which employ the theatre's visual trademark: stickers. Page 234: "Hello World" lecture poster, 2003. Design: Paul Sahre. Silkscreen poster (which I printed) announcing a lecture I gave at Rutgers University. The information on the poster could only be read when it was held up to a strong light. Page 234: "Exercises in Futility Part IV" lecture poster, 2000. Design: Paul Sahre. Silkscreen poster (which I printed) announcing a lecture I gave at the Maryland Institute College of Art in Baltimore. It was an experiment with how hard people will work to get information from a poster. Page 235: "Thinking about outer space always makes me feel better" lecture poster, 2003. Design: Paul Sahre. Silkscreen poster (which I printed) announcing a lecture I gave at the University of Connecticut. Pages 236-237: No Such Place, by Jim White, CD Case and Insert, 2001. Client: Luaka Bop Records. Design: Paul Sahre. Page 238: McVeigh illustration, 2001; Client: The New York Times; Art director: Peter Buchanan-Smith; Illustrator: Paul Sahre; Letters illustration which ran the day after the execution of the Oklahoma City bomber Timothy McVeigh.

Infiltrate / Paul Sahre

In order to more fully understand the term *Research and Development*, a focus group was convened on the evening of November 19, 1999. That focus group consisted of nine individuals enlisted at this spot on Walker Street. After negociating an intricate series of questions, their conversation turned to the subject of other focus groups in which they had participated. Someone suggested they vote for their favorite focus group anecdote and include the winning story with their findings. And anonymous man from Brooklyn recounted the winner, excerpted below.

"... and if it wasn't for a girl named Amy, the only one in our group not to have been fired from at least one job in her life, lil' Penny would have been layin' wood on Vanessa Williams. Either way I got my kicks free of charge."

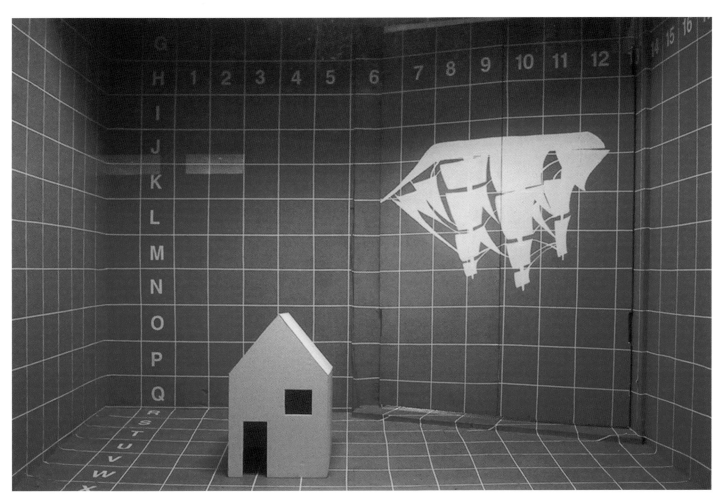

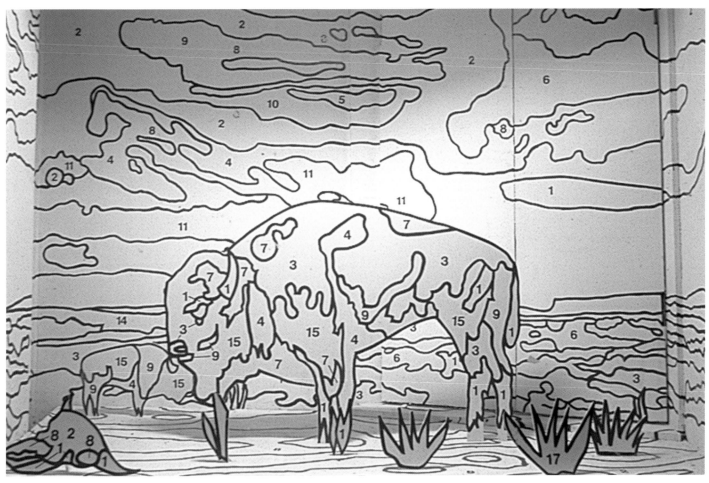

Page 239: The History of Western Philosophy by Bertrand Russell, book cover, 2002; Client: Scribner; Creative director: John Fulbrook III; Design: Paul Sahre; Photographer: Jason Fulford; Since its first publication in 1945, Lord Russell's A History of Western Philosophy has been universally acclaimed as the outstanding one-volume work on the subject. In seventy-six chapters he traces philosophy from the rise of Greek civilization to the emergence of logical analysis in the twentieth century. The cover and back cover use images of roads as a metaphors for this dense subject. The redesign is an attempt to "update" the cover of the book, which was last "updated" in 1972. I hope my cover lasts 30 years. Page 239: Fire in a Canebrake by Laura Wexler, book cover, 2002; Client: Scribner; Creative director: John Fulbrook III; Design: Paul Sahre, Jean Marc Troadec; Photograper: William Eggleston; This book is an account of the murder of two black couples in Walton County, Georgia, in July 1946.Following clues from published newspaper reports, FBI and legal records, and interviews conducted in 1997 with the participants who were still alive, Wexler plots a dramatic narrative involving sex, jealousy and violence. The cover features an image by William Eggleston, which recalls the spot where this violent act occured. The typography emerges from underneath the image, suggesting the violence rather that showing it. Page 239: The Body by Hanif Kureishi, 2003; Client: Scribner; Creative director: John Fulbrook III; Designers: Paul Sahre and Tamara Shopsin; Photographer: Paul Sahre; A book cover for a novel by Hanif Kureishi, in which an aging playwright is offered the chance to exchange his failing 'old body' for a 'new body,' thru a secret, underground surgical procedure. we used nesting dolls (painted different flesh tones) as a metaphor of the story. Page 239: Frank(s) triptych, 2002; Client: Personal project; A series of personal pieces, silkscreen editions which are really just language play. I could have used the word fuck(s) instead of Frank(s).A word which can be a verb or a noun etc...they are meant to be a triptych. It started from a New York Times headline "Franks Comes Out Swinging." I thought it was a typo, but Franks is the last name of a politician. Frank can be a first or last name, a group, or a personality trait.

STARS
BY
Francine Volpe

...HO REP
R&D
March 7-10
(212) 479-7979

SOHO REP. &
Theodore C.Rogers
present
CAT'S-PAW
By Mac Wellman
Starts Dec. 15
(212) 479-7979

EMPTY
ISLAND
by Caden Manson
& Big Art Group

SOHO REP.
R&D
June 11-15
(212) 479-7979

SOHO REP.
WRITER
DIRECTOR
LAB
April 1-4

SOHO RE
WRITE
DIRECT
LAB
April 1-4

(A)

(B)

SIGNALS OF
DISTRESS
by The Flying Machine
Based on a novel
by Jim Crace

SOHO REP
R&D
September 27-30
(212) 479-7979

Soho Rep.
The Year of the Baby
By Quincy Long
Starts March 22
(212) 334-0962

CAT'S
PAW

By Mac Wellman
Dec. 8-11

S O H O R E P .

```
 ┤++++++++++++++++++┤
 +  C A T ' S   P A W  +
 +++++  +++++++++++++┤
```

R & D SERIES

BY:
MAC WELLMAN

DIRECTOR: DANIEL AUKIN

SET DESIGNER:
TROY HOURIE SOUND DESIGNER: COLIN HODGES
 LIGHT DESIGNER: MICHAEL O"CONNOR
 COSTUME DESIGNER:
R & D PRODUCER: MAIKO MATSUSHIMA
TONYA CANADA
 PRODUCTION STAGE MANAGER:
 BRIBGET MARKOV

MASTER CARPENTER: FRANK HANSEN

A
S ASSISTANT DIRECTOR: KARA
M : SMITH
: SCHIFFNER
J
E M
S A S P E C I A L T H A N K S
S D
I R →
C I
A Order
 of
 appeara
CAST::::::::::::::::::::::nice:::;HILDEGARD BUB:::::::MELISSA HART
 JANE BUB::::::::::::::::::::SALLY WHEELER
 JO RUDGE::::::::::::::::::::TRINA WILSON
 LINDSAY RUDGE::::::::::::::CYNTHIA CAMERON
```

----------The performance runs 90 minutes.-------
--------THERE WILL BE NO INTERMISSION._____

PETE SIMPSON----Apppeared at Soho Rep. last March as Francis Parkman in Richard Maxwell's Cowboys and Indians." He recently returned from the European tour of Richard Foreman's Hotel Fuck. Pete also conti ues his run with the "Blue Man Group".   Pete first worked with Matt as classmates at the National Theatre(er) Conservatory.  Earlier this year,

MATTHEW SCHNECK performed in Gross Indecency: The Three Trials of Oscar Wilde at the Alley Theatre(er) in Houston, Texas. He made his debut in the Tony-nominated production of "London Assurance at the Roundabout Theatre(er). He has also performed at the Fulton Opera House, Denver Center Theatre(er) Company, American Folklore Theatre(er), Ensemble Studio Theatre(er), Dance Theatre (er) Workshop, and the WestBeth Theatre(er) Center.

In January, Matthew will be off to

Cleveland

to perform in The Wild Duck at The Great Lakes Theatre (er)

 Festival. Matthew received his MFA at Nat ional Thea tre( er)

Con ser va to l y.

| No.* | Abbreviation | Density/ Centrality I | Financial Security II | Isolation III | Long-Term Residence IV | Service Employment V | Spanish American VI | Poor Health VII |
|---|---|---|---|---|---|---|---|---|
| 36 | PRM1ND | .827 | | .292 | | | | |
| 17 | HUSWFE | -.822 | | | | | | |
| 34 | OWNOCC | -.812 | | | .276 | | | |
| 35 | POP | .757 | .295 | | | | | |
| 11 | DENPOP | .738 | | | | | | |
| 46 | WHITEC | .653 | | | .263 | .315 | -.293 | |
| 5 | B1949 | .547 | | | .629 | | | |
| 47 | UNITS3 | .5 | | | -.292 | | | |
| 1 | AUTOFO | | | | | | .322 | |
| 18 | ILT3K | | | | | | .251 | |
| 19 | 17K13K | | | | | | | |
| 3 | AUTOPO | | | | | | | |
| 48 | FAMILY | | | | | | | .421 |
| 49 | POOR | | | | | | .397 | |
| 2 | AUTOF2 | | | | | | | |
| 40 | SPANC | | | | | .260 | | |
| 30 | 06570 | | | | | | | |
| 38 | RT6099 | | | | | | | |
| 41 | UNITS1 | | | | | | | |
| 50 | RELATV | | | | | | | .474 |
| 28 | 01949 | | | | | | | |
| 45 | VLGT25 | | | | | | | |
| 33 | OCCWC | | | | | | | |
| 14 | EDCOLL | | | | | | | |
| 39 | RTGT150 | | .679 | | | | | |
| 44 | VL1520 | | -.628 | | | | | |
| 31 | OCCBG | | -.607 | | | | | |
| 43 | VLLT15 | | -.486 | | | | | |
| 20 | IGT15K | | .434 | | | | | |
| 15 | EMPL52 | | .425 | | | | | |
| 32 | OCCSER | | -.381 | | | | | |
| 27 | NOTEMP | | -.298 | | | | | |
| 13 | ED912 | | .280 | | | | | |
| 12 | EDLT5 | | -.280 | | | | -.349 | |
| 16 | FEMALE | | | .705 | | | | |
| 4 | AUTOP2 | | | -.667 | | | | |
| 47 | BENFIT | | | .592 | | | | |
| 7 | 86570 | | | | -.605 | | | |
| 6 | 86064 | | | | -.661 | | | |
| 29 | 06064 | | | | -.417 | | | |
| 8 | CNEGRO | | | | | .891 | | |
| 10 | CWHITE | | | | | -.865 | | |
| 26 | NEGROC | | | | | .293 | | |
| 9 | CSPAN | | | | | | .783 | |
| 37 | RTLT60 | | | | | | .428 | |
| 51 | WWIVET | | | | | | | .749 |
| 25 | MORTAL | | | | | | | .695 |
| 21 | MARRY | | | | | | | .634 |
| 24 | MORBID | | | | | | | .418 |
| 23 | MOBLE | | | | | | | |
| 22 | MENTAL | | | | | | | |
| % Variation explained by factor | | 13.34 | 11.60 | 7.45 | 6.54 | 6.37 | 6.82 | 4.89 |

* Variable numbers correspond with those used in Table 5.

PAUL SAHRE: EXERCISES IN FUTILITY, PART IV

APRIL 7, 2000 4PM BUNTING 110 M.I.C.A.

FREE

Paul Sahre

Paul Sahre

"Thinking About

Outer Space

Always

Makes

Me

Feel Better"

April

16,

4:30pm

The Dodd Center,

UCONN

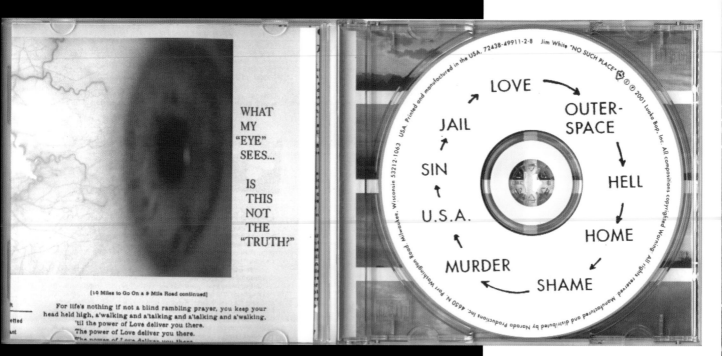

WHAT
MY
"EYE"
SEES...

IS
THIS
NOT
THE
"TRUTH?"

[10 Miles to Go On a 9 Mile Road continued]

For life's nothing if not a blind rambling prayer, you keep your
head held high, a'walking and a'talking and a'talking and a'walking,
'til the power of Love deliver you there.
The power of Love deliver you there.
The power of Love deliver you there

LOVE → OUTER-SPACE
JAIL ↗   ↓
SIN ↑   HELL
U.S.A. ↑   ↓
MURDER ↖   HOME
  ← SHAME ↙

Infiltrate / Paul Sahre

In this matter-of-fact manner, the two officers described an occurrence which is totally inexplicable. Meteors do not hover or shoot upward. No known aircraft is elliptical, and glows bright red in flight, not to mention the observed performance.

JERUSALEM, MECCA, ROME, ELVIS, SHED, PEW

## Man Found Dead On Delivery Van

MERIDIAN, MISSISSIPPI—In a related incident, the lifeless body of O.E. Parker, 43, was discovered Monday morning atop a postal delivery van by startled dayshift employees.

Police confirm that Parker was found clutching in his hand a white plastic bag containing: a black wig, a hat, a silver revolver, a stocking mask, a picture of Jesus, an alarm clock, a roll of white bandage tape, a brown paper bag, and a stamped envelope containing $1,304.87 in cash and coins.

When asked as to the curious circumstances surrounding Parker's death, Deputy Clyde Calaffee replied, "We got it all figured out but the letter. It was addressed to a party in the town of Pensacola, Texas, but when we attempted to contact law enforcement officials there we were told there's no such place."

## HANDCUFFED TO A FENCE IN MISSISSIPPI

I'm handcuffed to a fence in Mississippi. My girlfriend blows a boozy good-bye kiss. I see flying squirrels and nightmares of stigmata. Then awakening to find my Trans-Am gone. Still, I'm feeling pretty good about the future. Yeah, everything is peaches but the cream. I'm handcuffed to a fence in Mississippi, where things is always better than they seem.

*Things is always better than they seem.

I see the guitar that my cousin played in prison, floating with the tv in the swimming pool. I'm calling for the owner of the motel, then noticing the bloodstain on the door. I'm reaching for the shoes under the bushes, just in time to hear the sirens sing. I'm handcuffed to a fence in Mississippi, where things is always better than they seem. (*)

[You know freedom's just a stupid superstition, 'cause life's a highway that you travel blind. It's true that having fun's a terminal addiction. What good is happiness, when it's just a state of mind?]

For in the prison of perpetual emotion, we're all shackled to the millstone of our dreams. Ma, I'm handcuffed to a fence in Mississippi, where things is always better than they seem. (*)

## THE WOUND THAT NEVER HEALS

Long about an hour before sunrise she drags his body down to the edge of the swollen river wrapped in a red velvet curtain stolen from the movie theater where she works.

Quiet as a whisper, under the stanchions of a washed-out bridge she cuts him loose . . . and watches as the flood waters spin him around once, then carry him away . . . Then she removes the gold ring upon her finger . . . and she throws it in. And I wonder:

[Baby why don't you cry? Baby why don't you . . .
Baby why don't you cry?]

Three days later in a bar in southern Mississippi she meets a man by the name of Charles Lee. She introduces herself to him as "Lee Charles". "What a coincidence," he says . . . and one week later they are married. He wakes up one night six months down the line to find her staring at him in the oddest way . . . When he says, "Honey, what's wrong?" she says, "Oh nothing dear . . . except that tears are a stupid trick of God." And by the time they find his body six weeks later . . . Well hell, she's a thousand miles away.

[And I wonder: Baby why don't you cry?
Baby why don't you . . . Baby why don't you cry?]

She runs from devils. She runs from angels. She runs from the ghost of her father and five different uncles. Blinded by their memory, seared by their pain, she'd like to kill 'em all . . . then kill 'em all again.

She don't think much about what she's done or the funny feelings that she feels. No, she don't. To her it's just a condition she picked up as a child . . . a little thing she calls, "the wound that never heals", she calls it, "the wound that never heals."

[And I wonder: Baby why don't you cry?
Baby why don't you . . . Baby why don't you cry?]

## THE LOVE THAT NEVER FAILS

Devils' tools not hammer, nor nails. Everyone loving feels unnamed fears. Call them hummingbirds, 'cause the real words no one can say . . . hey-hey-hey . . . It's not why I'm here, it's who I'm with. From baby's breath to the rattle of death . . . I seek the love that never fails. I seek the love . . . the love that never fails. Oh, beautiful world!

I won't go there. There ain't no room for dreamers in heaven. Silver linings seldom appear— except in horrible storms. See, it's not why I'm here, it's who I'm with. From baby's breath to the Angel of Death I seek the love that never fails. I seek the love . . . the love that never fails.(*) Now hope's a tricky . . . a tricky little snare. I'm stuck on the corner of "Confused & I Don't Know". Been waiting for that long, long, long, long overdue ride home. See it's not why I'm here, it's who I'm with. From baby's breath 'till the final kiss of death. I seek the love that never fails. I seek the love . . . the love that never fails.

Jesus and the fiery furnace. Devil and the deep blue sea. God was drunk when he made me, but that's okay, 'cause I forgive him. [&]

## Doomsday Predicted for Today

Raleigh, N.C. (AP) – Scores of religious fundamentalists are heading an author's predictions that a prelude to Christ's second coming is near, and some are selling their worldly goods to prepare for the end of the world.

The "Rapture" is expected to strike before sunset today, according to the book "88 Reasons Why The Rapture Will Be In 1988," which was written by former NASA rocket engineer Edgar C. Whisenant.

He used mathematical calculations and biblical interpretations to pinpoint the event to the 48 hours of this year's Jewish New Year – 40 years and 180 days after Israel became a nation on May 14, 1948.

According to his book, millions of the faithful will be suddenly, silently called to Heaven this week and global disasters will follow.

In West Virginia, a minister reported a bedlam boom and in Ohio a retired firefighter spent $2,700 for a newspaper ad to tell people that Jesus Christ will return this week to take believers to heaven.

Turpentine, Nebraska, Mississippi, sorrow, freedom, fate, hell, bad luck, good luck suitcases, "the Unknown" tool shed, route, hospital, cemetary, morgue, circus, junkyard, suicide, honky tonk, truck stop, movie theatres, Hollywood, Babylon.

## JIM WHITE
## NO SUCH PLACE

0          9
MILES

## Seedy Character Jailed

A man who robbed several savings institutions armed with a cucumber recieved a 5 year sentence yesterday.

Mark Fitzpatrick, 30, robbed 5 savings and loans by threatening cashiers with a cucumber poked from behind his jacket to resemble a gun.

"Although you knew you were not armed, the women behind the cash counters did not. No one knows what fear you instilled in them," the judge who sentenced him said.

## 10 MILES TO GO ON A 9 MILE ROAD

They tell me miracles abound now more than ever, but I don't care. They say it's better to be blessed than it is to be clever, but I don't care. 'Cause I got 10 miles to go on a 9 mile road, and it's a rocky rough road, but I don't care.

For life's nothing if not a blind rambling prayer, you keep your head held high, a'walking and a'talking
'til the power of Love deliver you there.
The power of Love deliver you there.
The power of Love deliver you there.
The power of Love deliver you . . . you . . .

You don't get nothing for free, 'less of course you steal it, at least that's what the people say. The sad irony of Love is how so seldom you feel it, yet it's all you dream about, night and day. From the splinter in the hand, to the thorn in the heart, to the shotgun to the head, you got no choice but to learn to glean solace from pain or you'll end up cynical or dead. Me, I got 10 miles to go on a 9 mile road and it's a rocky rough road, but I don't care.

## GEOMETRICAL FORMATION CASES

All songs written by Jim White except King of the Road written by Roger Miller. All songs published by Chrysalis EDITIONS SCRL administered by EMI Music Publishing except King Of The Road published by Tree Publishing Co. Inc. /Warner Chappell.
Management: AthenaMgmt/SylviaReach@aol.com

Korenbasha appears courtesy of Cheeba Sounds/Sire. Andrew Hale appears courtesy of Epic Records. Q-Burns Abstract Message appears courtesy of Astralwerks. Schichiro Suzuki (World Standard) appears courtesy of Daisyworld/ Re-wind Recordings.
℗ © 2001 Luaka Bop, Inc. All compositions copyrighted. Warning: All rights reserved. Manufactured and distributed by Narada Productions Inc. 4650 N. Port Washington Road, Milwaukee, Wisconsin 53212-1063 USA. Printed and manufactured in the USA.

Special Thanks to:
Mark (you saved my ass) Robinett for his continued Pro Tools support, Sister Kate, Lori-belle & Tiki-Bird, Yoshi, Jeremy Lascelles, Polly Comber, Kate Cone & CMO, Gerard Mitchell, Roger Davies, Haroumi Hosono, Ani & Goat, Scott Fisher, Jim Fleming, Johnny Dowd for his depressing inspiration, Lenora Hebert, Ryan Carey, Pam Corkey, Melanie Ciconna, Jim Krieg, Tyler Greenwell, Angel Ramos, Richard Osterweil, Poindexter, Einstein Chaumette & Frank Sol, Guy "Alsic Genns" Fisher, Joe Kirkwood, Dr. Alan Adkins DDS, all those cock-eyed fans who supported an obscure album called Wrong Eyed Jesus, and the rest of my friends and supporters whose names escape me at this moment in the conflagration of my personal history.
No Such Place MVP:
Andrew "Downtown" Hale. God bless you, sir.

## CORVAIR

| SHAPE | |
|---|---|
| Disc | Sunlight in the weeds . . . I wish that I was blind . . . to the ghosts dancing in the breeze . . . blowing through my mind. |
| Disc | |
| Oval | CHORUS: Got a Corvair in my yard. It hasn't run in fifteen years. It's a home for the birds now. It's no longer a car. |
| Unspec. | |
| Disc | Last night I dreamed that I was swimming in a sea. Like always, with everything I want in too deep. (CHORUS) . . . Got a simple friend out west, and in the blink of an eye, I'd swap him straight, his life for mine . . . and never wonder "Why?". (CHORUS) |
| Spheres or discs | |

WHAT MY "EYE" SEES . . .

IS THIS NOT THE "TRUT

[10 Miles to Go On a 9 Mile Road continued]

| COLOR | |
|---|---|
| Silhouetted | For life's nothing if not a blind rambling prayer, you keep your head held high, a'walking and a'talking and a'walking, |
| Brilliant | 'til the power of Love deliver you there. |
| Unspec. | The power of Love deliver you there. |
| Red-purple blue-white | The power of Love deliver you there. The power of Love deliver you . . . THERE!!! |
| Blue-white | Sometimes you throw yourself into the sea of faith, and the sharks of doubt come and they devour you. Other times you throw yourself |
| Silvery | into the sea of faith only to find the treasure lost in the shipwreck inside of you! There ain't no guarantees, none of that nonsense like |
| White | on tv, just gotta roll the dice, and take your lumps. You're gonna get yourself knocked down, so better learn to stand back up, for those who dwell on disaster let sorrow be their master. Me, I got 10 miles to go on a 9 mile road and it's a rocky rough road, but I don't care. |

'Cause life's nothing if not a blind rambling prayer, you keep your head held high, a'walking and a'talking
'til the power of Love deliver you there.
The power of Love deliver you there.
The power of Love deliver you there.
The power of Love deliver you there.

My buddy Phillip works as a gas station attendant. Strangers call his name to him a thousand times a day. They don't know him, they're just asking "Phillip" for a "fill-up". Funny how fate plays tricks on us . . . that way—through the power of Love . . .

"These things in the sky"

## Track Listing

1. Handcuffed To A Fence In Mississippi
2. The Wound That Never Heals
3. Corvair
4. The Wrong Kind Of Love
5. 10 Miles To Go On A 9 Mile Road
6. Christmas Day
7. Bound To Forget
8. God Was Drunk When He Made Me
9. King Of The Road
10. Ghost-Town Of My Brain
11. Hey! You Going My Way ???
12. The Love That Never Fails
13. Corvair Reprise

① ② ③

6:00    :05     PHASE
CHANGE-OF-PHASE

BIRTH
DEATH
REBIRTH
REDEATH

Texas · Love · Selma · Home · Cleveland · Hell · Death · Friendship · Angela · The South · Cash · Safety · I.O.U. · Mind's Eye · Car · Sorrow · The Devil · Georgia

## GYRATING LIGHT

"My guiding principle for many years was the famous closing line from William Faulkner's The Wild Palms, which stated, 'between grief and nothing I will take grief.' One day I confessed this sad truth to my mysterious friend, Diego Riswald. For a moment he stared at me, as if in a daze, then suddenly he started laughing uncontrollably, replying, 'Okay, man, but for me the prospect of 'nothing' is so much more interesting.' To this day Diego's laughter rings happily in my ears. Thank you sir. —JIM WHITE

ed through Mr.
is the fulfill-
lling is wrong,
s or by lethal

country today,
ened.

ROB HAM
., June 12, 2001

Timothy Mc-
e 11):
ciety, we must
he valued the

tion that I and
low citizens do
as deeply as
s, Amnesty In-
st of the liberal
ch I am a part-

thy J. McVeigh
ne sacrifice is
way of saying
the lives they

olence"; this is
brate; this is a
tful response.
s.

CLARK N. ROSS
., June 11, 2001

for Oklahoma
ge, June 12):

The execution of Timothy J. McVeigh on Monday was accompanied by widespread contempt at his lack of contrition; but really, did we give him time to begin to change from the person who detonated that bomb?

Soul-searching is not an overnight process, and we cannot have it both

June 11, 2001 7:10 a.m.

June 11, 2001 7:14 a.m.

Paul Sahre

ways. We can either speedily execute, or we can force violent offenders to spend decades staring at walls, locked up with their minds.

I believe that a deeper, more appropriate punishment almost always accompanies a life sentence: the perpetrator eventually confronts the

o the Edito
It is an
million law-a
to the intelli
suggest that
to blame fo
inflicted by
("History a
editorial, Ju

While ant
promoted t
that violent
guns are cau
but by the gu
elevate this
ascribing th
ing to the fa
a gun owner

Director

To the Edito
Morris De
execution w
McVeigh int
right ("The
rorism," Op

Yet given
Investigation
ments relati
tigation, and
Veigh's was
tion since 1
imagine his

The
History of
Western
Philosophy

Bertrand
Russell

FIRE IN A CANEBRAKE

The Last Mass Lynching
in America

By Laura Wexler

THE BODY

HANIF KUREISHI

A conversation with Stefan Sagmeister, principal, Sagmeister Inc.

Gelman: You've been always very articulate about your design philosophy and the criteria you apply to your own work and the work of others. It's been a year since you've returned to work for clients. I'd like to hear about your experience, what you've learned, and what you are up to at the moment.

Sagmeister: That's a difficult setup; now, of course, I have to be articulate. We took this year off, starting last October. So it was a strange time to be restarting because it was the October after the September. During the year I had thought about what I want to do with the studio, or in what direction it should go. There were a couple of things that I knew very quickly that were going to stay the same. Mainly that we still didn't want to grow. The size was something I was very happy with. I think what I was not so happy with was the incredible concentration we had on music before.

Gelman: It seems that was your goal.

Sagmeister: At that time, yes.

Gelman: You were looking for it. And then found yourself working exclusively on CD packaging?

Sagmeister: When I opened the studio, the subtitle was "Design for the Music Industry." And that's what I wanted to do. And maybe under the heading "Be Careful What You Wish For," in the end we did mostly music. While, in general, the music industry has been great for us -- it was dusty has been great for us -- it was responsible for us being able to make a little name for ourselves; we survived well in it and met very interesting people and all that -- but I think there were a couple of reasons I was looking to be eager about other designs. One was, for sure, that packaging itself becomes less and less important due to MP3s and therefore the record industry doesn't take it as seriously anymore. Some of the advantages are not there anymore. I always loved CD packages because it's one of the few that doesn't get thrown away.

Gelman: Record labels don't rely on the design when selling records as much as they use to.

Sagmeister: It's eroding, it's eroding. And in general it just also became more boring. Not necessarily the format. I always enjoyed the small format and its limitations. But there is always a danger in the music industry of working for three clients: the band, their management, and the label.

Gelman: So many good ideas are being killed one way or another.

Sagmeister: Well, there are always similar political problems; once you've been through them numerous times, it becomes boring. It's like, "Oh, that again." At the same time I still love many of the challenges. I still love trying to come up with an idea or a concept by listening to music. I still love the visualization process. I still love music in general. But I decided to reduce its place in the studio. Instead of doing it all the time, we would do it a third of the time. And another third would be projects that interest me politically or that I find socially relevant, and last third doing straightforward graphic design, corporate design, to pay for everything. That was the plan.

Gelman: Did you accomplish that proportion?

Sagmeister: Basically. Actually, we almost overdid the music reduction. The way it turned out now is maybe 20 percent music and the other two are 40-40. There were a couple of surprises in there; one of the jobs that I took on for the money, our first annual report ever, turned out to be one of my favorite projects of the year. Both in the process, how we worked on it...

Gelman: Pretty lucky client.

Sagmeister: I don't know about that. I like to think they see themselves as lucky. They love the outcome. It's a company in Austria, called Zumtobel; they are an international lighting company, so they make lights for architectural purposes. I like what they are doing, meaning I love the company. I think they make a good product. And it's not that difficult to do an annual report for somebody who makes lights. There is a rich...

Gelman: Well, there is something to start from.

Sagmeister: And it was just a pleasure. I found, maybe after all that music, because of course the CEO was involved, I found it so easy to do. You talk to one person. You present it, they say yes and then everything falls into place.

Gelman: Well, it was probably the same experience in music when you dealt with artists who were in charge. Lou Reed or David Byrne, for example.

Sagmeister: Yes, exactly.

Gelman: Then there are no other layers there. If he wants to go with your idea then everything is okay.

Sagmeister: If that artist is with a company that lets them be in charge. You know, because there are famous artists out there that are not in charge.

Gelman: Like who?

Sagmeister: Well, we really ran into problems with Aerosmith.

Gelman: Yeah, I was going to ask you about this, sometime down the road. It's not in your book and it has been kind of erased from the history.

Sagmeister: Well, the reason of course is I would have loved to talk about it...

Gelman: You're not free to talk about it?

Sagmeister: You know there is some dispute over that.

Gelman: Has it been settled?

Sagmeister: Yeah, yeah, yeah. A long time ago. But they definitely did not want to be part of the record. They were the only client that refused to have been a part of the book. And legally even that could have been a dispute, but we had so many problems at that time that I had no desire to get into any fights with anybody.

Gelman: You prefer to not talk about it.

Sagmeister: I can tell you the whole story. I'm not sure I would be allowed to talk about it on the record. Meaning like I don't...

Gelman: Well, we can cut some stuff from the interview.

Sagmeister: But you know, I can tell you the Aerosmith story...

Gelman: I heard that story from Chris Austopchuk when it was still happening. So I don't know the ending. They sued Sony music?

Sagmeister: Well, I'll tell you the whole story, but I don't think I'm free to talk about it for the book.

Gelman: Sure, we'll talk about it off camera. But in general, do you feel that the more important the project is, that the more parties are involved and money, the less control you have and the possibility of doing good work lessens?

Sagmeister: I think that's been our experience so far. The more money involved.

Gelman: Always?

Sagmeister: There were some exceptions this year, but in general, my experience has been the more money is involved, the more people want to be involved, the more scared people are, the more difficult it is.

Gelman: The risk is high, so everyone is freaking out.

Sagmeister: Yeah, but this year we luckily had some different experiences. I think in general that probably everybody's experiences are the same, which is why many film directors find it easier to do a small movie rather than a really good large movie.

Gelman: Hollywood versus independent film.

Sagmeister: It's the same deal. Yeah. I see one good big-budget movie every five years. And I have incredible respect for those people who are able to pull it off.

Gelman: Yeah, because when you have to spend a lot of money you need to get approval of focus groups and such. In the end, any idea is watered down to something not very interesting.

Sagmeister: I have incredible respect for the people who are able to pull it off. And it doesn't matter the medium. Matt Groening with the Simpsons is unbelievable to me -- and on Fox TV.

Gelman: Who else?

Sagmeister: There are numerous examples out there that became really big and were of really high quality. [Maya Lin's]

Vietnam Memorial is one. For me the St. Louis Arch is another. It is totally popular, and, as a piece of architecture, totally beautiful. I think that would be the goal: to work to create something that is large and of high quality. Which I haven't quite --

Gelman: You could decide to grow the company, to, let's say, the size of Landor, with offices all over the place and still make good work.

Sagmeister: Yeah, but I have no desire to do that whatsoever. I think you can do large projects with a small company.

Gelman: Absolutely. A small company is much easier to control. If you have to staff your company with 50 people it's very hard to find 50 brilliant designers to work under one roof.

Sagmeister: Yeah, and I just found that if I want to grow the company, the act of growing it is so time consuming. And as the owner of the company you have to be involved in the growth of it and in the presentations. At least in my experience; I haven't found a way to not be involved and I had a larger company in Hong Kong. It was not mine but it felt like mine under the wings of Leo Burnett. But it felt like my design group. And I became a manager, a very silly manager. You know, you manage 10 people in a design group which, in the management world, is the stupidest management there is. If you really want to be a manager, go to Merrill Lynch and really manage something. At the same time I really do think it's a challenge to do things that are big and have high quality. You know like that whole group of European designers, specifically my age and older in that whole poster design, I mean you know it very well, from Eastern Europe westwards, the entire poster-festival circuit thing. Look at many of those posters: They're silkscreened in low quantities, and half of them are sent off to be part of design competitions. And in general I think it's all fine, it just seems like such a waste of talent. You wish they would design the stuff that's in the supermarket.

Gelman: Yeah, but somehow the supermarket is not trying to find those designers. Those designers are not trying to get into the supermarket. Maybe they are?

Sagmeister: They probably don't.

Gelman: There is a disconnect. And I'm not talking about just those poster designers but designers who do some good work and companies that produce and sell.

Sagmeister: Well, I think in general there's obviously room for both. And it's necessary that both are there. I think what I am sad about is that there seems to be a pretty clear distinction now. So that all the stuff that's being printed a million copies and over is done by marketing idiots that don't give a shit about how it looks or its effect on the world. And everything that's printed 500 and less is done by people who care about how things look, where they come from and all that. And it just seems that the cultural impact of the former is just so much higher than the cultural impact of the latter. And I would be very disappointed if the latter group becomes another little ghetto. Like the contemporary art market becomes a ghetto, the quality of which I love. For me the most interesting artwork in the art world has been done in the last 10 to 15 years, in the 20th century. But at the same time it is part of the fabric of society in New York and in London and nowhere else. And I think that's a pity because other art forms are not so detached. Music is not really removed. There's a certain kind that's removed, but in general there's high-quality music out there that is not removed from society.

Gelman: Well, graphic design is not removed. By definition it shouldn't be removed. But somehow it's getting...

Sagmeister: Well, it's splitting up in some ways. And I would wish that there would be a lot of people who try both. Well, let's say, like Soderberg as a film director who makes a big movie and a small movie. He would be one of the directors whom I most respect, keeping the whole thing connected.

Gelman: Yeah, that's a great goal. Let's talk about the Internet. The dot-com boom was a very exciting time for designers. Designers were making money. Companies were hiring right out of schools, paying huge salaries. Somehow design became important. People on the street knew what design was. During that time you were very active. At the same time, it was the reality of the companies who were expanding, adding ".com" to their names, buying and merging. You weren't really a part of this whole Internet explosion.

Sagmeister: No, not at all.

Gelman: And you never even had a website. Your e-mail is still at AOL.

Sagmeister: It will change though in two weeks, finally.

Gelman: Are you ready to have a website?

Sagmeister: Well. I think what happened in our case was that somebody else, there were a couple of other people out there who did websites with our work. I never paid much attention to them and recently I've heard quite often from people "Oh, I saw your website."

Gelman: How did you feel about that?

Sagmeister: Well, not good, because we didn't design those websites. And I would not have designed those websites like those people did. Basically, that was the main reason we were forced to do our own website -- so that we are represented in a way that we can live with. We are working on one right at the moment and it will be up in a month or so. Roughly.

Gelman: What's the URL?

Sagmeister: sagmeister.com.

Gelman: How did you manage that so late in the game?

Sagmeister: We had to buy it.

Gelman: Really?

Sagmeister: Yeah, we had to buy it from some Swedes who owned it. And in general we were not part of the Internet boom. I followed it closely because one of my best friends was an extreme part of it.

Gelman: Robert Wong, of course!

Sagmeister: So I had a little inside view from the front lines there. But we were surely not part of it. We had several clients who asked us to do their websites and we said, no.

Gelman: Well, you didn't have the capability and you didn't want it.

Sagmeister: Yeah, but you know, designing websites is not a difficult capability to get if you are interested in it.

Gelman: Sure!

Sagmeister: It was literally just a decision based on that I was just not all that interested in designing for the screen. And even to this point.

Gelman: Still not interested?

Sagmeister: I use the Web like everyone else. I'm on Google daily. And I find aspects -- well, I find everything about Google and other aspects of the Web very handy and comfortable. As far as designer websites are concerned, my God, they are horrible. When we designed ours, I actually thought, well maybe I should write down 20 designers I like and look up their websites. So I wasn't looking for website designers but for designers who have websites. And I was finished after five. Meaning I couldn't do it anymore. So I had the intern...

Gelman: It was so bad?

Sagmeister: It was unbelievable -- all these idiots who think that they have to reinvent how to get into their site. I mean the stupidity is mind-blowing. I mean it's literally...

Gelman: I know what you're talking about.

Sagmeister: It's like designing a book -- not even a book because at least with a book you have some incentive to open it -- let's say you design a brochure for your company yet first you have to find out, through trial-and-error, a complicated folding system that takes you five minutes before you are able to open the brochure. And then it's just bullshit inside. It's not like there's a clear advantage for you as the viewer to actually jump over that hurdle of how you get in there.

Gelman: So you couldn't find a single website that you were happy with?

Sagmeister: I mean there are websites by people who are known for their screen capabilities that are nicely done. Like your friend John Maeda's site.

Gelman: Actually, his website never had any navigation.

Sagmeister: Maybe that's the advantage.

Gelman: It was just a bunch of links.

Sagmeister: But maybe that's the advantage. Because I think when...

Interview continues at:
http://www.infiltratenyc.com/019

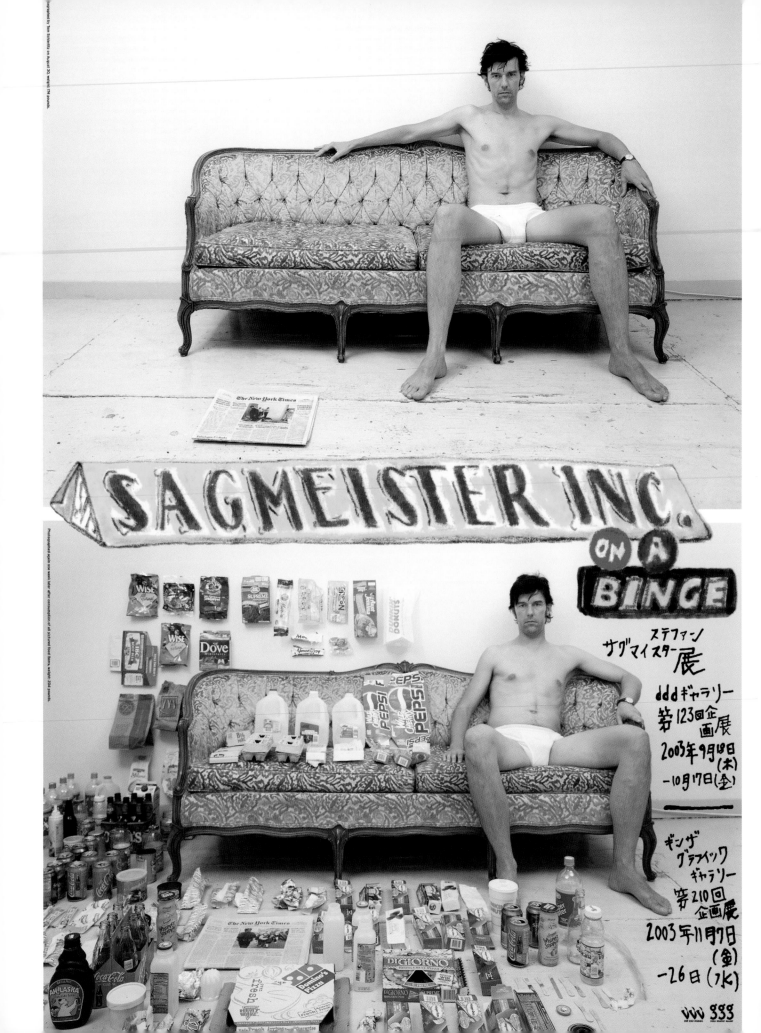

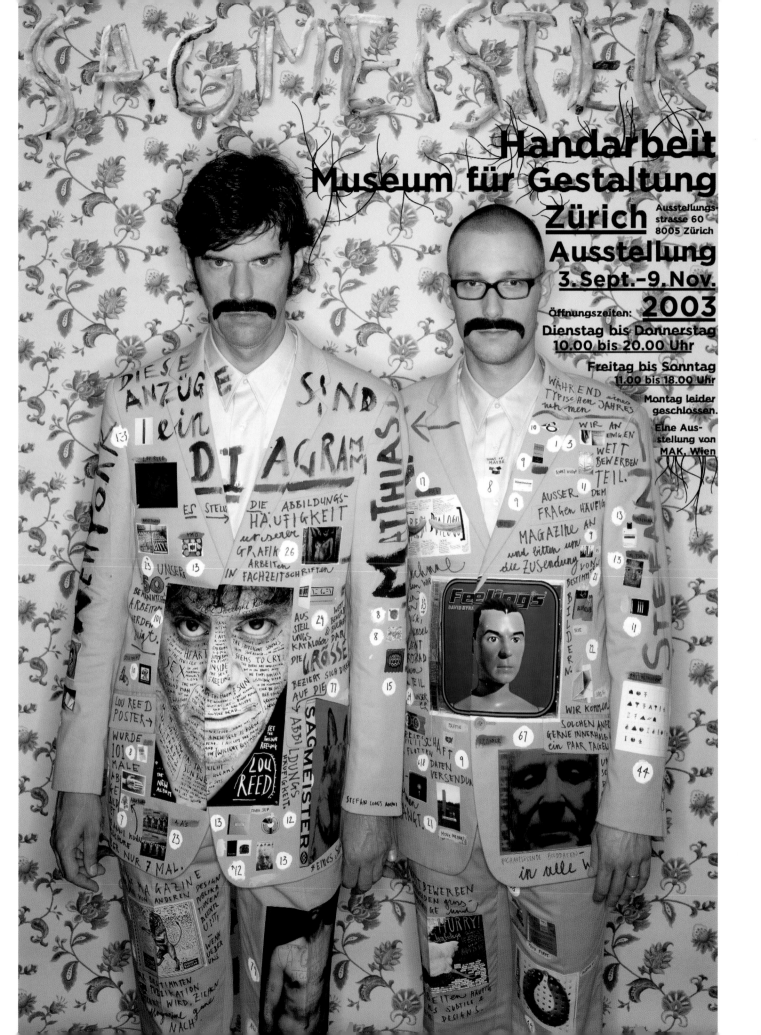

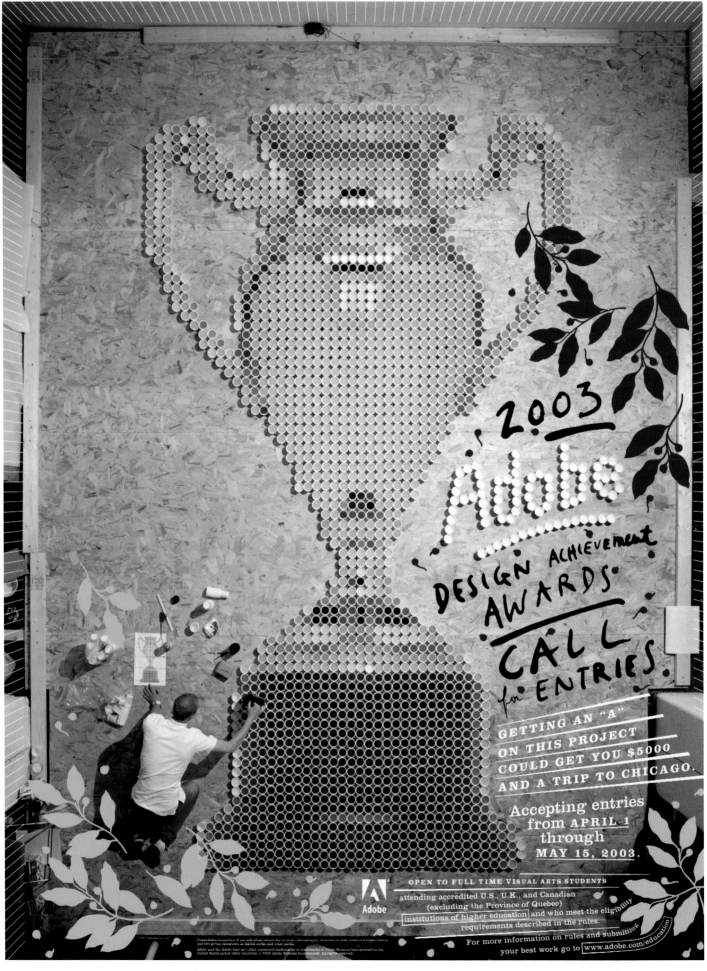

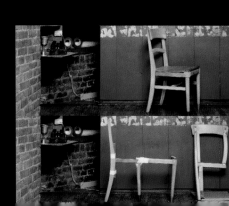

Page 242. Sagmeister on a binge, Japan, 2003. Client: Sagmeister. Designers: Stefan Sagmeister and Matthias Ernstberger, Miao Wang, and Gui Borley, Tokyo. Art Director: Stefan Sagmeister and Matthias Ernstberger. Photographer: Tom Schierlitz. A poster advertising design exhibitions in Osaka and Tokyo with a classic before/after situation. The top picture shows Stefan Sagmeister at 178 pounds, the bottom picture shows him one week later, having consumed all the shown food items and gained 25 pounds. Page 243: Sagmeister poster, Zurich, 2003. Client: Museum fuer Gestaltung, Zurich, Switzerland. Art director: Stefan Sagmeister. Designers: Stefan Sagmeister and Matthias Ernstberger. Photographer: Bela Borsodi. Poster for a design exhibit in Zurich. The suits represent charts showing the number of times any Sagmeister, Inc. design pieces have been pictured in design magazines. The larger the piece appears, the more times it has been published. Page 244: Adobe Design Achievement Award poster, 2003. Client: Adobe Systems. Art Director: Stefan Sagmeister. Designer/Illustrator: Matthias Ernstberger. Photographer: Zane White. Pages 246-247: .copy magazine spreads, 2003. Client: .copy magazine. Art director: Stefan Sagmeister. Designers: Matthias Ernstberger, Miao Wang, and Stefan Sagmeister. Photographer: Bela Borsodi. Page 248: Zumtobel annual report, 2002. Client: Zumtobel AG. Art Director: Stefan Sagmeister. Designers: Stefan Sagmeister and Matthias Ernstberger. Photographer: Bela Borsodi. Prototype: Joe Stone. Zumtobel is a leading European manufacturer of lighting systems. The cover features a heat molded relief sculpture of five flowers in a vase, symbolizing the five sub-brands under the Zumtobel name. All images on the inside of the annual report are photographs of this exact cover, shot under different light conditions.

247

A conversation with Glen Cummings, principal of Scanography.

Gelman: Looking at the tools you're using in your design, like scanners and paper shredders, and the ways you utilize different machines or sometimes people to create your design, it seems that you are trying to avoid any kind of presence of a personal touch in your work.

Glen: In graduate school, I became very conscious of how tools unintentionally influenced what I made. Sometimes this influence was good, but usually not. I would try to say one thing, but the tool would imply a second thing that had nothing to do with the first. You can't stop tools from speaking, but you can choose ones that say something helpful. I chose devices whose processes added a layer of meaning. Usually these procedures functioned as metaphors. If I design a poster by shredding type, it looks a certain way, and also might carry a reference to document security practices. I don't have to convey those ideas with the arrangement of images and words on the page. This design process conveys a story so that the arrangement of things can do less, or something different. Choosing tools can be very personal.

Gelman: And also it keeps you from making your own subjective decisions about the final outcome. Is it kind of a way to avoid responsibility?

Glen: It's a way of not getting hung up on very small aesthetic decisions by designing a situation that plays itself out. It's a way to be a fan of the outcome instead of becoming too attached.

Gelman: When you set up the situation and then let that situation play itself out, you create a certain distance that allows navigation on a different level.

Glen: One way is by comparing directing to acting. You don't have to act to express something, you can organize in advance and then allow the performance to happen, adjusting things slightly as you go along. The main thing is to plan the progression, choose the performers, set the scenes and then help it along... instead of playing every role yourself.

Gelman: You were doing a lot of different things before becoming a designer. Can you talk about how you came to graphic design?

Glen: First I studied engineering at the Cooper Union, then painting at SUNY Purchase. I played music at the same time. I would study, then drop out when I landed record deals, or tours. I wrote songs, recorded and produced six records, toured the US, Europe, Australia, etc. Some records were for labels, some I would fund and release myself. I wound up living in Nashville, Tennessee, after 10 years of playing music. I thought I'd like to do something else, and also eat every day. Returning to engineering wasn't attractive, nor was painting. Design seemed to have the best of both.

Gelman: What kind of painting did you do?

Glen: Figurative. Narrative frames, really large.

Gelman: Oil on canvas?

Glen: Yes. I thought, if I have a career in music that's not going anywhere, then I don't need two more careers that aren't going. <Laughs> I used to buy and sell instruments from the classifieds. Right next to the musical instrument section was a computer section and I started looking at computers and I thought, I could sell a guitar, buy a computer and do some graphic work. I could...

Gelman: Third career?

Glen: Maybe I could develop a third career that won't go anywhere? Actually I felt very excited! My introduction to music was buying a guitar and figuring out what to make with it. My entry to graphic design was to buy a tool. My first "design" job was managing preproduction for a magazine, and later designing it. When I first interviewed they asked, "Can you run our drum scanner?"

Gelman: Did you have any concept what that was?

Glen: No, but I said, "Yes, I can run it." You just figure it out. So I designed there, worked as a designer/art director in advertising, moved to Chicago and worked for some inspiring people at Studio Blue. Designing came together quickly because it can be a lot like making music: composition, balancing things, and pacing. My work now is visual instead of sonic. So that's my winding path.

Gelman: But then later on you were able to integrate your music knowledge and experience into your design work, like the piece with electric wires. The train piece.

Glen: Yeah, that was big for me.

Gelman: The time came to combine your experiences.

Glen: I finally realized that I only do one thing, in different mediums: designing, painting, engineering, or guitaring.

Gelman: It all collapsed together!

Glen: I don't know if I've ever showed you any of the video work I was doing two years ago. They're short, fast, infomercials that explain complicated things in a purely visual way. They are also very self-referential. So after making these 30-second pieces I stepped back and thought, wait, I've controlled every single aspect of this, the video, the sound, the color, the pacing, the editing -- it was so incredibly constructed when I finished the project. I had to find a way to do the exact opposite. The first attempt was "Between Stations." I planned, recorded video, modified a program to play certain videos as sound. Let the camera deal with the wires, let the program play the video. It's beautiful.

Gelman: Basically you wrote software that can read musical score from the video.

Glen: The challenge was to modify software to read a video of electrical wires moving up and down, which looks very musical, as a composition. To play in key, to count measures, progress.

Gelman: When did you start doing all this scanning? Taking a regular flatbed scanner with you and scanning grass, people, sky... was it after that?

Glen: Much earlier. Before "Between Stations" there were almost two years of free experimentation. One morning I took a scanner and turned it sideways to make an image that defied gravity. You only ever see images made with a scanner facing up. What I got was an image that defied gravity and time! I made an image of water pouring into a cup, but because the technology works in certain way the surface rises diagonally. It's really nice. Six months later a friend bought a portable USB scanner so he could go to the library and scan from books without having to check them out. Well if you can take a scanner to the library then you can take it to the park or the beach. I was looking at some NASA photos of the surface of the moon. I became interested in how you could document "the surface of something with a limited "alien" technology. If you make images of a surface, it's already going to have a point of reference. Upon beginning I found that there were other interesting aspects. One oddity was that the scanner controls the light directly under itself, but around the edges exterior light leaks in, so there is constant variation. That led to the grass scans.

Gelman: Depending on the clouds...

Glen: Depending on the clouds, if people walk past casting shadows, the edges of the scan change. You can see it as a shifting strip of light. There was a lively duality to that process.

Gelman: So by looking at the final image you can tell that when you started scanning it was sunny and then there was some kind of shadow or cloud. What's interesting is that the scanning process is really the capture of a certain period of time, and it's not immediate. The beginning of that scanned image and the end of it are different in time.

Glen: Yes.

Gelman: And there are a lot of interesting discoveries in your work of that nature.

Glen: When designers incorporate traces of their processes, work becomes self-indulgent. So how can you induce life without showing the eraser marks or getting personal? For me a machine can get personal, telling all about its role in the process and also making a rich thing.

Gelman: Tell me about your experiments with typefaces.

Glen: Yes.

Gelman: Which one?

Glen: Well my favorite is the Helvetica that you scanned with a different angle. What's interesting to me is that it's really kind of a joke. You can probably elaborate on this...what's interesting to me is that you are changing the angle of the pixel from A to Z and it makes the

Interview continues at: http://www.infiltratenyc.com/020/

Swiss Posters

1950 ——————— 2002

October 21 ——————— November 11  2002

# Helvetica Disoriented

ABCDEFGHIJKLMNOPQRSTUVWXYZ

abcdefghijklmnopqrstuvwxyz 0123456789

BUILT BY BLLhCUAAIhOS

Page 249: Swiss Posters poster, 2002. Designer: Glen Cummings. Production: Silkscreened by ABArt Inc. Poster for an exhibition of Tom Strong's Swiss poster collection. The poster's grid stretches to illustrate the timespan of the collection. Pages 250-251: Helv Disoriented/Go Fuck your Grid font and poster, 2001. A font based on Helvetica in which no two characters share a common grid. Page 250: Brixel, 2001. Production: Created in Adobe Illustrator/RoboFog. A font physically constructed with children's blocks, photographed and then flattened into 2D characters. Page 251: Helvetica Neue R Scanned Glen Cummings (font family), 2002. Client: Paul Elliman. Production: Created on a Cannon Canoscan flatbed scanner and Adobe Illustrator/RoboFog. HNRSGC is a family of nine fonts made by pulling Helvetica across a scanner bed at nine different speeds. Pages 252-265: Scan (book), 2002. Production: Made with a large-scale flatbed scanner, QuarkXPress, Staples computer paper and an Epson 1280 inkjet printer. A two-year investigation into processes and ideas implied by the visual language, and optical mechanics of the desktop scanner.

SCAN

01

02

Infiltrate / Scanography

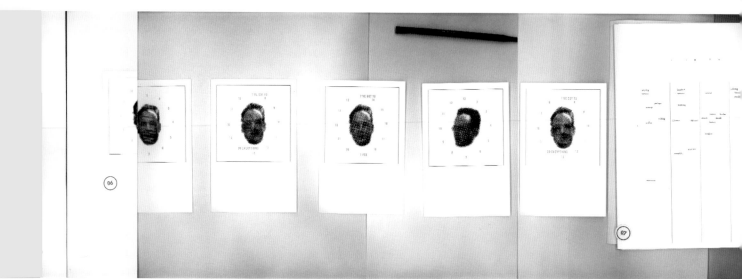

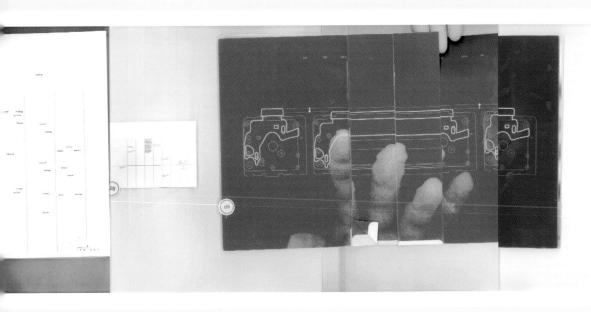

all school lecture
yale university school of art

# ELIZABEETH
# MURRAYY

6:00 p.m.
weds. feb. 28, 2001
yale university
art gallery lecture hall

1111 chapel street
entrance on high street
for additional information
call 432-2606

SHIRIN N[
TUESDAY, APRIL 3, 2001 / 7:00 P.M. IN THE SMART R

# PAUL MCCA

¡Lucha De Toros!
¡¡En El Patio De Toros!!
4 FUENTE FAMILIA
BY 640 X 480 FFOUNDRY

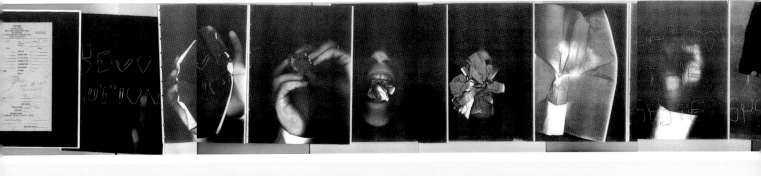

CORRIDA FAMILIA FU
RONDA DE TOR
FCO. RIVERA "PA
¡PLAZA DE TOR

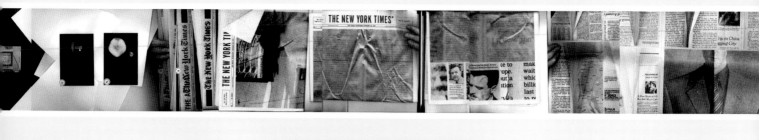

# 8 Minute Book

This is R__ The tran__

Rebecca Ross' Thesis Slide Show originally delivered at Yale University School of Art on the Seventeenth of November, 2001. __ formation from physical page to digital file was calculated to take eight minutes, the __ e original presentation's exact duration.

ONE WOMAN
THREE CHORDS
OCT 4-6, 01 / 8:30 & 11PM
DOORS OPEN AT 7 AND 10PM
203.432.1566 FOR RESERVATIONS
YALE CABARET / 217 PARK STREET
WWW.YALECABARET.ORG
GO UNDERGROUND

__OMAN
THE CHORDS
OCT 8:30 & 11PM
7 AND 10PM
203.43__
PARK STREET__
YALE CABARET.ORG
GO U__

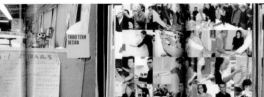

OUR SENSES EXPERIENCE
ONE TIME
WHILE OUR MINDS
THINK
ANOTHER

THREE
TWELVE

SEVEN
PM

DO WE REALLY
TELL TIME
BY THE NUMBERS T
HE HANDS GESTURE
OR BY READING
CLOCK'S ANGLES?

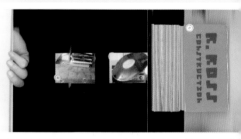

FEEL TIME & CLOCK T

*What*

*Times*

ARE IT?

50% DAY
50% NIGHT IS
A LIE

D YNIGHTTIM

DAYTIMENIG

PM
=ISH

RE
E

IS THERE
ANOTHER WAY
TO ILLUSTRAT
THIS SITUATIO
WITHOUT USING
A CLOCK?

DON'T ORBIT
AROUND ONE CENTEF
OUR SOLAR SYSTEM
HEN WHY DO WE
REPRESENT TIME
THAT WAY?

TREE,
MEE?

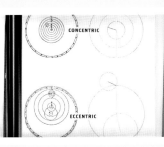
CONCENTRIC

ECCENTRIC

THAT EVERYTHING IS CONNECTED

Phone
none

Phone Phone

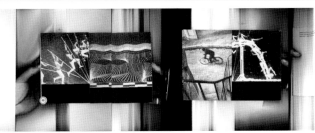

Yea        ok      omer      NayNo

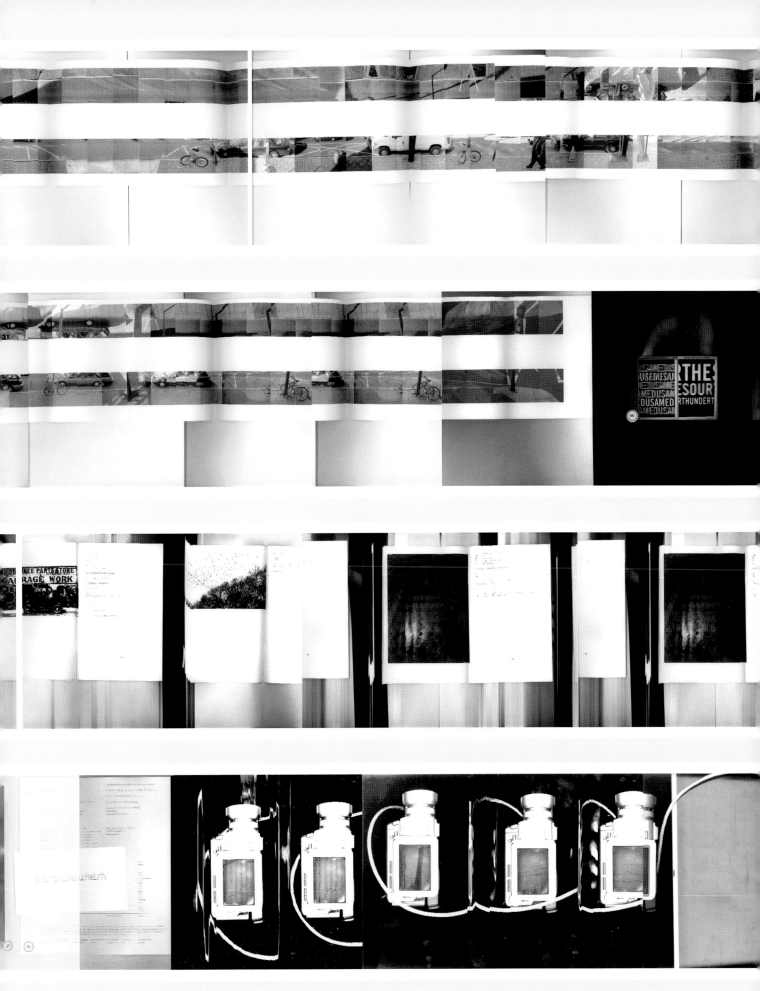

ER CAFE

Bought & Sold Everyday
Open 7 Days

ven ..... 787-6147

72

---

In applying for the Alice Kimball English Traveling Fellowship, I want to take my scanner thesis on the road. I intend a employ a car, digital video camera and portable computer to scan a strip of the country. Instead of traveling to a final destination, I would use the process of my traveling as an opportunity to make a final work. I propose a one-month car trip across the United States beginning in New York and following a single latitudinal line west, during which time I would visually document, and sonically translate, my surroundings from this constantly changing point of view. The final work would be an audio visual document, as well as a piece of software which enables a automobile driver to hear the landscape which they are currently driving through.

My thesis analyzed the desktop scanner considering the implications of a single lens which moves across a defined field translating it into a digital file. In my thesis I describe the cumulative image that the scanner produces as being like the memory one has of a place after traveling through it by car. The terrain is never seen in its entirety, yet a mental image is constructed from multiple moments, and perspectives, that linearly extend across that terrain.

One of my final thesis projects was to author a piece of software that converts landscapes into music through the use
of a video camera and a moving vehicle. It is in the process of moving past the landscape that music is created. In this project, riding the train became an equivalent of scanning. The passenger experiences the landscape as a 'scan' through the window of the train.

I want to take my software for a trip across the country, letting it computationally translate a strip of America into songs which reveal the structure of the country as seen from a moving vehicle. This would not be an interpretive work but rather a direct sonic translation of what already exists. I foresee this project culminating with an exhibition, and with the release of the software I am currently refining.

Robert Frank's *America* and Walker Evans' *American Photos* are the second sources of inspiration for this project. Both Frank and Evans traveled from town to town stopping to take still photographs, which were ultimately made public through books. Unlike Frank and Evans, my work will be made from a moving vantage point, and the results will be made public, as software.

I hope I am chosen to receive this honor, and am grateful for the opportunity to submit this proposal which claims 'graphic design' is an activity that exists outside the walls of the design studio.

Gln Cummmmmings

UNITED STATES

73

A conversation with Young Kim, principal, Suitman.

Gelman: We met in Japan several years ago at Wieden+Kennedy. After that I saw you here and there. Recently I found out you're back in New York and heard about the Hungry Man and Alife. After all this transcontinental changing places and roles, help me put the pieces together.

Young: Since I saw you in Japan?

Gelman: Before and after.

Young: I'm Korean-American. I've been here some years. I was raised in a very strict and traditional family, where I was expected to go to school to become an engineer, or a doctor, or a lawyer. When it was time to go to school, I really didn't want to work in any of those fields. I wanted to do something more creative, but as the oldest son, I had family responsibility. I chose architecture and engineering. I have a degree in architecture and engineering. I worked for about a year in Boston and had a change of heart. I was 21 years old, kind of lost, didn't want to work.

Gelman: Twenty-one is a little early for a mid-life crisis...

Young: Yeah, I took some time off and just traveled cross-country. I just hitchhiked cross-country. I just traveled for about two years, doing odd jobs, construction work, and then decided to go back to school, at the Massachusetts College of Art, and spent about three years there. I got out with a Bachelor of Fine Arts, again found myself out of a job. I couldn't do anything with my BFA degree. That was around 1986. That was when I first showed up in New York from Boston and I just started doing odd things. I knew I wanted to be in the creative industry, so I started freelancing for magazines. I was very lucky, ambitious, and hungry. I got into DoubleSpace and became a designer there for like two or three years.

Gelman: I didn't know you worked there.

Young: Then I saw an ad in a music magazine, Ear, looking for an art director. They gave me a chance. I had two jobs, working at DoubleSpace during the day and then at night I'd run over and start putting out this music magazine. I was trying to get as many jobs as I could. From there I went to a fashion magazine. There was a very famous French magazine art director, Guillaume Bruno. He did French Glamour, he redesigned Mademoiselle here. I started as his apprentice and worked my way up and became a design director. I started redesigning magazines, I worked on the New York Times men's fashion supplements for a couple of years with Carrie Donovan and Hal Rubenstein. Then I went to Wieden+Kennedy in Portland, Oregon. I didn't know anything about advertising; Not a clue. I had done a lot of freelance work for Bloomingdale's with John Jay. When John went to Wieden+Kennedy, he asked me to come. He gave me a chance.

Gelman: So you went to Portland.

Young: Yeah, Portland. I had no interest in advertising. Until then, I was kind of lost -- I knew I wanted to do my own work, get back into creating my own art. Then I got a call from Wieden+Kennedy. So I decided to make that move; they told me that they wanted me to spend time in Portland to get to know the spirit of the firm. I spent about a year and a half there. I did a few national campaigns for their largest account, then they asked me to start an office in Tokyo.

Gelman: At McCann's office?

Young: Yeah, basically it was complicated because American companies can't just go into Japan and start operating and start doing business. There are a lot of complicated things such as media buying. There are three major TV stations and if you're a foreigner you can't buy media directly.

Gelman: It's a law.

Young: Wieden+Kennedy had an alliance with McCann Erickson, in which we had creative control. I took over part of their creative team, which was four designers, and filled the other positions with new staff. It was complicated. I spent two years setting up, meeting people. And again, in Japan, things do not work the same as here. You can't just call people and say, "Hey, my name is Young Kim, I'm from Wieden+Kennedy, I'd like to meet you." It doesn't work like that; it's all by introduction. They observe you for a while and see what kind of work you are doing. Then they approach you. Two years of just building the foundation and searching for designers, art directors, and film directors, but also I hit the streets. I hit all the nightclubs, the art scenes, and I met up with DJs, rappers, and curators, architects, yakuza and artists. I started bringing high school kids into the studio. I let them intern, and I watched how they worked, and I slowly began doing projects with them, allowing them to become designers by actually doing it professionally, hands-on. I don't really know if it's still done, but then it was entirely new. In Japan there's a very strict system. If you want to be a designer, you have to go to college. If you don't go to college you can't do it. So I was going against the grain and bringing all these kids into.

Gelman: Did you learn this approach in Portland? Or did you bring this approach to Wieden+Kennedy?

Young: I think that might be part of the reason they hired me at Wieden+Kennedy, because I've always been interested in street, alternative creative scenes. I've always kept in touch with the street/creative community. When I was at Ear, that was a total underground magazine. We just did it because we loved the music. And I kept in touch with all those people. I never looked at it like that then, but all those contacts became my assets. I think that's what Wieden+Kennedy saw in me and when I went to Tokyo. New York is the hub of an international creative pool, so I met a lot of Japanese people in New York and some of them ended up going back to Tokyo. So, when I got to Tokyo, I just called them and they started hitting me with all the right contacts, where to go for all the cool happenings.

Gelman: How did the professional community react to all of this?

Young: They said, "Hey, that's not fair," and I said, "Hey, life is not fair." If we're doing what we're supposed to be doing, targeting the youth market, we have to get to know what these kids are doing and be part of that. We can't just sit up in an ivory tower and say, "I think this is what kids like these days. This is what's hip in music now." By the time it's in Vibe, Studio Voice, or Relax, that shit is already old. You have to hit the ground and find it yourself. When I see Sprite commercials, all these hip-hop things, that shit is lame.

Gelman: But in the design community you started to gain a reputation as a troublemaker?

Young: I don't know about troublemaker. I just never really was part of it. I just did my own thing and that was it. I never entered any competitions -- when I was at DoubleSpace they would enter some of my projects and I won some awards, but that was never my interest.

Gelman: You made a lot of people upset?

Young: Yeah, in Japan. My colleagues in Japan. If you're a creative director, that means you put in about 30 to 40 years in a company. By the time you hit your late '40s or '50s that's when you get the title of creative director. I showed up, early '30s, and I'm totally against what they're doing. I go in and I get my work done. I was very outspoken about that and I guess they didn't like that. When I went to Japan, I was very naive. I was trying to change things in a very Western way of doing business: "Bam, I want this done right now, and do it my way."

Gelman: Did you succeed?

Young: No. I was very naive. There's a balance of things. There are certain things in the Western way that I don't like and there are certain things in the Japanese way that I really respect. I had to make a decision on...

Gelman: How to mix the two?

Young: Yeah. The two different ways of doing things and making it into one. So these are the things that I learned. It was the greatest experience that I've ever had. I didn't know what it required or what I needed to do. If I had known, I probably wouldn't have taken the position. But I was still young and crazy. It was the hardest thing I had ever done in my life. But I did it, I am proud of it. No paid education could have given me this lesson. It gave me great credibility, and I met some great people. But I started losing interest in advertising and design, just climbing up that ladder, people started doing things to get awards, to be in trade magazines. That was when I met you, coming close to that crossroad where no matter how hard I worked for someone or a company, it was never going to be mine.

Gelman: You don't own it.

Young: I don't own it. It doesn't matter how many awards you have, how great a reel you have, that's not going to pay your bills when you get old and that's not going to give me a name. That's when I decided that I really wanted to focus on something that's mine. With all these things that I've learned, I wanted to apply them and make something out of it.

Gelman: So that's when you started your Suitman project.

Young: The Suitman project actually started when I moved to Portland. I had to ship all of my belongings and I decided to drive my car out. I decided that I was going to wear my black suit every day until I got to Portland. It took me seven or eight days to drive out there. I was wearing this suit driving through the Midwest. I also had these tinted yellow glasses on and I was just encountering people in passing. They had such a bizarre reaction towards me because I was wearing a suit.

Gelman: Sure.

Young: They didn't know how to deal with me. I had teenagers coming up to me and they were disgusted. Some asked me if I was a famous movie star from Hong Kong -- all kinds of weird responses. I had to document it.

Gelman: How?

Young: I had a friend driving with me and we started to take pictures. It was more like a photo journal that I was keeping through the trip. While working in Portland, I started traveling a lot to weird absurd little towns in Europe and Australia. I started taking this suit and the rest is just history. People ask me what the meaning is behind it. It's all about my alienation in my so-called home [America] and where I am from [Korea]. I don't fit in either place. Therefore, my existence as an alter ego creates its own world to travel through.

Gelman: And you've built a substantial body of work.

Young: It's 5,000 photos and 10 videos. In 1997, Yohji Yamamoto from Tokyo called me up and asked me to create an image for his second line, called AAR. I proposed some ideas and showed him some of my photographs. He said, "I don't like it, I like your photos. Do something with that." I came up with a concept; he said, "Do whatever you want." I shot five commercial spots with Suitman. I won some awards again. It was picked as one of the fashion campaigns of the year in Japan and Studio Voice. That gave it a little bit of a name. A year after that he invited me to Paris for men's fashion. I did another piece out there. I've been very selective about who I want to work with. I felt the time wasn't right, until this year, when I was offered to have a show at Alife by Rob Cristofaro.

Gelman: An exhibit.

Young: It was a very successful turnout. I used every resource that I had. And everybody came and pitched in. I wanted to do something where people get involved in the events. I did a little performance art, and that's where the process of Suitman development is right now.

Gelman: What's next for Suitman?

Young: People ask me, "What is Suitman? What do you do?" I take pictures, I design products, I've been doing film, performance art. I want to start doing clothing lines, and I want to make suits. There are all these things starting to open up to me.

Gelman: New opportunities...

Young: I was approached by Sony a few years ago to develop a video game for Suitman, where the character would be dropped off in the middle of major cities, like Paris or Tokyo, and he has to find the quickest way to the bus terminal, train station, or airport. I'm working on a website for Suitman and going to start having products, all this merchandise will be on sale. I just need to focus and choose which direction I want to take.

Gelman: Are you working on any commercial projects at the moment?

Young: After I left Wieden+Kennedy I started directing commercials. I have a pretty good reel right now. It's been five years. I've been with three different production companies. Right now, I'm with RAW Film.

Gelman: Tell me about this place.

Young: This studio is called Alife Creative. I have four other partners. Basically its the Alife New York crew: Rob, Tony, Arnaud, Tammy, and I. I met Rob 10 years ago at the fashion magazine where he was my assistant. When I moved back to New York City three years ago, we reconnected again. We've always said we should work on some projects together. We are working on two or three small projects right now. Alife is a new center of street artists that are coming together; that's the hub right now. During the day so many corporations -- like Adidas, Puma, you name it -- all these major youth market people just come in there, sit down, and ask questions about what's hot in the street right now, what's going on. And they're always asking -- the Alife guys are very friendly, telling them what's going on and shit. And these companies are turning around and making money off that stuff. So we said "Wait a minute! There's something wrong here." So we decided to open an office.

Gelman: If you want to know what's going on...

Young: We'll give you a full report. We've been asked to do things for seminars but they'll say, "We don't have any money but it will be great exposure for you. We got all these major corporations from around the world, they're going to come and listen to everything and see everything you're doing. So can you put together a two- or five-minute video?" Then they start bragging that these people are paying 150,000 dollars to be here. In this room there must be about 500 people, and they're paying 150,000 dollars each; shit, that's a lot of money. Where's our cut? It's not right.

Gelman: You're well acquainted with the business and corporate world.

Young: I'm from there.

Gelman: But you can really leverage and create that image.

Young: I don't look like I'm from the business world. But I've been in that world most of my career. Now I'm playing it on my own turf, on my own territory. I don't really need to kiss anyone's ass. I don't need to make a million dollars as long as I can pay my bills.

Gelman: Have you thought about becoming an advertising company?

Young: Becoming part of an advertising company?

Gelman: Being an advertising company. Or a new youth marketing company?

Young: Yes and no. That idea sounds good. I've had people offer me partnerships for opening another agency. Do what I did for Wieden+Kennedy in Tokyo and all this stuff. I don't really know if I want to go back there again. Unless I change things around drastically to a new way of working.

Gelman: You can do it on your own terms.

Young: When you say, "On my own terms," usually they say, "Yes, yes, yes," but the reality is that...

Gelman: You have to play by the rules.

Young: Society has strict rules, there's only a certain amount you can change and I'm not going to be a dreamer. I would rather just control my small surroundings and I'm happy. I'm not saying no if opportunities are just right and everything is right, but now it's not something I'm looking for.

Gelman: Right.

Young: It's really interesting; about a month ago I was reading this article. A British creative director -- he was saying there's nothing fresh in advertising. I've been to some of these agencies, like Cliff Freeman, while I was at Wieden+Kennedy. You get these young art directors and writers that try to be hip, cool, and street. They talk the lingo like "Yo, what's up ninja? How's it going homey?" They got all the right shoes and the right pants and haircut. They're getting that shit from somewhere else. They're not the originators. They go out and come down to the Lower East Side to see what's cool. They take from magazines and serve it up for the masses.

Gelman: Processed and appropriated.

Young: I would rather have someone do their own shit even though it sucks. Just stick to it and be persistent and do it. That's what I did with Suitman. When I first showed people, they laughed at it. Galleries were laughing at me, "Yeah, thanks we don't need your family album photos." I have a piece at the Standard Hotel in L.A. The new downtown one. I never thought they would call me and ask to put one of my pieces there. You have to be persistent and believe in yourself and just fucking keep doing it.

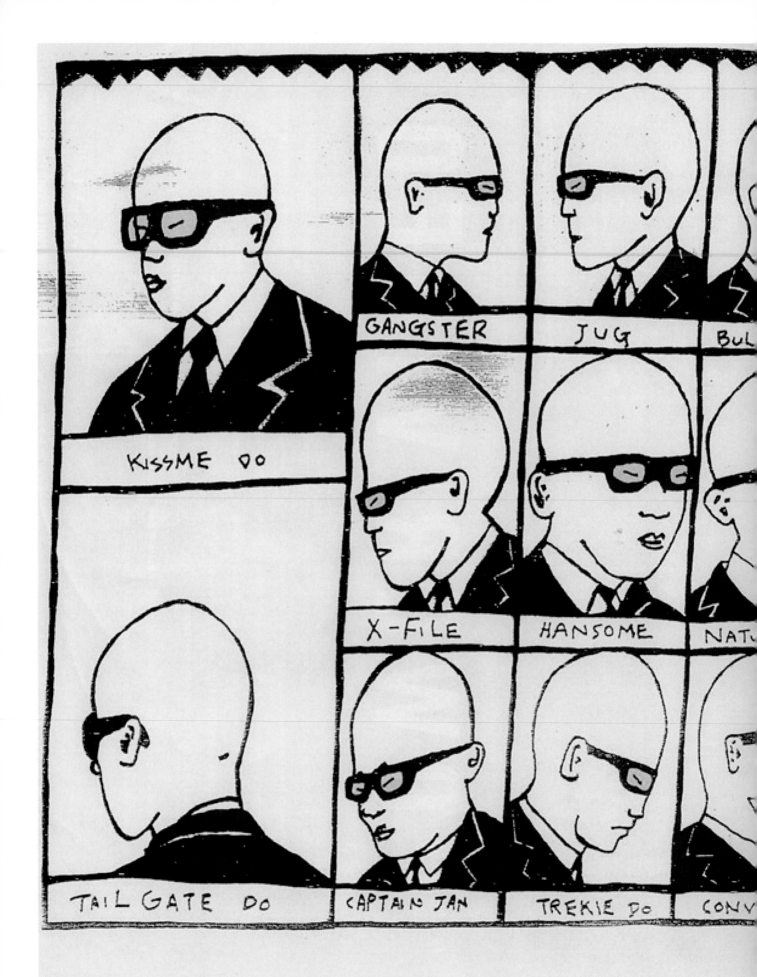

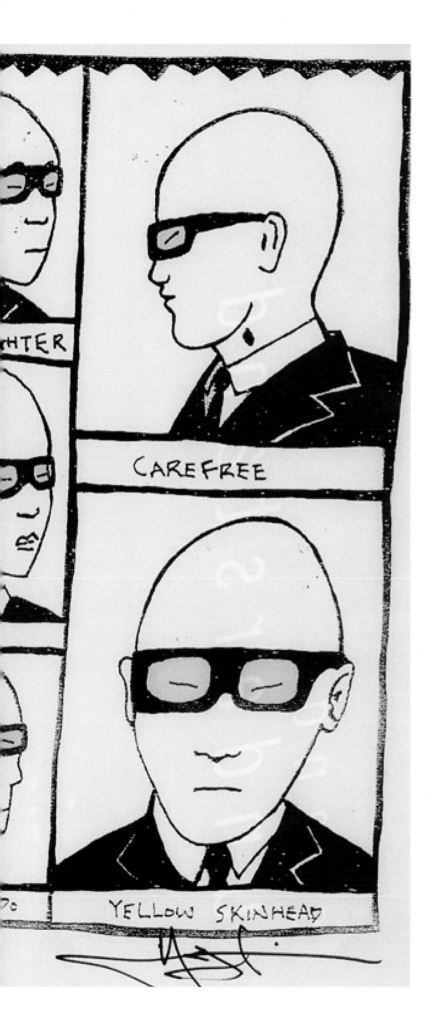

CAREFREE

YELLOW SKINHEAD

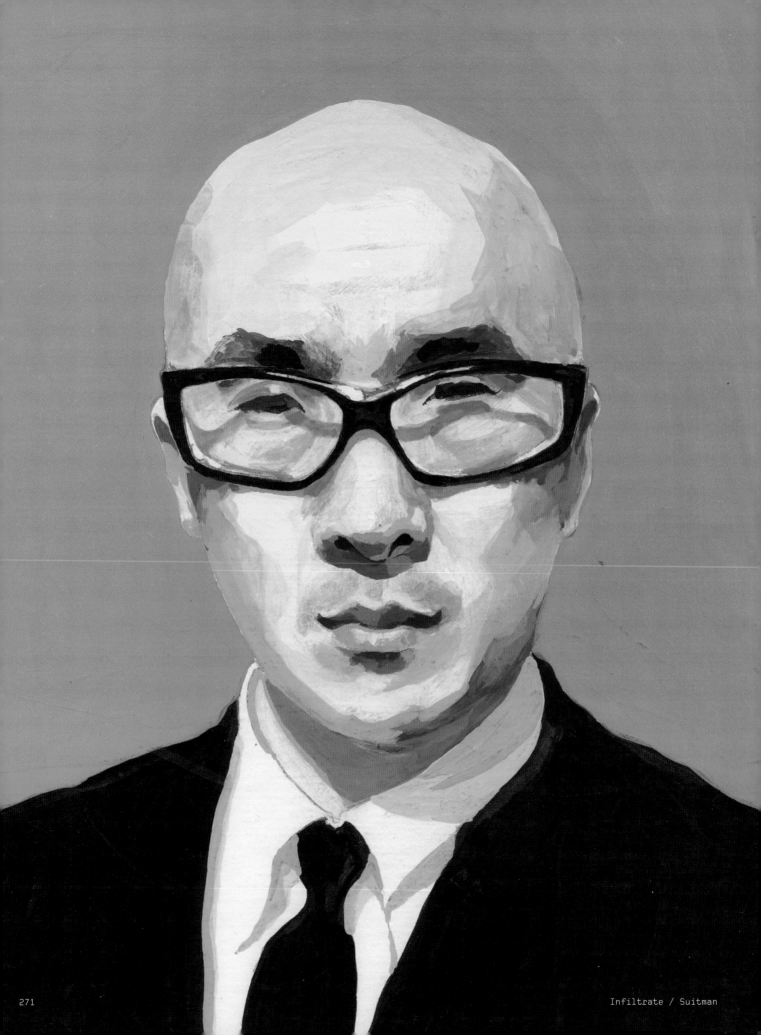

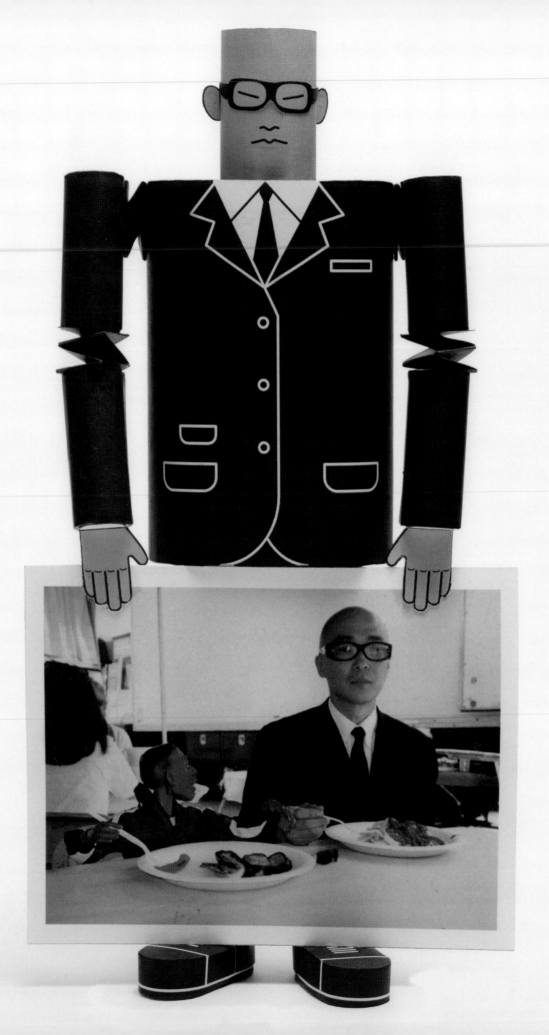

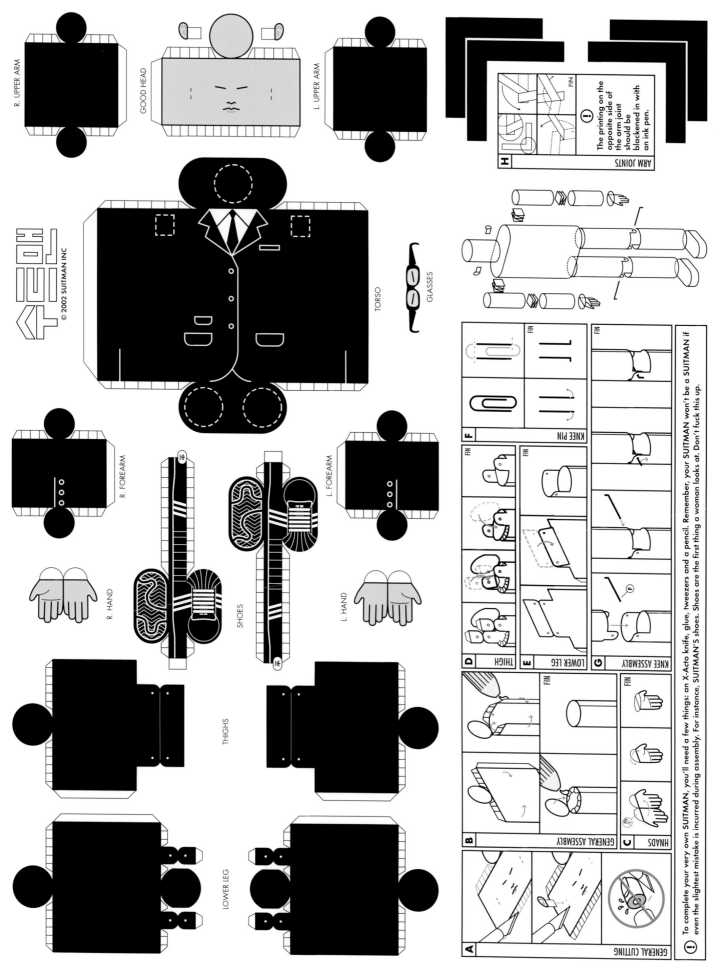

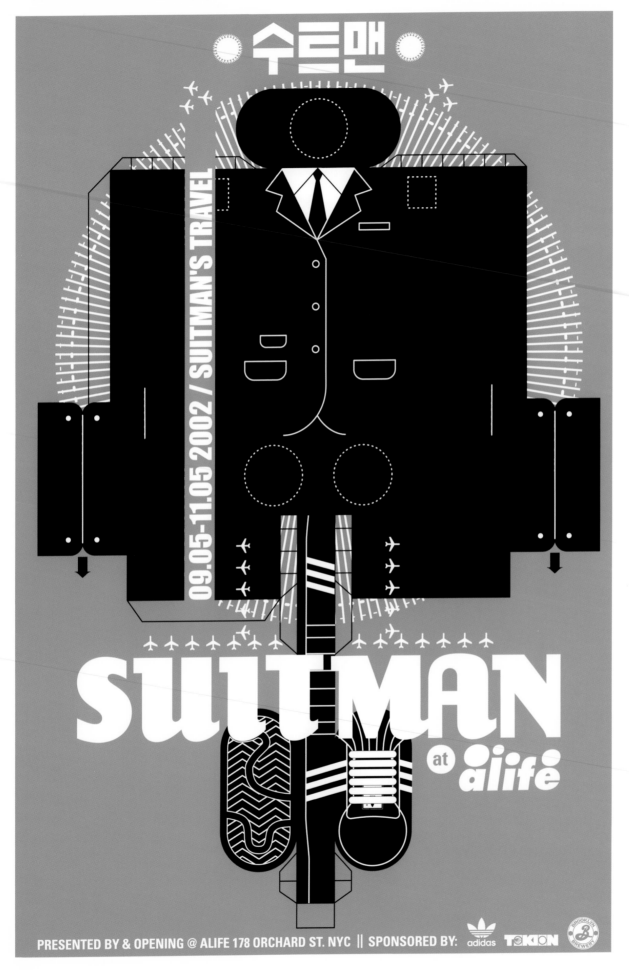

SUITMAN at alife

09.05-11.05 2002 / SUITMAN'S TRAVEL

PRESENTED BY & OPENING @ ALIFE 178 ORCHARD ST. NYC ‖ SPONSORED BY: adidas TOKION

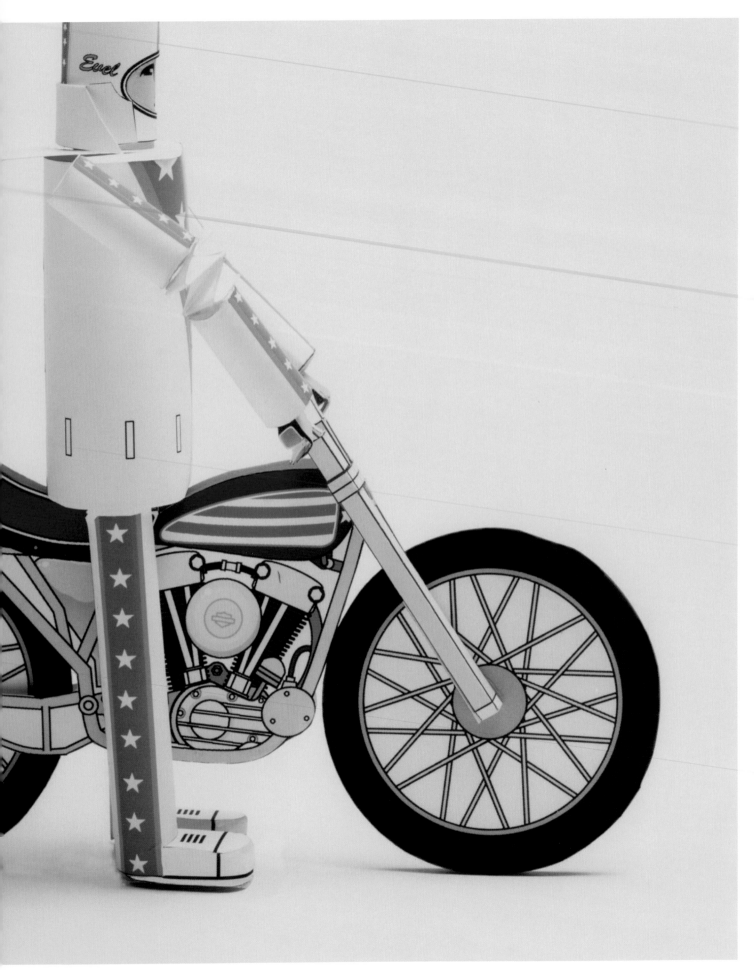

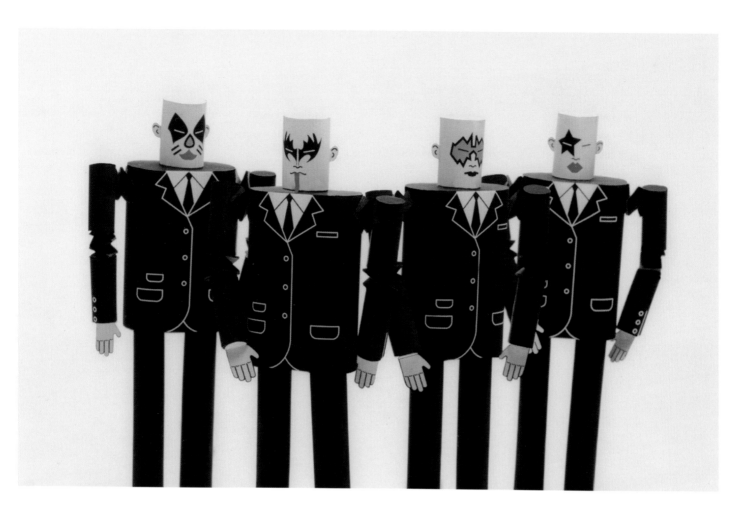

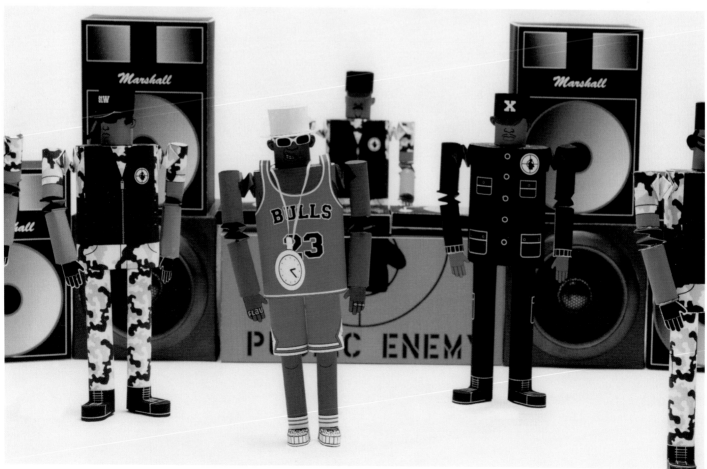

Infiltrate / Suitman

Pages 268-269: Barber menu. Ink and paper. Pages 270, 273: Alife 2002 Show Giveaway kit. Client: Adidas, Tokion. Designer: Craig LaCombe. Creative director: Young Kim. Page 271: Portrait. Artist: Big Bird Shiramizu. Acrylic on board. Page 272: Suitman. Designer: Craig LaCombe, Davi Russo, Kumi. Creative director: Young Kim. Paper and glue. Page 274: Suitman's Travel Show poster. Designer: Chris Rubino. Silkscreening: Sean Donnelly, Roger Bova, Craig LaCombe. Pages 275-276: Evel Knievel. Designer: Craig LaCombe. CD: Young Kim. Paper and glue. Page 277, top: Kissmen. Designer: Craig LaCombe. Creative director: Young Kim. Paper and glue. Page 277, bottom: P.E. Designer: Craig LaCombe. Creative director: Young Kim. Paper and glue. Page 278: Bruce Lee; Designer: Craig LaCombe. Creative director: Young Kim; Medium: Paper and glue. Page 279, bottom: Portrait of Suitman; Painter unknown; Gift from artist in Japan. Pages 280-285: Suitman's Travel, Young Kim and various friends on the road. CD: Young Kim.

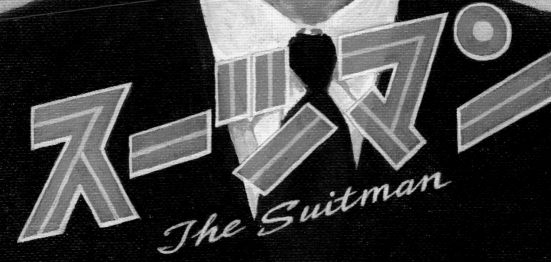

東 京 TOKYO

スーツマン
The Suitman

一 番 NO.1

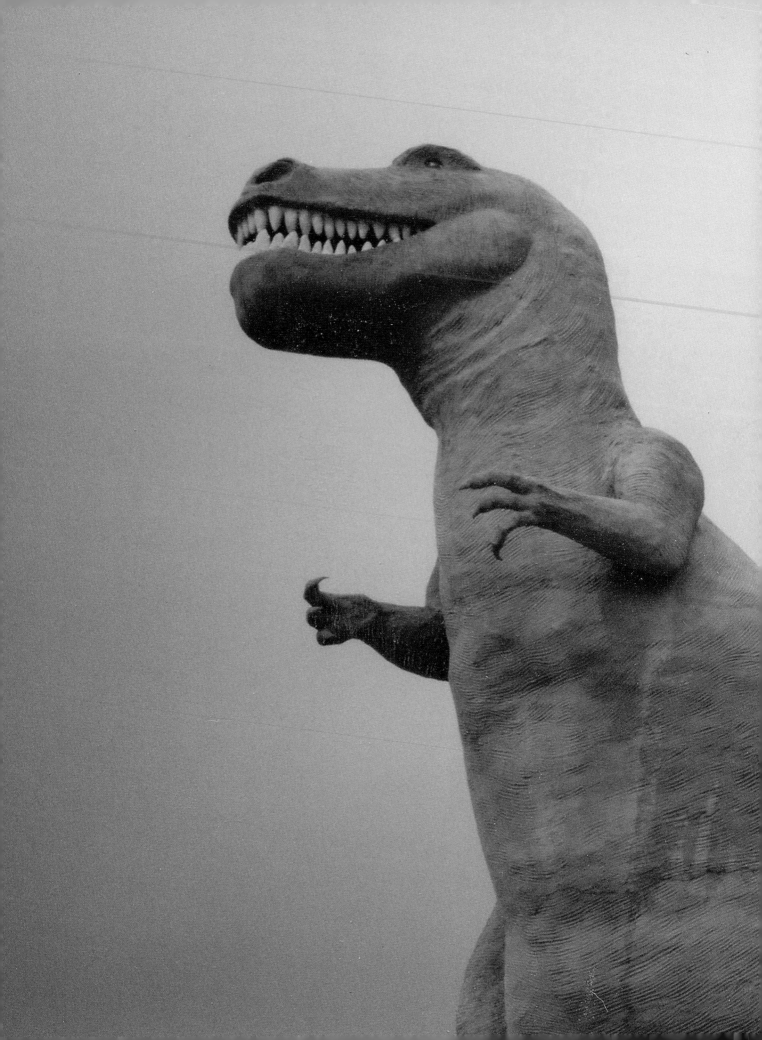

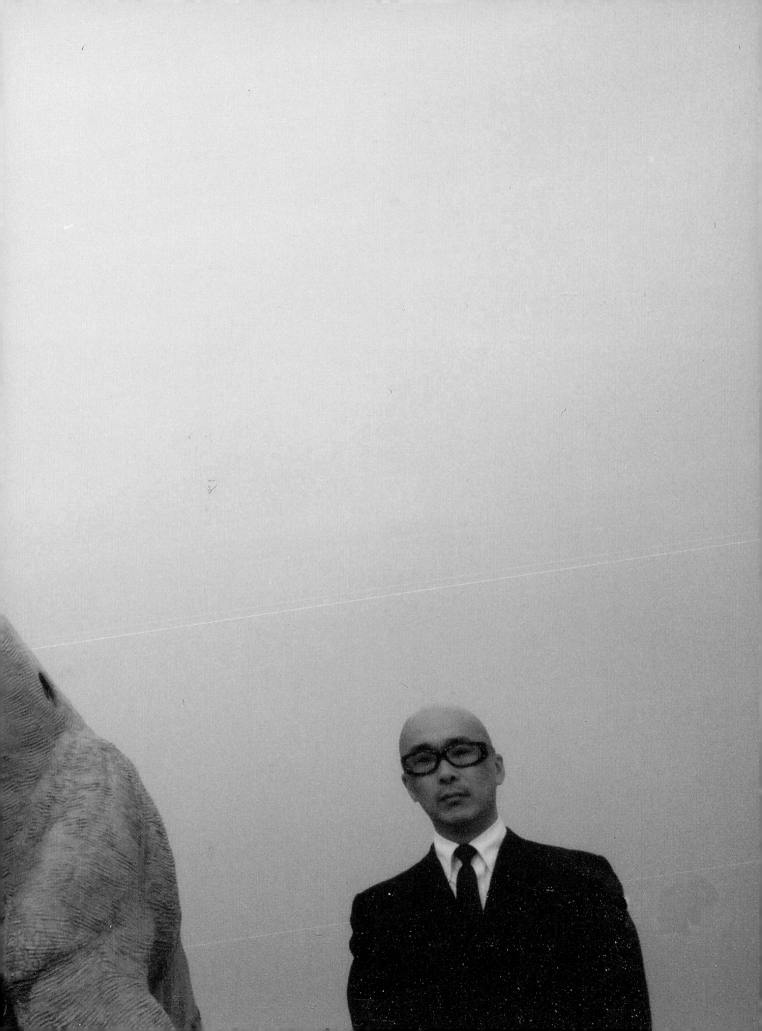

282

Infiltrate / Suitman

Infiltrate / Suitman

Infiltrate / Suitman

A conversation with Sung Joong Kim.

In compliance with the subject's request,
all sensitive information has been
blurred.

Interview Continues at:
http://www.infiltratenyc.com/022

Infiltrate / Sung Joong Kim

*This obscure formula describes the complex structure underlying the multiple (to say the least) narratives of Perec's wonderful novel, *Life A User's Manual*. A 'bi-square' is an elaboration on the familiar 'magic square' in which no number recurs and in which all the rows and columns add up to the same total. In a 'bi-square' each space or location is occupied by two elements instead of just one: e.g. by a letter of the alphabet as well as a number or by two numbers drawn from independent series. Perec's 'bi-square' has ten locations in each direction and thus is 'of order 10'. A 'quenine' is a mathematical formula invented as a formal constraint in the writing of poetry by Raymond Queneau – hence its name. A fuller description of these devices can be found in David Bellos's *Georges Perec: A Life in Words*.

Edited and Translated by John Sturrock

288

Page 288: "I was born," 2000. Text: Georges Perec, edited and translated by John Sturrock. A single sentence from the essay occupies each page of this book. The sentences are sequenced in reverse and the vellum paper gradually reveals/hides the earlier sentences. The book can be read from the back to front to arrive at the "present" (cover) or from the cover to the back (delving into past). Page 289-292: Curren[t]cy (Version A and Version A Alt.), 2001-2002. Designer: Sung Joong Kim. Technical support: Dan Michaelson. Production info: Macromedia Director-based program (prototype). The Curren[t]cy project is an experiment in the visual/informational representation of modern paper currency. Rather than exploring static forms or cultural icons, live financial data (currency exchange rate) is collected and applied to the visual form of the currency in real time. The bill is in constant flux responding to the value. The project consists of the prototype program, project book and a dispenser machine which prints the bill of the moment as you touch the bill on the touch-screen. Page 289: Curren[t]cy project book. Designer: Sung Joong Kim. Includes three alternates: the visual form responding to the value; the physical property of the bill itself is modified according to the changes in value; revealing a subliminal message from growing wealth (as bills get stacked). Page 292: Curren[t]cy project book (spreads). Designer: Sung Joong Kim.

Infiltrate / Sung Joong Kim

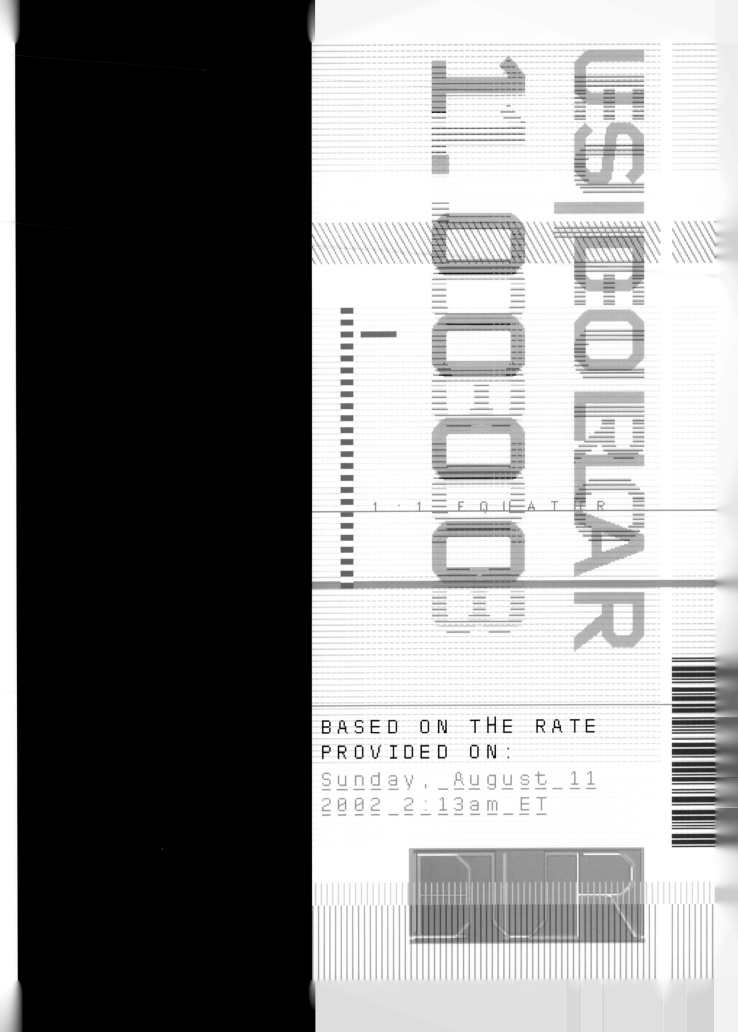

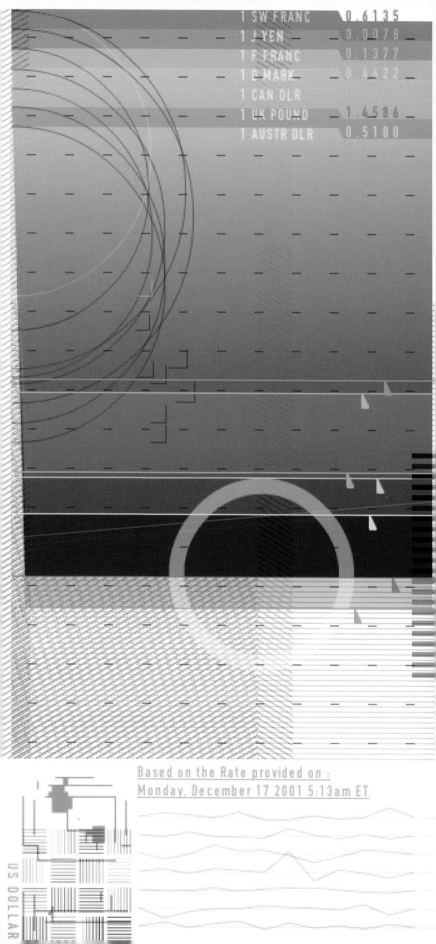

| | |
|---|---|
| 1 SW FRANC | 0.6135 |
| 1 J YEN | 0.0078 |
| 1 F FRANC | 0.1377 |
| 1 G MARK | 0.4422 |
| 1 CAN DLR | |
| 1 UK POUND | 1.4586 |
| 1 AUSTR DLR | 0.5180 |

Based on the Rate provided on :
Monday, December 17 2001 5:13am ET

US DOLLAR

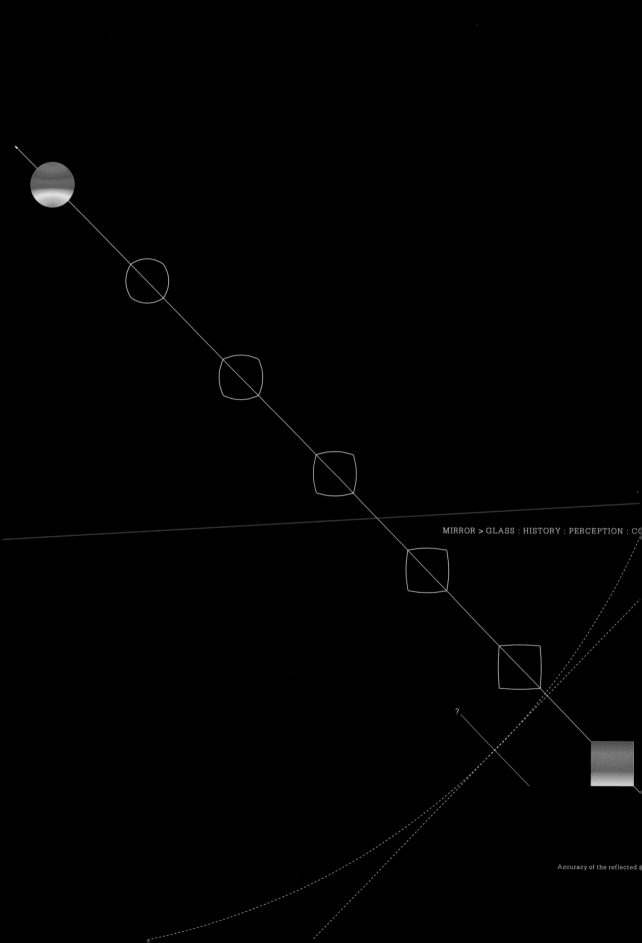

MIRROR > GLASS : HISTORY : PERCEPTION : C(

?

Accuracy of the reflected I

*design eye:*

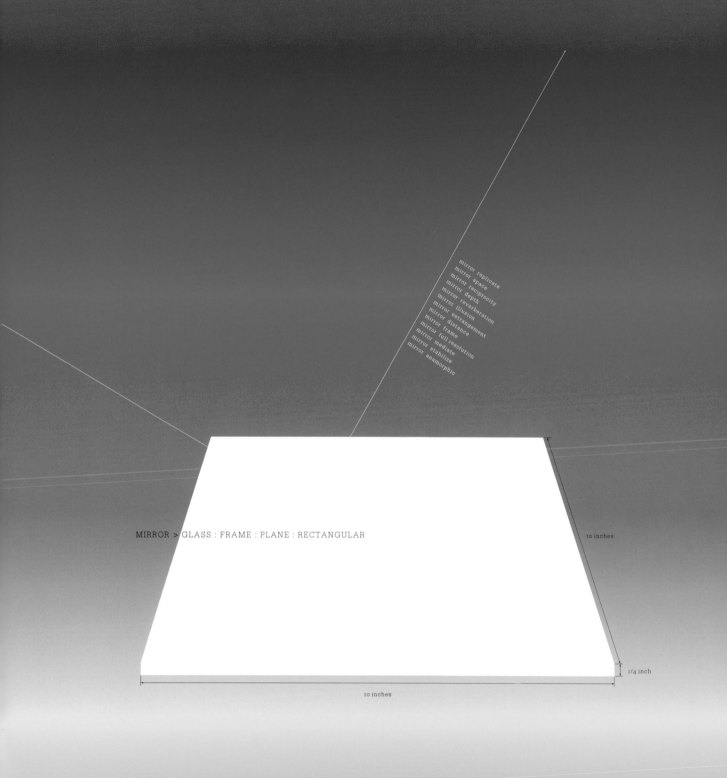

MIRROR > GLASS : FRAME : PLANE : RECTANGULAR

mirror replicate
mirror space
mirror reciprocity
mirror depth
mirror reverberation
mirror illusion
mirror estrangement
mirror distance
mirror frame
mirror full resolution
mirror mediate
mirror stabilize
mirror anamorphic

10 inches

1/4 inch

10 inches

1

2

3

Pages 293, 294 (bottom): Non-symbols, 2001. A project based on selecting an animal and devising symbols representing its characteristics. These drawings are from the last stage of the assignment in which the basic symbols of sloth were mixed together to form new symbols. Page 294, top: Open, 1998. A "teaser" poster for a personal book project on non-linear reading. The quote by Jorge Luis Borges was projected on an empty spread of a book using a slide projector. Page 296: *Monthly DesignNet*, March/July 2000. Client: Monthly DesignNet. Editor & co-art director: Jong Won Baek. Art direction and design: Sung Joong Kim. Invited as a guest designer for *Monthly DesignNet*, I designed the special features section where the format of the pages would change month to month. Initially scheduled to be an one-off project, the collaboration was extended an additional three months. Pages 295, 297, 298: Mirror, 2001. A set of three posters exploring various properties of an object. Throughout the set, the spectrum of color (visible light) is used as the main element in representing the object "mirror" since its property is always being changed and defined by light.

Infiltrate / Sungjoong Kim

A conversation with Jakob Trollbäck, president, Trollbäck & Co.

Gelman: I think I met you about seven years ago, when you were --

Jakob: I was only 23 then, if I'm...

Gelman: <Laughs> Yeah. You were creative director at R/GA -- we actually got to work on some projects together. And you left a few years later.

Jakob: Yeah, I left about five years ago.

Gelman: Did you simply feel you were ready to go on your own, or were there other reasons?

Jakob: I stayed at Greenberg for a long time because it was a great place to work, and a great place to learn things, and because there were so many talented people there. And it just became an issue of what kind of business I wanted to do -- what kind of work. Greenberg was a big company with huge overhead, and that means that you don't do small jobs, you don't do a music video, you know...

Gelman: It doesn't pay.

Jakob: Yeah. So I was interested in doing something that was a situation where I could control whatever I was going to do -- it's as simple as that. I had been talking for a long time, actually for many years, with Antoine [Tinguely] that one day we should do something together. So I knew there were people that wanted to work with me.

Gelman: I remember your crew; they were a tight group of people. You built that group at Greenberg, and then you took some of them with you.

Jakob: Yeah, well we were two people who -- it was me and John DiRe -- and we got a really strong team together, with good vibes. In the end, only four people came and worked here. They didn't leave at the same time, but we all got together in the end. I think that has helped us a lot, because many new companies have a lot of political bullshit to deal with, and these were people that I had worked with for a long time, the core group. So it was sort of the same good team, but now we could control what we were doing.

Gelman: What was Bob's [Greenberg] reaction to that?

Jakob: Well, you know, Bob -- it's funny because I was asking him at one point [when] there was a big flurry of people leaving I said "Well how is this?" And he said, "Well of course it's not fun, but you learn that people have to do what they have to do." And I was thinking about leaving when John DiRe, who was the other creative director at that point, went in and said, "I'm leaving." So then I knew if I left he would be out of creative directors; I was nervous, but all he said was, "That's a bummer, but good luck."

Gelman: So you stayed friends?

Jakob: Yep. Yeah, we did. I think that there's a lot to be said for that. I wouldn't have stayed at Greenberg that long if we didn't have a good relationship, and a good relationship can survive those kinds of things. And it did.

Gelman: Did you inherit any clients?

Jakob: No. There's been one or two people, well probably more than one or two, that have come here since. I think that the only thing that was sort of overlap was that we did something for Intel that I had been doing while I was at R/GA, and then Bob was like, "Yeah, I think you should just do it." It's not as true now, but when we started, there was so much work out there that it wasn't an issue.

Gelman: Who was your first client, or first few clients?

Jakob: Well, the first job that we got was to do a remix of a video for Blondie that they had shot and then they looked at it and it looked completely uninteresting and boring. So they came to us and asked if we could save it.

Gelman: It was their first video after the reunion?

Jakob: I think. First or second. Probably the first. What we really did was a remix of it, a visual remix, where we were doing a lot of things, editing and running stuff at different speeds. We did a lot of image treatment.

Gelman: You used their footage, cut it up, and pasted it back together?

Jakob: Yep. We shot the monitors with video cameras, gave it an experimental art look. So it was fun. But I guess that we've never had..well actually until we got the job to redesign AMC -- which was last fall -- until then we haven't had one client we felt was "our client."

Gelman: What defines 'your client?'

Jakob: They're not going to anyone else; the only thing that they're discussing going to someone else for is print, which we've now started discussing as well.

Gelman: You do print?

Jakob: Well, we're designing a magazine, and a lot of us have print backgrounds, and for almost all of the pitches that we do for broadcast work, we present a print campaign with it.

Gelman: So you think you have a chance to get the print portion of AMC?

Jakob: I think that would be very logical; there is, of course, the conception that you have to talk to certain people for certain things, and that means you're a specialist. And that means that if you're going to do a print campaign, then you go to an ad agency. But if you find a really good conceptual design studio that is defining what a brand is, it may be best to ask them what the print should be in order to craft a complete image. I don't mean to sound arrogant, but I think that most motion design studios don't necessarily have the in-house capabilities to do anything else, because you need writers and people that are conceptually involved in the branding. Whereas, we have those skills. AMC had a couple of conferences here, and they are truly looking at us as branding gurus.

Gelman: Your business is still primarily the moving image, film titles, etc. A better place for a motion graphic company is Los Angeles. At what point did you open your office in L.A.?

Jakob: I think it's been around for almost three years. But now we're discussing getting production in there. So far it's just been basically an outpost, for our L.A.-based clients.

Gelman: But all the work is still done in New York?

Jakob: Yeah. So far. I think that next year we'll do some production there. I don't know if it's really true that it's better in L.A. It's definitely different, but the kind of titles that we're doing -- first of all, you're not going to make money on titles, regardless of budget; you can break even, but not that often. So if you're doing that, you might as well work with the most interesting movies. And those filmmakers are often in New York. There is good advertising being done on the West Coast...

Gelman: L.A. and San Francisco?

Jakob: Yeah, and Portland, Seattle, you know, that whole thing. But there's more work happening in New York. But what we're doing more and more now, is we've been starting to work with different kinds of installations and environmental design. One thing we are working on is a project for a big public space in Korea, which we were planning on doing different kinds of installations about communications, installations about --

Gelman: Video installations?

Jakob: Yes, and some more esoteric ideas as well. And we got an installation for the renovation of HBO Films office in L.A. That's something that we're getting more and more excited about. Because once you get it out in an environment, it's endless what you can do. All of a sudden you can do a lot of things that are unexpected and conceptual.

Gelman: But still tied in to that medium in one way or another?

Jakob: Yeah. The idea for the HBO office is not even a show space. It's a space designed for the people who work at HBO Films. And what they want to do is that they want to feel like they're not just in L.A., isolated, so we've been talking about different ways to pipe images from all over the world and display them on the walls, and doing different things with that -- one idea that we had was to do web cams in 24 different time zones and have that running as a ribbon through the whole space, so you could literally see the sun going up and setting in different locations all over the world.

Gelman: HBO locations, or whatever locations?

Jakob: No, just whatever locations. The whole idea was just to bring the whole world in there. We would definitely do stuff with swimming pools, art pieces;

we were thinking about shooting people from below, diving in, and doing stuff with that, maybe in slow motion, and then also at the same time maybe also pipe in information from Times Square. Maybe also having parallel situations, you know, having someone walking down the street in New York, and someone walking the beach in L.A. It's so different when all of a sudden you're doing installations that are in work spaces or public spaces. That's the best. The thing that I've been talking to people about lately is, in order to stay young, in life and as a company, you just have to change all the time. And we're in a phase of constant flux, we're always changing. We may start to do a lot of environmental design, then that may lead to. God knows what. I mean I think that it would be great to design fabrics, product design would be fabulous; we've just installed some software and set up a room so we can start to do original music.

Gelman: What kind of software?

Jakob: We're working with Logic, Reason, and Live, and then we have a couple of keyboards and guitars and stuff like that. And it's very -- well, frankly it's just me having fun at this point. But if I find someone, some talented person, who wants to do more of that, that may grow.

Gelman: So far, who has been doing your soundtracks? Obviously the client supplies some, but who else?

Jakob: We've worked a lot with Sacred Noise. I've worked with them forever, and lately we've started to work with another music company as well.

Gelman: Which one?

Jakob: They're called Human. They're really cool. The advantage of working with someone for a long time, like Sacred Noise, is that you know them, you can communicate, you can say what you want. The disadvantage is, it's like eating at just one restaurant all the time: Sooner or later, doesn't matter what you order, it's all gonna taste the same to you. You start to get the taste of the actual restaurant. I've experienced that many times.

Gelman: For example.

Jakob: Well, there was a restaurant in Sweden which was a brilliant restaurant, and I went for lunch every day there, because I had a record store there that was right next door to it. You know, this is Europe, so you close your store and you go and have dinner, or lunch.

Gelman: You had a record store?

Jakob: I did. Yeah.

Gelman: Crazy. I knew you were a DJ, but I didn't know you had a store.

Jakob: Yeah, it was a small store, and I had it with a few friends. It was fun. It was sort of -- very much like what Other Music would have been, you know, 20 years ago.

Gelman: Like Brian Eno and Fripp and...

Jakob: Yeah, yeah, yeah, all that stuff. And a large section of world music -- if you wanted Indian music, you came to us; we knew the difference between North and South Indian classical music, and --

Gelman: In Stockholm?

Jakob: It was in Stockholm, yeah.

Gelman: Is it still around?

Jakob: Nope. We were getting tired of never being able to pay our bills. I mean we always sort of, almost, broke even. We got an offer from a person who wanted to start a big record store in a central place, and he wanted to take our record store and add a section with basically rock music to make a commercial store out of it. When I was done with that, I got involved with a club and being a DJ.

Gelman: What kind of music?

Jakob: Well, you know, this was mainly through the '80s.

Gelman: New wave?

Jakob: No, it was a lot of funk and soul and jazz, Brazilian and African music.

Gelman: So it was a club for grown-ups?

Jakob: Yeah, yeah it was. <Laughs>

Gelman: Do you want to get back to that?

Jakob: The way it works, since it's a big company, is that these days, I do basically nothing hands-on. I get a lot of input and satisfaction from seeing all the creativity that's happening in the studio. But for me, I feel like, okay, what's gonna be next?

Gelman: You're always thinking about the next thing.

Jakob: Yeah. So that's why I started to do some music. And it's funny, because it's the area that's closest to my heart, and it's the one area that I have no idea if I'm any good at it. I know that I'm a good DJ, and I know that I'm good at reproducing songs on my guitar, like sitting and playing. But I don't know if I have it in me to make original music that's any good. That's for the future to see.

Gelman: Who in your opinion is doing original music today?

Jakob: You should listen to Akufen. It's a Canadian guy, I forget his name. He's doing something that's called micro-sampling. So he's creating a basic beat, and then he's just stealing little snippets of audio, and he gets music out of it, and it's fantastic. You'll dig it. The interesting thing with some of those people is that they start to do stuff that, you know, the modernists of 20th-century classical music were doing. You realize that it's sort of the same approach as Alderetsky, or Lutoslawski, or Stockhausen, or, you know like Senakis, and Bariza, Bullies, and it's really great to hear that kind of experimental music-

Gelman: Using new technology and new instruments.

Jakob: Yeah. Or like George Antheil, who did this piece, I forgot the name of it, that had jet motors in it. I mean, that's something, it was at that point when you needed to have a jet motor. Now, of course, you can do things like that-

Gelman: Jet motors in the studio?

Jakob: I don't remember how the hell he did that, but, yeah. It's like, one of the things that excited me the most in the early '80s was a recording by Thomas Dolby, who was a brilliant producer, and unfortunately I don't think he ever lived up to his potential. But he made a pop song, and then all of a sudden he had a pneumatic drill out on the street, like, you know as a break, like "Pd-d-d-d-d." And I remember being so excited.

Gelman: The effect of the software is amazing; any kind of sound source can be used to create music.

Jakob: Yeah. So it's great, and in the last three to four months I've started to read all of these music magazines, and computer music, and future music, and what is that magazine called, Next? Exit? Exit is another magazine.

Gelman: It's a fashion magazine, I think.

Jakob: They have just like plain colors, good magazine.

Gelman: Just a gold-leaf cover.

Jakob: Yeah. They have one green, one black, one white, whatever. But anyway, when you start to read all this stuff and start to understand the potential for making music today, it's just amazing. I really like it. I think that I was also very excited about Akufen because it's sort of the same thing as being a DJ, because when you're DJ, you're really sort of a curator of audio experiences. If anyone is asking me what I think, what my strength is, it's that I was a really good DJ. And I understand how people react if you're doing this and that, and I can look at something in motion and feel like, "Oh, but now this is slow, something there, and now we need to break it off." And it's something that is very choreographed, a way to invoke --

Gelman: I think that's where it comes close to art direction. It's about creating an experience. I remember a project you didn't want to take credit for [at R/GA], you said that your job was just to pick the right people.

Jakob: Well, I think the thing is, when I started at Greenberg, and I was of course a designer, and you want to get more influence, you want to make more money, so you want to move up, so it becomes competitive, and it matters that your design is picked. You know, you wanted your story boards to be picked, et cetera. And then, when you reach a certain level, you realize, okay, I don't have to prove to the world or to me that I can do this, and then it becomes interesting. How can I just facilitate really good stuff happening? And, you know, many times I -- I don't even know today how I would work without all of these people-

Gelman: Without Antoine? <Laughs>

Interview continues at:
http://www.infiltratenyc.com/023/

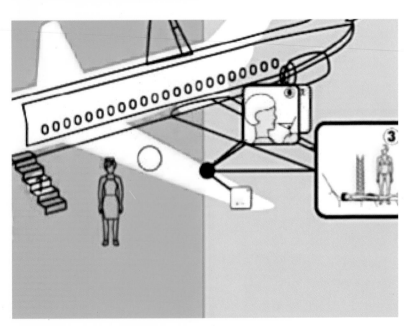

HBO FILMS PRESENTS

GENA ROWLANDS

EXECUTIVE PRODUCERS
UMA THURMAN, JASON BLUM, AMY ISRAEL

SCREENPLAY BY
LAURA CAHILL

DIRECTED BY MIRA NAIR

Page 302, left: Travel Channel Illustrations, 1999. One of our first projects. We made a number of small graphic branding devices for the Travel Channel to use in different promotion pieces. The folks at Trollbäck & Co. fly a lot and we used to collect all kinds of airline emergency instructions. The idea that you would be aided through one of the potentially most serious moments of your life by brightly colored children's book illustrations always seemed humorous to us. The style has been overused since... Page 302, right: Hysterical Blindness, 2002. Client: HBO Films. Directors (sequence only): Jakob Trollbäck and Mira Nair. The Emmy-winning title sequence for director Mira Nair's film, which introduces a difficult problem facing Uma Thurman's character -- a sudden case of blindness. Page 303: TED 8, 1998. Client: TED. Opening titles for the annual TED conference. The speakers' names spin in extruded orbits and finally fall together into an "8".

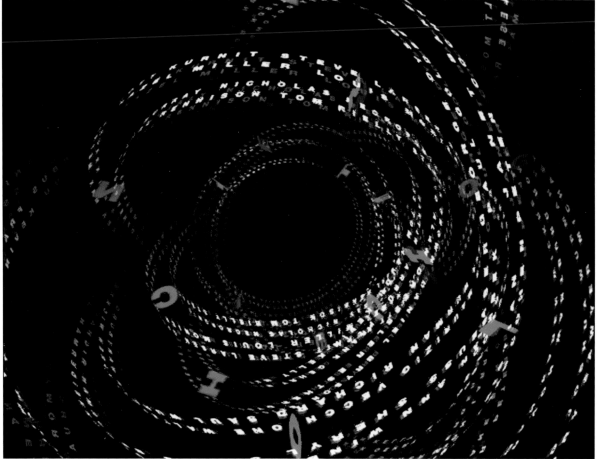

Infiltrate / Trollbäck & Co.